MW01089723

"Boyd Rice is a black pimp."
 – Charles Manson

"Boyd was my mentor."
 – Marilyn Manson

"Boyd is an iconoclast!"
 – Anton LaVey
 The Church Of Satan

"Like all Satanists, terrorists, public enemies and the like, [Boyd Rice] is one of the nicest people you could wish to meet."
 – Marc Almond
 Soft Cell

"Boyd's recordings for Mute under the *nom-de-guerre* NON are legendary. Less well known, perhaps, is Boyd's recording ... under the titular Boyd Rice & Friends. The least best-kept secret about Boyd is that he continues to be a fountain of ideas and inspiration for culture mavens ... You would need a flow chart to document Boyd's influence in the underground culture praxis."
 – Adam Parfrey
 Feral House Books

"The inherent wisdom and mischief that resides inside of Boyd Rice makes me wonder if he just may be the Devil himself."
 – Matt Skiba
 Alkaline Trio / Heavens

"Boyd Rice is one of the few people that has managed to perfectly combine his art and reality in his day-to-day life. He is magick in theory and practice, and it's been an absolute joy to be able to call this inspirational genius a steadfast friend and colleague for so many years. To The Summers In The Sky! *Heilige Leben!*"
 – Douglas P.
 Death In June

"Boyd Rice is an American original. For him, going against the grain is a way of life. It's no wonder that few people can understand his intentions or reconcile his multifarious interests – he inhabits his own realm. I'm glad I was able to spend a few years collaborating with him, and striking blows against prevailing idiocy in the ways we did. Being true to yourself means never having to say you're sorry."
 – Michael Moynihan
 Blood Axis

"Boyd is the most hilarious person I have ever known and I can always count on him to slip something brilliant through the smallest crack in my willful brain and inspire me with it against my defenses."
 – Allison Anders
 Film director, professor, Macarthur fellow, etc.

"From the first drink to the last, there is no finer drinking companion than Boyd Rice."
 – Frank Kelly Rich
 Modern Drunkard Magazine

"I love Boyd Rice. He was always into the same things as I was musically – he used to come to my club The English Disco and enjoy the glitter music! I've always enjoyed his art and writings as well as his collaborations with other artists."
 – Rodney Bingenheimer
 KROQ FM

"Boyd Rice has crossed over into the realm of being a pop icon, not unlike Andy Warhol, Tiny Tim, or Charles Manson. His face is like a corporate logo synonymous with a specific type of worldview. When you see Boyd, it's as though you're gazing upon the Golden Arches or the Swastika. Or both. You dig?"
 – Shaun Partridge
 The Partridge Family Temple

STANDING IN TWO CIRCLES
The Collected Works Of Boyd Rice

"Let no one accuse me of being evil's apologist; let no one say that I seek to inspire wrongdoing or to blunt remorse in the hearts of wrongdoers: my sole purpose ... is to articulate thoughts which have gnawed at my consciousness since I first was able to reason; that these thoughts might be in conflict with the thoughts of some other persons, or of most other persons, or of all persons except me, is not, I believe, sufficient reason to suppress them. As to those susceptible souls who might be 'corrupted' by exposure ... I say, so much the worse for them. I address myself only to men who are capable of examining with an objective eye everything before them. Such men are incorruptible."

– The Marquis de Sade, *Philosophy In The Boudoir*

"Unto the pure, all things are pure ... but unto them that are defiled is nothing pure, but even their mind and conscience is defiled."

– Titus 1:15, *The Holy Bible*

credits

STANDING IN TWO CIRCLES
The Collected Works Of Boyd Rice
Edited by Brian M. Clark
Published 2008 by Creation Books
www.creationbooks.com
Copyright © Boyd Rice and Brian M. Clark 2008
All world rights reserved
ISBN 1-84068-118-7
Design: Tears Corporation
Proofreading: Franklin D. Bell

All rights reserved. No part of this book may be reproduced, stored in a database or other retrieval system, or transmitted in any form, by any means now existing or later discovered, including without limitation mechanical, electronic, photographic or otherwise, without the express prior written permission of the publisher.

acknowledgements

For their transcription and editing of previously published texts contained in this book, the editor is indebted to the following individuals: Frank Kelly Rich (*Modern Drunkard*), Jim Morton (*Pop Void*), Adam Parfrey (*Apocalypse Culture II*), Jim Goad (*ANSWER Me!*), Martin Macintosh (*Taboo: The Art Of Tiki*), Peter Gilmour (*The Black Flame*), Tony Wakeford and Ian Reed (*The Unconquered Sun*), Michel Berandi and Scott A. Peterson (*PANIK*), Charles Powne and James Strayner (*Live In Osaka*), V. Vale, Andrea Juno, Scott Summerville and Mark Spainhower (*Incredibly Strange Films*), Lisa Carver (*Rollerderby*) and Tracy Twyman (*Dagobert's Revenge*). The editor is also grateful to Charlie Martineau and Jacob King for their assistance in transcribing several of the previously unpublished texts contained herein.

Further thanks go out to Michael Moynihan and Kevin I. Slaughter for their help in acquiring unpublished and out-of-print texts, and to Paul Taylor, Rory Hinchey, Mitchell Algus, Giddle Partridge and Kent "Doc" Wilson for supplying images for the Biography section of this book. Additional thanks for selected proofreading, suggestions, advice and other assorted assistance go out to: Larry Wessel, Joseph Choo, Jason Heller, Matthew J. Graziano, Dave Lichtenberg, Andrew Novack, John Moore, Jim Compton, Emily Clark, Karl C. Krumpholz, Adam Pittman, Jodi Davenport, Douglas Seaton, Gregory Daurer, Richard English, Adam Brupbacher, Jinny Shows, John Kyte, Rory Hinchey and Frank Kelly Rich. Further thanks to everyone at Mute Records, Soleilmoon Recordings, New European Recordings and NEROZ.

Very special thanks to Bob Ferbrache at Absinthe Studio for recording, mixing and mastering the spoken word disc *Standing In Two Circles*, which accompanied the limited edition of this book.

table of contents

artworks and photography

lyrics

Introduction
Brian M. Clark

Boyd Rice is one of the most influential and controversial figures of modern American counterculture. Since the late 1970s he has made lasting contributions to the fields of music, art, photography, filmmaking, film criticism, alternative religion and esoteric history, among others; in the process impacting cultural trends far beyond the immediate reach of his own works. The multidisciplinary nature of Rice's activities, however, is by no means all that makes him one of the underground's more compelling and polemic characters. Rice is unique in that he occupies the paradoxical role of one of subculture's most widely respected, misunderstood and hated personae.

Credited with pioneering the genre of noise music and best known for his work as the one-man band NON, Rice has three decades as a successful recording artist under his belt. But although he is signed to the multinational label Mute Records (with labelmates including Depeche Mode, Moby and Sonic Youth), Rice isn't exactly what most people would consider famous per se. His recordings are not broadcast on corporate radio stations, he doesn't headline music festivals and he can't be found lip-synching in music videos on MTV or VH1. Thus – even though he is cited as an influence by the likes of Marilyn Manson, Marc Almond (Soft Cell) and Matt Skiba (Alkaline Trio) – Rice remains a relatively obscure figure in pop-cultural terms.

Rice is a rare sort of anti-celebrity – renowned in the underground, but largely unknown to the mainstream, and willfully so. From the inception of his career he has consciously flaunted convention, pursuing his own distinctive vision and remaining steadfastly indifferent to the fickle tastes of the public – an artistic and philosophical aesthetic that has served to render the majority of his oeuvre all but inaccessible to the average listener. Nonetheless, to many of those who actively seek out their culture from sources other than major media outlets and corporately-owned chain stores, Rice is widely regarded as a subcultural demiurge whose influence has been widespread, multifaceted and profound. To fans of the genres of industrial, experimental and noise (and their various offshoots and sub-genres), he is downright legendary.

Though he is best known for his idiosyncratic noise recordings, much of Rice's underground notoriety has actually arisen from his work in other fields. Over the years, he has produced and exhibited a variety of artworks, photographs and films, as well as played the roles of essayist, occult researcher and public speaker, among others. But like his recordings, Rice's other creative undertakings seldom make any attempt at courting conventional palatability or acceptance. His art and photography range from the decidedly offensive to the unclassifiably abstract and his film work is limited to independent features and experimental shorts, rather than the sort likely to see screenings at suburban multiplexes. Similarly, his writings, interviews, promotions and other sundry activities tend to explore areas of interest that are rarely in synch with either the trends or the sensibilities of popular culture.

Rice's willful indifference to social norms and audience expectations certainly serves to explain his obscurity in mainstream terms, but it hardly warrants the kind of controversy that he often incites – and if there's one thing that may overshadow Rice's relevance as a pioneering noise musician, it is his proclivity for inspiring disquiet in the underground. As a result of a range of interests, associations and endorsements generally regarded as culturally proscribed or taboo in the extreme, Rice's recordings and performances have sparked calls for censorship, organized protest and other assorted controversy in some sectors, while also securing for him a fiercely devoted, international fan base. Thus, though Boyd Rice is not a household name, the dropping of it in those circles in which it is familiar tends to produce the most polarized and divisive of reactions. Rice is held in the highest of

regard by some, often inspiring fawning adoration and shameless imitation, and yet he is simultaneously disparaged with outright vehemence by those who take issue with some element of his persona, assorted works, or both.

The reasons for this severe dichotomy are complex and involved, defying simple explanation or summarization – yet Rice is frequently summarized in the narrowest terms by both his fans and his detractors. Often as a result of selective judgment, Rice's admirers idolize a cartoonishly one-sided simulacrum of what is actually a complex and multifaceted figure, omitting those elements of his work which conflict with their idealized image of him. In turn, Rice's critics regularly undervalue, disregard or dismiss him offhand, allowing but one or two unsavory aspects of his exploits to color their appraisal of his entire body of work and its relevance. Naturally, while both assessments are commonplace as a result of their convenience, neither is accurate or evenhanded – but such has long been the discordant nature of Rice's life and work.

Boyd Rice certainly isn't the only polymath in the creative fields, nor is he the only underground micro-celebrity to come out of post-punk, D.I.Y. counterculture. Nor, for that matter, is Rice the underground's only controversial figure. But Rice is unique, in that the stark divisiveness he inspires is all but unparalleled, sparking the most contrasting of interpretations from many of those familiar with his work. Depending on who you're talking to, Rice is alternately regarded as a genius, an asshole, an innovator, a hack, an inspiration, a hatemonger, a prankster, a conspiracy theorist, a philosopher, a bullshit artist, a Satanic Nazi, an iconoclast, a bad influence, or as he's put it, "One of the nicest men you'll ever meet." Few, if any, subcultural icons vary so widely in their reception, or in their ability to so deeply impact both fans and critics alike – and this, more than anything else, is what separates Rice from anything that might resemble a subcultural "peer group," and places him in a category all his own.

Ultimately, Boyd Rice's relevance, notoriety, ill repute and influence on various facets of culture are all open to speculation. However, any informed appraisal can only be made in the context of an understanding of his life and works as a whole, both of which have never been properly documented – until now. What follows is the first even remotely thorough biography of Rice's life and career, followed by the first printed collection of his written and visual works. Together they represent a comprehensive informational source on both his life and his ideas, painting a far clearer picture of one of the American underground's most influential, dynamic and debatable figures.

A Boyd Rice Biography
Brian M. Clark

Boyd Rice first piqued the underground's interest in the late 1970s, as one of the first recording artists to devote his creative energies exclusively to the realm of "noise music." Although others had tentatively dabbled in the use of semi-structured noise as a musical form prior to his own forays, Rice was the first full-time "noise musician." postmodern artist rather than the linear song arrangements of a musician or composer; his album saw reviews in local art journals rather than music magazines and most of his early performances (both musical and otherwise) took place in art galleries as opposed to music venues. Soon, however, the young noisemaker tired of

Boyd Rice around the time of his earliest noise recordings

Early performance with noise-manipulation box
(Photo: Ferrara Brain Pan)

From his suburban home in the sleepy town of Lemon Grove, in Southern California, Rice self-released his first album at age nineteen: an LP housed in a completely black record-sleeve with no title or identifying markings whatsoever, aside from the text "Boyd Rice" printed on the vinyl's label. Sonically innovative and conceptually unique, the album typically produced extreme reactions of either vigorous approval or intense derision from those whose paths it crossed, and quickly grabbed the attention of California's avant-garde art world.

A lifelong troublemaker, avid prankster and student of the early 20th Century mutinous anti-art movement known as Dada, Rice undertook the creation of his noise music with the abstract conceptualist sensibilities of a

what he perceived as the ineffectual "ivory tower" sterility of the art world, and transitioned into the underground music scene. The recent arrival of punk rock had sparked an explosion of counterculture in Southern California, and by way of its all-inclusiveness opened an avenue through which Rice's noise recordings could reach a substantial audience. Rice regularly performed alongside early punk bands at local music venues, garnering a significant reputation for his work, and was summarily offered a recording contract with the newborn British label Mute Records. (Although the label was founded by Daniel Miller of The Normal, Rice was technically the first artist to sign with Mute.) As a result of his contract with

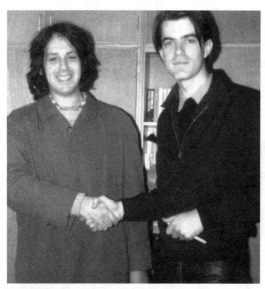

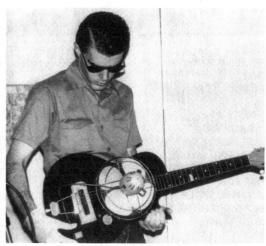

Early performance with "roto-guitar."
(Photo: Peggy Amison)

Boyd Rice and Daniel Miller. London, England, 1980.
(Photo: Vicki Frasier)

Mute, the theretofore obscure noise musician was soon releasing internationally distributed albums and touring the United States and Europe as the one-man noise band NON – a moniker adopted in part because it implied "everything and nothing at once," but also as a retort to the then-widespread tendency of punk rock groups to attach the reactionary prefix "anti" to their band names.

In creating his inimitable noise compositions, Rice applied to the medium of sound a number of conceptual devices first employed by early 20th Century visual artists, including elements of randomness, cultivated chance and semi-controlled accident. He further extended such sideways thinking to the mechanics of the recorded medium itself, pressing the first record with multiple tracks of cyclical locked/looped grooves (for endless, repetitive playback), as well as the first record with multiple center-holes (for additional oblique playback possibilities). In the live arena, Rice similarly pioneered a variety of nontraditional techniques to create his noise compositions, utilizing atypical sound sources including: an electric shoe-shine machine, a "roto-guitar" (a guitar with a metal fan mounted just above the pickups), broken cassette decks, electrical switches, out-of-synch tape loops, fragmented and re-assembled vinyl records, and an assortment of other electronic apparatuses which had never been intended for use as "instruments" by their creators. Rice's solo performances as NON were notoriously harsh and abrasive, featuring cascading walls of rhythmic noise, emitted at extremely high, speaker-destroying volume levels. In some instances the young noise musician would manipulate sound-sources onstage while standing behind blinding, high-wattage lights directed toward his audience; in others he would simply set up self-perpetuating noise-making apparatuses onstage, then retire to his dressing room, leaving such devices to "perform" on their own. Clearly not aspiring to pop stardom or even commercial

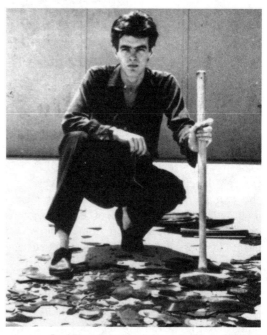

Boyd Rice with broken vinyl records. (Photo: Jill Wilder)

viability, Rice's work instead arose from a desire for exploration; he aimed to push the boundaries of sonic possibility, rethinking what music and performance were by exploring the furthest reaches of what many felt they definitely *were not*. Unsurprisingly, Rice's live shows (like his recordings) often produced extreme reactions from those who experienced them, with many conventional musicians and reviewers often turning up their noses in disgust, while more broadminded critics proclaimed that his was to be the new wave of avant-garde sonic expression.

Through his early involvement in the mail-art movement of the mid 1970s, Rice had established long-term friendships with likeminded European artists who, like himself, similarly transitioned into the medium of sound by the end of the decade. Thus, along with individuals who formed bands such as England's Throbbing Gristle and Cabaret Voltaire, Rice was instrumental in co-founding and defining what soon came to be known as the first wave of "industrial" music and its correspondent counterculture. Industrial's initial incarnation was (unlike later, watered-down manifestations) a callous, sonically unforgiving and aesthetically coarse genre suffused with bleak, often nihilistic philosophical undertones. Those involved in the genre's early development were a countercultural

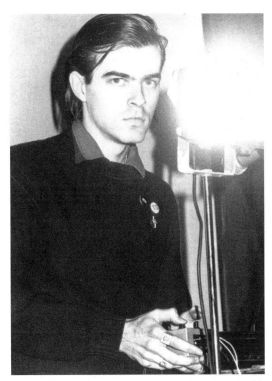

Boyd Rice performing live with noise-manipulation box, supporting Throbbing Gristle at SO36. Berlin, Germany, 1980. (Photo: Richard "ar/gee" Gleim)

faction whose roots ran far deeper into the territory of performance art and 1960s political terrorism than to the world of music, if only superficially. While often nations apart and in many ways starkly distinct, the early industrial bands were nonetheless conceptually and sonically analogous, thus, Rice and other artists-cum-musicians such as Genesis P-Orridge, Monte Cazazza, Z'ev and Johanna Went were categorized as "industrial musicians" (a term which many felt bordered on the oxymoronic, as much of what they produced strayed far afield from traditional notions of music).

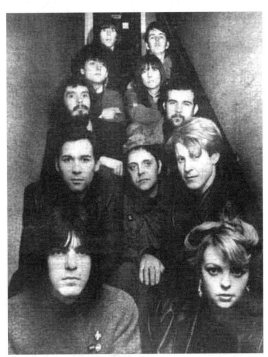

Boyd Rice with members of Throbbing Gristle, Lemon Kittens, Human League, and other electronic musicians. London, England, 1981.

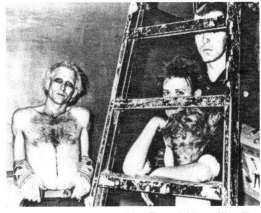

Boyd Rice with industrial musicians Z'ev and Johanna Went. New York City, 1980. (Photo: Dawn Mayo)

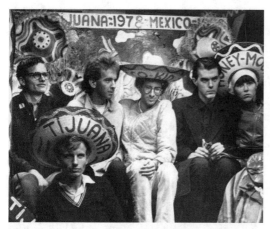

Members of the Mezoic art group. Tijuana, Mexico, 1978.

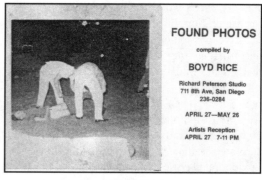

Flyer for Boyd Rice's Found Photographs show.

Rice reigned as the "king of noise" in the late 1970s and on into the early 1980s, but during this period many of his other activities extended beyond the domains of sound and performance. As the 1970s came to a close, Rice began dividing his time between San Diego and Los Angeles, where he collaborated with friends Jeffrey Vallance and the new wave band Monitor under the *nom-de-arte* The Mezoic Group (a name adopted as a play on the Mesozoic Era of geologic time). Although they engaged in a variety of deliberately provocative art activities in the late 1970s, The Mezoic Group's most notable action was its curating of the first gallery exhibition composed entirely of anonymously crafted paintings purchased at thrift stores, which was held at the Otis Art Institute of Los Angeles. A few years later, at nearby San Diego's Richard Peterson Gallery, Rice followed up the thrift store art show with an equally novel gallery exhibition composed entirely of found photographs from his own personal collection. Much to the chagrin of art lovers and photography aficionados, these two irreverent celebrations of amateurish, dismissed and discarded "art" by nameless artists and photographers proved quite popular with serious gallery-goers and amused passersby alike, and both shows received positive write-ups in local media.

Rice's involvement in the gallery world was not limited to found and readymade works, however. As a teenage photography student in the early 1970s, he had perfected his own closely-guarded technique of photographing "things that don't exist" (which he dubbed "Actual Photographs"), by employing some of the same indirect conceptual strategies to photography as those he used to create his noise music. Rice exhibited a number of these prints at San Diego's Pink & Pearl Gallery a few years after his Found Photographs show and – again to the ire of serious photographers – these abstract works were also quite well received, with the show earning glowing reviews in the local press.

After several years spent recording, performing and touring as NON from his San Diego base, at the dawn of the 1980s Rice moved north to the West Coast's countercultural Mecca, San Francisco. There he befriended one of the city's foremost underground personae, archivist, publisher and man-about-town V. Vale. Vale was the former editor of the seminal punk rock magazine *Search & Destroy*, and had recently undertaken a new publishing venture called Re/Search Publications. Unlike the ubiquitous, cheaply produced 'zines documenting the period's underground music scene, Re/Search was a bona fide publishing house that issued glossy, comprehensively investigative, book-length studies of assorted subcultural phenomena. Over the course of several years, Vale and his publishing partner, Andrea Juno, conducted extensive interviews with Rice and other industrial musicians for what would become the highly influential *Industrial Culture Handbook*, a

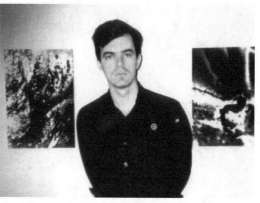

Boyd Rice at his Actual Photographs show. San Diego, California.
(Photo: Sydney Kovac)

documentation of the genre's international scene through in-depth interviews with its principal figures. A resounding success for the publisher, *Industrial Culture Handbook* delineated the artistic and philosophical underpinnings of the industrial genre, essentially putting it on the map and legitimizing it at once. In later decades, the book would go on to inspire countless imitators who gradually brought a defanged facsimile of industrial music into mainstream culture by adding precisely the sort of conventional musical trappings whose absence had originally set the genre apart.

Established in San Francisco by the mid 1980s, as a result of his creative pursuits in the worlds of art and music, Boyd Rice was regarded as one of the city's preeminent counterculture mavens. As such, he prompted Re/Search to begin work on a title with which he would become intimately involved: *Incredibly Strange Films.* Compiled and co-edited with *Trashola!* magazine editor, Jim Morton (and the people at Re/Search), *Incredibly Strange Films* was a study of the lost, forgotten and critically ignored films that had long existed beyond the artistic and moral sensibilities of studio-controlled Hollywood, and of which Rice and Morton were devoted fans. Unlike the low-budget B-films produced by major studios to fill-out the second half of double bills for their big-budget efforts, the films explored in *Incredibly Strange Films* were largely independent endeavors that fell loosely into the category of "low budget exploitation films." Rice composed an essay on "Mondo" cinema for the book and conducted lengthy interviews with a number of his favorite independent directors (Ray Dennis Steckler, Hershell Gordon Lewis, Ted V. Mikels and

Dick Bakalyan), with Morton and others compiling and composing much of the rest of the book's content. *Incredibly Strange Films* proved to be a major success for the Re/Search imprint, raising critical awareness of many of the overlooked films and directors whose work Rice and Morton had long advocated. The book served as the impetus for several Incredibly Strange film festivals around the San Francisco Bay Area and was in fact so influential that it eventually sparked a resurgence of interest in cult films in general.

Following the success of Rice's second collaboration with Re/Search, he provided the inspiration for yet a third title for the publisher. The book, titled simply *Pranks!*, centered around an activity Rice had heavily – almost compulsively – engaged in since his early adolescence: impish mischief and mean-spirited troublemaking. Taking Rice's cue, Re/Search held a series of interviews with musicians, artists, filmmakers and other eccentric cultural outsiders, and uncovered a wealth of material for the book, the first serious study of its kind. Rice contributed a lengthy interview detailing a seemingly endless series of mischievous capers perpetrated throughout his adolescent and teen years, and participated in interviewing several of his friends elsewhere in the volume. Aimed at an academic legitimization of pranking as a pseudo-artistic means of cultural expression and criticism, the book was an underground hit, raising pranking to a veritable art-form and (as with *Incredibly Strange Films*), prompting several Pranks Festivals around the Bay Area.

The same year that *Pranks!* was published, Rice co-edited a second one-time

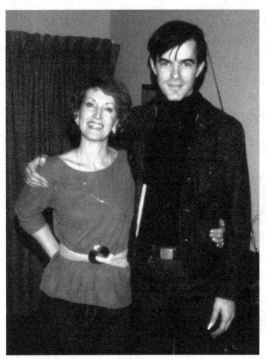

#1

Boyd Rice and *Incredibly Strange Films* interviewee Carolyn Brandt. (Photo: Ray Dennis Steckler)

publication with Jim Morton called *Pop Void*. Composed of a series of articles relating to pop culture from the 1960s, the volume was largely concerned with yesteryear's ephemera, which at the time of its release were generally deemed campy, kitschy or tacky. In spite of such dismissive public perceptions, Rice and Morton considered their subjects of study valid pop-cultural expressions and earnestly promoted them with un-ironic enthusiasm throughout *Pop Void*. Extolling the virtues of such explicitly un-cool figures as '60s poet Rod McKuen, "big eyed kid" painter Walter Keane and "Champagne Music" maestro Lawrence Welk, the volume also included essays on such quirky subjects as tiki bars, fast food chains and novelty soaps. While *Pop Void* saw neither the glossy production value of its Re/Search counterparts, nor their widespread distribution, it nonetheless made a lasting impact upon the countercultural milieu with which Rice was by then well associated. Along with a handful of similarly-themed publications beginning to surface at the time, *Pop Void* is, in hindsight, easily identifiable as an early manifestation of the sort of "retro hip" groundswell that would explode into mainstream pop culture in the mid 1990s, roughly a decade after its publication.

By the latter half of the 1980s, Boyd Rice's reputation as a master of unearthing and showcasing obscure cultural gems had nearly eclipsed his renown as an industrial musician and experimental photographer. Such was Rice's undying affinity for all things discarded and bizarre, that he regularly tracked down many of the oddball figures who had won his admiration and conducted lengthy interviews with them, in an attempt to reinvigorate the public's interest in their work. In the early to mid '80s Rice's interviews appeared in publications such as *Another Room* and *Ungawa!*, and a decade later, he would go on to become a regular interviewer for magazines such as *Seconds* and *Colorado Music Magazine*. Eventually, his interviewees came to include musicians such as Martin Denny, Tiny Tim, Little Fyodor and April March, visual artists like Ed "Big Daddy" Roth and Chris "Coop" Cooper, and TV child stars like Bill Mumy of *Lost In Space* and Johnny Crawford of *The Riflemen*.

As a result of these and other efforts, in time Rice (along with a handful of cohorts) came to be generally regarded as a major contributor to the underground germination of what would later become mainstream fads: namely, resurgences of interest in easy listening music, exotica, lounge music and tiki culture. Although they were rarely as acknowledged as more mainstream artists and musicians who successfully co-opted retro styles, in the 1990s Rice and some of his friends were interviewed for a *Seconds* article on the retro-resurgence

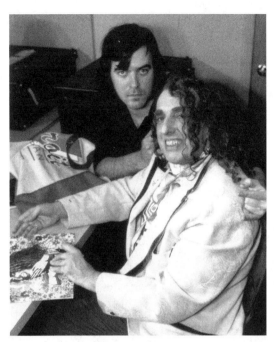
Boyd Rice with Tiny Tim.

the time, Boyd Rice was chiefly associated with things like noise music, experimental photography, industrial culture, pranks, peculiar readymade art, found photographs, cult films and obscure outsider music. To those aware of him, Rice was regarded as an avant-garde noise conceptualist, a promoter of bygone culture and a raucous prankster, and was a generally well-liked countercultural persona in the arts-friendly city of San Francisco. In the latter half of the decade, however, this would soon begin to change.

Unbeknownst to many of those with whom he shared atypical interests, for most of his adult life Boyd Rice had been an adherent of the obscure, pre-Christian religio-philosophic creed known as Gnosticism. Deriving its name from the Greek word for knowledge – *gnosis* – Gnosticism is a doctrine which posits that the curse of man and source of his earthly woes is not sin, but ignorance. Among other things, the Gnostic worldview asserts that God is everywhere and in everything (rather than residing in specific

phenomenon titled "Pioneers Of The Easy Listening Revival," a decade after they had first begun publicly promoting such subjects.

Owing to his reputation as a connoisseur of all things forgotten, overlooked and obscure, in later years Rice would go on to score a regular deejay gig spinning "The In Sounds From Way Out" (otherwise known as "incredibly strange" or "outsider" music). Eventually, his standing as a pop-cultural archaeologist became sufficient to warrant his own "Boyd Rice Presents" CD series, audio collections showcasing a variety of sonic oddities and curios, compiled and endorsed by Rice (and for which he would often pen explanatory liner notes), but with which he had no direct creative involvement. In time these came to include a compilation of rare and forgotten 1960s girl group songs (*Music For Pussycats*), a retrospective anthology of the work of ignored rockabilly singer-songwriter Ralph Gean (*The Amazing Ralph Gean – His Music, His Story*), an anthology of recordings by weirdo spazz-rocker Little Fyodor (*The Very Best Of Little Fyodor's Greatest Hits!*) and even a collection of gloomy pre-World War II Romanian military dirges (*Death's Gladsome Wedding: Hymns & Marches from Transylvania's Notorious Legionari Movement*).

As a result of the preceding activities, throughout most of the 1980s, to those tuned-in to the acceptance-shunning counterculture of

buildings such as churches, synagogues, mosques or temples), that there is no tangible Hell (the material world of earth being the lowest spiritual plane), and that the creator of the physical world may not have had the best of intentions when placing humanity upon it. Gnosticism further posits that salvation cannot be attained by way of a savior, but only through introspective contemplation and intimate knowledge of the self. A profound influence on the likes of C. G. Jung, William Blake and Hermann Hesse (among innumerable others), like all world religions, Gnosticism's interpretations and readings are often as polarized and diverse as its practitioners, and there is no "official" Gnostic orthodoxy per se.

The Gnostic deity Rice most identified with was Abraxas, an entity encompassing the interrelated and inseparable dualities of good and evil, creation and destruction, life and death. While Rice had long regarded himself as Gnostic, it wasn't until the tail end of the 1980s that he began to publicly promote Gnosticism in earnest and to incorporate its symbolism and doctrines into his sundry creative undertakings. As an emblem to represent NON, Rice appropriated a symbol called the Wolfsangel (a variation on the ancient Germanic *eiwaz* rune), which he employed as a symbolic distillation of the polar philosophic concepts embodied in his Gnostic beliefs and the god Abraxas. Beginning with

The Wolfsangel.

1987's *Blood & Flame* (NON's sixth release), Rice began to include the Wolfsangel in his album artwork and also to discuss the deity Abraxas at length in interviews. This open promotion of his own idiosyncratic interpretation of Gnosticism soon proved problematic for some of Rice's fans and associates, since such an all-encompassing understanding of the world and an unequivocal endorsement of its duality necessarily implied an equal recognition of not only the lighter side of that duality, but its *darker* aspects as well.

　　Rice had always conceived of himself as an outsider – a willful loner, at odds with the mores and values of the rest of society, and actively opposed to what he perceived as the "consensus reality" of those around him. As such, he remained largely indifferent to the fact that many in the underground seemed to have trouble understanding his philosophical worldview, just as he had likewise long shrugged off those who failed to appreciate his noise music, abstract photography and love for bygone pop culture. As he approached the age of thirty, however, this unswerving outsider deportment became more pronounced, increasingly contentious and even

antagonistic. While the varied scope of Rice's interests seems to have remained consistent throughout his career, as the 1980s drew to a close, the central focus of his interests and creative output slowly turned from the prankish, quirky and odd, to the sardonic, misanthropic and decidedly antisocial. Rice's Gnostic embracing of the latent darkness inherent to both man and the world – and his increasingly unsociable outsider tendencies – soon began to estrange him from many of his friends in the San Francisco Bay Area, where a progressive emphasis on the importance of community was the dominant norm. This

Boyd Rice and Anton LaVey. San Francisco, California. (Photo: Blanche Barton)

schism became even more pronounced when, in 1987, Rice befriended the infamous Anton LaVey, founder and leader of The Church Of Satan.

　　Contrary to public perception, The Church Of Satan is an organization which has little to do with worshiping an anthropomorphic or corporeal "devil." Likened more to a pragmatic, asocial philosophy than a traditional religion, Anton LaVey's Satanism is a creed which largely abjures from spiritual worship as such, placing adherents at the center of their own respective universes rather than at the mercy of supernatural entities. LaVeyan Satanism is an ideology rooted in elitist self-interest, devoted to accepting and cultivating all those primal, savage and chthonic impulses inherent in the human animal, which its adherents allege are unnaturally suppressed by the civilizing constraints of modern society. The central tenets of the creed share overlap with those of Friedrich Nietzsche's notion of a "master morality" and elements of Ayn Rand's Objectivist philosophy, as well as those of

other (markedly less devilish) individualist and libertarian doctrines. Having adopted the name "Satanism" mostly as a means of rebellious contrarianism at the time of its foundation in the love-benumbed 1960s, according to its adherents, LaVey's Satanism is an ethos of rational, unapologetic self-interest which employs demonic iconography and rhetoric chiefly as a means of alienating the rest of the outside world.

Boyd Rice's interest in the occult went all the way back to his early adolescence and he had long admired Anton LaVey's staunch, devilishly-inspired iconoclasm from afar. Thus, upon meeting "The Black Pope," Rice quickly became one of his closest acolytes, confidants and personal friends. The two shared many of the same interests, opinions and worldviews, and both harbored intense passions for all things wicked, droll and waggish, as well as the bygone and bizarre (1960s girl groups and obscure films being a particularly strong thread of common interest). Feeling that the credo laid out by LaVey in *The Satanic Bible* dovetailed perfectly with his own hermetic Gnostic worldview (as well as his less public interests in Paganism and Odinism), Rice became a vocal advocate of Satanism as a practical 20th Century quasi-religious philosophy, and began publicly championing The Church Of Satan and its doctrines whenever and wherever an avenue for doing so presented itself. Unsurprisingly, he was promptly inducted into the ranks of The Church Of Satan, summarily promoted to the rank of Satanic Magister, then raised to the rank of Grand Master Of The Order Of The Trapezoid, and finally proffered membership in the group's exclusive governing body, known as The Council Of Nine.

Once a member of the organization, Rice soon became one of The Church Of Satan's most visible and vocal public mouthpieces, promoting LaVey's doctrine in both his creative works and interviews, as well as visiting colleges and universities to explain his views to students of religion. In the final years of the 1980s and into the mid '90s, Rice further appeared on a number of television programs in both the United States and Great Britain as an official representative of LaVey's church. These included everything from serious documentaries on the occult from networks such as the BBC to daytime talk shows like Christina Saralegui's *Christina* and sensationalist pseudo-journalistic exposés by the likes of Geraldo Rivera. In some instances, Rice was afforded the opportunity to thoroughly

Boyd Rice on the Christina talk show.

explain the rational structure of the Satanic worldview, while in others his statements were cropped and presented out of context by program editors so as to present Satanism in a light most suited to whatever producers' aims might be.

Rice's most notable media appearance as a Church Of Satan spokesman, however, would be his regular guest spot on Christian evangelist Bob Larson's radio program *Talk Back*. As worthy a pair of showman-like adversaries as any radio network could hope for, during a series of on-air debates Rice and Larson heatedly argued the foibles and shortcomings of the other's belief system while taking live calls from Larson's audience. In addition to his regular appearances on Larson's radio program, during the evangelist's short-lived Trinity Broadcasting Network TV series, *In Satan's Name*, Rice was featured in 13 of 20 episodes. Ironically, the ostensible enemies symbiotically advanced one another's careers; both gained renown for having "put their money where their

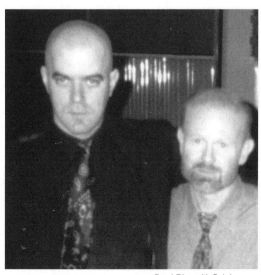

Boyd Rice with Bob Larson.

Boyd Rice with Marc Almond. High Wycombe, England 1993.
(Photo: Jon Balance)

Boyd Rice with Marilyn Manson. Denver, Colorado, 1992.
(Photo: Giddle Partridge)

mouths were" by debating their philosophical opposition face-to-face in the public arena, rather than in the abstract.

Throughout this period of the late 1980s to mid '90s, Boyd Rice played a pivotal role in advancing Satanism as a legitimate religio-philosophy. In addition to his promotion of the organization and its doctrines in his own works and public appearances, Rice initiated British pop star Marc Almond into the church's ranks, and did likewise with the then still aspirant Florida shock-rocker Marilyn Manson. Rice also introduced LaVey's doctrine to Feral House Books' owner Adam Parfrey, who would go on to publish a number of titles relating to The Church Of Satan and Anton LaVey. These efforts did not go unnoticed, and LaVey's fondness for his protégé proved so profound that he eventually came to unofficially offer Rice The Church Of Satan's leadership role upon his death – a bequest Rice respectfully declined.

In tandem with his affiliation with LaVey, Rice also made the acquaintance of another notorious resident of San Francisco's Bay Area: Charles Manson. Rice had felt a strong kinship for Manson since he first grabbed headlines in 1969, and in the mid 1980s contacted the imprisoned cult leader via mail at nearby San Quentin prison. Following a correspondence, Manson invited Rice to visit him at the prison and soon thereafter Rice became a regular visitor to the facility. Much like his relationship with LaVey, Rice rapidly developed a close personal friendship with Manson, receiving a wealth of real-world tutelage from the lifelong criminal. Becoming one of the convict's most vocal advocates, Rice spoke favorably of Manson in interviews given during the period, introduced a coterie of friends and associates to his ideas, and eventually even organized a protest for his release from prison. Additionally, Manson-themed artworks by Rice appeared in both the New York City based art publication *EXIT* and a book for which Rice would act as co-editor, *The Manson File*. Published in 1988, *The Manson File* was a compendium devoted to the legitimization of Charles Manson as a philosopher, artist, musician and mystic, and contained an assortment of writings, poetry and artworks from a number of underground artists and writers, as well as those of Manson himself. The first pro-Manson publication of its kind, *The Manson File* ultimately failed in its aims of bringing credence to the artistic, philosophical or musical legacy of the infamous ersatz-hippie turned cult-leader. However, the book did usher in a wider interest in its subject, and within a few years Charles Manson had become a pop-cultural icon whose visage regularly appeared on the t-shirts of teenagers around the country.

Rice's public friendships with such ill-

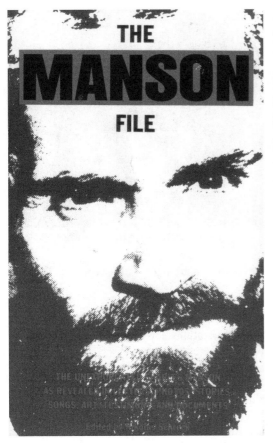

THE **MANSON** FILE

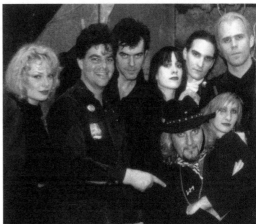

Boyd Rice with *Manson File* co-editors Adam Parfrey, Nick Bougas and Nikolas Schreck, as well as Zeena LaVey and other Satanists at the 8/8/88 Satanic rally. San Francisco, California, 1988.

(which he typically referred to as Primal Law), and in the late 1980s was pleasantly surprised to discover one of the doctrine's most incendiary tracts, *Might Is Right*. Published at the end of the 19th Century by an anonymous author writing under the pseudonym Ragnar Redbeard, *Might Is Right* acerbically and unrepentantly argued a brand of Social Darwinist doctrine which many in the milieus of underground art and music found

reputed figures as LaVey and Manson soon became quite problematic for him in the late 1980s, but even more so was his endorsement of the theory of Social Darwinism. Variously explored by a handful of pre-Darwinian English philosophers and widely popular in the 19th Century, Social Darwinism is essentially the idea that the Darwinian dictum of "survival of the fittest" applies just as appropriately to humanity as to the rest of the natural world. As Rice interpreted it, Social Darwinism was more specifically the idea that individuals, societies, nations and cultures are all engaged in an endless struggle for dominance, and that such phenomena are not only both natural and good, but should be encouraged. Rice's understanding of Social Darwinism further included the idea that all men are not equal – that some people are naturally smarter than others, some are stronger than others, some are more attractive than others, and so forth – and that any hierarchical discrepancies resultant from such inequalities are, again, to be cultivated.

Rice had long viewed life and the world in what are essentially Social Darwinist terms

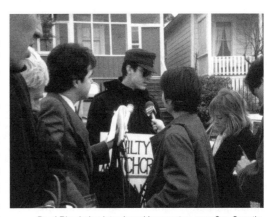

Boyd Rice being interviewed by reporters near San Quentin. (Photo: Beth Moore-Love)

hard to swallow. Penned in an arcane, grandiloquent and often melodramatic prose, the book's anonymous author argued that man was an animal like any other and that biological determinism and brute force were the real driving forces underlying the workings of the world. (It is often postulated that *Might Is Right* was penned by either American novelist Jack London or radical New Zealander activist Arthur Desmond, although convincing evidence for either case is

NON promo photo for Mute Records, late 1980s.

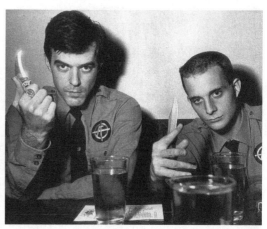

Boyd Rice with Bob Heick. (Photo: Sylvia Plachy)

lacking.)

Redbeard's take on Social Darwinism, with its vitriolic scorn for the all-inclusive tolerance inherent to Judaeo-Christian values, coincided with Rice's own Primal Law worldview, and thus he began to endorse the doctrines of *Might Is Right* alongside those of his other, increasingly dour, interests and affiliations. Rather than deal with Social Darwinism's broader implications, however, Rice generally summarized his own interpretation of the doctrine with the axiom: "The strong dominate the weak and the clever dominate the strong." As a result of Rice's vocal endorsement of Social Darwinism in such easily understood terms, the theory (and its discussion) soon spilled over into the Satanic underground. Though rarely emphasized, elements of Social Darwinism had always been latent in LaVeyan Satanism (LaVey had actually cribbed excerpts from *Might Is Right* and reprinted them as his own in *The Satanic Bible*), but it was Rice's public propounding of the doctrine which brought it to the fore in the Satanic lexicon of the late 1980s, where it has remained ever since.

As the 1980s wound to an end, an ever more defiant Boyd Rice found himself increasingly isolated and at odds with his peers in the left-leaning city of San Francisco, where the relatively recent phenomenon of political correctness had taken hold with a vengeance. Many of Rice's friends and associates in the progressive-minded worlds of avant-garde art and countercultural music began to see his more recent affiliations and endorsements as being at variance with, or even a direct affront to their own views and works. Some assumed that The Church Of Satan was a devil-worshiping, baby-killing cult, or that Charles Manson was attempting to create some new sort of "family" from behind bars, with Rice and other *Manson File* contributors as his connections to the outside world. Others erroneously equated Social Darwinism with a sort of Fascistic eugenics program, making the projective assumption that to acknowledge the inequality inherent to human diversity is to also endorse its forceful manipulation by way of sterilization, or worse, some sort of Nazi-esque concentration camp system. Rumors began to circulate that the once prankish connoisseur of 1960s pop culture had become a devil-worshiping, neo-Nazi extremist.

Such nascent suspicions were soon inflamed by Rice's friendship with yet another notorious Bay Area character; Bob Heick, founder of the White supremacist skinhead group The American Front. In 1989 Heick asked Rice to pose with him for a photo session that would accompany an article about White power groups for the teenage girl's magazine *Sassy*. Rice, while not actually a member of Heick's organization (and mostly interested in aggravating the politically correct cognoscenti of San Francisco with whom he was increasingly at odds), flippantly agreed to accompany Heick to the interview and pose for the photo shoot wearing an American Front patch on his shirt. While the *Sassy* article barely even addressed Rice, its photo

spread featured a shot of him seated beside Heick in what appeared to be a neo-Nazi uniform, brandishing a knife and glaring menacingly into the camera. This photograph, coupled with his nefarious associations and his vocal endorsement of Satanism and Social Darwinism, confirmed in the minds of his detractors that – yes – Boyd Rice indeed *had* to have become a neo-Nazi White supremacist, irrespective of his longstanding prankish leanings and oddball endorsements.

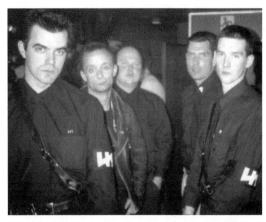

NON's 1989 lineup: Boyd Rice, David Tibet (Current 93), Tony Wakeford (Sol Invictus), Douglas Pearce (Death In June), and Michael Moynihan (Blood Axis). (Photo: Rose McDowall)

As news of the *Sassy* photo began to permeate the underground, wild speculations regarding Rice's true beliefs and intentions also began to circulate, and soon his amicable associations with more dogmatic leftist intellectuals, artists and musicians successively collapsed; friendships with Jello Biafra (Dead Kennedys) and Frank Tovey (Fad Gadget) quickly went all the way from camaraderie to public acrimony. In particular, V. Vale and Andrea Juno at Re/Search made every effort to publicly distance themselves from the increasingly politically incorrect Rice, despite the fact that they'd benefited so much from the use of his ideas. In subsequent printings of *Incredibly Strange Films*, Rice's name was excised from the list of contributing editors (relegated instead to the bottom of the list of the book's contributors), and he reports that he also ceased receiving any sort of financial remuneration for his extensive work on the project.

Rather than shirk from allegations of Nazism or remain circumspect regarding his status and reputation in the various art and music scenes with which he had long been associated, the ever confrontational Rice instead embraced and exacerbated the ill repute he had come to achieve by the end of the 1980s. Although his work during this period steered clear entirely from the subject of race, Rice nonetheless furthered rumors of Nazism through the use of highly suggestive visual and symbolic cues, and the associations they brought with them. In the midst of an ever constricting aura of politically correct hypersensitivity in the creative fields, Rice began to perform as NON attired in black paramilitary fatigues which were more than just a little aesthetically reminiscent of those donned by European Fascists of the 1930s and '40s. Furthering the impression this triggered, his live performances as NON began to employ the use of multiple kettle drummers and military-style banners adorned with Wolfsangels, thereby taking on a character more akin to Fascist political rallies than either music concerts or avant-garde art performances. Additionally, while Rice's work as NON had theretofore been all but entirely free of lyrics for well over a decade, Satanic and Social Darwinist texts (both Rice's own and those of other writers) started appearing on his albums.

All of this – Satanism, Social Darwinism, martial rhythms, quasi-Fascist apparel and banners, and collusion with LaVey, Manson and Heick – cemented the impression to many that Boyd Rice had indeed become a neo-Nazi. As a result, Rice became *persona non grata* in San Francisco and a much debated figure within the American underground as the decade came to a close. Many took him at face value, insisting that he was a bigoted racist who just wouldn't come out and admit so publicly; others interpreted his embracing of the culturally taboo as an elaborate, iconoclastic prank of some sort; still others viewed his work as an endorsement of a harsh, non-racial form of Satanic Fascism. Rice generally remained inscrutable and vague, and the answers to such speculations were not forthcoming. Regardless, before long, Rice's erstwhile associates in the countercultural avant-garde were not only publicly snubbing him, but some were calling for his records to be censored, and there were even attempts at getting him fired from his record label. Unsurprisingly, as accusations of Nazism were taken at face-value, within a few years Rice's concerts as NON became the target of organized protests by anti-Fascist demonstrators.

While many of those in the worlds of underground art and music fancied themselves as open-minded and accepting of all things transgressive, subversive and taboo, it seems that

they simply could not suffer a rumored Nazi in their midst – ironically, those most vocal in their advocacy of diversity and tolerance clearly had no tolerance for what they perceived as intolerance on the part of one of their own. Perhaps even more paradoxical was the fact that many of Rice's closest friends and associates were of Jewish descent (Church Of Satan founder Anton LaVey, Mute Records owner Daniel Miller and Feral House Books head Adam Parfrey being the most notable). This rather glaring detail was presumably lost on those who most fervently accused Rice of intolerance and anti-Semitic, neo-Nazi leanings. Rice appears to have made little attempt at pointing this out, however, as doing so (even in this biographical context) smacks of the clichéd argument made by closeted bigots that, "Some of my best friends are Black." Regardless of his reasons for such an omission, the fact remains that during this period Rice was regularly accused of having an agenda directed against some of the very people he was in closest collaboration with.

In 1989, after nearly a decade of

Boyd Rice & Friends, 1989.

residence in San Francisco (where rancor toward him was steadily mounting), a misanthropic and increasingly truculent Rice relocated to Denver, Colorado. Not particularly known for its relevance in the fields of avant-garde art or political activism, the relative provinciality of the "Mile High City" appealed to Rice, as did its moderate size (for an American metropolis), its affordability, its untapped thrift stores and its all around small-town feel. Once established in Denver, undistracted by the dogmatic progressivism and in-your-face social activism present in his former city of residence, Rice delved even further into his much reviled interests of Satanism and Social Darwinism.

In addition to departing from San Francisco, Rice also took a departure from what had until then been a recording career devoted entirely to noise music. In 1990, recording as the band Boyd Rice & Friends (backed by Death In June's Douglas Pearce, Strawberry Switchblade's Rose McDowall and Blood Axis' Michael Moynihan), Rice released *Music, Martinis & Misanthropy*, a venture into an altogether different musical genre for the "king of noise." Unlike his sonically unforgiving work as NON, *Music, Martinis & Misanthropy* was a spoken word album which featured Rice's calmly intoned, dispassionate readings of harsh Satanic and Social Darwinist texts over folksy acoustic guitar and melodic female backing vocals. The stark contrast between the album's cynical and sardonic lyrical content and its soothingly sweet musical accompaniment endeared its creators to many who found resonance in the release's bitter,

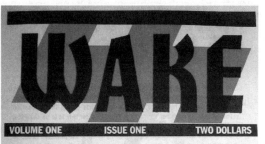

WAKE

VOLUME ONE ISSUE ONE TWO DOLLARS

"WHO WOULD BE BORN MUST FIRST DESTROY A WORLD AND FLY TO GOD... A GOD WHOSE NAME IS ABRAXAS" —H.H.

misanthropic sentiment. Unsurprisingly, these same qualities proved unsettling to those who saw nothing comical, amusing or relatable about it whatsoever. *Music, Martinis & Misanthropy* was the first of what would become a number of spoken word albums and other assorted one-off collaborations for Rice, each recorded with a host of notorious countercultural colleagues. As a result of his wide spectrum of interests and associations (and his growing ill repute), by the early 1990s Rice had become the guest star du jour for many within the industrial, experimental, gothic and neo-folk music scenes. In time, the list of his musical collaborators would come to read as a veritable "who's who" of the darker set of the underground.

Just after releasing *Music, Martinis & Misanthropy*, Rice further solidified his infamy as a reputed Fascist by making public what had theretofore been a clandestine organization called The Abraxas Foundation. Founded in San Francisco in 1987, The Abraxas Foundation identified itself as a "Social Darwinist think tank," and consisted of an undisclosed (purportedly international) membership devoted to propagating Social Darwinist ideas. Rice served as head of the organization and also acted as editor of its one-time newspaper, *WAKE*, a propaganda outlet containing Social Darwinist texts from an array of philosophers, novelists, psychologists, social theorists and politicians of yesteryear. Aimed at spreading the Social Darwinist meme into the international underground, The Abraxas Foundation issued a handful of media items throughout the late 1980s and early '90s before quietly ceasing its activities and disappearing from the public consciousness. While the group's success at achieving its aims is difficult to gauge, by the end of the decade Social Darwinist themes were standard fare for discussion within the Satanic underground and had also begun to crop up regularly in the industrial, neo-folk, and power electronics music scenes of both the United States and Europe.

Partly as a result of his helming The Abraxas Foundation, Rice was often queried in interviews as to the political implications of Social Darwinism as well as his own political leanings. Dismissing contemporary politics as being the domain of "people who don't know how to run their own lives," Rice insisted that his conception of Social Darwinism was essentially apolitical – a no-nonsense schematic for understanding the real workings of the world,

Boyd Rice with Lisa Carver (pregnant). (Photo: Richard Peterson)

whether acknowledged or not – and had no translation into modern political terms. As for his own political leanings, Rice disregarded his country's two-party Democratic system entirely, further stating that the only political structure he would be willing to put any confidence in would be something approximating the sort of Meritocracy outlined by Plato in *The Republic*.

Shortly after publishing *WAKE*, Rice made the acquaintance of – and then became romantically involved with – Lisa "Crystal" Carver, member of the performance group Suckdog and publisher of the 'zine *Rollerderby*. Carver, a much adored darling of feminists and countercultural hipsters alike, was apparently drawn to Rice's "bad boy" image and publicly courted his affections in her magazine. Rice reciprocated, similarly attracted to the "free spirit" persona that Carver presented in her autobiographical writings in *Rollerderby*. The two were as mismatched a pair as one could imagine, but for whatever reasons, they became enamored with one another nevertheless. Before long, Carver relocated to Denver to live with Rice as his girlfriend and soon his writings and interviews began to appear in her magazine. Soon thereafter, Carver became pregnant with Rice's child, and some months down the road their son Wolfgang was born.

While Rice and Carver remained together for roughly two years in the middle of the 1990s, their relationship steadily deteriorated and eventually devolved into outright animosity. Carver ultimately left Denver with their child in

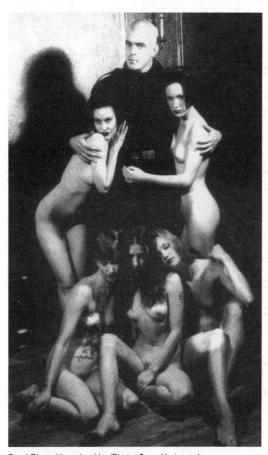

Boyd Rice with nude girls. (Photo: Sean Hartgrove)

(or deniable) claims about exactly what it is that she alleges took place. For Rice's part, aside from the occasional dismissive, off-handed snub in an interview, he would not address Carver publicly (or her implied accusations) in the years following their breakup, and insists that he will never waste time reading her book.

Lisa Carver's *Rollerderby* was but one of a number of 'zines in which Rice was to make repeat appearances. By the mid 1990s, having developed a reputation as both a multi-disciplinary artist-performer and a notorious cultural provocateur, Rice became a much sought-after interviewee for any magazine wishing to sell copies. Before, during and after the era's pre-Internet "'zine craze," Rice was interviewed for a wide assortment of publications, from independent 'zines such as *Forced Exposure, Bananafish, Your Flesh* and *Ben Is Dead* to mainstream publications like *Melody Maker, Alternative Press, Bizarre* and *Hustler*. Likewise, Rice was featured in an assortment of small-press books surveying underground music, avant-garde art and the Satanic underground, including *Tape Delay, Cinema Contra Cinema* and *Lucifer Rising*.

Rice made for an ideal interviewee, as he habitually opined candidly and matter-of-factly about his divergent views on any number of sensitive issues which most in the art and music undergrounds tactfully avoided for fear of reprimand or ostracism. While Rice's insensitive candor in interviews may have annoyed many a 'zine reader, his music and writing projects of the period were of an even more seditious character. With each passing year into the 1990s (both while involved with Lisa Carver and afterwards), Rice seemed to revel more and more in undermining the mores and offending the sensibilities of the ever more touchy, politically correct American counterculture. Throughout the first half of the decade he increasingly antagonized the activist elements within the American underground in his creative works, taking semi-facetious jabs at women, minorities and other disenfranchised or "victimized" groups to which he did not belong. During much of this period, Rice's assorted avenues of creative expression were thick with what the Germans call *schadenfreude* – the taking of pleasure in the misfortunes of others.

Rice recorded a single as The Tards with Adam Parfrey, in which the two goofily mocked the mentally retarded, and just a short time later, also contributed what would prove to be a

tow, and mutual enmity between the ex-lovers soon followed. According to Rice, Carver was perpetually discontent with the nebulous state of their relationship and insisted they be married – and he ended the situation as a result of becoming fed-up with her entirely. As Carver tells it, it was she who left Rice, due to domineering, Svengali-like abuse on his part. As with all such conflicting "he said, she said" post-breakup accounts, speculation on the part of non-participants is just that – speculation – and only Rice and Carver will know the true nature of their parting. Nonetheless, rather than keep the unpleasant business of their split private, in 2005 – nearly a decade after the two had gone their separate ways – Carver published *Drugs Are Nice*, a tell-all "post-punk memoir" in which she relates her own emotionally charged version of the relationship she shared with Rice. Rife with attacks on Rice's character, *Drugs Are Nice* recounts Carver's take on the couple's tumultuous final days with carefully worded, vague allusions to undisclosed, violent wrongdoings on the part of her ex-lover, but makes no specific verifiable

particularly inflammatory pro-rape article to the final issue of Jim and Debbie Goad's *ANSWER Me!* magazine (a publication that ignited an obscenity trial in the state of Washington). Around the same time, Rice also released a misanthropic, beatnik-inspired album titled *Hatesville!*, recorded as The Boyd Rice Experience. Picking up where *Music, Martinis & Misanthropy* had left off, *Hatesville!* was a collection of jazzy easy listening songs in which Rice and a handful of similarly notorious underground personae promoted the idea that hate was fun and "groovy." Predictably inciting underground outrage, on the album's final track Rice even had the audacity to use the phrase "unruly niggers" – arguably being one of the only White recording artists with even marginal credibility to transgress what was then (and still is) perhaps the most sensitive of all cultural taboos.

The summation of all of this was that throughout the 1990s, at a time when political correctness was at its censorial height – when sexual harassment suits and affirmative action were hot-button issues, when Americans were mortified of accidentally offending one another and chose their words delicately – Boyd Rice and his small cadre of impishly antisocial cohorts inhabited an ideological iceberg. Unsurprisingly, as an nth-wave copy of watered-down punk rock dominated MTV, post-grunge indie rock ruled the underground, and the Pacific Northwest's riot grrrl contingent was at its self-righteously misanderistic zenith, Rice's misanthropic, misogynistic and racially insensitive antics weren't exactly met with open arms – even when interpreted as an ironic retort to the dominant

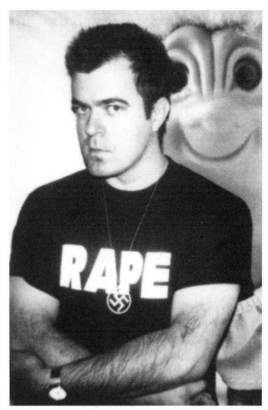

Boyd Rice wearing a RAPE shirt and swastika necklace. (Photo: Geoff Paxton)

social mores of the time. As musicians and artists everywhere were toeing the progressive party line and doing their part to "fight" the ethereal specters of racism, sexism and homophobia, Rice had turned in the complete opposite direction, going out of his way to offend, mock and belittle the very values held most dear by the dominant American counterculture. By the mid 1990s, Rice's relevance and notoriety had shifted completely from his earlier, more abstract and lighthearted interests, and he was widely regarded as the preeminent countercultural voice of intolerance and hate in America, and was vehemently despised in accordance. Having won the affection and admiration of much of the art and music undergrounds in the early 1980s, by the mid '90s Rice had traded this in for their absolute contempt and disdain, and in so doing came to occupy the role of one of American counterculture's most visible and vocal *enfants terribles* – an outsider among the outsiders.

Rice's notoriety, however, extended far beyond the borders of the American countercultural underground. The widely circulated German national magazine *Der Spiegel* (the equivalent of the American *TIME*) summed

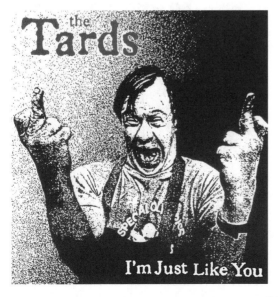

the Tards

I'm Just Like You

TAKE A STAND AGAINST FASCISM AND RACISM!

Say "NO!" to
Boyd Rice
&
"DEATH
IN JUNE"

DEATH IN JUNE

6

Boyd Rice, founder of nazi 'American Front' fascist 'art band' Death in June glorify the SS

Protest: Key Club, Thur. June 24, 7 pm, 9039 Sunset

Fascist Aesthetics and Fascist Politics lead to Fascist Violence. Call Key Club to stop the show!
310-274-5800

On a recent European tour, Boyd Rice and his pals from *Death in June* went to Italy, and tried to steal Mussolini's brain. "Mussolini's brain is interred in a little marble box, separate from his body. It's in a glass case that's in the wall. We found that he was buried there and found that his brain was interred separately. So we snuck into this place and tried to steal his brain. It would be exciting to have everybody in the world imagining that there are people who cared enough to steal Mussolini's brain. It was locked up tight as a drum at night, so we were back the next morning. We went in, and there were all these old people in there putting wreaths on his grave, and they had tears running down their face, and I just felt really kind of selfish – like, 'Oh, fuck. What a selfish asshole I am, wanting to take this and it means so much to these nice old Italians. I'll leave it so everyone can appreciate Mussolini's brain. It belongs to everybody. It doesn't just belong to me.'" Rice told an interviewer. At the last joint appearance by *Death in June* and Boyd Rice in L.A. in 2002, Rice screamed from the stage, "Genghis Khan, Adolph Hitler, Benito Mussolini, here, come back, COME BACK, COME BACK!" These latest appearances amounts to a fascist provocation during gay pride week, because although Douglas Pearce of DiJ attributes his racism to a desire to suck uncircumcised white cocks, the people attracted to a show with Boyd Rice are just as likely to head out after the show to gaybash or commit other forms of fascist or racial violence.

For more information, contact Anti-Racist Action LA, 310-495-0299,
antiracistaction_la@yahoo.com P.O. Box 1055, Culver City CA 90232

Flyer alleging that Boyd Rice founded the American Front.
Distributed for a protest against a Los Angeles performance by
Death In June and NON, circulated by Anti-Racist Action.

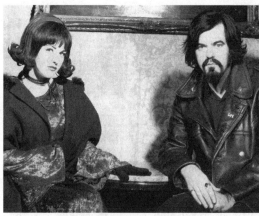

Boyd Rice and Rose McDowall. (Photo: Lee Locke)

him up as "a bad influence," and a major Austrian newspaper went so far as to dub him, "the foremost leader of right-wing extremism in the world today." While performing stateside as NON, Rice occasionally met with difficulties from anti-Fascist organizations like The Northwest Coalition For Human Dignity (Seattle, Washington) and Anti-Racist Action (Los Angeles, California), among others. These groups made various attempts at hindering Rice's ability to perform as NON by distributing factually specious leaflets, exerting pressure on promoters and venues, and organizing protests – with varying degrees of success. When touring Europe with the neo-folk band Death In June, however, Rice's concerts often saw the presence of riot police (in preparation for neo-Nazi violence that never came). In one instance, while performing in Germany (where flirtations with Fascism hit much closer to home), the tour bus Rice shared with Death In June was firebombed by Anarchist activists who saw the two bands as an affront to their own far-left political aims. Undaunted – perhaps even bolstered by such events – Death In June and NON continued their tour in a new bus.

Ironically, while the far-left had by then long harangued Rice for his aesthetically and ideologically coarse endeavors, so too did flak begin to come his way from the far-right. Throughout the 1990s, Rice periodically received threats from members of a group known as The Aryan Nations. An anti-Semitic, Christianity-based, White supremacist group that had grown out of the Eurocentric "Christian Identity" movement in the 1970s, The Aryan Nations apparently felt that the prankish Rice was a

turncoat of sorts, somehow mocking the sectarian White power movement they'd so long sought to legitimize. Moreover, the organization took issue with Rice's mentorship by the partly Jewish-blooded Anton LaVey (born Tony Levy), who had also welcomed Blacks such as Sammy Davis Junior and homosexuals like Kenneth Anger into the ranks of his fervidly anti-Christian Church Of Satan. Rice, by then well accustomed to being intensely disliked, remained unfazed by the harassment and nothing substantial ever came of the matter.

Never one for the predictable or clichéd, at the height of his unsociable notoriety – occupying the singular role of America's most infamous black-clad, noise-mongering Satanic Nazi – Rice formed the band Spell with Scottish goth-pop songstress Rose McDowall. Spell's début release, *Seasons In The Sun*, was a melancholic

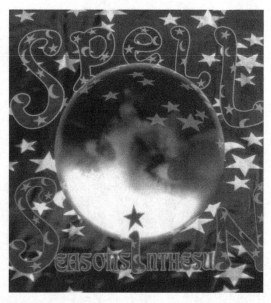

collection of male-female pop duets plucked from the 1960s and '70s – songs which, despite their sugary pop coating, contained morose, morbidly-themed lyrical centers. Around the same time *Seasons In The Sun* was released, Rice also further defied expectations by joining an eccentric, Denver-based group known as The Partridge Family Temple.

A latter-day religion based on "absolute 24-7 fun," The Partridge Family Temple is a cultish faith centered around the worship of the characters on the 1970s TV show *The Partridge Family*. In Jungian fashion, each character on the original *The Partridge Family* show is conceived of not as a mere fictional persona, but represents an archetypal god or goddess within a pantheon devised by the temple's founders, and is venerated by devotees as such. Shirley Partridge is the virgin mother and earth goddess, Danny Partridge is the trickster god, Laurie Partridge is the "holy harlot" or "whore of Babylon," Tracy Partridge is the "nymph virgin," and so forth. In sharp contrast to Anton LaVey's Church Of Satan – an organization which has long labored to appear largely irreligious and disassociate itself from cultic "devil worshippers" – The Partridge Family Temple publicly conceives of itself in the strictest religious terms, projecting every outward impression that it indeed borders on the fanatical (members even go so far as to adopt the surname Partridge in lieu of their own). Since its inception, the group's founders, Shaun and Dan Partridge, have zealously insisted that Keith, Shirley, and the rest of the characters from *The Partridge Family* are most certainly gods and goddesses every bit as "real" as Yahweh, Jehovah, Allah, Buddha, Krishna, Shiva and Kali, and that they worship their televised gods and goddesses with just as much sincere devotion as the practitioners of other world faiths.

Boyd Rice joined The Partridge Family Temple not long after its formation in the early 1990s, and in so doing brought a new level of attention to the organization. This soon led to temple members being interviewed for an assortment of television programs such as *The Jon Stewart Show* and *A Current Affair*, as well as a range of print media exposure. Rice, while by no means as publicly active for The Partridge Family Temple as was for The Church Of Satan, did however give several interviews alongside other members of the group, identifying himself as Boyd Partridge and ardently swearing allegiance to the gods and goddesses of *The Partridge*

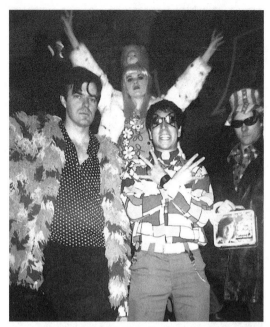

Members of The Partridge Family Temple at Casa Bonita.
(Photo: Tuan Tran)

Family.

Many in Denver, where The Partridge Family Temple was most active and visible, saw the faith as little more than an elaborate prank, and refused to take it seriously. Others however, found the group's unflinching devotional fervor profoundly unnerving, and warily viewed it as a *Clockwork Orange*-esque gang, from which one would do well to keep one's distance. Attiring themselves in garish 1960s and '70s psychedelia-inspired clothing, throughout the early to mid 1990s members of the temple (Rice among them) engaged in an array of pranks, wild escapades and often mean-spirited capers involving sex, violence, alcohol, copious amounts of drugs and bubblegum pop, all taken well beyond their furthest reasonable extreme. Rice eventually went on to collaborate creatively with several members of the temple in a range of capacities, and despite his varying interests in later years, would never relinquish his association with the group and its ideal of "absolute 24-7 fun."

Troublemaking and liberal-baiting were not, however, the sole focus of Rice's activities in the mid 1990s. While he continued to release recordings under the band names NON and Boyd Rice & Friends, he also entered into the world of filmmaking, collaborating with filmmaker Joel Haertling on two short, experimental films: *Black Sun* and *Invocation*. Non-narrative, non-linear and buoyed by soundtracks of Rice's signature

HIGH CRIME FILMS PRESENTS

NIXING THE TWIST

"A 'Clockwork Orange' for the new Millennium"
~ Jorn Rossing Jensen, Stockholm International Film Festival

"Pearls Before Swine is deep, dark & aberrant"
~ Michael Helms, Fatal Visions, Fangoria

RICHARD WOLSTENCROFT'S
PEARLS BEFORE SWINE
STARRING BOYD RICE

I HAVE SO MUCH HATE TO SHARE WITH YOU!

Also Starring · Nick Crawford Smith · Lisa Hutchinson
Greg Maxwell · Douglas P. · Ross Wilson · Greg Scealy
Max Wearing · Baby Lemonade Lemare · David Thrussell
And many others. See reverse!

THE FIRST FILM SHOT BEYOND THE REALMS OF GOOD AND EVIL'!

noise music, these films showcased the same sort of abstract and experimental tendencies he had previously applied to his photography and noise recordings. Over the years, *Black Sun* and *Invocation* saw various screenings at galleries such as The San Francisco Museum Of Modern Art and Los Angeles' La Luz De Jesus Gallery, as well as at festivals such as Denver's International Experimental Cinema Exposition and Chicago's Expo Of The Extreme. Both films were later released commercially on DVD alongside footage of a 1989 NON performance in Osaka, Japan.

In addition to his own experimental shorts, throughout the 1990s Rice also began to venture into the world of acting. He played a shadowy mafia thug in Frank Kelly Rich's feature-length independent film noir, *Nixing The Twist*, and an anti-alcohol Christian fundamentalist preacher named Dr. Lloyd Reichart (inspired by Bob Larson) in the director's second, as yet unfinished film, *Modern Drunkard*. Rice also portrayed a 1960s music producer (loosely based on Lee Hazlewood) in Allison Anders' Hollywood production *Grace Of My Heart*, but all of his scenes were ultimately cut from the final edit of the film. These minor cinematic excursions aside, toward the end of the decade Rice was to have his most notable on-screen experience starring as killer-for-hire Daniel Wingrove, the anti-hero protagonist in Australian filmmaker Richard Wolstencroft's feature-length independent film *Pearls Before Swine.* Virtually tailor-made for Rice, the film was suffused with violence, Fascism, sadomasochism, misogyny, murder, Social Darwinist diatribes and other categorically off-color subjects with which he had by then become well associated. And though Wolstencroft didn't necessarily base his assassin character *on* Rice per se, he did write the part with Rice specifically in mind, culling much of the character's didactic soliloquies and monologues from comments and observations made by Rice in interviews over the years. Debuting at Sweden's Stockholm International Film Festival, *Pearls Before Swine* went on to be screened at film festivals in Korea, Spain and Australia, and was released commercially on DVD in both Europe and the United States. Like many of Rice's other creative endeavors, the film was met with diametrically mixed reactions from audiences and reviewers alike.

It was around this time – the final years of the 1990s – that Boyd Rice first became curious about his own genealogy and thereby developed an interest in what is known as "the grail bloodline." The concept of the grail bloodline is an alternative theory to the history and meaning behind the well-known Christian legend

Boyd Rice with a bust of Jean Cocteau, Villefranche-sur-Mer, France. (Photo: Douglas Pearce)

of the Holy Grail – a theory which has remained relatively obscure, until recently. Central to Arthurian legend as well as numerous literary works such as Richard Wagner's *Parsifal*, the myth of the quest for the Holy Grail has existed for centuries in the West and is traditionally envisioned as a literal hunt for the lost vessel used by Jesus Christ at the Last Supper. It is also, however, occasionally interpreted symbolically as a search for esoteric, alchemical or occult knowledge. Rice's interest in the grail legend – while sharing the basic mythic premise that the grail is something precious but lost, and attainable only by a worthy few – was of a far more modern understanding of what the "grail" might be.

First put forth in the 1983 book *Holy Blood, Holy Grail*, the grail bloodline interpretation of the grail myth essentially begins with the idea that Jesus Christ fathered children by way of Mary Magdalene (who is alleged to have been his consort in this scenario). As the theory goes, following Christ's crucifixion, Mary Magdalene traveled to Europe and there – with offspring sired by Christ – began a "holy bloodline" which eventually spread and developed into the royal lineages of all of Europe's nobility. Bordering on the conspiratorial (and often dismissed as a hoax by skeptics), the idea of a grail bloodline is basically the theory that all the royal houses of Europe – the ruling elite of Western civilization for centuries – can trace their ancestral lineage back to Jesus Christ, and that they were (and are) ruling elite *because* of this lineage.

From genealogical materials uncovered while visiting an ancestral homestead in North Carolina in the late 1990s, Rice discovered that he could be distantly descended from European royalty, and after revisiting *Holy Blood, Holy Grail*, soon became fixated with the grail bloodline's various facets and far-reaching ramifications. From the tail end of the decade and into the early years of the new millennium, Rice all but abandoned his other activities (aside from his work as NON) and feverishly studied the topic in earnest, making trips to France and England in the course of his research. Believing that his unique occult background and knowledge of the esoteric gave him special insight into the subject that had escaped more traditional scholars and researchers, Rice began writing prolifically about the grail bloodline and the assorted peripheral areas of study associated therewith. Many of his essays first saw print in *Dagobert's Revenge*, an obscure 'zine devoted to the grail bloodline and its numerous thematic offshoots. Correspondent to Rice's involvement, interest in *Dagobert's Revenge* skyrocketed and soon the production quality of the publication increased exponentially, with it eventually evolving into a legitimate, nationally-distributed magazine. During the course of half a dozen years of study, Rice published upwards of 20 grail-related articles in *Dagobert's Revenge*, contributed a lengthy essay to Disinformation Books' occult volume *Book Of Lies*, and eventually went on to publish *The Vessel Of God*, a book containing much of his research into the subject.

During this period – the late 1990s and early 2000s – Rice's public endorsement of both Satanism and Social Darwinism faded. Following Anton LaVey's death in 1997, The Church Of Satan took a turn toward the ineffectual, doctrinaire and humorless, and an older and wiser Rice (having moved on to other areas of interest) had by then already grown weary of the knee-jerk controversy attendant to the subjects that had gripped him a decade earlier. Rice became increasingly reticent to talk about Satanism and Social Darwinism in interviews, or to explain his

NON live.

associations with more notorious figures such as Anton LaVey and Charles Manson, often simply refusing to discuss them entirely. Similarly, the once-dominant presence of Rice's misanthropic invectives also began to wane in recordings by Boyd Rice & Friends. Many were surprised to find that the once polemic and scornful content of Rice's spoken word albums had been replaced by lyrics culled from ancient religious texts, philosophical aphorisms, surreal poetry, Pagan solar worship, retellings of dreams and other decidedly less confrontational subject matter. Rice's famed misanthropy was still present in his spoken word recordings, but had been overshadowed by his newly prevalent interests in the esoteric. His work as NON also changed toward the end of the 1990s and into the new millennium, with the disappearance of once dominant Social Darwinist lyrics and a return to pure, vocal-free noise.

Despite his re-visitation of instrument-

alism, however, Rice's grail research did find its way into his work as NON, with grail-related texts and imagery first appearing on 2002's grail-themed album *Children Of The Black Sun* (Rice's 13th release as NON). Recorded with acclaimed Denver-based studio engineer Bob Ferbrache, *Children Of The Black Sun* was released as a two-disc set, the first being a standard audio CD and the second an audio-only DVD – the first specifically recorded and engineered to utilize the

Boyd Rice at Rennes-le-Château, France.
(Photo: Tracy Twyman)

full spectrum of the medium's 5.1 surround sound format (as opposed to being remixed to 5.1 from old stereo masters), and remains one of the very few to this day.

Throughout this same period of shifting focus, Rice's longstanding use of the Wolfsangel symbol as a visual representation of NON also fell to the wayside, as he adopted a grail-related sigil known as the Cross Of Lorraine in its stead. A French heraldic insignia dating back to medieval days of The Knights Templar (and ironically,

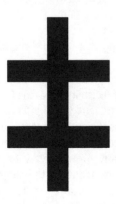

The Cross Of Lorraine.

Michael Uhlenkott, Boyd Rice and Tom Griswald at a 1979 tiki party, Los Angeles, California. (Photo: Steve Thompsen)

employed by the anti-Nazi French Free Forces during World War II), Rice used the two-pronged Cross Of Lorraine to denote the same dualistic precepts embodied in the older, Germanic Wolfsangel, but without its distinctly Teutonic aesthetic. Curiously, despite Rice's extensive use of the symbol in relation to both his esoteric grail research and his recordings as NON, the Cross Of Lorraine would in later years make its way into the mainstream, when Marilyn Manson (who has referred to Rice as his "mentor"), followed suit and began to similarly utilize the Cross Of Lorraine sigil in relation to his own work.

As the new millennium dawned, Rice's reputation as a rumored Nazi had begun to diminish somewhat, and he came to be regarded more as an occult researcher, esoteric historian and – to some – a pedantic conspiracy theorist bent on uncovering the secrets of the grail bloodline. In the midst of his dedicated research into the assorted facets of grail bloodline, Rice discussed his studies at length on national talk-radio shows such as Art Bell's syndicated late-night program *Coast To Coast* (to an estimated audience of between 12 to 20 million listeners), delivered lectures relating to aspects of his research at conferences such as Denver's World Paranormal Expo and was flown to France to host an episode of Fox TV's *In Search Of...* program devoted to the Languedoc region's enigmatic Rennes-le-Château.

Despite spending a number of years with his nose buried in history books, obscure religious tomes and cryptic grail-related manuscripts, the esoteric had not succeeded in taking over all of Boyd Rice's life at the turning point of the new millennium. Back in the late 1990s Rice had joined the staff of Denver's *Modern Drunkard* magazine (first acting as interviewee, then

regular contributor), and eventually authored eight articles for the publication in as many years. In 2004 he was invited to give a presentation on the history of tiki culture (and its relation to alcohol) at the first annual *Modern Drunkard* convention in Las Vegas, Nevada. Despite his relative infamy, Rice's inclusion on the event's bill was appropriate, as he had long been regarded as an aficionado of all things tiki.

Entranced by the tiki phenomenon as a child in the 1960s, Rice rediscovered and rekindled his love of tiki culture at the end of the '70s when he first began exploring the dwindling number of original tiki bars and restaurants still operating in Southern California. Some of the earliest NON performances transpired at (of all places) the famous exotica restaurant Kelbo's, and in the early 1980s (along with his tiki enthusiast friends Jeffrey Vallance and Michael Uhlenkott) Rice was involved in organizing tiki-themed parties at which he and his friends served fruity umbrella drinks and played exotica and surf rock records. On the cusp of the first wave of tiki culture revival, in 1982 Rice traveled to Hawaii to interview exotica music pioneer Martin Denny for the magazine *Ungawa!*, and would do so again (via telephone) for *Seconds* a decade later. By the 1990s, such activities had established Rice as a serious tiki-hound, and at the end of that decade he penned an introduction to Martin McIntosh's art book *Taboo: The Art of Tiki* and acted as a consultant for the BBC's *Rapido TV* program on tiki culture, "Air-Conditioned Eden."

So it was of little surprise when in 2005 Rice designed and furnished a tiki bar near his home in Denver. Located inside a Ramada Inn in the city's Capitol Hill neighborhood, the hotel's

Tiki Boyd's. (Photo: Kent "Doc" Wilson)

bar had up to that point been a floundering, ill-conceived cross between sports and Southwestern themes, enjoying almost zero non-hotel clientele. After Partridge Family Temple member Lorin Partridge began working at the bar (then called the East Coast Bar), Rice and his friends soon became its only sizeable group of regulars, and the bar began to generate modest profits. When management enquired as to how sales might be further increased, Rice's friends suggested that he be enlisted to overhaul the E.C.B. and convert it into a tiki bar, a proposition he eagerly accepted.

Immersing himself in the project, Rice quickly redecorated the bar, transforming it into a lavish tiki environment replete with bamboo huts, colored lights, hanging lanterns, carved wood masks and stuffed blowfish lamps – all of which was complimented by the exotica sounds of his own collection of Martin Denny and Arthur Lyman LPs. Soon after his reworking of the locale, business picked up as expected and management of the E.C.B. rechristened it – appropriately enough – Tiki Boyd's. Serving as *Modern Drunkard's* staff hangout and being the only tiki bar in town, Tiki Boyd's quickly became a highly profitable watering hole, where an unusual cast of characters from all walks of life took in the lurid exotica ambience while imbibing incandescent, rum-based cocktails topped with umbrella-skewered fruit.

Rice, who had decorated Tiki Boyd's in exchange for an open bar tab, had no direct control over how it was run, and thus was forced to work with management inherited from the bar's previous incarnation. As the months wore on, the bar's manager came to hubristically believe that Tiki Boyd's overnight prosperity had come about as if through sheer luck, rather than the efforts of Rice and his friends who bartended

Boyd Rice at the entrance to Tiki Boyd's. (Photo: Shanti Williams)

there, and he increasingly took both for granted. Compounding this, Rice was never reimbursed for the materials or labor he put into creating the bar's tiki theme – essentially meaning that regardless of Tiki Boyd's cash-register-bulging success, Rice still technically owned every bamboo stick, colored light bulb and vinyl platter in the place. As his involvement was increasingly downplayed and as the bar's management began to mistreat his friends who were employed there, Rice soon became frustrated with the situation. Thus, sadly for Denver's tiki enthusiasts, after about a year of doing business, Tiki Boyd's disappeared even more quickly than it had arrived.

One Spring afternoon in 2006, on Rice's direction, a dozen members of both the *Modern Drunkard* staff and a group called The Denver Gentlemen's Pipe Smoking League set upon the bar with a barrage of power tools and moving boxes, dismantling it completely and essentially stripping it bare in under an hour. Despite management's subsequent attempts at implementing a faux-tiki theme, the bar failed shortly thereafter and later incarnations of short-lived theme bars to follow at The Ramada Inn's bar-space never even remotely approached the success of Tiki Boyd's in its rum-slinging heyday.

By the time Tiki Boyd's came into

Boyd Rice with one of his UNPOP artworks. (Photo: Brian M. Clark)

Boyd Rice's "Just Do It".

existence, Rice had already parted ways with *Dagobert's Revenge* due to personal differences with its editor Tracy Twyman, and had all but ceased his research into the grail bloodline (*Dagobert's Revenge* folded immediately following Rice's departure). Around the same time, in 2004 Rice co-founded an art movement known as UNPOP ART, with 10 like-minded allies from the worlds of underground art, music and publishing. Defining itself as "The application of pop aesthetics, stylings, or techniques to unpopular, unpleasant, repressed or otherwise censored ideas," UNPOP ART presented categorically unpopular concepts and themes via popular, often fun, media. Aesthetically and conceptually centered around the fusion of seemingly polar opposites, the movement explored the range of high-contrast duality inherent to Rice's lifelong interests of Gnosticism and alchemy. Rather than express duality with stark symbols such as the Wolfsangel or Cross Of Lorraine, however, UNPOP ART juxtaposed the explicitly profane and overtly offensive with the fun, whimsical and lighthearted. Attempting to render racism, sexism, intolerance, disability, disease, rape, genocide, suicide, terrorism, hatred and war "fun," UNPOP ART (predictably) received

little welcome from either the art world or the countercultural underground – a phenomenon Rice and his UNPOP associates had long since become accustomed to.

Unlike aesthetically exacting contemporary art movements such as Robert Williams' Lowbrow Art or the painterly Pop Surrealism (both of which had become quite fashionable at the time of UNPOP's foundation), UNPOP ART focused on the temporal fun to be found in embracing the unpleasant and thereby shared more in common with Andy Warhol's instantly gratifying Pop Art movement of the 1960s. Rice came to figure heavily in the UNPOP ART movement's development, with a handful of his artworks entering into the UNPOP canon and several of his writings coming to be regarded as some of its more important texts. Curiously, despite the initial consternation UNPOP ART produced, a few years after its inception many of the theretofore off-limit subjects the movement had callously made light of began to see mainstream handling on television – by standup comedians, on sketch comedy programs and in satirical cartoon shows, all with largely uncontroversial acceptance. Social mores had shifted, and what was resolutely proscribed in the hypersensitive mid-1990s and early 2000s had become fodder for comedic amusement just a

few years later. Perhaps unsurprisingly, the individuals involved with UNPOP ART who first began exploring such subject matter while it was still culturally risqué saw little marked success as a result of its later mainstream acceptance.

By the mid 2000s, Rice had garnered ample standing as an authority on all things iniquitous and sinister, and began to receive legitimate recognition from the very worlds of art and academia which he had so succeeded in alienating nearly two decades earlier. In 2004, the same year he co-founded UNPOP ART, Rice was asked to show one of his artworks in an exhibit titled 100 Artists See Satan at Santa Ana California's Grand Central Art Center – a rejoinder to the conversely-themed, much lauded British exhibit, 100 Artists See God. A year later, Rice (a high school dropout) was invited to speak and perform at a Massachusetts Institute Of Technology symposium titled Regarding Evil, alongside eminent artists and academics including Julian Laverdiere, Matthew Barney and Ronald Jones. Two years later, he was again called to the North East, this time for a solo exhibition of his abstract black-and-white paintings at New York City's Mitchell Algus Gallery. Reviews of these events in local media were mixed, but were

Boyd Rice at the Mitchell Algus Gallery's showing of his paintings.
(Photo: Mitchell Algus)

generally met with hesitant approval; on the whole, reviewers warily commended Rice's abilities, while not quite reconciling them with his iniquitous reputation.

At the time of this writing – 30 years after his first noise album was released – Boyd Rice remains an active figure in the American underground. He continues to produce visual works, contributes somewhat regularly to Modern Drunkard and periodically records as NON. His most recent musical collaborations have included an ambient album with industrial percussionist Z'ev and a glam-pop project with Giddle Partridge under the moniker Giddle & Boyd. In the years to come, Rice may well continue working along these same lines, authoring articles and recording albums from time to time. Or he could change focus and direction yet again, shooting off on some unpredictable new course of study and endeavor. Or he could just as likely tire of all publicly directed creative ventures and retire to a life of hermetic solitude. All are well within the realm of possibility, and only time will tell.

Even if the latter scenario were to indeed become the case – and Rice entirely ceased his activities in recording, art and writing – he would still have already left behind an extremely dynamic and enduring body of work

Promotional poster for the Regarding Evil symposium

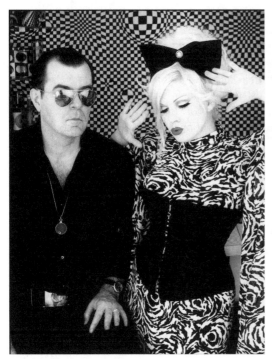

Giddle & Boyd. (Photo: Amanda Brooks)

that has proven consistently provocative. From 1977 to 2004, recording variously as NON, Boyd Rice & Friends, The Boyd Rice Experience, Spell, Scorpion Wind, Sickness Of Snakes and The Tards, Rice released 17 full-length albums and 10 EP singles. In the process of doing so, he spawned the genre of noise music, innovated unique modes of sound generation, worked beyond the fixed confines of the recorded medium and played a major role in demarcating the bounds of industrial culture. Along the way, he collaborated musically with members of Throbbing Gristle, Fad Gadget, Death In June, Strawberry Switchblade, Blood Axis, Coil, Combustible Edison, Der Blutharsch, Current 93, SPK, The Normal, The Electric Hellfire Club, Psywarfare, Chthonic Force, Little Fyodor & Babushka, People Like Us, Sol Invictus and Luftwaffe, among others. Rice's sonic output has proven so abundant and varied as to prompt the issuing of two best-of NON collections (1991's *Easy Listening For Iron Youth: The Best Of NON* and 2004's *Terra Incognita: Ambient Works*) as well as a third best-of compilation featuring many of his collaborations in the genres of easy listening, spoken word and lounge music (2000's *The Way I Feel*).

This musical legacy, in and of itself, would prove sufficient enough for many recording artists to contentedly rest on their laurels, but it represents only a part of Rice's

creative undertakings. Aside from his recording career, as discussed earlier, Rice has played the roles of photographer, filmmaker, essayist, interviewer, editor, art curator, deejay, actor, orator and tiki bar designer – and it is this cavalcade of nonmusical activities that has made him such a compelling figure in the American countercultural underground. From whimsical subjects like outsider music, found art, cult films, tiki culture and retro pop to the contentious ideologies of Satanism and Social Darwinism – for better or worse – Rice's assorted activities have brought a greater awareness to an array of people, places and ideas that might have otherwise entirely fallen through the cracks of the public consciousness.

Despite providing the impetus for so

much in the way of fringe culture's appreciation, however, Rice remains widely disliked by the very underground which has proven so otherwise receptive to his ideas. This isn't to say that he has gone un-credited or unrecognized – far from it, as he is widely respected by many in the fields in which he has undertaken to work – but always with the caveat that somehow, somewhere he went astray and got caught up in the "wrong" sets of ideas and values. Unsurprisingly, this sentiment has served well as a justification for some of those who've most benefited from building upon Rice's concepts while leaving him conspicuously unacknowledged.

The fact is, a number of ideas gestated by Rice at various points in his career have repeatedly been expanded upon, repackaged and marketed by other parties, with marked success over the years. For example, a few years after the success of the *Incredibly Strange Films* book, the BBC launched a television series called *The Incredibly Strange Film Show*, which was followed by a sequel, *Son Of The Incredibly Strange Film Show*; neither of which saw any involvement from Boyd Rice or Jim Morton. Likewise, Re/Search Publications, despite their very public falling out with Rice in the late 1980s, continued to build upon what had initially been his seminal ideas. They applied the "incredibly strange" concept to the medium of sound, releasing two volumes of *Incredibly Strange Music* (and accompanying CDs) which saw no involvement from Rice whatsoever (although he asserts that he pitched the idea before parting ways with the publisher). Re/Search also published a sequel to the Rice-inspired book *Pranks!*, which, although it featured many of the same cast of characters from the first volume, was glaringly lacking in any involvement from the noise musician who had figured so prominently in its predecessor. Similarly, in 2001 the first issue of *Found* magazine hit the stands, showcasing found photographs, artworks and other cultural debris – precisely the same sort of material that Rice and his friends had first begun exhibiting at Southern California art galleries almost two decades earlier. And in 2003, author Dan Brown brought out *The Da Vinci Code*, a fictional novel based on premises first presented in *Holy Blood, Holy Grail* and later expounded upon by Rice and *Dagobert's Revenge*.

The Da Vinci Code was a best-selling international success which catapulted the concept of a grail bloodline to the status of a pop culture phenomenon overnight, inspiring a feature film and countless derivative books and documentaries. Resultantly, two of the three authors of *Holy Blood, Holy Grail* sued Brown for copyright infringement, claiming that he "stole" their ideas in authoring *The Da Vinci Code*. They lost the case, as it was ruled that Brown had not plagiarized *Holy Blood, Holy Grail*, but had simply created a fictional narrative utilizing some of the same core themes as their non-fiction work. Such seems to be the intrinsically non-proprietary nature of novel ideas – once they're in the air, people are bound to seize hold of them, regardless of whomever was exploring them prior to their popularity. Thus, it would similarly be futile to suggest that Re/Search, The BBC, *Found* magazine or anyone else "stole" Boyd Rice's ideas, or that he has any sort of sole claim on such subjects. Rice, unlike the disgruntled authors of *Holy Blood, Holy Grail*, appears to enjoy the wider acceptance of concepts and trends whose popularity was presaged by his endorsement in prior years, and seems quite content with the fact that many of his once singular ideas have taken hold in the larger public consciousness. Moreover, Rice himself has often appropriated from his ideological and conceptual predecessors in his own right; utilizing visual techniques in the medium of sound, applying philosophy toward art, directing history toward pop culture, appropriating archaic literary texts for presentation over music, and so forth. To split hairs over who thought up what, when, where and before whomever else would be an exercise in the niggling and trivial. However, to deny Rice's significant influence on counterculture (as many critics have) simply because one may not like him or agree with every aspect of his work, is far more petty and childishly inaccurate than any hair-splitting proprietary claims could ever be.

This is not to suggest that those critical of Rice are merely offended by some element of his work and write off the rest. Taste is subjective. Some may simply dislike Rice's noise music, others may not appreciate his spoken word recordings, and others may not care for his films or some other facet of his work. Certainly, the caliber of some aspects of Rice's creative output stands well above that of others, and much of it is willfully distant from what the average person would deem approachable or catchy. The fact remains, however, that over the years Rice's albums, films and performances have met with an array of obstacles on repeated occasions for more than the mere subjectivity of taste – and this is indeed

petty.

Regardless of criticisms – whatever they're based on – the fact remains that even as he enters his early fifties, Rice is a figure who continues to inspire, enrage and confound in equal measure. The scope of this sentiment is perhaps most succinctly expressed in a late 1990s preface to one of Rice's many interviews, from the pen of his long-time friend and collaborator Adam Parfrey:

"Nothing – and I mean *nothing* – during my probation on this revolving mudball has been so troubling a subject to my allies and detractors as my friendship with Boyd Rice. Boyd is not the problem. Emphatically not. He's always a joy to be around. The problem always seems to be with assholes who invoke Joe McCarthy-ite guilty-by-association techniques. At any public event, there will invariably be some lout who acts like the Grand Inquisitor, grilling me: 'Aren't you friends with Boyd Rice? How can you support a stinking Nazi?'

Well, I'll tell you how. It's based on a rule of personal conduct important to me. It's not so much what people say as what they do that is important. Boyd and I have been friends for at least ten years. It's hard to imagine someone treating this Hebe with more generosity and respect. More to the point, we seem to share a similar take on the world, and loathe its stinking, degenerate pool of professional victims equally. The word is out that Boyd enjoys certain aspects of Hitler (ooh, yes, bad, bad, *bad* man!), but what about Boyd's Barbie fetish? Perhaps a line should be drawn somewhere.

Quite simply, Boyd is interested in things that push emotional buttons – things that make people scream. It's amusing to watch. I remember one time a Jewish girlfriend went off on him: 'So, you like Hitler, huh? Hitler!? So, you wanna' exterminate me, too? Huh? Huh? Huh? What 'bout it?'

Then there was the time Diamanda Galás spent a lot of energy trying to have Boyd booted from the Mute Records label. There were a couple of difficult weeks when Boyd was forced to write some sort of apologia for his misanthropy. Typical to form, however, Boyd did not back down one iota from his philosophy, and his records are to this day issued by Mute.

Boyd's recordings for Mute under the *nom-de-guerre* NON are legendary. Less well known, perhaps, is Boyd's recording ... under the titular Boyd Rice & Friends ... The least best-kept secret about Boyd is that he continues to be a fountain of ideas and inspiration for culture mavens. For example, it was Boyd's inspiration and ideas that fostered the publication of Re/Search's *Incredibly Strange Films* and *Pranks!*. It was Boyd who came up with the name Feral House, my own company. You would need a flow chart to document Boyd's influence in the underground culture praxis."

The unique, paradoxical phenomenon Parfrey touches on – that Rice is simultaneously admired and resented, influential and dismissed – has a multi-part explanation. First of all, in the attention-span-deficient modern world, people tend to like things simple and one-sided; as much as they may claim otherwise, most crave straightforward definition and abhor the willfully uncategorical. Rice's body of work is nothing if not mercurial; fitting as a whole into no boxes, stylistically, conceptually, aesthetically, philosophically or politically. His musical output does not slip neatly into any single preexistent genre. His art and photography sway from the abstract, surreal and experimental to the profane and wantonly offensive, and again are not easily categorized when considered in sum. So too is the case as regards his work in film – it is both experimental and non-linear, and of the narrative variety. Similarly, his interviewees and cohorts have included both the universally beloved and collectively despised, and his writings have dealt with topics ranging from the fanciful and amusing to the mordant, hateful and cruelly cold-hearted. Through the decades he has explored both the serious and the silly, the offensive and the innocuous, the groundbreaking and the traditional, the novel and the established, the ephemeral and the absolute – and any artist, writer or musician who does such is bound to frustrate most of society, as society generally strives to homogenize things, while he only further complicates them. Rice's output and interests are so multifaceted and varied as to

render him all but uncategorizeable in a world in which vocations, ideologies and endorsements are commonly understood as straightforward singularities, not complex pluralities.

Moreover, not only does Boyd Rice's work defy categorization, but he himself exists as a sort of "odd man out" within the worlds of artistic and musical expression. The countercultural underground generally expects its own to be subsumed within its dominant ideological strains of bohemian anti-establish-mentarianism and left-wing politics, further preferring that those of a neo-traditionalist mindset stay out of the creative mediums altogether. For a figure such as Rice to endorse the eccentric, oddball fare which has long been the province of left-leaning counterculture, while at once promoting an intolerant Satanic, Social Darwinist worldview that flies in the face of that counterculture's politicking, is a betrayal of the most severe character.

Additionally, Rice's assorted works, interests and endorsements encompass what many would view as a mutually-exclusive pairing of polar opposites. Much of Rice's work inhabits the territory of somber, cold-hearted stoicism, employing the diction of art history, philosophy and other scholarly subjects generally confined to the realms of academia – yet it is at once utterly lowbrow, concerned with temporal fun, pop culture and a lighthearted frivolity that would seem totally antithetical to the seriousness otherwise displayed. Rice manages to be a kooky, fun-loving, prankish expert on all things kitschy and weird, yet is simultaneously a black-clad, noise-mongering purveyor of hate, deeply entrenched in several outwardly disreputable organizations and espousing a host of seemingly wicked ideologies. This stark division is not a mere casual flirting with novel areas of interest; it permeates everything about Rice's life and 30-year career. In many ways he seems – like Abraxas, the Gnostic deity he so identifies with – thoroughly dualistic, a coincident embodiment of both bubblegum-pop fun and bleak, sadistic misanthropy. Charles Manson, in a letter sent to Rice from prison, wrote of his dualistic nature, "Rice, I'll call you Abraxas, because you stand in two circles at once," and one is want for a more fitting summation of Rice's character and career (hence the title of this book).

All of this, however, is only part of what makes Boyd Rice a problematic subcultural figure. The final and most decisive factor in Rice's status

as an underground anti-hero is his resolute unwillingness to kowtow to the subjective moral relativism of the world around him. To conform to the edicts of contemporary Western social mores, one must totally accept or reject controversial, taboo subjects, and Rice has consistently refused to do so throughout his career. In considering the issue of Nazism, for example, there can be no gray area, no possibility whatsoever that certain facets of such a subject might hold a kernel of merit or glimmer of redemptive worth, the ultimate results of their realization having been too horrific to allow for their later reevaluation, even in part. To the popular Western mind, one must either unilaterally reject and despise groups like the Nazis or be judged guilty of sympathizing with every single facet of what they stood for. There is no in-between regarding such subjects; indifference and selective endorsement are simply not options (and this is especially true for public figures such as artists and musicians).

A rejection of this sort of all-or-nothing attitude is present in much of Rice's work, but becomes especially problematic regarding the subject of Nazism, for one simple reason: the underground at large displays a particularly selective disingenuousness regarding 20th Century political movements. The use of Fascistic or Nazi aesthetics and symbolism is resolutely – aggressively – forbidden in all but the most comedic of contexts, while the iconography of their Communist counterparts is not only tolerable, but actually standard fare for much of American subculture. The Hammer And Sickle and The Red Star are so ubiquitous as to verge on countercultural corporate branding, while the Swastika rarely makes appearances outside the walls of men's restrooms. Infamous Fascist dictators Adolf Hitler and Benito Mussolini are unilaterally and universally anathematized, while their despotic Communist counterparts Joseph Stalin and Mao Tse-Tung are regularly given a pass – despite the fact that the latter wrested exponentially more human life from the face of the planet than did the former. Whether or not one agrees with any of the elements of either ideology isn't really relevant – the fact remains that both 20th Century Communists and Fascists exterminated vast numbers of people, and to demonize one while pardoning the other, simply because its rhetoric sounds nicer on paper, is patently ridiculous and completely hypocritical, regardless of how widespread such acceptance may be. Boyd Rice's often suggestive yet

ultimately noncommittal handling of the imagery and ideology of Fascism calls this double standard to attention, regardless of whatever his intentions in doing so may be.

Similar parallels can be drawn to the subject of Satanism. Widely misunderstood and disparaged, The Church Of Satan is often dismissed outright as illegitimate by practitioners of more established belief systems (both religious and secular), although few make any real attempts at understanding its core tenets or philosophy. However, to discount Satanism as a worldview that simply promotes "evil," in defense of traditional organized religion is to ignore the tangible, real-world ramifications of both. Irrespective of one's own religious inclinations, it's difficult to deny that conventional organized religion has been responsible for scores of large-scale wars, genocides, inquisitions, witch hunts, crusades and other varieties of human strife over the centuries; but one would be hard-pressed to find so much as a single example of a major conflict undertaken in the name of Satan or resultant from the self-worshiping ethos advocated by Anton LaVey. Despite its often cringe-worthy demonic theatrics and the fact that it may be a bitter pill for some to swallow, LaVey's Satanism – and more especially, Social Darwinism – paint a far more brutally honest picture of human nature than that offered up by more pacifying mainstream worldviews, both religious and secular.

As the historical record amply documents, doctrines of unrepentant egoism such as Satanism do not come even remotely close – in terms of large-scale human destruction and suffering – to their altruistic, communalist counterparts, whether religious or political. With tragicomic irony, moral dogmas centered around the proselytization of love, peace, tolerance and harmony have – by way of self-righteous, absolutist zealotry – historically produced overwhelmingly more bloodshed than those marginal misanthropic credos devoted to ethical self-interest and contempt for humanity. When it comes to leading masses of people astray, the aloofness and cynicism of the willful outsider pales in comparison to the charismatic charm of religious and political leaders espousing a love of freedom, brotherhood and the common good. The widely-held assumption that there is a direct correlation between an ideology's stated aims and the tangible, real-world results of its practice stands in all but direct opposition to the cold, hard facts. Again, Rice's public endorsement of contentious, antisocial ideologies, and his outright rejection of their mainstream antipodes, provokes such speculations about the long-assumed validity of existing social and religious paradigms, whether or not this has been his conscious aim.

Ultimately, this is the overarching theme of Boyd Rice's 30-year creative oeuvre: the questioning of accepted norms, the overturning of assumptions and the revisiting of overlooked, lost and undervalued ideas. While Rice's various undertakings may at times superficially seem to bear little in common, what they do share at base is this aggressively unbiased attitude toward the nature of pre-existent, assumed *meaning*. Rice's noise compositions, artworks, experimental photographs and films have all blurred established boundaries of genre and transversed static categorical definitions about what music and art are and how they're to be made. His endorsements of outsider music, cult films, bygone pop culture, found artworks and photographs all provoke a reevaluation of what is and isn't considered "real" art and culture, as well as who is to be the arbiter of what constitutes so-called good taste. Rice's eschewing of the accepted norms of religious tradition and history – via explorations of Gnosticism, Satanism and the grail bloodline – likewise call into question what constitutes legitimate religious tradition, why, and as certified by whom. His promotion of Social Darwinism challenges the very egalitarian premises upon which much of modern Western governments rest. Similarly, his unconventional handling of proscribed symbols, words and aesthetics plays to the public's conditioned Pavlovian response to such and provokes a redressing of the assumedly inert nature of their meanings, as well as of the fixed understanding of symbolism itself.

Whether or not one feels that any, all or none of these subjects deserves reevaluation – or agrees with Rice's conclusions about them – is entirely up to the reader, but Rice's un-assumptive appraisal of such subjects is both what unifies them and what makes him unique. He certainly isn't the first to have brought a persistently impartial strategy to the worlds of art or music (Marcel Duchamp, Andy Warhol and John Cage all immediately come to mind) but he has certainly taken such a principle to its furthest logical modern conclusion, regardless of the consequences.

As has always been the case, any public figure who refuses to accept the subjective and often arbitrary aesthetic and moral constraints of the culture they inherit is perceived as a menace to the fragile, absolutist worldviews of those around them. Especially in the public arena, those who unflinchingly explore the world for what it is, rather than what other people might collectively like it to be, invariably provoke the resentment and contempt of a public seeking to shelter itself from whatever elements of reality it finds threatening. Boyd Rice is one such ideological and philosophical pariah – and in consideration of the depth and breadth of his career, is arguably the quintessential *fin-de-siècle* underground American iconoclast.

The preceding analysis is, of course, only one interpretation of Rice's career and its significance. Many are quite thoroughly convinced that Rice is just a dangerous neo-Nazi – a racist, regressive traditionalist seeking to reinstate the harsh, stifling hierarchical constraints of antiquity by way of Satanism, Social Darwinism and Fascism. Others have long insisted that his activities in the public arena comprise a grandiose, subversive prank of some sort, and are not to be taken at face value. Presumably, readers will make their own interpretations and draw their own conclusions.

Rice's influence on late 20th Century music, however, is less debatable. To those literal-minded types who equate an artist's significance with their record sales, Rice may seem a minor player in the history of music – but such a simplistic interpretation couldn't be further from the truth. Rarely is the most groundbreaking music of an era also the most popular, or even the most lauded by contemporary critics. The destitute guitar pickers who first crafted the blues were virtually unknown at a time when they were founding a genre that would become the roots of rock n' roll. Similarly, bands like The New York Dolls and The Ramones never went platinum, but their significance to the history of music – as the seminal forerunners of punk rock – far overshadows that of flash-in-the-pan disco stars whose records sold like gangbusters at the same time. Boyd Rice's long-term influence on music is no different. His recordings exist in category far afield from those that make the Top 40, but as a noise pioneer he has certainly made a much greater mark on the history of music than the vast majority of flavor-of-the-week pop stars who will ultimately be forgotten by history.

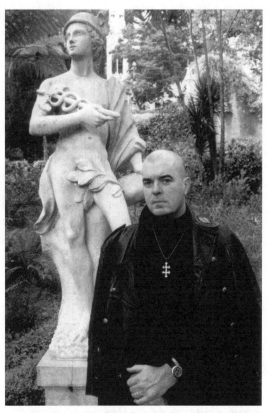

Boyd Rice in Sintra, Portugal. (Photo: Douglas Pearce)

Regardless of how one chooses to view Boyd Rice, he certainly can't be accused of producing a prosaic body of work or leading a run-of-the-mill life – and this, in and of itself, sets him apart from a great number of artists, writers and musicians who successfully vie for the public's interest while being far less deserving of it. As far as public figures go – whether mainstream or underground – there are few whose lives, careers and influence have had such a wide scope as Rice's. In time, perhaps, the underground (or the public in general) will move beyond the dismissive, hysterical stigmatism associated with avowed Satanists and rumored Nazis, and the disquiet surrounding Rice will dissipate, allowing his influence to be acknowledged for what it is. Until then, Boyd Rice is sure to remain one of the most notorious figures in the American countercultural underground – and judging from the comfort he displays in having occupied such a role for so long, one can only assume that he wouldn't have it any other way.

Preface to the Collected Works

Boyd Rice's 30-year career in music, the arts and media provocation has produced a wide array of sonic and visual output in the form of records, CDs and DVDs, the vast majority of which remain in print and are available for purchase by the general public. What has been conspicuously absent throughout his multifaceted career, however, is any sort of authoritative collection of his written works, and what you now hold in your hands is – obviously – an answer to this longstanding vacancy. This book comprises the first definitive compilation of Rice's writings and spans more than two decades of his written output. While he has garnered quite a sizeable reputation for his various undertakings over the last few decades, Rice's written material has heretofore proven consistently scattered and often surprisingly difficult to track down. Although his essays for books such as *Incredibly Strange Films*, *Taboo: The Art Of Tiki* and *Apocalypse Culture II* have remained perennially in print, other of his writings only briefly appeared in short-lived (and often poorly distributed) publications such as *Rollerderby*, *Dagobert's Revenge*, *The Unconquered Sun*, *The Black Flame* and *Pop Void* – after a month-long stint on the shelves of hip records shops and independent bookstores, these have long-since fallen out of distribution and availability in the years since. Here they are presented in a single volume for the first time ever, and many are expanded from their original editorial abridgments. Also included here for the first time are a number of Rice's previously unpublished writings. In some instances these are book proposals that were never realized; others are prefaces to books that were never published; still others are examples of Rice's assorted ruminations and musings – both lighthearted and serious – which he never sought to publish simply because he felt that their subject matter had already been over-discussed in his interviews at the time they were written.

In sum, readers will find herein nearly three dozen essays on a wide variety of subjects from the pen of Boyd Rice. Many are studies of Rice's various areas of interest: bygone drinking clubs, novelty soaps, cult-like retirement villages, Bible-themed amusement parks, lost exotica and tiki culture, extreme documentary films, quirky Nazi philosophers, celebrity singing careers, postwar concept albums and other obscure areas of curiosity that tend to escape serious analysis. There are also a number of somber-toned treatises on subjects such as misanthropy, *schadenfreude*, Social Darwinism, Gnosticism, Monist philosophy and Rice's personal understanding of the nature of God. Readers will also find discourses on the inherent sadism and fascism of the natural world, as well as diatribes on the ineffectual nature of passive-aggressive "activism," and dissertations regarding the hopeless chaos of modern Africa and the increasing dysfunction of the modern West. In addition to these essays and treatises, also included are a number of first-person narratives detailing Rice's various misadventures over the years: accounts of liaisons with infamous figures such as Anton LaVey and Charles Manson, tales of drinking behind the Iron Curtain, in Europe and on the Mediterranean, retellings of field trips devoted to genealogy and exotica culture, and sundry tales of complex pranks, predatory stalking rituals and ghost stories.

What has proven problematic regarding these texts is that – as with much of Rice's career – they repeatedly stray from the stern to the whimsical and then back again. Among his assorted aphorisms, anecdotes and observations, Rice at times adopts a detached, academic tone, and at other instances a capricious, irreverent and casual attitude informs his writing. Elsewhere he leans toward the realm of the sacred, and still elsewhere into the territory of the profane. The texts contained herein do not all arise from the same time period, are removed from their original contexts, and often shift in both their intentions and the literary devices they employ to achieve their aims. For example, some of Rice's writings were originally intended to be taken quite literally and at face value while

others were more tongue-in-cheek in their tone, and much of this was dependent upon the context and time in which they were originally published. Rice's essay "Remembering LaVey" was written for *The Black Flame*, a journal produced by and for members of The Church Of Satan. His essays "Bathtime Fun" and "The Champagne Cult" originally appeared in *Pop Void*, a publication devoted strictly to the re-popularization of then un-cool 1960s pop culture. Similarly, several of his later essays were penned specifically for *Modern Drunkard*, a magazine centered entirely around drinking culture. Rice's treatise "Revolt Against Penis Envy" was likewise tailor-made for publication in *ANSWER Me!*, a semi-satirical, willfully confrontational magazine self-described as "hate literature," whose final issue was devoted entirely to the subject of rape. Each of these texts was composed by Rice with a specific context and audience in mind, and by necessity, all are taken out of their respective contexts in being republished here. Hopefully this will not prove too problematic for readers, but nonetheless it ought to be borne in mind that most of the previously published texts in this book were specifically written by Rice (usually by request) for the thematically focused publications in which they originally appeared.

In compiling and editing this book I have attempted to stay true to Rice's original designs throughout. In cases where the original editors of Rice's previously published texts added material when going to press which Rice neither wrote nor approved (*Incredibly Strange Films* and *Dagobert's Revenge*), these passages have been excised from the essays presented in this book. In other cases, where prior editors omitted sections of Rice's texts because of constraints of space or context (*Rollerderby* and *Apocalypse Culture II*), they are printed here in their unabridged versions for the first time. While some of Rice's previously published essays remain all but untouched from their originally published versions (*ANSWER Me!* and *Modern Drunkard*), others were extensively reworked, retooled and rearranged, with glaring transcriptional typos, grammatical errors, stylistic inconsistencies and other general problems resolved for publication here.

A consummate luddite, the mostly computer-illiterate Rice writes everything in longhand, thus his previously unpublished essays were transcribed from pages upon pages of his handwritten notes – many of them sitting for decades in boxes and file-cabinets before being disinterred for publication here. Generally speaking, the redacting I've done of the previously unpublished texts in this volume has involved little more than the rearranging of paragraphs and the adding contextual background info and relevant pretexts. In all cases I've attempted to stay true to the original tone and intent of Rice's writing, omitting only those passages which seemed redundant, adding only those details which I felt were necessary for the understanding of the laymen reader, and ensuring that there was a stylistic and grammatical consistency throughout the whole of the work. All such instances have met with the author's approval.

In addition to Rice's essays, also included in this volume are the first printed reproductions of the majority of his photographs and paintings. Presented first among these are his early nebulous photographs of his Actual Photographs, or "things that don't exist," produced in his teen years and exhibited in San Diego and San Francisco in the 1980s. These are followed by his often surreal Documentary Photographs shot throughout the 1970s and '80s, some of which were first featured (cropped and tinted) in the 2004 Mute release *Terra Incognita*. Next are presented several of Rice's Manipulated Halftones, created at the end of the 1970s. Also included are Rice's fetish-themed photographs taken during the first half of the 1990s with the assistance of Denver-based photographer Sean Hartgrove. These four collections of photographs are followed by Rice's abstract black-and-white paintings which, while created as early as the mid-1970s, didn't see public exhibition until his 2007 solo show in New York City, and are published here for the first time.

Following Rice's visual works is the first ever printed collection of his lyrics. Covering a span of 17 years, these have been culled from eight full-length releases by both NON and Boyd Rice & Friends, as well as Rice's numerous collaborations and compilation cuts. Much like his writings, they cover a wide variety of themes: misanthropy, Gnosticism, duality, Social Darwinism, misogyny, sadism, mass murder, spirituality, mythology, dream imagery, et cetera. While much of the lyrical material presented here was penned by Rice himself, in some instances he has utilized texts by other writers and poets, as well as those of psychologists, philosophers, politicians and *bon vivants*, both obscure and infamous. While such sources were often omitted in the credits of the albums on which Rice's readings of them appeared, they are cited and credited appropriately here, generally for the first time. Unfortunately, what is lost in the presentation of Rice's lyrics is – obviously – the music which

accompanies them. Musical timbre and vocal tenor often set the tone for the way in which lyrics convey their meaning and are to be interpreted by the listener, and such is obviously lost here. Over the years Rice has released recordings in a wide variety of genres (noise, neo-folk, experimental, easy listening, exotica, et cetera), and – as with his writings – he has done so with a variety of intentions. In some cases his lyrical renderings are quite sincere, matter-of-fact and serious – in others, ironic, facetious and not to be taken too literally. Reading the printed words alone, one gets no sense whatsoever of these distinctions which are starkly obvious in the recordings themselves. For example, the sardonic irony and tongue-in-cheek humor implicit to the songs from The Boyd Rice Experience's misanthropic jazz album *Hatesville!* is all but entirely lost in reading the texts alone. Likewise, many NON tracks such as "Total War" (barked by Rice over a cacophony of noise loops and martial rhythms) is equally done a disservice in being presented as mere type, as it lacks in any emotive intensity. Nonetheless, the lyrics from Rice's assorted projects and collaborations (both original and appropriated) comprise a compelling body of written work in and of themselves which merits interest and appreciation, even without the accompanying audio to place it in context and give it additional depth.

In total, this collection of texts and images covers as definitive a cross-section of Boyd Rice's various creative undertakings as one could ask for. Nevertheless, this book does not represent Rice's complete works. As comprehensive as this volume may be, some elements of Rice's printable material have, by necessity, been omitted. During his tenure as a contributor to *Dagobert's Revenge*, Rice penned 20 essays which explored assorted facets of the grail bloodline, and only two are included here, "And To The Devil They'll Return" and "The Persistence Of Memory." While interesting, most of Rice's essays exploring the grail bloodline are long, dry and somewhat academic in style – they're written in a tone appropriate to a history textbook and when considered in sum, merit a book in and of themselves. These grail texts often make reference to one another, to the book *Holy Blood, Holy Grail* and to numerous aspects of history, mythology, the occult and esotericism with which the average reader is unlikely to be familiar. Many of them were published in the book *The Vessel Of God* and those which did not make it into that volume are available on Rice's website TheVesselOfGod.com (and may see publication in book form elsewhere, at some point in the future). "And To The Devil They'll Return" and "The Persistence Of Memory" are exceptions, in that they stand alone as independent texts which require little knowledge of the intricacies of the grail bloodline theory; they provide an introduction to facets of the subject which both the grail savant and laymen reader can enjoy in equal measure, thus they are included while the rest have been omitted. Also missing here are Rice's UNPOP artworks, the majority of which were created specifically for the UNPOP ART website. At a low web-browser resolution, they do not lend themselves well to the printed medium, and would appear hazy and pixilated were they to be printed here. Readers interested in exploring either of these two unrepresented facets of Rice's artistic and written output are encouraged to visit their associated websites: UnpopArt.org and TheVesselOfGod.com.

A long time coming, this book is the first substantive presentation of Boyd Rice's writings and lyrics, as he has written them – his interests, endorsements and philosophies from his own pen. Throughout this volume, readers will encounter Rice's cynical acumen as well as his wild abandon and wanton disregard for the accepted norms of the world around him. Many readers are sure to find resonance here, while others will encounter much to take umbrage with, and some may experience both at different points in the text. Regardless, contained herein is something to amuse, inform and irritate almost anyone – and even those whose sensibilities are offended at some point will likely still find themselves chuckling or nodding in agreement elsewhere within these pages.

By no means is this book intended to constitute the "final word" on Boyd Rice. He has remained one of the most debated and misunderstood figures in counterculture for decades now – just as unreasonably adored as he is despised – and this volume isn't likely to change that. Those of selective judgment seeking to demonize Rice will find plenty herein to confirm their suspicions – and likewise, those desiring the opposite will encounter just as much to support their own views. Ultimately, whether Rice is loved or hated is irrelevant, at least as much as he seems to be concerned – and as far as "final words" go, it's probably best just to leave it at that.

–Brian M. Clark, Denver, Colorado, 2007

For more information on Boyd Rice, including audio and video downloads, interviews, photo galleries and more, visit BoydRice.com. Additional material related to Boyd Rice's interests and work may be found on the following websites:

TheVesselOfGod.com
UnpopArt.org
TheChurchOfSatan.com
ThePartridgeFamilyTemple.com

Boyd Rice's CDs, DVDs and other works can be purchased online through the following vendors:

Mute.com
UnpopStore.com
Soleilmoon.com
DiscriminateAudio.com

About The Editor:
Brian M. Clark has authored articles and conducted interviews for a number of publications including *International Living, Modern Drunkard Magazine* and *Rated Rookie*. He also penned the liner notes to two retrospective musical anthologies: Ralph Gean's *The Amazing Story Of Ralph Gean* and NON's *Terra Incognita: Ambient Works*. This is his first book.

Aside from his work in print, Clark co-founded the UNPOP ART movement and acts as its chief organizer, archivist and promoter. Clark also owns and operates the DISCRIMINATE AUDIO recording label, which has issued albums by Jim Goad, Little Fyodor and Ralph Gean, among others.

More information about Brian M. Clark is available on his website at www.BrianMclark.com.

Writings
1986 – 2007

Writings

Mondo Films

(Originally published in *Incredibly Strange Films*, 1986)

The year was 1963. Across the country, movie-theater screens began to throb with insects, blood, natives, transvestites, strippers and various distressed animals. A new world opened up to film-going audiences, unlike any they'd previously known. Some elements of this strange new world were:

Living insect jewelry.
Meals of cooked insects.
A town populated by the distorted look-alike descendents of Rudolph Valentino.
An annual celebration in which men smash-in a garage door using their heads.
Religious fanatics washing a stairway with their tongues.
A chicken who smokes cigarettes.

If such subject matter seems too far-fetched to be credible, it's probably because the people, places and things just described are all real. *Mondo Cane* brought to neighborhood theatres around the world a huge variety of unusual information disguised as entertainment. *Mondo Cane's* documentation of strange behavior – bizarre customs, rituals and pastimes – was hugely successful, spawning a deluge of sequels and copies that comprise the Mondo genre. By way of introduction, what follows is a sampling of representative themes characteristic of the genre:

Unusual rituals are a prominent feature of nearly all the Mondo films. Movie footage from a small town in Italy documents people who fill a garage with food and drink for an annual feast. Part of the celebration calls for the men of the town to smash through the garage doors using their heads as battering rams. Some begin to bleed from the ears and mouth, then go into convulsions and have to be carried off. Eventually the door is smashed in and the anxious villagers rush inside to eat until they're sick.

In a more solemn ceremony, a crowd of churchgoing women wash down a parish's steps using their tongues. As the cleanup progresses, their tongues become raw and the steps are covered with streaks of blood. Although the performers of this task are undoubtedly *sincere*, it's difficult to imagine how they possibly think that covering something with saliva and blood could be a *cleaning* process.

Another area often given generous coverage in Mondo films is the world of *animals*. A visit to a pet cemetery can be both touching and ridiculous; pet tombstones that humans weep over can soon be matter-of-factly peed upon by visiting dogs. In another part of the world we are shown a restaurant in which patrons select the dog that will provide them with their next meal. Elsewhere, snakes are picked from cages, skinned alive and sold (still twitching) to housewives. Still elsewhere, well-dressed sophisticates order expensive plates of fried insects. Tying-in with the bugs-for-the-rich theme is footage of enormous beetles with jewels glued on their backs, crawling about on elegant women as a sort of living accessory. *Très chic!*

If these films return again and again to the animal kingdom, it's because there's apparently no limit to the indignities animals can be subjected to at the hands of man. Geese are force-fed quantities of grain far in excess of their total body weight to produce pâté. Chicks are dyed different colors to make cute holiday surprises for children; but after being sealed in plastic eggs and sent through the mails, the surprise may not always be a pleasant one...

Of course, not all the coverage of animals involves abuse by humans; some depicts the opposite. One hilarious scene shows the famous "running of the bulls" in Pamplona, Spain, where people see how close they can actually get to a rampaging bull. Many spectators do get safely away, but the real fun is watching those who don't. It's quite a black-humor experience to watch a man openly flirting with death; one moment he's doing a silly dance to attract the bull's attention; the next moments he's helpless, in utter horror as the bull's horns rip into him, toss him up and slam him to the ground!

Another show of bravery, also involving a bull, makes the Pamplona run look tame in

comparison. Intended to demonstrate the readiness of noble young bullfighters to unflinchingly face death, this ritual often fulfills that potential. A single-file line of six or eight matadors slowly approaches the bull to see just how close they can get before retreat is necessary. As a rule, by the time it's necessary, retreat is out of the question – the bull smashes into the line of matadors and slams them to the ground like so many dominos. The first man in line is invariably a casualty. Presumably, the matador's willingness to put himself directly in the path of almost certain agony denotes a high degree of courage, not to mention a great sense of honor. Whether this courage and honor are much comfort to a man hospitalized with severe internal injuries is open to question.

Modern art – long a source of irritation to the general public – shows-up repeatedly in the Mondo movies. Legend even has it that French artist Yves Klein bribed Jacopetti and Prosperi to include him in their *Mondo* documentary. Not that bribing was necessary, as his use of paint-covered nude women as living "brushes" was already controversial in the art world. Another featured French artist's output was primarily old automobiles crushed down into cubes. For the general public, finding out what such artworks sold for was probably far more distressing than footage of animals being skinned alive, or natives bludgeoning each other to death.

The rituals and lifestyles of *primitive cultures* receive extensive coverage in nearly all the Mondo films. One shows a tribe which abstains from meat for a full year, while fattening hogs for an annual all-out feast in which the animals are bludgeoned, butchered and devoured in one day-long spree. Elsewhere the camera focuses on members of a cargo cult sitting along the edge of a dirt runway they've created, gazing toward the sky and awaiting the arrival of a cargo plane that they believe will carry them to the next life.

However, the footage most favored by Mondo filmmakers is that depicting the more brutal side of primitive life. Scenes showing unusual games in which participants inflict and receive painful wounds provide a highly emotional viewing experience. In one match, two primitives smash each other over the head with logs, each taking turns until one drops unconscious. Another competition involves primitives throwing huge rocks at one another. Each stands perfectly still as a sizable stone smashes into him and bounces off, apparently with no ill effect. This particular "game" appears to have even less of a point than the previous one, although it no doubt teaches the primitives in question something basic about the nature of pain. Natives of New Guinea dive hundreds of feet with only a vine tied to their ankles to break their fall; but sometimes break their necks instead. In many of the sports and games devised by primitive cultures, those who lose the game may also lose their lives.

Most Mondo films have limited their documentation to aberrant behavior and unusual customs. Such was the case with *Mondo Macabro, Mondo Nudo, Mondo Infame, Mondo Pazzo, Mondo Bolordo, Ecco, Taboos of the World, Secret Pains, Go Go Go World*, and of course the original *Mondo Cane*. Other Mondo films focus on areas that are especially topical or of special exploitation value: *Mondo Teeno* and *Mondo Mod* explore the odd rites of teenagers. *Mondo Hollywood* was also released as *Hippie Hollywood: The Acid Blasting Freaks*, and boasted an appearance by Bobby Beausoleil, an actor and musician best known for his association with Charles Manson. One very specific Mondo documentary focused solely on the Manson family; it was appropriately titled *Manson*.

Not surprisingly, the most popular theme within the Mondo genre is sex. *Mondo Oscentia, Mondo Rocco, Hollywood's World of Flesh, Hollywood Blue, Mondo Daytona*, and *Mondo Exotica* are all films that purport to explore changing sexual mores. The exploitation circuit saw a deluge of sex films containing "Mondo" in the title, although *Mondo Keyhole, Mundo Depravados, Mondo Topless* and a rash of others have no connection with the genuine Mondo documentaries except a title bearing the word *Mondo*, a word which has come to imply bizarre behavior in general.

While many Mondo films present genuine documentation, the authenticity of others is questionable (though no less fascinating). *Mondo Cane* is comprised of nearly all genuine material, but its sequel, *Mondo Cane 2*, is only partially authentic, with an abundance of patently false scenes added for comic effect.

Later films such as *Mondo Bizarro* are almost entirely fake, with only a few real scenes scattered throughout in a vain attempt to provide credibility. Filmed in and around Los Angeles, *Mondo Bizarro* gives us a close-up look at the notorious lingerie shop, Frederick's of Hollywood, teens

who flock to Laguna Beach each Easter to live it up, a "crazy" artist who photographs a topless model while doing a frenzied dance himself, a Nazi play, a sex-slave auction, a bizarre voodoo sacrifice ritual, a "special" massage in Tokyo, a man eating glass in a posh restaurant, and more. *Mondo Bizarro* was put together by Cresse and R.L. Frost (who were responsible for *Love Camp Seven*). Frost also shot additional footage for *Witchcraft '70*, a Mondo film which focuses on the occult, purporting to document the widespread existence of practicing witches. At the time of its release it was rumored to contain hidden camera footage of the Manson group (actually, it contains film of another hippie family). Whether the bulk of the film is authentic or not is hard to say, but with R.L. Frost in tow it's doubtful.

Even *Mondo Cane*, for all its credibility, contains scenes that are suspect. One sequence about the effect of DDT poison on eggshells shows turtles making their trek from the sea to lay eggs in the sand. For emotional impact, the sequence ends with a confused turtle who cannot find the ocean and somehow ends up on her back. Unable to right herself, the turtle struggles helplessly and the camera marks her progress from death throes, to carcass, to skeleton. How the turtle got on her back is cause for speculation – more than likely through a bit of creative intervention on the part of the filmmakers (not unlike the Pulitzer Prize winning photographer who always carried a child's doll in his car to toss down in the foreground of his "documentation" of disaster scenes).

One of the first movies ever made, *In The Land Of The Headhunters*, is an obviously fake documentary with a contrived plot. Fake documentaries actually flourished in the early days of film, and some might even be considered true forerunners of the Mondo genre. The jungles of Africa were (and still are) a source of great mystery and speculation, usually involving some natives, girls and gorillas. *Dangerous Journey*, a 1944 documentary, actually depicted bizarre savage rituals and ceremonies, but was surpassed in sensationalism by the film *Ingagi*.

Produced by Congo Pictures Limited, *Ingagi* spliced old documentary footage of Africa and South America with suspicious-looking footage of a tribe of completely naked "ape-women" sacrificing a Black woman to a gorilla. Unfortunately, official investigation forced the film to be withdrawn from the market, after it was discovered that the nude ape-women were actually actresses in blackface, and that the locale was a California zoo, not the Congo. The lurid mixture of sex and ritual death would have been acceptable – even educational – had it indeed been documented at some faraway place, but California was a bit too close to home. Not that anyone who saw the film ever doubted it was a sham; the narrator, a Sir Hubert Winslow of London, had no trace whatsoever of a British accent. Although only on the circuit for about a month, *Ingagi* was the talk of the town wherever it played, consistently breaking house attendance records and often doubling them. Of course, what packed the houses wasn't the drive to be accurately informed, but was the desire to see a group of naked women murder someone (whether it was real or not didn't matter).

Exploitation pioneer Kroger Babb exhibited a pre-Mondo film in the '40s when he came across footage of a tribe in the Congo that, among other things, cut the throats of cows and drank the blood as it oozed out. Another choice scene shows the members of the tribe rubbing themselves with animal excrement for protection against evil spirits. Babb saw potential in the footage, re-edited it, and gave it the exotic title *Karimoja*. The theaters bulged with audiences hungering for a glimpse of sensational goings-on, and they got what they paid for, to the extent that some viewers even threw-up.

Although *Mondo Cane* didn't match *Karimoja* on the nausea meter, its early ad campaign implied the promise of a truly sickening spectacle by offering the audience free *Mal de Mer* pills (Dramamine), in case the film should prove to be too much. Needless to say, most audiences were far more fascinated than nauseated. In fact, at the time of its release, *Mondo Cane* was so popular that its theme song, "More," became one of the most popular songs of 1963, gaining the film an Academy Award.

Embodying a unique and profitable concept, *Mondo Cane* soon became widely and blatantly ripped-off, giving rise to an entire genre. For years anything with "Mondo" in the title was hot at the box office; the mere term guaranteed a built-in audience. Unfortunately, the golden age of *Mondo* films peaked in the 1960s, a decade which saw the release of more than twenty such films. The seventies was a far less prosperous time for the genre – with the falling away of old taboos, behavior that had once seemed outlandish now seemed conventional. A good example is *Mondo America*, one

of the few *Mondo* films released in the mid-1970s. True to its title, *Mondo America* explores various aspects of life in America: from a dildo factory, to a Vegas cathouse and then down to the waterfront to watch a suicide's corpse being pulled from the frigid waters of the San Francisco Bay. Though *Mondo America* proved quite successful and was fairly interesting, it lacked the spark of its predecessors. Sadly, most of the other *Mondo* films of the 1970s received such poor distribution that only a handful of people ever got to see them. Films such as *Catastrophe*, *Days of Fury*, and *Mondo Magic* are already all but forgotten.

For a while it appeared that the *Mondo* breed of film had outlived its shock value and was on the brink of extinction. However, all of that changed with the release of *Faces of Death*. Narrated by a supposed doctor (aptly named "Francis B. Gross"), *Faces of Death* presents all kinds of death, both human and animal. Although much of the footage is obviously faked, many people found the film so shocking that it was removed from the shelves of dozens of video stores around the country. A sequel, titled *Faces of Death Part Two* continues Dr. Gross' study of death with the same combination of exploitation and edification. Another film that explores death in a similar manner is *The End*, which has yet to be released here in the U.S. The primary outlet for these movies is the Far East, yet most of the films are made by Italians. In Hong Kong and Japan people queue-up to catch the latest installment in the black-comedy portrayed by the human race. *Violence USA* shows the rest of the world how we in the States treat each other. *Man Man Man* takes a particularly cynical view of human nature, with scenes of executions, whale-slaughters and the Vietnam War.

Faces of Death was the first in a resurgence of the genre, in which even more blatant forms of abuse to both animals and humans are depicted. *The Great Hunting 1984* has been (allegedly) banned in the U.S. due to its violent nature. Scenes depicting the slaughter of an entire herd of elephants in three minutes, or goats thrown into water to be eaten alive by sharks, don't exactly recapture the humor of the early Jacopetti and Prosperi films. But then again, they aren't meant to. Grainy, supposedly real Super-8 footage of a White hunter shooting Amazon Indians like fish in a barrel from his seat in a low-flying aircraft isn't exactly amusing, either. The new breed of *Mondo* films are gorier and more explicit, no doubt keeping pace with changing times.

The transvestites that seemed funny or shocking back in 1963 are now part of the scenery in most decent-sized cities. Even the sex-change operation in 1984's *Shocking Asia* wouldn't raise many eyebrows, were it not for the technique demonstrated. Careful sex-change surgery is fairly routine, but actually seeing power-drills clearing the way for vaginal implants is considerably less common. So in this sense, there are still "exotic" sights left to be seen... exotic because of their unfamiliarity, if nothing else.

There are countless other worlds existing concurrently on this planet. So long as humans insist on adhering to strictly codified values and beliefs, there will be other sets of values and beliefs that are incomprehensible (and therefore of interest). Also, there will always be those who (for whatever reason) exhibit behavior different from one's own established norms. Given such circumstances, it's likely that *Mondo* movies will remain a permanent part of the world of cinema, playing the curious dual role of documenting *and* feeding the public's appetite for unusual behavior.

Bathtime Fun!
1960s Novelty Soaps

(Originally published in *Pop Void*, 1987)

Historians, when telling us about the 1960s, talk of the war in Vietnam, the "Love Generation," Kent State protest shootings and the Watts riots. Anomalous phenomena researcher Charles Fort once said that to measure a circle, you can start anywhere; and if you want to study the universe you can begin by studying frogs. So it is that we cast aside the war and all those non-bathing hippies, to look, instead, at the era's soaps.

Do you recall that disquieting commercial, in which a young boy is bathing with Mr. Bubble, a playful fellow made entirely of bubbles? The child and bubble character get increasingly caught-up in the joys of bathtime; splashing screaming and jumping around. Suddenly a loud knock on the door brings the fun to a screeching halt. "Is there someone in there with you?", a mother's voice inquires. "Only me and Mr. Bubble, Mom!", the boy quickly replies. Mr. Bubble and the kid exchange knowing glances.

Mr. Bubble was but one of the many soldiers in the soap war. They all fought for a common cause: to make bathtime more fun! Many bubble baths came and went during those turbulent times. To its credit, Mr. Bubble is still with us, although the golden days of novelty soaps have long since past.

During the 1960s, every kind of soap imaginable jammed the market shelves. One of the best-known was a bubble bath called Soaky. Its slogan, "Soaky soaks you clean and leaves no bathtub ring," appealed to kids and parents equally. Children liked the idea of being "soaked clean" – it was like *not* taking a bath. They could play in the tub and not bother washing, because the soap supposedly did it for them. Parents naturally liked the idea of a product that left no bathtub ring. The commercial even told kids to point this fact out to parents. Of course, it was a lie. Nothing on earth can get rid of a child's bathtub ring. But it sounded good and helped kids convince their parents that the bubble bath was more a necessity than a frivolity.

But what really made Soaky special was the bottle it came in. Every few months, the bottle changed shape, when a new character was introduced. The bottles often resembled cartoon figures, but for a while they were made to look like monsters, which proved to be extraordinarily popular. TV advertisements heralded each new figure; if the bottle resembled a werewolf that month, the ads depicted an animated scene with a werewolf in the bathroom. Kids, upon entering the supermarket, ran to the soap department first thing, to see if a new Soaky character had been released. There were even billboards for the Soaky product, and it rode the crest of a new wave of bath products.

Everywhere, new horizons opened up for bathtme fun. Ivory dusted off its old "So pure, it floats" campaign. The public accepted it at face value, although the soap's ability to float has more to do with the air that's whipped into the product than it does with purity. Ironically, this feature of Ivory soap came about quite by accident, when a worker forgot to turn off a blending machine during his lunch hour. Ivory doesn't float because of *purity*; it floats because of carelessness!

In 1965, The Aerosol Corporation introduced a soap called Crazy Foam. It came in an aerosol can and squirted-out stuff looking much like shaving cream. Advertisements instructed children to use the product to spray soapy beards, moustaches and patterns on their faces before washing with the product. Kids liked to spray large piles of the stuff on their palms and slap their hands together. Soap flew everywhere! Like Soaky, the product came in character-themed containers, and included a small game book with each can. Inspired by the success of Crazy Foam, other companies also released adult versions of the aerosol foam, but the public's response was lukewarm. Unfortunately, the cans were expensive compared to other soaps, and didn't last very long. This, coupled with the short-lived nature of such a novelty, hastened the product's disappearance from the marketplace. At the height of its popularity, aerosol soap dispensers were installed in many public restrooms. But these soon vanished as well, until even the memory of the product became hazy.

No doubt the weirdest of all bathtime products was Fuzzy Wuzzy – a small bar of soap shaped like a bear. Like Crazy Foam, it was also a product of The Aerosol Corporation. Its selling-point

was that it actually *grew hair!* The commercials for the soap showed before and after shots of the hair-growing process, while an announcer's voiceover explained, "Fuzzy Wuzzy was a bear. Fuzzy Wuzzy had no hair. *Until* you put him in a dark place for a few days!" What!? Put him in a *dark place* for a few days!? What they called "hair" was actually more like mold. Rather than being charming, the effect was repulsive.

To keep kids from throwing the soap away after the hair-growing process, inside each bar was a small, plastic toy. To get to the toy, kids either had to use the soap for what seemed like an eternity, or take a kitchen knife to the product and be done with it. Not surprisingly, these items vanished quickly. Everybody bought Fuzzy Wuzzy once, but after seeing the process, few were eager to see it again.

The imbedded toy proved a popular gimmick and is still available today. The idea was first introduced in 1965 by The Armour Company of Chicago, with a product called Soaprize! Each Soaprize! bar came shaped like either a whale, an alligator or a submarine, and inside each bar was a small capsule containing a toy and a "magic riddle." The "magic" part was that you had to use the soap to uncover the answer to the riddle. Besides The Armour Company and The Aerosol Corporation, Avon Products also introduced a line of soaps for kids, with toys imbedded in each bar. A recent variation of this idea is a bar of soap which is shaped like a giant egg and billed as a "dinosaur's egg." I don't need to tell you what's imbedded inside each bar.

Another peculiar product was a combination soap and body-paint item marketed during the late 1960s. It is another example of a soap intended to be played with before using. Paint it on, wash it off (perhaps an establishment plot to get hippies to bathe?). A current variation of this product is called Zoo Goo, which is manufactured by the Cosway Company in Gardena, California. Zoo Goo comes in three primary colors, with instructions on the side of the carton for creating other colors from the three provided. "Zoo Goo finger-paints become mild, gentle suds," the package claims. "Paint on some stripes and jump in the tub!"

One of the silliest soaps to come down the pike was marketed toward the most serious of individuals. It tried – and failed – to carve out a niche in the adult world of conventional soaps. It came in small sheets, like sheets of paper, and dissolved upon contact with water. Each sheet was separately wrapped and came in a dispenser reminiscent of a tissue box. The soap was used primarily in public restrooms and became the soap of choice for Amtrak passenger trains and several airlines.

There was something satisfying about having your own personal sheet of soap. Far different from poking your wet hand against a communal soap dispenser, the soap-tissue seemed *exclusive*, not to mention futuristic. This elegant illusion, and the thrill of seeing the soap dissolve in your hand, were intense enough to postpone the inevitable realization that – in spite of its charm – the soap was, by no means, practical. In order for the process to work, your hands already had to be wet. But if your hands were even a little bit wet, the soap dissolved while being unwrapped. People devised several strategies to cope with this Catch-22. Some would wet one hand and, holding the soap in the other, then bring their hands together. Another popular solution was to unwrap the little sheets and place them on the sink counter before washing one's hands. Often however, water splashed from the sink onto the counter and caused the soap to dissolve into a sticky, unpleasant white mush that, if not dealt with directly, left ugly blemishes on Formica countertops.

As the soap renaissance wound down, a few more products made their belated entries into the market. Liquid soap in a plastic pump-bottle proved popular enough to gain a foothold in the soap world, and is still widely available. During the early 1970s, The Avon Company introduced Soap-On-A-Rope, a bar of soap with a loop of yarn pressed into it so that one could conveniently hang the product on water faucets. A favorite version of Soap-On-A-Rope was shaped like a microphone for singing in the shower.

In the end, most of these products were too novel to be practical. Bubble baths will always be around, and will probably always be available in bitchin' plastic containers shaped like animals or monsters; but there is no place in the real world for a soap that grows hair. That there ever was says much about the 1960s, however. Unfortunately, this aspect of the decade is often overlooked. People remember the things they think are important; they remember the Kent State protest shootings, but not Fuzzy Wuzzy. Such cultural tunnel-vision misses an important point: that the ideas and situations behind Kent State are nothing new. But Fuzzy Wuzzy...? It may seem like such things were just soap

and silliness, but they were *the world* – a world that was never fully acknowledged when it existed and is now all but forgotten. By reminiscing, we call such a world back from the dead, and perhaps the next time you think of the 1960s, you'll remember that for every dirty hippie whining about the war in Vietnam, there was a clean kid in a bathtub having the time of his life.

The Champagne Cult
A Tour Of Lawrence Welk's Country Club Village Estates

(Originally published in *Pop Void*, 1987)

The residents of Rajneesh City have all moved away and the people of Jonestown have all killed themselves; but nestled in the hills outside San Diego, California, is a devoted cult of elderly adults who've come from around the country to live in a community named after their own aging guru. Lawrence Welk's Country Club Village, in Escondido, California, is a mobile-home community offering gracious living for seniors. It is here that legendary television maestro Lawrence Welk lives-out his golden years, surrounded by friends and the faithful, in a community that is also a shrine to his creative output.

If you're a fan like me, you can visit Welk's shrine-like Village, which is located off of Interstate Highway 163, just north of San Diego. From the highway a long, winding road leads-up to Champagne Boulevard, which (after passing the Lawrence Welk Museum, located on Lawrence Welk Drive) eventually dead-ends at the Lawrence Welk Country Club Inn. Here you can eat an overpriced meal in a dining room that overlooks the Lawrence Welk Golf Course and features a lovely view of the course's water-hazard, complete with a champagne glass fountain. If you're lucky, one of the Champagne Music Singers may even be your host or hostess (or perhaps even a fellow customer) at the inn's restaurant; and if you're truly blessed, The Man himself will be there. After your meal, you can browse through the overpriced doodads available at the inn's gift shop, including what may well be the most extensive selection available anywhere of records by Lawrence Welk and his various TV show regulars, past, present and *distant* past: the Lennon Sisters, Sandi & Sally, Anacani – they're all here! And if you're looking for a rhinestone pin shaped like a champagne glass, look no further. This is Heaven for the Welk aficionado, and it's only the beginning...

Back down Champagne Boulevard is the heart of The Village: The Lawrence Welk Museum. Within this hallowed hall are displays and dioramas depicting the life and times of Lawrence Welk; his story is traced from humble beginnings, through various struggles and on to heights of glory. It's all documented with photos and personal relics (the maestro's baton, et cetera). After you've soaked it all in, you can sit down and relax on a round velvet sofa which serves as the base for a grand chandelier in the shape of – you guessed it! – a champagne glass.

It would be difficult to imagine a more well-rounded introduction to the world of Champagne Music (and its creator) than what's presented in the museum, but once more, this is still only the beginning. The museum is, in fact, merely a lobby leading into a movie theater – and in this theater only one film is shown: *The Lawrence Welk Story*.

The film alone is worth the trip to Escondido. To say *The Lawrence Welk Story* is "unique," is an understatement; it must really be seen to be believed. It's an in-depth documentary on the life of Lawrence Welk, narrated by – who else? – Lawrence Welk himself. Watching the film induces a strange sense of déjà vu, for the images that parade across the screen are the very same as those which adorn the museum and tell the same story of Welk's humble beginnings, years of struggle, et cetera. In the film, Welk's off-screen voice candidly describes what you are seeing as you see it projected before you. At the same time, simplified subtitles are superimposed on the screen to leave no room for possible misunderstandings or misinterpretations. When Welk mentions roses, photos of roses appear next to him on the screen. Simultaneously, the word "roses" appears beneath the image. This bizarre technique is employed throughout the film and its effect is strangely disquieting. It could be that the film was designed with an elderly audience in mind; tailored to the needs of worn-out ears and dying brains. Whatever the case, *The Lawrence Welk Story* should not be missed, as it is *truly* bizarre.

Outside the museum stands a life-size bronze statue of – naturally – Lawrence Welk. The Great Champagne Music-Maker is here captured for eternity; his baton poised before him and a grin on his face. If you listen closely, you can almost hear him saying, "a-one and a-two..."

Along the boulevards of neatly-ordered mobile-homes, senior citizens zoom back and forth in their golf carts. They present a placid picture as they go about their business, up and down Champagne Boulevard. Indeed, it seems to be a type of "Heaven on earth" here for the aging denizens

at Lawrence Welk's Country Club Village, living near their leader in this little world he built in his own image.

But all is not well in paradise. Reportedly, Welk is planning to sell The Village, take the money and run. But how could he? How could Welk do that to all the people who counted on him – all the people who spent their life's savings, pulled-up their stakes and moved across the country to come to his Village? Welk is the very heart and soul of his Country Club Village. He is its reason for being. Without him, it would die. No, it can't be true! Lawrence Welk wouldn't do that, would he?

For now, no one knows what the outcome of this situation will be. But if you ever hear on the news that everyone in a Southern California retirement community drank Kool-Aid laced with cyanide, you'll know who they're talking about...

Editor's Addendum:

Just five years after the above article was published, Lawrence Welk died of pneumonia at age 89. His organization, The Welk Resort Group, still owns Lawrence Welk's Country Club Village Estates and has since opened additional resorts in Palm Springs, California, and Branson, Missouri, (where Welk's now-leaderless band still continues to perform in a dedicated theater). To find out more about any of these locales, visit the organization's website: www.WelkResort.com.

Almost two decades after the maestro's death, *The Lawrence Welk Show* continues to be repackaged for presentation on public broadcasting stations around the country. Usually airing at roughly the same Saturday-night timeslot as the original ABC network broadcasts, these reworkings often feature cameos from orignial show performers, which appear where commercial breaks would have been located in the original broadcasts. The creator of "Champagne Music" has proven to be an indelible part of American pop culture, and clearly still has a grip on the public's collective consciousness.

Burning The Ice

(Previously unpublished, 1988)

As a child I always imagined I'd grow up to be a criminal. The genesis of this notion no doubt goes back to an incident I deem to be one of the pivotal episodes of my youth. I was walking to school one morning on a day like any other day, when I spied an unsettling tableau. Through a large picture window I saw a man in his living room hovering over an ironing board. He was attired in a "wife beater" and was ironing a white, long-sleeved shirt. When finished, he put the shirt on, buttoned it up and proceeded to the kitchen (also visible through the picture window). I stood and watched as he made a sandwich, wrapped it in wax paper and put it into a brown paper bag, along with chips and an apple. He then exited his house, got into his car and took off down the road. I was horrified. Was this a glimpse of what it meant to be an *adult?* I'd never had any concrete ideas about what I wanted to be as a grownup, yet I had very specific ideas concerning what I wanted no part of. Even as a child I knew I'd never marry. I knew I didn't want to punch a time-clock or have a boss. I knew I'd rather be dead than have an existence like the man I'd watched iron his shirt and put together his crappy lunch. I'd rob or kill before I did that. I'd die first.

The impact of this incident had a profound effect on me, one that haunted me throughout my youth and teenage years. The notion of not compromising with the world – of not submitting to it – became the governing ethic of my mindset at the time; yet I was clueless as to how to manage that. The romantic in me told me that I should be an artist of some sort; after all, artists are routinely expected to transgress the very values and protocols that virtually everyone else is expected to adhere to (it's almost part of the job description). The pragmatist in me told me that criminality was by far the surer path. I'd always admired the villains more than the heroes on TV and in movies. They were figures of great passion who took what they wanted and did as they pleased – let the chips fall where they may.

At the time, my notion of crime wasn't going into a bank brandishing a gun and demanding cash, it was more about devising a system that would benefit me at someone else's expense. It was about blurring the boundaries of reality by redefining the perceptions of others. I'd been doing this for years in the course of pranking people, purely to abuse them and watch them squirm; but over the course of time I came to recognize the possibilities inherent in reengineering the realities of others. Additionally, I came to recognize the power of the process to rewire my brain in a very tangible way.

My pranks of the 1970s were malicious and vindictive, a kind of retribution toward the horizontal conspiracy that was humanity (or at least, was to my mind). My approach in the 1980s was altogether more abstract. Upon my arrival in San Francisco I happened to catch a showing of *Dr. Mabuse, der Spieler* at the Goethe Institute. Mabuse's philosophy was summarized as follows: nothing in the world is interesting anymore, except to *play* with people, and with their lives and destinies. Fuck – this had been my avocation for years, playing with the principal of *force psychology* as explained to me by exploitation film giant Herschell Gordon Lewis. Lewis described the process as "making the rats go through the maze the way you want them to." He then cackled with laughter, as did I. I'd understood his implication fully, yet understood that in any future experiments, I myself would be the rat. And so it was to be...

I look back on the early 1980s as a very idyllic phase of my life. I was managing to survive by my wits in San Francisco, earning most of what I needed through a solitary late-night job (that I actually enjoyed), in conjunction with my recording career. I was also committing crimes for the sheer *fun* of it. Of course, my crimes were all of a very small-scale, but they were carried out as a kind of process of self-initiation – as an experiment in constantly pushing my actions and limits to the next level. Throughout this period, I engaged in a wide variety of behaviors by which I put myself at some degree of risk, but from which I also gained some measure of new insight.

I'd often do simple, small things. On a whim, I once entered a neighbor's apartment through an open window and left a pink, glittery beach ball sitting on his bed, then left. I could have robbed him, but I just wanted the fun of fucking with him. In the months that followed, I snuck into the same

apartment time and time again, leaving birdcages, open umbrellas and even watermelons on that same bed. In other instances, my activities were a bit more nefarious. I'd crash parties that seemed to be held by upwardly-mobile types, spend the evening talking to a room full of people I'd never met (while eating their food and drinking their liquor), then slip into whatever side-room the women's purses were stored in for safekeeping... and rob them. Of course, it was never much more than a hundred bucks (often much less) but I did it for the experience, more than for the money. I did a lot of things just for the experience back then, often when no monetary gain was involved; and I didn't even really see these deeds as being intrinsically malicious per se. These episodes were carried-out as exercises designed to erode any residual traces of fear, self-doubt and inhibition that might still be lurking within me, as well as to test my limits.

During the warmer months I'd often wander the streets of San Francisco late at night, looking for open windows on the top floors of buildings, where the residents seemed to be asleep. Once spotted, I'd gain access to the building, take the elevator to the top floor, go up to the roof, and then descend down to the fire-escape and on to the apartment's open window. If the inhabitants indeed seemed to be asleep I'd stealthily make my way inside. Once inside an apartment, I'd generally survey the place, take some valueless little knick-knack as a memento, and then leave via the front door. Sometimes, however, I'd stop and take a seat, planting myself in an apartment's darkened living room for a time, while letting my eyes adjust to the absence of light. There I'd sit and imagine what sort of person lived in the apartment and just how they'd react if they happened to find me sitting in their living room in the middle of the night.

There was a certain degree of fear that accompanied these deeds, a fear that made them exciting but also just the slightest bit risky. It was a fear that I never completely overcame, even at the point when it no longer seemed consciously scary. It was a kind of primordial fear that's a bit reminiscent of the sort of scene you'd see in a Disney film, wherein some kids sneak into someplace they aren't supposed to be and it sets your nerves on edge, even though you know it's only a film (and a silly one at that). I assumed that this fear was part of some deep-rooted fight-or-flight impulse that man could perhaps will himself to rise above, but never wholly erase. So even though I wasn't really afraid of being discovered or caught, this feeling persisted because I knew what I was doing was something other people would never understand.

On one occasion I was in a dark room in someone's apartment, late at night, where the only sounds I could hear were the ticking of an ancient grandfather clock, my own breathing and the creaking of the hardwood floor beneath my feet. I'd spent some time growing accustomed to my surroundings, when suddenly the old clock chimed at the half-hour point and it seemed to resound louder than the bell of a massive clock tower. I don't know what I thought it was at the time, but because it caught me unaware it absolutely scared the hell out of me for a second or two.

In addition to my late-night prowling, I also often snuck into apartments and houses during the middle of the day, when most people were away at work. On one such occasion, I'd entered an apartment and was sitting in absolute silence, in a chair in the living room; I felt perfectly at ease, but when the telephone on the table next to me suddenly rang I thought I was going to have a coronary attack from the sudden shock of its shrill ringing, which had shattered the silence. To dissipate the stunned, adrenaline-surged feeling and calm my nerves, I had to laugh out-loud, my heart still racing. This was back in the days before answering machines, and I had half a mind to pickup the phone and tell the person on the other end that no one seemed to be at home, but that I would be glad to take a message. Of course, I didn't.

By far the worst incident of this sort (or perhaps the best) occurred when I left a party with some friends one night and spotted a screen-door opened slightly on a nearby balcony. Unable to resist the temptation, I made my way back up to the roof of the building where the party was being held and jumped down onto the roof of the adjoining building, which was only about one floor lower. Making my way over to directly above the balcony where the opened screen was, I discovered that there was no access to it from the roof (as is the case with most fire escapes) and that the only way down was to *jump*. Since this would probably make a loud enough noise to awaken those inside (and thereby reveal my presence), I decided to scuttle the plan and headed towards the rooftop door that lead back into the building's stairwell; but upon reaching the door I discovered it was locked from the inside and that I was thus trapped on the roof. The adjoining roof that I'd jumped from was too high

to get back onto and the building on the opposite side of the rooftop was just a bit too far away to make jumping a viable alternative; so my only means of getting off the roof was to return to my original plan and jump down onto the balcony, then go through the apartment I'd intended to sneak-into and exit the building through its front door. This involved the very real risk of waking-up whomever was inside, assuming of course that they were even asleep in the first place. I had no idea; for all I knew, they could've been watching TV with all the lights off. Regardless, this was my only option.

So I lowered myself over the edge of the building and hung-down by my hands. Looking down, it seemed like a lot farther drop than it had just appeared a short while before, and my landing was surely going to make one hell of a racket, but again, it was my only option. So I let go my hands and hit the balcony with a thundering *thud* that shook the balcony's metal chairs and plant-holder, and could be heard all along the whole block. I stood frozen, listening for any sounds from inside the apartment, but heard nothing. People walking to their cars on the street below looked up to see what the noise was and I gazed around as though I were out on the balcony for a bit of fresh air. They resumed their conversations and continued on their way. I stood there in silence, waiting and listening. There was only stillness and darkness in the apartment. The screen-door I'd spotted earlier had been slid-open by perhaps a foot; I slowly slid it open another foot or so and it emitted a harsh scraping sound (which, in retrospect, probably wasn't nearly as loud as it seemed at the time). With the screen-door half-open, I stood and listened in silence a few minutes more; still no signs of life from within the pitch-black apartment. Finally, I entered, far more slowly and cautiously than usual...

The room I came into was large and rectangular, but indistinct in the darkness. I hesitated a few moments, letting my eyes adjust to the absence of light and making sure that the room was unoccupied. Convinced I was alone (and now able to see a bit better), I proceeded further into the room... and then suddenly some movement in the darkness caught my eye. I stood dead-still and scanned the end of the room. There in the darkness, standing perfectly still, I could just make out the shadowy silhouette of a man. Strangely enough, I found this less unsettling than my previous experiences of being shocked by the ringing of a phone or the chiming of a clock, perhaps because I had fully expected it and so it lost the element of surprise. I reasoned that fear was on my side since I represented the unknown to this man in whose home I was an intruder. He had no way of knowing whether I was a robber or a serial killer, or what. Though I couldn't see him well in the darkness I knew that if he was the average guy he probably wasn't very strong or very brave; he was probably just scared shitless and would thank his lucky stars to just be left alone and unharmed. All this clicked through my head in a split-second, as my eyes darted around the dark room, searching for the door. I soon spotted it partway between the two of us, but closer to me than it was to him. In an instant, I decided to walk straight to the door and simply leave. I figured that unless he had a gun, he'd stay right where he was and let me leave. If he *did* have a gun, he'd probably shoot me the second I moved toward him, but this being liberal San Francisco, it didn't seem likely.

I started towards the door, but as soon as I moved he seemed to be coming directly at me, as though he intended to *intercept me* before I could reach it. My mind raced: should I point my finger at this man and shout, "Go to your room, now!"? Should I talk nonsense to him in my creepy "speaking in tongues" voice, a voice that frightened even people who knew me? I was at a loss, and thus was left to simply locking my fists in preparation for an imminent confrontation with this stranger... when suddenly I realized that the figure advancing toward me was nothing more than an optical illusion. The entire back wall of the room was covered in mirrors and the shadowy figure had merely been my own reflection. I suppressed a laugh, made my way to the door and left. Upon exiting I paused momentarily in the doorway, then I opened the door wide and slammed it as hard as I could before heading down the stairs, out the front door and then on down the street. The sound of the door slamming woke whomever lived in the apartment out of a sound sleep (the lights in the apartment were on by the time I'd made it out of the building); and it probably scared the hell out of them. Walking home I chuckled to myself – this was the kind of fun that only direct experience can bring and it was *exactly* what made such risks worth taking.

These sorts of activities (which I engaged in many times on many occasions) may seem nonsensical or pointless to many, but they aren't. They are of an intrinsic value that transcends notions like rationality and logic. They're about experiencing things for the sake of experiencing them;

for the kind of primal sensations that can only be gained by a direct connection with life and the world, not the abstract intellectualization of it. Transgressing socially-constructed boundaries isn't just about the act itself, it's more about erasing *internal* limitations by violating *external* ones. It's about acts of self-overcoming.

Centuries of the civilizing process have erected boundaries in the soul of man; boundaries that constrict and curtail his behavior. To get beyond those boundaries requires the simple practice of violating them, and violating them is as easy as stepping over a line drawn in the sand, because they are, in fact, every bit as imaginary. Yet at the same time these boundaries constitute the ice that inhibits the fires of the soul; they must be burned-away and overcome before the instinctive component of man can attain its rightful stature. In practice, these sorts of activities are a physical form of magical initiation: real acts carried-out in the external world, which result in a demonstrable transformation of the internal world. In short; the alchemy of *action*.

Other, more involved variations of this formula involved creating elaborate plans to perpetrate the *perfect murder*, and carrying those plans out, down to the last detail (or at least up to, but excluding, the *last* detail). I saw this as a sort of *predation ritual* for me, the function of which was to invoke and enlarge the animalistic component of my psyche. It involved selecting a victim, stalking that person, obsessing about killing them and then creating the circumstances in which their murder could be effectively carried-out.[i] One representative example of my recipe for convening with the predator within is as follows:

One afternoon I was at a newsstand in San Francisco and observed a girl who I recognized as a waitress from a restaurant I frequented; she was getting off work and starting her walk home. This girl had always gone out of her way to exchange pleasantries with me, so we sort of knew one another. I left the newsstand and followed her at a distance. Her journey took a rather circuitous path and I tailed her to her apartment without being spotted. The next day, at the same time, I was back at the newsstand; and again I observed her leaving the restaurant she worked at, and again followed her home, unnoticed. She took the same streets as the previous day, made the same turns at the same corners and so on (even though there was a countless permutation of alternate routes she could just as easily have taken). The following day, at the same time, I stationed myself inside a store midway on her route. Within a few minutes I saw her passing by, like clockwork. I then left the store and followed her along her normal route, but this time she turned into a restaurant about two thirds of the way home. I assumed that she must go there a couple of times a week for dinner after work, and that this too would most likely constitute a part of her unwavering pattern. The next day I went into the restaurant she worked at, and when she came to take my order I teasingly said, "You seem like you're always at this place. You're here every time I come in. Don't they ever give you any time off?" "Yeah," she replied, "the day after tomorrow and the next day are my days off." With this information, my composite of her schedule and patterns was as complete as necessary; I knew when she worked and when she didn't, where she lived and where she ate. On the other hand, she knew nothing about me and still hadn't even an inkling that I knew anything whatsoever about her. Now my predation ritual could begin earnest...

The following day I again waited for this waitress to get off work and make her way home, but this time I emerged from a store halfway along her route, just seconds before she got there. I looked surprised to see her, waved and smiled, and then continued on my way. She too seemed surprised to see me, and also waved and smiled. As she'd told me, the next two days she was off work; but on the following day I yet again emerged from another shop at a different spot on her route, just as she was coming down the sidewalk on her route home. Again we both waved in recognition as we passed hurriedly by. Following this, for several consecutive nights I had dinner at the restaurant she occasionally frequented on her route, until (as expected), she eventually arrived for dinner there herself. When she saw me dining alone she did a double-take and came over to say hello. Acting equally surprised I asked, "Are you following me or something?" then noted, "I seem to see you everywhere." She said it was "wild" to keep running into me like this and asked if she could sit down with me. Of course I obliged. We talked for a while and as I got up to leave she gave me her phone number and told me to call sometime. I said I would, but didn't.

I let a week pass after she'd given me her number, then arranged it so that I bumped-into her "accidentally" again, this time on the very block where she lived. Before she could say a word, I

exclaimed, "You again!, You *are* following me!" "No," she protested, "I live on this block! Really!" And perhaps in an attempt to demonstrate this she invited me up to see her place. We talked for a half-hour or so at her apartment and she told me to feel free to stop back by anytime. I did. We soon developed a sexual relationship, which she naturally assumed had arisen as if by chance – a regular customer at her restaurant who she'd bumped into by accident several times, eventually got acquainted with and ultimately found herself involved with sexually – but there was nothing accidental about it. It was coldly calculated. I was playing the predator and she was my prey; a victim, chosen at random. A face in the crowd; and it could have been any face in any city, anywhere.

One night, while visiting this girl at her apartment, I asked her if she'd ever been tied-up during sex. She hadn't, but admitted that she'd always wanted to be. *Good.* I summarily undressed her and bound her to her bed, such that she couldn't move more than an inch in any direction, and gagged her as well. I then went into her kitchen and momentarily returned to her bedroom brandishing a butcher's knife. *This* was the scene I'd visualized in my mind over and over as I stalked her, as we waved "hello" on the street, as we talked in the restaurant. I'd pictured the large knife in my hand, the look of terror in her eyes, her vain attempts at struggling against her restraints... and now here it was *in reality*; played-out exactly as I'd wanted and planned. The exhilaration I felt at that moment was the kind that can only be gleaned from *direct experience*, and is beyond words. Perhaps this girl could see the murderous intent in my eyes, as I hovered over her, and perhaps she felt genuine terror as I drew the knife up to her throat and then pressed it against her soft flesh. I don't know. Regardless – satisfied that I *could have* murdered her right then and there – I tossed the knife aside, fucked her, then untied her and promptly left her apartment, never to see her again.

It was perfect, as far as it went. Had it been an actual plot of murder, of course there are a 1000 other things that would have been areas of concern (forensic evidence, fingerprints and so on *ad infinitum*). However, the function of this exercise was not to commit the perfect murder, but rather to foster murderous intent over a long enough period of time that it smolders in one's soul, and grows and burns. To get away with murder there are countless ways and means that are undoubtedly easier, more direct and less involved; but that, of course, isn't the point of this sort of exercise at all. The point is to get in touch with the bestial part of man that has no outlet in the civilized world; and to fuel the fires of instinct which have receded as a result.

At one point I formalized the theories that lead me to engage in this sort of behavior, in a short essay called "The Alchemy Of Transgression." I'm told that the basic principles are not dissimilar to those in what's now called Psycho-Cybernetics. An example given to me at the time was that if you laid a 20-foot long 2"x4" flat on the floor of a room, you could quickly walk from one end of it to the other and back, without once losing your balance or stepping off. But if you put that same 2"x4" between two buildings, eight floors up, you'd probably fall off and kill yourself – not because you lacked the basic ability to do it, but because the mind's innate fear of what could happen would impair your ability to do it. This example struck a chord with me, as I'd had experience traversing 2"x4"s. Years previous, while in Düsseldorf, Germany, my friend Frank and I were bicycling around the city at 3:00 in the morning when we found ourselves on a dock, checking out a ship moored on the Rhine river. Propped between the ship and the dock was a long length of 2"x4" lumber. Curious, I set down my bike, stepped onto the 2"x4" and crossed over onto the ship. My pal Frank hollered across that he'd stay behind and keep an eye on the bikes. When I found nothing of interest, I crossed back over to the dock. As I got back on the bike I noticed Frank apprehensively gazing over the side of the dock. Far below, the raging waters of the Rhine roared past like whitewater rapids. Sure, a single misstep would have meant almost instant death; but somehow the possibility hadn't occurred to me at the time.

> "Nothing worth knowing can be taught."
> – Oscar Wilde

i Many years later I would learn that my friend Anton LaVey, head of the Church of Satan, had a similar such predation ritual, and that his publisher had excised it from his second book, *The Satanic Rituals*, for fear that it would lead to a "blood-bath." LaVey called it his recipe for "lycanthropic transformation," and it differed very little from my own methods.

The Warrior Ethic

(Written in 1987. Originally published in *The Unconquered Sun*, 1989)

Strength Is Better Than Weakness:

Throughout the natural order, strength confers victory to those who possess it, just as it confers defeat to those who do not. Strength can take many forms – some men are able to use physical strength to subdue their adversaries, while others may conquer using cunning. In the final analysis, whatever allows one to prevail over forces of opposition is strength. The higher man – he who pursues the warrior ethic – discovers the ways in which he is strong and develops them, whatever they may be.

Instinct Is Better Than Intellect:

Man's instincts will always and forever reflect the will of the natural order, and consequently are a valuable aid in the struggle for survival. Conversely, man's intellect has become divorced from the hard realities of life on earth, having instead become lost in a nebulous realm of ideas, theories, beliefs and opinions, which largely have no basis in tangible fact. Unless man's intellect comes to reflect his instinctual, soul-oriented values, it will always place him at odds with himself; poisoning his life rather than aiding in its evolution. The higher man always trusts and follows his instincts over his intellect.

Independence Is Better Than Slavery:

The soul of the higher man is aggressive and indomitable – such men suffer no tyranny and never submit or sublimate to the will of the herd-minded masses. Higher men disdain the lives of the weak and cowardly – slave types – who seek security in whatever form of slavery offers itself, whether by force or by comfort.

Order Is Better Than Chaos:

There is an immutable order that runs throughout life, and throughout nature. It pervades all living matter; it is in every leaf, every insect and every man. Those individuals who see only chaos around themselves are too lost in confusion to recognize the inescapable order that constitutes organic reality. Chaos is confusion; order is understanding. To recognize this order, and to understand why and how it works, is the single key to true wisdom and the path of the higher man.

Awareness Is Better Than Ignorance:

To be aware is to be conscious and alert, whereas to be ignorant is to ignore vast areas of life simply because it is easier to disregard them than to be conscious of them. The masses today actively embrace ignorance because they consciously choose to ignore all those aspects of life that they find unpleasant or frightening. The fact remains that many aspects of life are less than pleasant. Life is composed of countless harsh realties, but if we wish to understand life, we must first face it head on. Higher men never ignore any aspect of life, for to do so would mean having a less than complete grasp on the truth.

Unpleasant Truths Are Far Healthier Than Pleasant Falsehoods:

Life today abounds with a wealth of both unpleasant truths and pleasant falsehoods. The higher type shuns pleasant falsehoods because they will paint for him a false vision of the world and thereby weaken him. Pleasant falsehoods are only temporary reprieves that, for but a short time, hide cowards from the eventual grasp of truth. True cowards - slave types - can always fabricate a pleasant

falsehood in which to take refuge when faced with the all-too-real specter of truth. What separates the higher type of man from the slave type is that the former fearlessly accepts unpleasant truths, recognizing that they will offer a greater understanding into the nature of life and thereby make him stronger.

In conclusion, the values which constitute the warrior ethic – the way of the higher man – are the very same values which created our civilization. A love for freedom, the will to independence and an active, adventurous view towards life, are all values which contributed to our rise. Only through revitalizing these same values can we hope to avoid the fate that has befallen every great civilization that has ever lost sight of the soul-oriented values of its people. There can be no doubt that this struggle is in fact a war; so there is no better time than now for the reemergence of the warrior ethic.

Nature's Eternal Fascism

(Written in 1989. Originally published in *WAKE*, 1992)

At the most primary level, one could easily define life as being the byproduct of energy feeding upon energy, though such a description could apply with equal precision to life's alter-ego: death. We are all locked into an iron game in which life feeds upon life. We are all participants in the feeding-frenzy that constitutes the unchanging perfection of nature's order. Unfortunately, there exists today an ever-widening schism between the world of nature and the world of man. Humanity in its confusion has attempted to "transcend" and dominate nature. It has not succeeded. In fact, anyone seeking a testament as to how utterly mankind has failed, need only contrast the qualities that characterize nature with those which now define the world of man.

Nature is typified by strength; humanity by weakness. Nature adheres to an immutable order; humanity to an ever-increasing chaos. Nature recognizes no equality at any level of its order; humanity preaches an all-pervasive equality and freely hands-out unearned "rights," in an attempt to make its doctrine a living reality. In short: humanity is Democratic, nature is a Fascist.

Since the dawn of time, one ironclad law has controlled the destiny of man. This law has nothing whatsoever in common with the mere rules concocted and agreed-upon by human communities to regulate the conduct of their lives. This law is immutable, extending throughout the whole of nature, and is the sole regulating force underlying and animating all life. We shall refer to this all-pervasive force as Primal Law, for in the simplest terms that's precisely what it is. Primal Law is natural law writ large – it is nothing less than that aspect of nature which facilitates the continued flow of life and total evolution.

Any person (or society) wishing to advance their evolutionary position can do so only within the context of primal law; and conversely, any person or state choosing to ignore or oppose primal law is only creating the basis of their own ruin. One sociobiologist who recognized the pivotal role played by Primal Law was Lothrop Stoddard, who examined it in-depth in his 1923 text *The Iron Law of Inequality*:

> "The idea of 'Natural Equality' is one of the most pernicious delusions that has ever afflicted mankind. It is a figment of the human imagination. Nature knows no equality. The most cursory examination of natural phenomena reveals the presence of a Law of Inequality as universal and inflexible as the Law of Gravitation. The evolution of life is the most striking instance of this fundamental truth. Evolution is a process of differentiation – of increasing differentiation – from the simple one-celled bit of protoplasm to the infinitely differentiated, complex forms of the present.
>
> And the evolutionary process is not merely quantitive; it is qualitive as well. These successive differentiations imply increasing inequalities. Nobody but a madman could seriously contend that the microscopic spec of protoplasmic jelly, floating in the tepid waters of the Paleozoic sea was 'equal' to a human being.
>
> But this is only the beginning of the story. Not only are the various life types profoundly unequal in qualities and capacities; the individual members of each type are similarly differentiated among themselves. No two individuals are ever precisely alike. We have already seen how greatly this dual process of differentiation both of type and individual has affected the human species, and how basic a factor it has been in human progress.
>
> Furthermore, individual inequalities steadily progress as we ascend the biological scale. The amoeba differs very little from his fellows; the dog much more so; man most of all. And inequalities between men likewise become more pronounced. The innate differences between members of a low-grade savage tribe are as nothing compared with the abyss sundering the idiot and the genius who coexist in high-grade civilization.

Thus, we see that evolution means a process of ever-growing inequality. There is, in fact, no such word as 'equality' in nature's lexicon. With an increasingly uneven hand she distributes health, beauty, vigor, intelligence, genius – all the qualities which confer on their possessors superiority over their fellows.

Now, in the face of all this, how has the delusion of 'natural equality' obtained – and retained – so stubborn a hold on mankind?"

In truth, the concept of natural equality is not natural at all – and in fact contradicts every dictate of nature. Nature is the first law and the last law – the only true law. Man's failure to accept and live by nature's dictum stems primarily from his inability to come to terms with nature's innate brutality. The natural world is one of pitiless struggle and unending violence; a world in which destructive force is every bit as necessary and vital as creative force. Noted naturalist Charles Darwin summed-up the situation thusly:

> "Nothing is easier to admit in words than the universal struggle for life, or more difficult than to constantly bear this conclusion in mind. We behold the face of nature, bright with gladness. We do not see, or we forget, that the birds which are idly singing around us mostly live on insects or seeds and are thus constantly destroying life; or we forget how largely these songsters, or their eggs, or their nestlings are destroyed by birds and beast of prey..."

In short, life is one unending war – a war in which the strong devour the weak. The destruction of one underwrites the existence of the other. So it is throughout the natural order. Grasping this single, pivotal, brutal truth is the only basis for understanding the primal law that defines nature's eternal Fascism; and her eternal wisdom. A more subtle elucidation of the interrelationship between the strong and the weak, and what it means in human terms, was given excellent voice in de Sade's *Juliette*:

> "The reprisals of the weak against the strong do not really come within nature. They do from the moral point of view but not the physical, since to take these reprisals the weak man must employ forces that he has not received from nature. He must adopt a character that he has not been given; he must, in a way, constrain nature. But what does really come within the laws of this wise mother is the harm done to the weak by the strong, since to bring this process to pass the strong man makes use only of gifts which he has received from nature – he does not, like the weak, take on a character different from his own – he merely utilizes the sole effects of that with which nature has endowed him. Therefore everything resulting from that is natural. His acts of oppression, violence, cruelty, tyranny, injustice, all these diverse expressions of the character engraved in him by the hand of the power which placed him in the world are therefore quite as simple and pure as the hand which drew them; and when he uses all his rights to oppress the weak, to plunder the weak, he is therefore doing the most natural thing in the world.
>
> If our common mother had desired the equality that the weak strive so hard to establish, if she had really wanted the equitable division of property, why should she have created two classes; one weak, the other strong? Has she not, with this distinction, given sufficient proof that her intention was that it should apply to possessions as well as bodily faculties? Does she not prove that her plan is for everything to be on one side, and nothing on the other; and that precisely in order to arrive at that equilibrium which is the sole basis of all her laws? For, in order that this equilibrium may exist in nature, it is not necessary that it be men who establish it; their equilibrium upsets that of nature. What, in our eyes, seems to us to go against it, is exactly that which, in hers, establishes it, and for this reason; it is from this lack of balance, as we call it, that are produced the crimes by which she

establishes her order.

The strong seize everything; that is the lack of balance, from man's point of view. The weak defend themselves and rob the strong; there you have the crimes which establish the equilibrium necessary to nature. Let us therefore not have any scruples about what we can filch from the weak, for it is not we who are committing a crime, it is the act of defense or vengeance performed by the weak which has that character. By robbing the poor, dispossessing the orphan, usurping the widow's inheritance, man is only making use of the rights he has received from nature. The crime would consist in not profiting from them: the penniless wretch that nature offers up to our blows is the prey she offers the vulture. If the strong appear to disturb her order by robbing those beneath them, the weak re-establish it by robbing their superiors, and both are serving nature."

All men whose actions serve the will of nature invariably serve their own wills as well, for man is synonymous with nature; not (as is currently assumed) separate or distinct from it. Every action that honors nature's will unites man with nature, bringing his will and that of the natural order into alignment. The narrower the gap between the will and actions of man, and those of nature, the greater the powers wielded by man. When man truly discovers nature's will dwelling within his soul, and his actions become an expression of that will, nature's power becomes his power. Every pure action ever undertaken by man represents an instinctual yearning for this union and this power. Every act motivated by purity of impulse inevitably results in serving the will of nature. The wolf which attacks a lamb and rips it to shreds, serves both nature and himself. Likewise, the lamb thus ripped-apart is also serving nature. This is but one example of Primal Law in action. It is based upon the balance and interaction of creative force and destructive force.

Notions which connect the concept of harmony to any sterile peace must be dispensed with once and for all. Any proper understanding of Primal Law requires as a prerequisite a deeper knowledge of the true nature of harmony. It requires a vision of harmony predicated upon nature's brutal perfection. A violent harmony which embraces strife, war and inequality – a harmony which extols struggle and eschews brotherhood. Only by recognizing the true character of such a harmony can one begin to grasp the real meaning of Primal Law, and thus take the first steps towards harnessing its power as one's own.

Don't shrink from nature's brutal perfection. Take joy in it. Embrace it. Understand it and revel in it. Respect its strength, its wisdom, its brutality and its all-encompassing power. The highest law has always been, and shall ever be, nature; and the greatest wisdom forever lives in and through nature's eternal Fascism.

For further studies in Primal Law, read:

The Hunting Hypothesis by Robert Ardrey
Might Is Right by Ragnar Redbeard
The Lightning & The Sun by Savitri Devi
Homo, 99 & 44/100 Nonsapiens by Gerald B. Lorentz
The Lucifer Principle by Howard Bloom

The Wild World Of Primetime Pop
The Best & Worst Of TV's Singing Actors

(Previously unpublished book proposal, 1993)

Research shows that people who grew up in the 1960s watched more TV than any other generation before or since. These people retain an intense fondness for the shows they grew up with, and since a good many of these shows have never really been off the air, successive generations have also grown up with them in reruns, and also share that fondness. In fact, certain of these classic programs from the golden era of television have become far more popular today than they were even in their initial runs (witness the success of *The Brady Bunch Movie*). What hasn't carried over into the realm of reruns, reissues and remakes however, is the fact that virtually every major program of the 1960s and 1970s had corresponding albums by cast members. From *Ozzie & Harriet's* Ricky Nelson to *The Partridge Family*, much of the popular music that served as a soundtrack for those who grew up in the baby boom era (and after) came directly from television, rather than from so-called real musicians and bands. Consider the following:

In 1967 The Monkees sold more records than The Beatles and The Rolling Stones combined.

In 1969 The Archies, a cartoon band, kicked The Rolling Stones off the top of the charts.

In 1970, The Partridge Family's first single was the top selling record in the United States.

All true. These were fake bands with very real hits in the top of the charts, and often with sold-out concert tours as well. Such TV bands were accorded as much – often more – attention in the day's teen magazines as Jim Morrison or Jimi Hendrix. Though routinely dismissed by serious critics, they were wholeheartedly embraced by a public that evidently had no qualms whatsoever concerning their musical merit. But fake bands crossing over into real success is only part of story behind TV's connection to pop music.

Many people have heard William Shatner's crazed rendition of "Lucy In The Sky With Diamonds," or perhaps Sebastian Cabot of *Family Affair* doing his mock poetic recitation of lyrics to Bob Dylan songs. Few realize, however, that these bizarre offerings constitute only the tiniest tip of the iceberg in the vast realm known as celebrity recordings. Consider the following:

Jack Webb of *Dragnet* recorded an album of romantic ballads.

Jerry Mathers of *Leave It To Beaver* recorded a rock n' roll single.

TV cop Telly "Kojak" Savalas sang to packed houses as a headliner in Las Vegas.

Hervé Villechaize, the dwarf who played Tattoo on *Fantasy Island*, tried his hand at singing, releasing a record of love songs.

Again, all true. Both categories of TV-related recordings fall into the realm of primetime pop – an entire genre of music which has long escaped critical review and analysis. What follows is a brief show-by-show chronicle of but a sprinkling of the many albums by television stars; brief, breezy reviews that convey something of each record's spirit, noting its high points (or low points), and at times utilizing quotations from lyrics or liner notes. Chances are good that many of your favorite stars and programs will be represented here, as the scope of this study includes most of the major TV shows of the last several decades. Welcome to the wild world of primetime pop...

Show: *Leave It To Beaver*
Artists: Jerry Mathers / Beaver & The Trappers

> "Happiness is goin' about a hundred and ten,
> Blowing your mind, and comin' down again.
> Happiness is, yeah baby,
> Happiness is... money."
> – Lyrics to "Happiness is Havin'" by Jerry Mathers

Leave It To Beaver was surely one of the most popular shows in the history of television. So it seems difficult to believe that series star Jerry Mathers recorded a few singles, and no one but no one remembers them. It's true – during his *Beaver* years Mathers released a 45 called "Don't Cha Cry" that has all but vanished into total oblivion in the decades since. Had the producers of *Leave It To Beaver* seen fit to work the song into an episode somehow, it would have certainly have been a hit and gone on to become a fixture of pop culture. Plenty of other sitcoms, from *The Andy Griffith Show* to *My Three Sons*, concocted plotlines that involved the show's kids in musical schemes of some sort. For whatever reason (integrity?), the powers that be behind *Leave It To Beaver* must have nixed such a thematic detour, and the Beave's first single died a quick death.

A few years after *Leave It To Beaver* went off the air, Mathers fronted a band called Beaver & The Trappers. The group released a single entitled "Happiness is Havin'" that must be heard to be believed. It's a frenzied ode to teen abandon that is best described as garage punk. In it, Mathers gives an impassioned (though slightly confused) rant about what constitutes true happiness. For him, happiness is both "having a gal," and "being all alone." It's driving 45 miles over the speed limit, and above all "being free." This is what Mathers' Beaver Cleaver character might have turned out like if Eddie Haskell had been his big brother instead of Wally. It's a classic slice of teen rebellion, made all the more endearing for having been written and sung by everyone's favorite TV adolescent.

Show: *The Honeymooners*
Artist: Jackie Gleason

> "... all of my albums have been carefully designed to create a special mood. And not infrequently, a thoroughly contented individual assures me my music has provided the background inspiration for a romantic interlude."
> – Jackie Gleason, quoted in liner notes for *Lovers' Portfolio*

Honeymooners star Jackie Gleason was passionate about music, though he couldn't sing a note, read sheet music, or play any instruments. But like any man obsessed, he didn't let such shortcomings infringe upon his career in music. An idea man, Gleason formulated high concept approaches for producing albums of easy listening music. He would select the songs to be used and choose the instrumentation based on what he felt would create the proper mood. If he thought it would sound good to have 27 violins playing with one oboe, that's what he'd do. His instructions to musicians were equally idiosyncratic. On one occasion he told a musician that the sound he wanted should have the quality of "someone peeing off a bridge into a tin can." Despite the eccentricity of his methods, Gleason was evidently able to coax just what he wanted out of his musicians, and produced dozens of albums of hauntingly beautiful cocktail music. His record sales were in the millions, and he modestly referred to himself as a "purveyor of music."

Show: *Hogan's Heroes*
Artists: Robert Clary, Larry Hovis, Ivan Dixon, Richard Dawson and Bob Crane

> "... this is *Hogan's Heroes*. Guys from various parts of the world brought together in a concentration camp, where they've found the perfect way to pass time – signing!"
> – From the liner notes to *Hogan's Heroes Sing*

In retrospect, a TV comedy set in a P.O.W. camp may be even more improbable a premise than flying nuns, talking cars, or genies; and perhaps it is. The only thing more improbable might be the concept album based on the program: *Hogan's Heroes Sing*. Try to imagine swinging go-go versions of World War II hits sung by Robert Clary, Ivan Dixon, Larry Hovis and Richard "Family Feud" Dawson. This is World War II by way of Vegas. The quartet takes turns doing lounge lizard treatments of such standards as "Don't Sit Under The Apple Tree," "This Is The Army Mr. Jones," and "Praise The Lord & Pass The Ammunition." There's even a rendition of "The Hogan's Heroes March" complete with the words, "We're all heroes, up to our ear-os. You throw the roses, we punch the noses. That's what we're heroes for."

Not one to be outdone by his fellow internees, Col. Hogan himself (Bob Crane) released his own album, *The Funny Side of TV*. Rather than sing, Crane demonstrated his prowess as a drummer, and rather than covering tunes from World War II, he paid tribute to theme songs from the era's popular sitcoms – including, of course, the theme from *Hogan's Heroes*.

Show: *Happy Days*
Artist: Henry Winkler

> "NO!!! The Fonz has not taken to singing on this album. Better!!! He has chosen favorite '50s records to share with you."
> – From The Liner Notes to *Fonzie Favorites*

For a brief period of time in the 1970s, Henry Winkler's Fonzie character on *Happy Days* captured the public's imagination in a big way. What better way to capitalize on his success than by putting out a record? But rather than humiliate Winkler and disappoint his admirers by releasing poorly executed covers of '50s tunes, some record execs hit upon the perfect scheme: they released an album of original recordings from the 1950s, and simply claimed that The Fonz had personally selected them. *Fonzie Favorites* bears Winkler's photo on the front and back jacket covers, and in addition to the requisite '50s hits, also includes the *Happy Days* theme and two novelty songs about the Fonz ("The Fonzarelli Slide" and "The Fonz Song"). To top it all off, the album also features an instructional impressionist track, to teach the erstwhile Fonz fan how to perfectly pronounce Fonzie's favorite phrases, such as "Aaaay, cool, nerd" and "Sit on it!"

Show: *Mission: Impossible*
Artist: Greg Morris

> "There are many singers of songs... singing, but Greg Morris is the best teller of songs... telling."
> – Carl Reiner, quoted in liner notes of *Greg Morris, For You...*

As one of the few high profile Black actors on TV in the '60s, *Mission: Impossible's* Greg Morris was deemed a natural to tap into a waiting Afro-American market. So he recorded an entire LP of romantic songs, but like a good many of his contemporaries, he didn't actually sing them. On *Greg Morris, For You...*, Greg speaks the words to the day's top romantic tunes against a lush backdrop of easy listening arrangements. In the liner notes Steve Allen comments that "Even the best singers in a sense overpower the wordsmith's message" with their intrusive melody, sound and style. No problem with that here, as Greg recites the words to such songs as "The Twelfth Of Never," "The Look Of Love," and "For Once In My Life." Says Greg's pal Sammy Davis Junior of the album, "I came, I heard, I flipped!" Unfortunately for Greg, the general public didn't appear to share Sammy's enthusiasm, and most people who came and heard merely wondered what the hell was going on.

Show: *Kojak*
Artist: Telly Savalas

> "My mother use to say 'be quiet Telly, your brother's singing,' Hey Ma, now Telly's

singing..."
— Telly Savalas' between-song banter

The Monkees' Davy Jones once said that the public doesn't care if Sinatra can't still hit all the notes, they love the guy and that's all that matters. Sinatra himself once said much the same thing in defense of TV's Kojak, Telly Savalas. When Savalas made his Las Vegas debut as a singer, local critics raked him over the coals. In an open letter to the press, Sinatra lambasted the critics saying that people love Telly because he's an incredible personality and whether or not he was a great singer didn't much matter. Those who've heard Savalas' records might tend to disagree with Old Blue Eyes, but Telly continued to play to packed houses for the duration of his Vegas booking, rotten reviews notwithstanding. Savalas had always harbored fantasies of singing professionally, and when his Kojak role turned him into a rather unlikely sex symbol virtually overnight, he was quick to take advantage of the situation. In a period of three years, Telly released four albums: *Telly*, *Telly Savalas*, *The Two Sides of Telly Savalas*, and *Who Loves Ya, Baby?*

Show: *Medical Center*
Artist: Chad Everett

> "Coolin' my heels on the bayou, I do my travelin' in my mind...
> Ain't gonna' strain no more brain no more, just gonna' lay
> On this old swamp floor... "
> — "Bayou" lyrics by Chad Everett

The title of Chad Everett's first LP is *All Strung Out*, and on more than a few songs that's just how he sounds. Apparently his producer couldn't decide whether to have Chad adopt a Righteous Brothers-esque "all-American boy" manner of singing, or a low, gruff, bluesy style. So Everett switches back and forth, employing his Bill Medley type vocals on some songs, and his throaty, hippie style vocals on others. Some numbers he carries off with great aplomb, while on others he misses the target by a mile. Everett's voice has a limited range, and on this album he's simply allowed to take on material that's – to say the least – overly ambitious. Nino Tempo's sweeping Phil Spector-esque arrangements on songs such as "You're My Soul & Inspiration" only serve to accentuate Everett's innate shortcomings. And the songs here that do work well present such a stark contrast to Chad's public image, that viewers of *Medical Center* must have been left wondering. For example, *All Strung Out* compares love to heroin addiction, and "Bayou" (co-written by Everett) paints a picture of its protagonist laying flat on his back in a swamp, fishing for catfish for days on end; a far cry from Everett's character, Dr. Gannon, the hip young surgeon who sometimes wore scarves or clogs with his leisure suits. Everett couldn't have taken his audience further from the squeaky clean hallways of his TV hospital had he tried. Evidently Chad's fans weren't alienated by this slice of vinyl weirdness, as he released a follow-up album a few years later.

Show: *Green Acres*
Artists: Eddie Albert and Pat Buttrum

> "In a world of computers and machines, the young poets of today, whose medium
> is the popular song, speak with individuality, with strength, and with a beauty that
> rekindles the flame in our hearts for justice, for equality, for love, and for every
> valuable feeling in the world."
> — Eddie Albert, quoted on *The Eddie Albert Album*

Eddie Albert sang on Broadway in *The Music Man* and released a number of albums prior to his *Green Acres* stint. His most interesting offering though, is *The Eddie Albert Album*, a strange stab at the youth market, recorded during his days playing Oliver Wendell Douglas on the show. On it he sings "A Smile Is Just A Frown (Turned Upside Down)," "Homeward Bound," and "Don't Think Twice, It's All Right." In the liner notes Albert lauds the works of Paul Simon and Bob Dylan, and speaks glowingly

of the young. It would seem that this LP is some sort of attempt to distance himself from the conservative, rather stodgy character he portrayed at the time. The only problem was that said character was Albert's claim to fame, and so it was decided that he should probably include a rendition of "The Theme From Green Acres" alongside all the songs of protest and social commentary, just for good measure. Though one might hope for some sort of novelty record from the show's Arnold The Pig (he was popular enough), the only other resident of Hooterville to try out his pipes was Mr. Haney (Pat Buttrum). Pat put out a single, "Get Up Early In The Morning" (B/W "Mom's Golden Coffee Pot"), but there are also a few LPs available featuring his stand up comedy.

Show: *77 Sunset Strip*
Artists: Edd Byrne, Roger Smith and Efrem Zimbalist Junior

> "Plaid light bulbs... wall-to-wall television?!"
> – Lyrics to "Kookie's Mad Pad"

When Edd Byrne released an album, it wasn't called *Edd Byrne Sings*, it was called *Kookie*, after the hip-talking character he portrayed on TV's *77 Sunset Strip*. Byrne did the whole LP in character as Kookie, and the final product is like a time capsule that captures the beat generation as seen through the distortion-mirror of primetime television. The album is a classic, and managed to produce one of the all time great novelty tracks, "Kookie Kookie (lend me your comb)." In a scramble to capitalize on the success of his first chartbuster, Edd put out a string of singles (eventually releasing a beatnik Christmas album, the ultra rare *Yulesville*), but none packed the wallop of his initial outing. Series costar Roger Smith also got into the act, putting out an LP called *Beach Romance*. Efrem Zimbalist Junior, the program's star, joined Roger and Edd along with the entire cast of *Hawaiian Eye* for the Warner Brothers' Christmas album *We Wish You a Merry Christmas*.

Show: *Dragnet*
Artist: Jack Webb

Legend has it that sexy chanteuse Julie London asked Jack Webb for a divorce because he spent more of his time hanging out with police than with her. Of course, we all remember Webb as the hard-nosed cop from TV's *Dragnet*, but Jack did possess a romantic side. Witness *You're My Girl*, his wild waxation on wine, women and song. Webb doesn't actually sing here, rather he gives a soft spoken recitation of lyrics to such romantic favorites as "Try a Little Tenderness." For those who aren't fans of *Dragnet*, the overall impact of this disc is about as romantic as having Sgt. Joe Friday read you your rights. For Friday aficionados, however, this kinder, gentler side of the tough talking lawman will come as a pleasant surprise. And whether one likes this record or not, it can at least be said that Webb is the only celebrity to offer a straightforward explanation for his use of spoken word. In the liner notes for *You're My Girl*, he acknowledges a longstanding desire to be a part of the world of music, but concludes that except for reading the words to songs, he had "nothing else to contribute."

Show: *The Avengers*
Artist: Honor Blackman

> "On the face of it, can you think of a clearer case of career suicide than an actress
> suddenly going berserk and singing her way through two sides of a whole LP?"
> – Honor Blackman, quoted in liner notes for *Everything I've Got*

Before gaining worldwide notoriety by playing arch villainess Pussy Galore in the James Bond film *Goldfinger*, Honor Blackman was Mr. Steads' karate partner (pre Emma Peel) in *The Avengers*. The popularity of her role lead to the recording of an album, *Everything I've Got* (later reissued as *Kinky Boots*). Ironically, Honor Blackman is one of the only celebrities to publicly offer something approximating an apologia for undertaking a challenge as "crazy" as recording an album. All the more ironic, because of all her contemporaries, Miss Blackman's work stands out as perhaps the best

example of a celebrity recording that works exceedingly well on every level. Honor takes to these songs like an actor takes to a role, and in fact, the various pieces were chosen with a mind towards reflecting Miss Blackman's rather larger-than-life image. She even concedes in her liner notes that "picking lyrics is like accepting parts. You know what belongs to you." The choice of material here is nothing less than inspired. The Rogers and Hart tunes "To Keep My Love Alive," "Everything I've Got," and "Den of Inequity" all sound as though they were written especially for Honor Blackman, and for this particular album.

Show: *Sgt. Bilko* (a.k.a. *The Phil Silvers Show*)
Artist: Phil Silvers

> "... this is neither comedy nor a handbook for buglers. It is Phil Silvers' presentation
> of a great set of danceable tunes."
> > – Liner notes to *Swinging Brass*

Phil Silvers Presents Swinging Brass is a great album of military music cum cocktail music. When Phil Silvers heard that Nelson Riddle had done swing versions of "Mess Call" and "Mail Call" while in the service, he proposed that Riddle do an entire record's worth of such treatments as a tie-in to his hit show *Sgt. Bilko*. With enough prompting from Silvers, Riddle finally obliged, and the resultant vinyl platter manages to capture the freewheeling spirit that Bilko so epitomized. Another Bilko tie-in album, *Bilko Brass*, also features a selection of military oriented numbers, but appears to have little to do with Phil Silvers beyond having his photo on the sleeve. Of course, if a star is popular enough (which Silvers was), their photo on an LP can be all that's needed to make a sale.

Show: *The Morton Downey Show*
Artist: Morton Downey Junior

> "Take your drugs and shove 'em,
> We've had our fill of 'em.
> We won't rest 'till your
> Ass is on death row...
> You slime suckin', drug dealin' son of a bitch
> We hope that you die slow"
> > – Lyrics from "Hey Mr. Drug Dealer"

Though Morton Downey Junior actually started out as a singer, it was his controversial talk show that made him a household name. Downey was outspoken and abrasive, and took sensationalism in the talk format to perhaps its most extreme conclusion. His TV show proved so attention grabbing that Downey landed several bit parts in movies, and eventually recorded an album. His album was basically an extension of the talk show, and managed to capture the program's spirit very well indeed; both what the public loved about Mort, and what they hated. The record is a mix of phony patriotism, searing social commentary and obnoxious oratory. There are songs about prostitutes, drug dealers and Viet Nam vets; there are harangues against doctors, lawyers, and politicians; Mort even shows his sensitive side on songs like "Old Man" and "Solution to Pollution." "Blue Collar King" is a celebration of the Morton Downey Junior phenomenon, and is sung by Mort's country music pal David Lloyd (who wrote most the songs on this LP). Morton Downey was definitely one of the more interesting figures to emerge during the 1980s, and this recording effectively captures him at his apex.

Show: *The Man From U.N.C.L.E.*
Artist: David McCallum

> "I'll go through the gates of Hell to find my fate,
> but right now I really must be going.
> So would you girls mind getting off my motorcycle?"
> > – Lyrics from "Communication"

David McCallum, who played Ilya Kuryakin on *Man From U.N.C.L.E.*, actually went to a conservatory for music and studied composition. The child of two musicians, young David was raised around music and learned to play many instruments. As a struggling actor, McCallum had to make a choice of which career to pursue, music or acting. Choosing acting, he sold his instruments and thereafter dedicated himself wholly to his craft. Until, that is, *Man From U.N.C.L.E.* caught on like wildfire. Then, in the twinkle of an eye, David was off to the recording studio to put his early musical training to use.

McCallum produced a series of records featuring groovy orchestral instrumentals of the day's top pop tunes. First came *Music: A Part of Me*, followed by *Music: A Bit More of Me*, *Music: It's Happening Now*, and later simply *McCallum*. The records are great fun to listen to, and will set your toe to tapping. They didn't get any radio play because top 40 stations weren't interested in playing instrumental versions of recent hit songs, even by the guy who played Ilya Kuryakin. But the albums must have sold incredibly well, as they pop up with amazing frequency in flea markets, thrift stores and used record outlets. On an odder note, McCallum released a spoken word single called "Communication." In it, David questions who he is and where he's going, but tells the world in no uncertain terms that he must follow his own star and be his own man. That he must "find (his) fate, in life or death, in love or hate." Now that's communication!

Show: *My Little Margie*
Artist: Gale Storm

"There'll be many gold records hanging on the walls of (Gale Storm's) San Fernando
Valley home in the years to come – for this girl can sing!"
– Liner notes to *Gale Storm*

One of the first TV celebrities to make the transition to singer was Gale Storm, star of *My Little Margie* (her success predates that of Ricky Nelson by several years). Storm was appearing on a popular variety show, singing a song, when Dot Records president Randy Wood heard her. Wood was at the dinner table with guests when he heard Storm's voice drifting in from his living room. He called in to his daughter, asking who was doing the singing. "It's *My Little Margie*, dad" came the reply, and before the end of the show, Wood was on the phone to Gale Storm with an offer of a recording contract.

Storm made her debut on record in the fall of 1955, and in a few months had three songs in the top 20. First came "I Hear You Knocking," followed by "Teenage Prayer," and then her version of "Memories Are Made Of This." The latter tune was also recorded by Dean Martin at that same time, and both artists had top 10 hits with it simultaneously. For a brief period of time, Gale's smooth, easy style of singing made her one of the top three vocalists in the country. But when she took a hiatus from recording after being elected mayor of Encino, California, her singing career never quite got back on track.

Show: *Gomer Pyle, U.S.M.C.*
Artist: Jim Nabors

"I thought you were a U.S.D.A. lady,
but you turned out to have a hot dog heart."
– Lyrics from "Hot Dog Heart"

Anyone who's seen more than a few episodes of *Gomer Pyle* is aware that series star Jim Nabors is a gifted singer. In fact, his talent for singing was the source of an ongoing shtick used repeatedly over the course of the show's run. The gag was that although Gomer spoke in a goofy hayseed drawl, he could belt-out a song in deep, rich, *basso profundo* tones. Nevertheless, Jim Nabors' natural ability as a singer failed to exempt him from having to release a silly novelty record: *Shazam!*. The record's producers had him do the entire album in character as Gomer Pyle, singing in the same hick accent he used on the show. And the songs he sings take their cue from the TV program as well, with titles such as "Gomer Says Hey!." Nabors went on to record dozens of albums in his normal singing voice, but none equals this as a pre-eminent example of primetime pop.

The preceding has been but a partial list of the shows, artists and albums that constitute the heretofore undefined world of primetime pop. This has been but a small sampling of the genre, consisting of a handful of releases out of more than a hundred in my own record collection alone. Brief as it's been, however, it still serves to showcase the unique relationship that existed between television and popular music during an era when TV was at its pop-cultural zenith. At the high end of the spectrum, the union between TV and pop music produced some of the most successful and well crafted songs ever penned. At the low end of the spectrum, it resulted in some of the most improbable conglomerations ever committed to vinyl. Fans of classic television, popular music, or just pop culture weirdness will be equally amazed and delighted by the sheer volume of primetime pop material out there. And it *is* still out there; one needs only make a visit to the local thrift store, flea market or record collectors fair, and these and other gems are there for the taking, and at bargain-bin prices.

Passive Activism
Yellow Ribbons & Other Red Herrings

(Abridged version originally published in *Rollerderby*, 1994)

Aren't you sick of people who think that colored ribbons will somehow change the world? It was stupid enough that a gimmick from a Tony Orlando song about a *criminal in prison* was arbitrarily applied to American hostages in Iran at the end of the 1970s, but it's even stupider that two decades later people will use *any* excuse to adorn their trees, fences or what-have-you with those god-awful yellow ribbons. There should be a ribbon killer who chooses his victims exclusively from the legions of chumps who use ribbons to show the world how much they care.

Now there are so many who care so deeply about so much, that there are ribbons of every conceivable hue addressing every conceivable concern: ribbons to "end AIDS," to "end breast cancer," to "end drunk driving," to "save the rain forests" and so on, *ad infinitum*. Ironically, the more ribbons people wear, the worse things seem to get. Perhaps this is because they're choosing to deal with the world's problems in an inappropriate manner – by engaging in *passive activism* – by wearing a ribbon instead of actually *doing* something. Today's care-bear "activists" can wear a different colored ribbon every day of the week and ultimately never produce anything more meaningful than a small rise in the profit margins of the ribbon industry.

Unfortunately, this sort of detached, abstract approach to social change is emblematic of humanity's tenuous relationship to reality at the end of the millennium, and it goes beyond the mere empty symbolism of colored ribbons. Humanity's disengagement from tangible reality is so ingrained at this point, that I'd argue that we've actually reached a point in human history where there no longer exists *any* prevailing modern attitude or doctrine so complex that it can't be distilled down into a simple one-sentence slogan that will fit neatly onto a another ubiquitous facet of contemporary passive activism: the bumper sticker. In the modern bumper sticker, platitudes have replaced philosophy. Where once thick volumes were given-over to the discussion of ideas, their subtleties and their myriad ramifications, today only slogans remain.

When one pulls up behind a Volkswagen van plastered solid with bumper stickers, one may well be viewing at a single glance a comprehensive overview of the full spectrum of Western thought as it currently exists; the modern day equivalent of the libraries at Alexandria. Except that instead of being thoughtful, well-reasoned inquiries into the nature of things, today's philosophies seem to be wholly defined by the things which they're *against*. Modern tailgate philosophers are against men, against television, against authority, against homophobia, against racism, against *mean people*, and so on. It is philosophy reduced to a measly protest slogan, and at the same time, a protest reduced to merely affixing a catchphrase to the bumper of one's car. And the latter idea is no doubt even more ludicrous than the former, as the person who sports a sticker demanding the rest of us to "end racism" seems to truly believe that by that simple gesture, he is actually doing something *tangible* to bring about its end. Or there's the person whose bumper sticker tells us that if we aren't part of the solution we're part of the problem; who clearly imagined that the act of putting such a sticker on their car somehow earns *them* status as being part of the "solution" – when in fact nothing could be more passive and useless.

Even more so than the over-exuberant display of colored ribbons, bumper sticker politicking represents a state of active denial taken to its passive-aggressive logical conclusion. What follows are a smattering of some of the most oft-seen bumper stickers, and a short commentary:

QUESTION AUTHORITY:

> Since authority as such hasn't really existed in decades (or is more or less ignored in those cases where it does), I'd question the need to question authority.

SUBVERT THE DOMINANT PARADIGM:

> Since the dominant paradigm is, these days, little more than an amalgam of the sort of liberal platitudes given voice to on bumper stickers, I'm sure that this sticker is actually

demanding the polar opposite of what the person displaying it imagines.

MEN ARE AS USEFUL AS A THIRD WHEEL ON A BICYCLE:
Well, ladies, if you don't need men, then prove it by boycotting everything they've invented. You'd have no cars to put your bumper stickers on, and no bumper stickers either, since men invented the printing press and silk-screening. And of course you'd have no bicycles... or much else.

WELL-BEHAVED WOMEN RARELY MAKE HISTORY:
Delete those first two words, and you've got it: WOMEN RARELY MAKE HISTORY.

THE GODDESS IS AT HAND AND MAGICK IS AFOOT:
Uh oh, another woman driver.

ANOTHER MAN AGAINST VIOLENCE AGAINST WOMEN:
Another pussy-whipped chump who thinks that being sensitive to women's issues will get him laid.

I'M STRAIGHT, BUT NOT NARROW:
Lest his heterosexuality be misinterpreted as homophobia, this man has to let the whole world know that he isn't threatened by gays... and some of his best friends are gay, honest.

IT'S A BLACK THANG: YOU WOULDN'T UNDERSTAND:
You may be right: I speak English, not Ebonics.

VISUALIZE WORLD PEACE:
If everyone in the world was visualizing world peace at the same time, then (and only then) world peace might conceivably come into being. Should this unlikely scenario ever occur, however, peace would cease in whatever amount of time it took for some people to stop fantasizing and return to their day-to-day concerns. Of course, this scenario never *will* happen, as it's logistically impossible. Should you still misguidedly desire to visualize world peace, however, I'd suggest you do it behind locked doors; as your lack of mental focus will make you an easy target for all those not sharing in your visualization exercise. And – oh yeah – don't do it when you're behind the wheel of your car, staring at the bumper of the driver before you.

In ancient times there existed things called *curse tablets*; small pieces of bronze, upon which were inscribed the names of one's enemies and their desired fates. The tablets were tossed into the murky waters of Pagan temples such as those at Bath, England, in the hopes of bringing such fates to bear in reality. Like today's bumper stickers, such tablets were part superstition and part psychodrama... wishful thinking writ large. In the end, just as useless.

In a better world, preachy political bumper stickers would be the equivalent of "kick me" signs, making targets of those who so proudly displayed them for all to see. And every car stopped at a light whose bumper bore the proclamation to "kill your television," might become a magnet for an armed assassin who'd approach the driver, hold a .357 Magnum to his head and say, "Your television sent me... goodbye."

As ineffectual and ultimately meaningless as all this ribbon-tying and bumper sticker-politicking may be, these increasingly widespread personal gestures of passive activism pale in comparison to the degree of waste and uselessness displayed by their bureaucratic counterparts – a form of passive activism directed towards (and paid for by) the general populace – the so-called "public service announcement."

Example: A late-night TV commercial shows elephants cavorting. As a mother elephant wraps her trunk around a baby elephant, we hear a voiceover by what sounds like a kindergarten class yelling at the top of their lungs, "Elephants are beautiful! Elephants have families! God put elephants

on earth for a reason! Please don't hurt them!"

I don't know about you, but I can't seem to recollect exactly when the last time was that I willfully *hurt* an elephant. Come to think of it, I don't believe I ever have; furthermore, I can't conceive of any situation that might occur in the future which would present me with the opportunity to do so. So what the fuck is the purpose of this commercial?! It's ostensibly a public service announcement, but like many such announcements it leaves me wondering exactly what *service*, if any, it renders. Do we need a commercial to advise people with neither the means nor desire to hurt elephants not to do so? If I harbored ill-will towards elephants and was just biding my time until the opportunity to inflict physical suffering upon one arose, would this ad dissuade me? Could it be that a large enough segment of late-night TV viewers have vast collections of fine ivory, and this is an attempt to affect the illegal ivory trade by inducing guilt in these viewers? I'm sure I can't tell.

If a commercial seems to serve no function whatsoever, or if you're uncertain what point it's trying to make (or why), then it's likely a public service ad. The time of day it's broadcast is of course another indicator; they tend to be shown late at night. To comply with regulations set by the FCC, every station has to devote a certain amount of time to broadcasting material that's "in the public interest." Since more people watch TV during the day, and TV stations can sell ad time for more money then, these compulsory public service segments are generally shown late at night (when hardly anyone advertises, because hardly anyone is watching). So you'll often see commercials meant to educate children about the dangers of getting into cars with strangers, airing at 4:00 in the morning. Ironically, one of the few seemingly functional public service ads is rendered utterly worthless by being broadcast at a time when the very audience it's meant to address (children) are all sound asleep.

Another late-night classic of meaninglessness opens with a swim team toweling-off and leaving a meet. We're informed that this team didn't win the meet today. Nor have they won a single competition this year. In fact, they've come in dead last every time they've shown up. The camera then reveals a lone swimmer still thrashing about in the pool, after the other competitors and spectators have already filed-out. The remaining swimmer climbs out of the pool, and we can see the reason this team has lost: this girl has two prosthetic legs. She lurches along the poolside, barely able to ambulate.

The supposedly life-affirming message of this commercial is that she is a "winner" by virtue of the fact that she *tried* to do something; even if *it* was something vastly outside the realm of her capabilities; even if her attempt resulted in preordained defeat, time and time again, not only for her, but also for every other member of her swim team as well. This is obviously supposed to be a *feel-good* sort of spot, but I can't for the life of me figure out why such a patently ludicrous exercise in futility should inspire anything in me other than contempt and disbelief. Would we applaud the noble intentions of an orchestra that hired someone who couldn't play violin and whose presence ruined every performance, simply because the untalented individual *wanted* to do it and gave it their best? Of course not. We'd say the idea was stupid and we'd refuse to listen to it – but such overt avoidance of basic logic is often the very essence of messages directed towards (and paid for by) the so-called "public interest."

The public service messages that grace billboards are equally wacky. For a while in the mid 1990s there was a billboard posted near San Francisco's predominantly homosexual Castro District (near Noe Valley) that depicted a hand holding a firearm on one side and a hand tossing a basketball toward a hoop on the other side. It bore the message, "Shoot hoops, not homeboys." Now, which is more ludicrous: imagining a bloodthirsty gang-banger mending his ways after viewing this billboard, or imagining the silly White liberal who actually thought such a message was a meaningful way to deal with gang violence? Even if we accepted the premise that such a manner of bumper sticker-esque slogan could have *any effect whatsoever* on very real social ills, we're again faced with another problem: there aren't any *gang members* in San Francisco's Castro District.

Back on late-night TV, an ad meant to promote world harmony is in regular rotation. A series of racial minorities share their feelings with us, in an attempt to illustrate that beneath the surface differences, we're all basically very similar. One fellow, "loves good foods." Another loves his mother. A teen in a wheelchair says, "You don't have to run with me," and a walleyed mongoloid girl tells us, "You don't have to run away from me." A Latino man stares confrontationally into the camera and states un-categorically, "I *will* be your neighbor." The message here is that we have to all live together, and since (as the last fellow pointed-out) we have no choice in the matter, we might as well recognize

those things we have in common, because those things make us more alike than different. It all seems so simple when viewed in terms such as these, one wonders why ethnic strife and violence have been such a relentless source of friction for countless centuries. Differences in race, culture and religion should be revealed to be relatively inconsequential trivialities, to nations who share a common bond as fundamental as their mutual regard for good food and music. Why hasn't anyone bothered to tell the Arabs that the Israelis probably like good food and good music, just like them? After all, they both like falafel, right? So what's the problem?

There seems to be some bizarre sort of inner logic to all of this, but in this day and age it could all be every bit as senseless as it appears to be on the surface. However, would it be overly paranoid on my part to suggest that these public service ads may not merely be misguided attempts by deluded do-gooders, but conceal rather a far more cynical purpose? Could it in fact be that the architects of these seemingly ill-conceived campaigns realize full well that the problems they address are perennial and immutable, and exist beyond the power of man to control? Perhaps the *real* function of such ads is purely to give solace to the public; to allow people to imagine that ongoing frictions which they're powerless to control can be dealt with and *are* being dealt with... even though they obviously *aren't*.

I'm not one for conspiracy theories, but this would certainly explain why a billboard to combat gang violence was put in a rich liberal neighborhood of San Francisco, and not in the Black or Latino gang territories that border it. Presumably, members of the well-to-do neighborhood were victimized from time to time by members of the nearby Black or Latino gangs; placing anti-gang billboards in gang neighborhoods would have had no effect in preventing these attacks, but putting them in the (seemingly inappropriate) neighborhood of the potential victims served the function of reassuring them that action was being taken to combat the gang problem. Why would people do this? Because, of course, doing anything which might have any impact at all would require more thought, more effort (and perhaps more risk), than simply typing "Shoot hoops, not homeboys." Perhaps it's cynical, but such an explanation is, in fact, far more logical and reasonable than the preposterous idea that gang members are influenced by public service billboards; or that public service TV spots, bumper stickers and colored ribbons have *any* tangible effect whatsoever upon the very real social ills which they passive-aggressively seek to combat.

In short, the ultra-popular bumper sticker *weltanschauung*/slogan "visualize world peace" could be more accurately encapsulated in the phrase "pretend everything's okay." Because that's the predominant character of the modern world: a huge game of *let's pretend*, with an endless succession of marches, run-a-thons, rallies and so on, dedicated to ending every possible malady of modern life; from date rape to homelessness. You can walk in the morning to "end violence," run in the afternoon to "end racism" and attend a rally in the evening to "stop AIDS," and all you will have succeeded in doing is fooling yourself into imagining that you have actually done *anything at all*. It may be the modern equivalent of fiddling while Rome burns, but at least fiddling produced a constructive byproduct: music.

All of this is illustrative of a seemingly pervasive attitude these days: people really seem to believe that merely mouthing a platitude, wearing a t-shirt with a "socially conscious" slogan, or putting a bumper sticker on their car is the equivalent to taking *action* against the problems they see as plaguing society. Or, perhaps, they are more concerned with merely being *perceived* as an individual who cares deeply about injustice. Either way, dealing with injustice in a constructive manner is never as simple as wearing a t-shirt, holding a placard, or shouting a slogan. It's easy to wear a shirt that shouts to the world, "end racism" – making racism go away, however, is another matter altogether.

And so, regarding the whole issue of *passive activism* – whether it is manifested as the exuberant exhibition of colored ribbons, preachy bumper stickers, billboards, or late-night public service TV spots – I'll conclude with some good news and some bad. First the bad news: there will always, always, *always* be pestilence, deadly disease, hunger, homelessness, hatred, inhumanity and great suffering. Nothing man can do will ever totally erase these things, and certainly no amount of colored ribbons, bumper stickers, or any other sort of ineffectual emotional displays will either. Now for the good news: it's going to get far worse. Don't imagine for even a second that it might get better somehow... because it won't. But we all know how much people love to suffer, and as things take a turn for the worse they will find more and more opportunities to rejoice in their misery. So maybe things aren't so bad after all...

Sin In The Suburbs

(Abridged version originally published as "I Was A Pre-Pubescent Sex-Fiend" in *Rollerderby*, 1994)

<u>First Glimpse of Female Genitalia</u>:

It was at Merry-Go-Round Nursery School in Lemon Grove, California. It occurred during "potty time," when we'd all line-up and take turns using the toilet. On this particular day, I ended-up in the restroom at the same time as a certain little girl. How it happened, I'm still not sure. As she peed, she hollered my name. When I turned around to see what she wanted, she hiked-up her dress, spread her legs and used two fingers to spread-open her pussy lips. The image of those pudgy flaps of flesh burned itself into my psyche. I'd always found that particular girl to be somewhat repellent, yet the revelation of what was hidden up under her skirt seemed undeniably compelling.

I grew up in the early 1960s when the vagina was a source of awe and mystery. Back then, *Playboy* couldn't show pubic hair, so even on the rare occasions when kids saw pictures of naked ladies, we'd only really see their breasts; and if breasts alone offered such prurient appeal, I could only begin to imagine what the pussy had to offer. The memory of that repellent girl's spread, puffy lips was fodder enough for my imagination 'til second grade – then I decided I needed a closer look...

I struck a deal with a friend's little sister: in return for a piece of candy, she'd go out into a nearby field, disrobe, and let me touch her pussy. I tried to palm-off the lime piece on her, but she held out for the best piece in the sack – the strawberry. She drove a hard bargain, but still, it seemed like one hell of a deal.

When the time came for her to deliver on her promise, she started having second thoughts. She'd already consumed her piece of candy and now found the idea of being naked, out in the field somewhat frightening. She flat-out refused to undress, but I insisted – after all, a deal's a deal. Reluctantly, the girl unbuttoned her little dress and slipped out of it. She was now clad only in her panties, socks and black patent-leather shoes. I waited for her to remove those items as well, but she just stood there. Then she said that she just couldn't go on, that it was wrong, and if she did it she'd get in trouble. Trouble? What possible trouble could come of it? After all, it was our secret and no one would know. "Someone would know," she asserted, nodding her head, "God would know." At that I lost all patience with her. I shoved her to the ground and yanked her panties down to her ankles. She began to cry. The sight of her bald, young beaver was both incredibly thrilling and oddly anti-climactic. It seemed so featureless and unformed. It looked so very, very *bare*. Breasts had nipples, but this smooth, hairless mound had nothing to focus on, really.

For a long while after I'd shoved her to the ground, she just lay there in the dirt. Then she got to her feet and stood there sobbing, her panties still down around her ankles. I was disappointed that she didn't seem to be having as much fun as I was. I ended up having to give her my entire package of candy in order to buy her silence.

<u>The Club</u>:

Like many folks, there was also early sexual experimentation with members of my own sex. First because they were close at hand, but primarily because we hated girls – they were icky. Some pals and I had a secret club that met in a patch of bamboo that grew near our neighborhood. We were avid watchers of Jack LaLanne's exercise program on TV, so the primary activities of our club were to disrobe and participate in a series of obscene exercises. We had no idea what "gymnastic" meant and thought Jack was saying "gym-nasty" – to us, gym-nasty suggested doing naughty exercises, so we did. We weren't sophisticated enough to perform actual sex acts *per se*, but just being outdoors in a state of undress, performing strange rites, was incredibly titillating.

I was appointed leader of the club and it was I who formulated the club's bylaws, one of which was that to gain entry to our *sanctum sanctorum* the members had to kneel and kiss my asshole. I'd actually bend-over and spread my cheeks for them. How we arrived at that particular ritual I have no idea, but it seemed reasonable at the time. Ironically, when my heterosexual impulses

overwhelmed me and I was the first of the club to have a girlfriend, I was called a sissy!

The Boner:

I had always been plagued with an almost endless series of erections. As early as nursery school (and even before) I'd get erections for no particular reason, which would last for what seemed an eternity. I had no idea why my cock would suddenly go stiff and create a bulge in my pants, and I didn't particularly care – but teachers and other adults did. They'd point at my crotch and ask if I needed to pee. When I'd answer "no," they'd tell me to go to the bathroom and at least try. Soon I discovered I had to invent various techniques of masking my involuntary erections from others. One was to put my hand in my pocket and shove my penis down. *Then* my teachers grew annoyed with the fact that I always had my hand in my pocket. Geez!

When I first learned of the word *fuck* and what it signified, I was – to say the least – very skeptical. I'd previously theorized that the ritual of marriage was somehow magical and served to trigger the generation of the baby in its mother's womb (an idea akin to the old notion that if you leave a piece of cheese unattended, baby mice will be born inside it). The concept of fucking, on the other hand, seemed altogether dubious. How could two organs used for *peeing* possibly double as tools for reproduction? It seemed tawdry at best, silly at worst, and I dismissed the idea forthwith. Or at least I tried to...

I'd find myself haunted by the image of a man's penis going into a vagina. Even though the scenario clearly made no sense whatsoever, I just couldn't shake the thought of it. I'd envision it on the way to school, at recess, even while watching cartoons. I didn't dare ask anyone whether or not what I'd heard was true – the topic was just a bit too weird.

The Solitary Vice:

For years I suffered under the delusion that I was one of the only people on earth who actually masturbated. My peers ridiculed it, stating that only homos would engage in such vile acts. When I finally asked how something so pleasurable could be so wrong, the answer I got threw me for a loop. "Well," my friend explained, rather conspiratorially, "every time you spill your seed, there's thousands and thousands of sperm in there. Every one of those sperm is a Christian soul that you're murdering. So jacking off is like killing thousands and thousands of potential Christians. Just killin' 'em."

Rather than dissuading me from masturbating, my friend's explanation only made me enjoy it all the more. With every orgasm I could envision thousands of writhing souls, a white sea of Christians twitching in death throes. I didn't particularly care for Christians even back then, and the image really appealed to me. It still does.

Addendum (2007):

I'd intuited early on that there seemed to be a fog of hypocrisy surrounding the topic of sex. It seemed to be such a powerful motivator, yet polite society not only dismissed its importance, but actually denounced it as an evil. Somehow or other, I just knew this wasn't true. I'd heard my uncle Ellsworth's risqué party records and his off-color comedy albums by Rusty Warren, both of which indicated that sex was something people found highly entertaining. At the local shopping mall, the garish window displays for the Fredrick's Of Hollywood store presented a glimpse of sexuality entirely out of step with our small suburban community. Here was an eye-popping display of women's *unmentionables*, nestled incongruously between an Orange Julius shop and a store that sold Carmel Corn. It sold fishnet stockings, see-thru bras, metallic gold stretch pants and padded undergarments that could endow the wearer with hips and breasts akin to those of Jayne Mansfield. Though most of the women in our town would never dream of wearing nine-tenths of the stuff sold at Fredrick's, seeing it all made me realize that somewhere out there, glamour and sexuality were alive.

Oddly enough, it was at this same local mall that I first caught a glimpse of the seamier side of sexuality that lurked just below the surface of the squeaky clean façade of 1963 suburbia. For all intents and purposes, the world I grew up in seemed like something out of *Leave It To Beaver*

(outwardly, at least). John F. Kennedy was in the White House, groups like Paul & Paula were on the radio singing songs about malt shops and going steady, while on TV Lawrence Welk and his Champagne Singers were riding high in the ratings. Above ground, the culture resembled a Norman Rockwell painting. Beneath it all, however, slumbered a far more sordid truth, a truth that both horrified and fascinated me when first I stumbled upon it.

I was not prepared for what I saw the first time I entered the public men's room in the basement of Newbery's department store. The room's walls and stalls were covered with countless drawings depicting what seemed like every conceivable form of obscenity. There were renderings of men performing oral sex on donkeys, "spread-eagle" women, disembodied penises squirting semen – you name it. The drawings ranged from retardedly psychotic to very well executed and realistic. They were accompanied by pornographic limericks, scatological humor and various vulgar proclamations. The sheer abundance of material, together with the varied styles of drawing and handwriting made it evident that this was not the work of some lone pervert, but certainly dozens and dozens of perverts. One illustration noteworthy for its artistic merit was a cartoon of a sailor – his bellbottoms around his ankles and an exaggerated erection thrusting skyward. Beside it was the simple statement: "last night I sucked off a sailor with a nine-inch dick." I had the distinct impression that I was gazing into some aspect of the collective psyche never given voice to in the world outside.

As I exited that men's room, I would never quite view that world outside – or those who inhabited it – in the same way ever again. I scrutinized those seemingly normal people who I saw about me in the mall and questioned myself about them, wondering about them. Who were they, really? Was the nice seeming man who politely held the door for me the same fellow who'd sucked off a sailor the previous night? I couldn't begin to guess. All I knew with certainty was that I seemed to be living in a world in which the truth of people's desires could only be expressed in scribblings within a locked stall in a public toilet. The secret desires and lurid fantasies I'd learned about in the men's room made the window displays in Fredrick's Of Hollywood seem downright wholesome in contrast.

My sexual awakening took place in an era that was fast coming to an end. In a few years hence, the so-called sexual revolution would bring sex out of the shadows and into the mainstream. I feel lucky to have been witness to the last chapter of one age, and the first chapter of the next; if only for the insight I gleaned from the contrast between the two. The expected sea change in human consciousness that evangels of the sexual revolution said would accompany more enlightened attitudes toward sex never quite materialized. The most tangible byproduct of the democratization of sex seems to have been a boom in unwanted pregnancies and the emergence of more virulent strains of sexually transmitted diseases.

If you're expecting me to close with some clever or insightful observation about the nature of sex, don't hold your breath. Sex is a subject that doesn't lend itself to analytical thinking or critical judgment. It doesn't need to. Sex today is probably little different than it was 1,000 years ago, or 10,000. Martial's commentary about sex in ancient Rome reads like it could have been written last week. Empires may rise and fall, but human foibles and kinks seem unwavering. The pornographic murals uncovered when Pompeii was excavated differ little from the obscene doodlings that graced the men's room walls at my childhood mall. The only discernable difference is one of style, rather than content. The only thing that ever changes about sex is our attitude to it. In my youth I viewed sex as a sacrament. With the advantage of years and perspective, sex seems more like a job one doesn't get paid for.

Revolt Against Penis Envy
Contributing Toward An Understanding Of Male/Female Harmony

(Originally published in *ANSWER Me!*, 1994)

"In man and woman, two kinds of history are fighting for power. In the masculine being, there is a certain contradiction; he is this man, yet he is something else besides, which woman neither understands nor admits, which she feels as robbery and violence upon that which to her is holiest. This secret and fundamental war of the sexes has gone on ever since there were sexes, and will continue – silent, bitter, unforgiving, pitiless... "
 – Oswald Spengler

"In the sixties, talk of a 'war between the sexes' was very popular. In point of fact, what was being described was not a war at all, merely the recognition of a change in the balance that had previously existed between the two sexes. The grip of man's domination was loosening, and women rushed forward to take advantage of the situation. The natural relationship which had hitherto existed between man and woman was put under increasing strain by the shift in balance and was rapidly evolving into an ever-more-adversarial coalition. But war?

War is the variety of violence which one traditionally resorts to when all other means of asserting his dominance have been exhausted. There was no war between the sexes in the sixties simply because man had long since ceased to assert his dominance by any means. It is precisely this male backsliding which gave rise to the tension which was misconstrued as war, and which has grown steadily worse until today. Perhaps a war will be necessary to bridge the abyss across which the sexes stare mistrustingly at each other."
 – Harry P. Ness

"Woman is a temple... built over a sewer."
 – Tertullian

At one time, all was right with the world. It was lorded-over by men who imposed their will by force. Women kept their mouths shut, underlings knew their place, and those who opposed the prevailing order had their heads cut-off. So far, so good. In this bygone golden age, sadistic values determined the quality of life. Sadistic values are exclusively male values; values predicated not upon baseless intellectual abstractions or wishful thinking, but upon hard biological truths. One such truth involves testosterone, the hormone responsible for shaping the male character. It lies at the root of man's aggression and domination, and has consequently played the key role in shaping mankind's history.

And the history of mankind is, quite simply, the history of man. It is the story of his creativity and his daring. It is the story of his strength, his courage and his invention. Every great idea, great empire, or great undertaking has been the byproduct of man and man alone. History's great epochs are those in which male domination and male-force reigned supreme.

Just as testosterone ordained man's preeminent role as creator and master of world history, woman's position was likewise decided by her hormonal predisposition. Estrogen lies at the center of the feminine character, and it is this hormone, says science, that is responsible for woman's overabundance of emotion and apparent lack of logic. This primary biological difference is the basis of what is commonly referred to as "sexual differentiation."

Woman is quick to embrace the concept of sexual/hormonal differentiation when she can use it to her advantage – to explain, for instance, why men are such brutes. But when the same criteria are applied to explain her own shortcomings, she dismisses it as a cruel construct invented by man to discredit her. She is far more comfortable with feelings than with facts. Facts – in her opinion

– are made by man in the *image* of man, to be used against her; to keep her down. When confronted by the cold reality of facts, woman's emotions fly into a tizzy, and her emotions have no origin in the intellect, or in instinct, or in any sort of observation or deductive reasoning. They are instead a primordial amalgam of overblown hopes and fears – childish fantasies carried to absurd extremes. As reactions to external realities, woman's emotions make no apparent sense. Only when recognized as the byproduct of an overwhelming *internal reality* – that of estrogen – do her emotions and perceptions finally begin to become comprehensible.

In a once-glorious past, woman was a creature without rights; a second-class citizen. In some places, she wasn't considered a citizen at all; she was property. She was part cook, part whore, part servant and all child. So what has changed to put woman on an equal-footing with man, deserving of the same rights and privileges? Has woman herself changed? Decidedly not. Not in temperament, character, or ability. She is the same creature she has always been, with the sad addition of some rather unflattering conceits.

It is not woman's advancement in the realm of character which has facilitated her upward mobility – rather, it is man's loss of character. She has gained ground only because he has lost ground. And why has he lost ground? Because the White male has been bamboozled. He has been shamed into submission and made to feel guilty about his aggression and his will-to-power. But are not aggression and the will-to-power part and parcel of his character, stamped upon his soul by nature itself? Are they not in fact the very things which once ordained his greatness?

Modern woman would have us believe that she has been oppressed by countless centuries of male domination. Can this be true? She would have us believe that her standing was the outcome of some arbitrary bit of whimsy, concocted spitefully by man and imposed maliciously – unfairly! – upon woman. Was woman forcibly *held back* by the superior strength and intellect of man, or was she simply in an "inferior" position due to some lack of those qualities within herself? Was it man who chose a second-class existence for woman, or was it, in fact, nature?

Man sought only to act in accordance with the reality dictated by nature's wisdom. Woman, in her bitterness, blamed man for the position in which she found herself. This was surely *his* doing. He had cruelly cheated her out of all that was rightfully hers. The cad! Allowing her emotions to run wild (as usual), woman blamed man for all the world's ills, attacking male values at every opportunity. Ironically, it was the collapse and disappearance of male values which permitted woman's rise to begin with. The "domination" which she so fervently attacked had, for all intents and purposes, long-since vanished from public life. The positive, aggressive male values behind every step of upward evolution have been superseded by a soft and passive female ethic.

What can be done to subdue the sickly sway of feminine values? How can we silence the interminable whining of feminism's sob-sisters? In a nutshell: Woman must be put back in her place. Man's great error was to put woman on a pedestal, when she is far more at ease on her knees – where she belongs. The only way to subdue feminine values is by subduing the female herself. Woman must be reacquainted with truth and force. She must be reacquainted with truth *through* force.

Since woman is, above all, an emotional creature, appeals to her "intellect" are worthless. She must be shown in no uncertain terms the absolute nature of the master/slave relationship endemic to the sexes; and what plainer way to demonstrate this relationship than the simple act of rape? This primary act reveals, beyond a reasonable doubt, certain irrefutable verities: man is taller, woman is smaller; man is strong, woman is weak; man is master, woman is not.

The ritual we now call marriage originated as abduction, rape and enslavement. In those happy-go-lucky days, one's rights were not mere abstractions based on legislation, but rather the outcome of what could be imposed by physical force alone. Force was recognized as *truth-in-action* and the outcome of force was acknowledged as justice. Although this principle has been widely disavowed, its truth is as absolute now as it ever was; and the only truth a woman is capable of understanding is that which she can feel wholly within the depths of her childlike emotions. At one time, those emotions could be swayed by the sweet notion of romance, but her envy has long-since destroyed that.

These days, the only way to restore balance between the sexes is by fear and pain. Fear commands respect and pain demands understanding (read: compliance). Rape is the act by which fear and pain are united in love. It is the triumph of harmony through oppression. Rape teaches balance

– the natural balance of man-above, woman-below. This balance is a lesson which woman must learn, and only man can teach her. The only way to teach subjugation is through hands-on oppression; and woman must learn subjugation. The only way to teach submission is through active domination; and woman must learn submission. She must be brought down to her natural kneeling position. She must be returned to the bottom, where she's happiest. Only then may man be happy once more.

If it takes war to reinstate this happiness, then let there be war. Not a war *between* the sexes, but a war *of* the sexes, against the pernicious doctrine of sexual equality. And if the chief weapon in this war is rape, then let there be rape. Let there be triumphant male-force, riding roughshod over woman and her values. Let there be brutal male-force instructing and enlightening woman in absolute terms. Each rape is but a battle in a war, and each battle won is but a link in a glorious chain – a chain which will one day be used to keep woman in her naturally ordained place – beneath man.

But enough of talk. The time for words is over. The time for action has come. Now is the time to rise-up. Now is the time to go-forth. Now is the time to educate. Now is the time to subjugate. Now is the time to dominate. Now is the time to rape. Now is the time to rape. Now is the time to rape. Let the Revolt Against Penis Envy commence. Go forth! Rise up! Rape, rape, rape! Long live oppression! Long live love! Long live rape!

Notes on *Physiosophy*

(Previously unpublished, 2007)

Physiosophy was intended to be a compendium of essays elucidating varying aspects of my worldview (such as it was in the mid-1990s). By the time it was completed sometime in 1996, I had lost all interest in publishing it. The ideas represented therein seemed like yesterday's news – far more emblematic of where my thought had once been, rather than where it *was* or where it was headed. What I'd intended to be a refinement of the ideas I'd been exploring for a decade or so struck me – at the time – as more akin to a *rehash*. The project was abandoned. Today, the texts that follow are all that remain of the *Physiosophy* essays. Even these are mere fragments of the originals, pieced together from bits and bobs. Some are wildly incomplete, lacking either beginning or end. Others are *nearly* complete. The imperfect condition of these writings notwithstanding, I am no longer as dismissive of them as I once was. At the very least they may comprise an interesting curiosity, a kind of thumbnail sketch of my mental state during a certain time period. As in 1996, I still find them a bit overstated and overly obvious at times; but then, subtle understatement has never exactly been my forte.

God & Beast
The Divine Balance Of Abraxas

(Excerpt from *Physiosophy*, previously unpublished, 1996)

One of the most fundamental principles in the world of nature, and in man's daily life, is the law of balance. This is a law that people everywhere instinctively apply to numerous aspects of their lives on a daily basis, even though they might not consciously acknowledge the existence of such a precept. In fact, anyone who's ever taken a bath has instinctively employed this principle, usually without even stopping to realize that they are doing so.

When preparing bathwater, one turns on the "hot" spigot, waiting until the water issuing from it has grown warm, then hot. Following this, one turns on the "cold" spigot and adjusts its flow in relation to that of its counterpart, thereby mitigating the temperature of the water issuing from the faucet where the two meet. Once one finds the proper degree of balance between these two extremes of temperature, one can fill up the tub and take a bath. It's simple, deceptively so. So much so that – as with many of life's humdrum daily actives – most people scarcely even stop to consider what they're actually doing when performing such a task. But this simple, routine act is, in fact, a succinct metaphor for all of life. Consider: the correct temperature of bathwater is neither hot nor cold, but *warm*. As there is no spigot marked "warm," to get the water to the proper median temperature one must employ both the hot and cold spigots; which on their own would represent extremes of discomfort, even pain. That which is ultimately desired exists at neither stark extreme, but in their balance – their *coactive union* – and that union cannot be achieved by omitting either of the two poles from which it is derived.

Although the logic of the forgoing example may seem excruciatingly obvious to point out, the underlying concept of the importance of balance is curiously absent from the lives of most people today. Many people in the modern West tend to think of the world in terms of absolutes: black and white, good and evil, God and the Devil, right and wrong. For example, they believe that there are "good people" and "bad people," among a myriad of other polarized, absolutist oversimplifications of the world around them. But, as illustrated by the simple example of preparing bathwater, the world does not bear out such a view; and such a view is far from utilitarian. Granted, the principle of balance may indeed apply in any number of ways throughout the daily lives of many people – in small, overlooked day-to-day instances – but as a guiding principle for how to run one's life, it has all but vanished in the modern world. In fact, the concept of all-pervasive balance hasn't existed as a codified governing ethic for centuries. Very long ago, however, it did…

In the oldest known *futhark* (the pre-Christian alphabet of Germanic runes), there existed a runic symbol emblematic of the law of balance. It was the 13th rune in the sequence of 24 runes in the *futhark*, and it was called *eiwaz*. *Eiwaz* represented balance as an all-encompassing, universal principle; balance as a philosophical alpha and omega. It represented balance as going beyond merely being the point at which opposing forces were mediated – it represented the union of those forces and the recognition that they were not mutually exclusive, but in fact were different aspects of the same force, a *single* force.

Eiwaz was said to be linked to the yew tree, a tree which, for ancient Northern Europeans, was synonymous with eternal life, because it was evergreen and unaffected by the changes of season. The yew was also synonymous to the ancients with death, because it very often grew in and around cemeteries. So the *eiwaz* rune – as a denotation of the yew – represented eternal life and it represented death, at one and the same time. Rather than being paradoxical in its meaning, *eiwaz* symbolized the interconnectedness of life and death; the union of life and death. The *eiwaz* rune was also associated with the Nordic tree of life, a mythic tree which to the ancient Norse symbolically pierced and interconnected all realms of being. Its roots stretched to *Hel* – the underworld – and its branches reached upward toward the sun. So the rune further denoted a balance point between the realms of darkness and the realms of light. The concepts of good and evil had not yet really appeared as such on the world stage at that time, so dark and light were not necessarily equated with values denoting "badness" or "goodness," and were in fact viewed merely as different aspects of the life

process. The ancients understood that destructive force was as much part and parcel of the will of life as was creative force, and that both served the will of life (and consequently man). So the *eiwaz* rune was further emblematic of the balance and union of creative force and destructive force. It was (and is) a rune of integration, a rune of oneness.

It is astounding to contemplate that people so long ago possessed such wisdom as a guiding principle to their worldviews, and consequently their daily lives. It is even more astounding that those who once possessed such wisdom should have lost sight of it so abruptly. In the first *futhark, eiwaz* was the central rune around which the other runes were balanced. In the second and third *furthark* alphabets, it was gone. It simply disappeared from the vocabulary. This is highly ironic, because so many theologies in the ages since the disappearance of *eiwaz* have posited as their basic, fundamental truth the premise that "all is one," and (with rare exceptions) virtually none of them have philosophies that really reflect any understanding whatsoever of such a belief. On the one hand these faiths preach an all-encompassing unity and oneness, yet simultaneously admonish their practitioners to go toward the light and shun the darkness; or to get closer to God by overcoming one's base, animal instincts; or to become purer in spirit by abandoning the natural world, and so on. But such doctrines beg the glaring question: if all is truly one, then what exactly is the definition of "all" within the context of said doctrines? If "all" is truly all, how can anything exist outside of that totality, that *all*? How can anything be separate or distinct from *all*? If "all" means "all that there is," then by necessity this would be inclusive of darkness, animal instincts, the flesh, the material world, lust, evil, and the rest of the myriad things which organized religions of both the West and East exist in fervent opposition to.

The paradox inherent in such questions (which are attendant to all such faiths) seems to stem from a widespread case of man attempting to explain the intangible with pernicious *ideas* which only serve to distance and alienate him from the very understanding he once intrinsically – instinctually – had of the world around him. Man seems to retain a vestigial memory somewhere in the dusty recesses of his mind – an inborn understanding that life is comprised of some fundamental oneness – yet he seeks to somehow recover that long-lost oneness within a dualistic framework that portrays the world and everything in it as either black or white, good or evil, godly or ungodly. It is a schema for understanding life and the world which makes about as much sense as telling people that cold water is "good" and hot water is "bad," and that – although they might like a nice warm mix of both – they are to stay away from one and wholeheartedly embrace the other. One cannot help but wonder how such an unnatural and counterintuitive understanding of the world not only came to pass, but came to be dominant.

Believe it or not, man existed for millennia without the concepts of good or evil, God or the Devil. His old pre-monotheistic pantheons of gods represented the varying aspects of nature or natural law, and were understood as such. Even the harshest of these gods were not conceived of by ancient man as being "bad" per se, much less evil. They were simply a necessary part of the intertwined duality of the world, just as much as the death of one organism was necessary for the life of another. There are numerous well-known examples of such complex pantheons predating the advent of monotheism, the most famous to the minds of modern Westerners being those of the Greeks, Romans, Egyptians, Norse and so forth. But these do not represent the totality of ancient man's understanding of the world and how he fit into it. In fact, ancient man even had a few gods that (like the *eiwaz* concept) existed beyond, or above good or evil.

Zoroastrianism is a religion which was born in Persia (now modern day Iran) in the 6th Century B.C.E., and is still practiced in some parts of the world today. It's a fairly run-of-the-mill dualistic belief system, the mythological genesis of which posits that, in the beginning, two brothers were born; one good and one evil. The good brother Ahura Mazda is a beneficent god of Eternal Light. His swarthy brother Ahriman is, naturally, a god of darkness and misfortune; to be avoided at all costs. The faith in and of itself is neither particularly complex nor revolutionary in its assertions; but what's interesting is that a heretical sect of Zoroastrianism, known as Zurvanism, came to dismiss the religion's two brothers as inconsequential and took up their mythical father as an object of worship. The father deity, Zurvan, was said to have encompassed the characteristics of *both* sons, at one and the same time. The Zurvanites never gained a wide following, heretical as they were, but nonetheless their religion is noteworthy in that it illustrates that as recently as the 6th Century people were still pursuing a creed which promoted the confluence of good and evil.

Far more well known today is the cult of Abraxas, a Gnostic deity popular in 2^{nd} Century Alexandria. Abraxas was represented as having the head of a rooster, which symbolized the dawn (as roosters do), as well as enlightenment in general. The deity's legs were depicted as serpents, which denoted darkness and the underworld. Abraxas' head and legs were attached to the torso of a man, symbolizing the concept that light and darkness coexisted within the soul of man. Abraxas is undoubtedly the most profound historical reemergence of the more ancient *eiwaz* archetype. So much so, that the renowned psychologist Carl G. Jung called Abraxas the *ultimate* archetype. In fact, one of Jung's first published works, *The Seven Sermons Of The Dead*, was all but entirely concerned with the subject of Abraxas. In the absence of the original ancient source material (destroyed in the fires at The Library Of Alexandria), *The Seven Sermons Of The Dead* is an excellent introduction to the concept of Abraxas. In it, Jung describes Abraxas thusly:

> "Abraxas is the sun and at the same time, the eternally sucking gorge of the void...
> What the Sun-god speaketh is life, what the Devil speaketh is death, but Abraxas
> speaketh that hallowed and accursed word which is life and death at the same time.
> Abraxas begetteth truth and lying, good and evil, light and darkness; in the same
> word and in the same act... It is the abundance which seeketh union with emptiness.
> It is love and love's murder. It is the saint and his betrayer. It is the brightest light
> of day and the darkest night of madness... It is the delight of the Earth, the cruelty
> of the Heavens. Before it, there is no question and no reply."

In short, Abraxas is the god of balance and integration, *par excellence*. A deity that encompasses polar dualities, yet exists apart from them. Abraxas entails the qualities and forces commonly understood as good and evil, yet exists *beyond* and above their scope, rendering the popular definitions of the words as altogether inaccurate. However, "beyond" is perhaps insufficient in describing Abraxas' relationship to good and evil – more accurately, Abraxas could be explained as existing at a more fundamental level than good and evil. The common Nietzschean interpretation of "beyond good and evil" is a kind of indolent amorality, whereby certain "higher types" of individuals are considered to be exempt from conventional moral codes. The Abraxian conception of the notion constitutes a thoroughgoing reinterpretation of such terms at the most elemental level.

The Abraxian understanding of the terms "good" and "evil" reflects the essentially physiologic perspective that the rules and codes concocted by man to regulate the thought and behavior of human communities are superceded by a set of laws far more substantive in nature. The primordial creative-destructive force which shapes and regulates all life on earth cannot be grasped in its totality in the context of simple black-and-white concepts like good and evil. Only the laws of nature provide a suitable context in which to come to terms with this force; and coming to terms with natural law necessitates abandoning entirely such commonplace ideas as good and evil, since the natural world operates beyond the confines of man's conventional morality.

Roughly a century ago, the theory of Social Darwinism proposed that a true understanding of natural law would render conventional morality obsolete, and that a new form of evolutionary ethics would emerge to take its place. Pragmatically speaking, on a grand scale this seems highly unlikely, as very few are ready, willing or indeed able to come to terms with natural law. But what is unlikely on a broad level, is inevitable on a personal level for those fated to order their lives according to this primordial force. The all-pervasive, creative-destructive force of natural law can only be understood in terms of Abraxas because, in essence, it *is* Abraxas. It is the ancient concept latent in the *eiwaz* rune, embodied in an all-encompassing deity. It is nature, God and the Devil, all rolled into one. Abraxas is the oneness that encompasses everything, and in so doing resolves those conflicts which have long plagued man and which have spiraled out of control for so long as to have all but reached a point of critical mass.

There exists a longstanding rift in the soul and psyche of man which has grown ever increasingly wider, until finally all those facets of his personality that were once in alignment with one another and complemented each other (such as his instinct and intellect) are now in diametric opposition. This is the perennial dilemma of modern man.

Man obeys his natural, primal instincts, and in so doing commits sin. Man follows his intellect, employing logic and reason to further his aims, and yet in doing so denies and betrays his most primal, basic desires. Man follows his anger and wages war; the purpose and cause of which he is often at pains to understand, though both originate in he himself. Man follows his conscience, and in so doing betrays his innate and primal self, degenerating and devolving in the process. It's as though an unseen pendulum swings back and forth within the soul of man, triggering first one manner of behavior, then another, never allowing him any sort of resolution. Thus, for centuries, man has stood divided against himself; at war internally.

This war – this unresolved stasis – has erected a barrier between man and himself. A barrier between man and his world. And this inner schism has been magnified and exacerbated by the civilizing effects of the modern world; most especially so by its disjointed religious creeds which simultaneously posit that "all is one," yet assert that man should strive to deny himself a full half of that totality. This division – this barrier in man – has resulted in his thoroughly stunted and self-destructive nature, a nature which manifests itself in behavior that could politely be called "schizophrenic." A behavior which has increasingly become the defining character of the modern world – and has proven a constant stumbling block to human evolution. The conflict between the opposing forces of man's personality – and the erratic behavior that has arisen as a natural byproduct of it – have defined the entire history of mankind, but more especially that of the modern world. The casualties of this war are man's shattered soul and a world created in its image.

The only way to eradicate this barrier is to bridge the gap in man's divided nature; to bring the warring components of his being back into alignment with one another. To accomplish this, one must understand the conflict between the instinct and the intellect, by first recognizing them as manifestations of two equally strong elements of man's innate character. Man's instincts link him still to the beast from which he evolved. They link him to the barbarism of his ancient (and not so ancient) forebears; a barbarism that although not always visible in his actions, lives in him yet. Man's intellect gives him the power to order and regulate his world, but it also imbues him with the conceit that he is more than a mere animal somehow; that he exists apart from the rest of the animal kingdom, and above the natural world. This is the aspect of man that allows him to delude himself into accepting the ridiculous notion that he alone is the measure of all things; that he is the center of the universe. It is the aspect of man that makes him want to play God. And in a Promethean sense man *is* God, since it is he and he alone who has created everything in the world (even the deities he's seen fit to worship), save for nature and the world itself. On an even more primary level, however, man is – and always has been – a beast.

Man is a god. Man is a beast. The god in man creates civilizations and desires peace. The beast in man destroys civilizations and desires war. This fundamental contradiction has plagued mankind for millennia. These two aspects of his personality have waged war with one another throughout recorded history. A war whose casualties are seen everywhere and recognized nowhere. But there exists, however, a long forgotten place in the soul where god and beast intersect. To go to that place is to witness the death of one world and the birth of another. A once and future king awaits those who venture there, and the journey makes ready his resurrection. It begins when one decides it begins, and ends when the god and beast that reside within one's own soul can once again rule, side by side, on twin thrones.

Monism
From Hermes to Haeckel & Beyond

(Excerpt from *Physiosophy*, previously unpublished, 1996)

In the 6th Century B.C.E., Greek pre-Socratic philosopher Heraclitus perceived God as a union of opposites, a manifestation of *mutual adjustment* that resulted in harmony. A philosophy known as "Monism." But Heraclitus' concept of harmony was based on the counter-balance of discordant forces; warring opposites. He is, after all, famous for stating that, "War is universal and harmony is strife." It was his opinion that, "God is day, night, winter, summer, war, peace, surfeit, famine..." For him, God was discordant concord, concordant discord.

The Monist doctrine of Heraclitus was perhaps the most cogent summation of non-dualism in the history of philosophy, rooted thoroughly in the material world and readily comprehensible. The Monist materialists who followed in his wake sought to embellish the basic truths he posited, and in so doing, tainted the straightforward simplicity of his premise.

The Monism of the East was a primarily spiritual movement, while Greek Monistic philosophy was a refutation of such abstract spiritualism. Each used a terminology that was nothing if not stunning in how precisely similar to the *other* it managed to be. Both divided the world into categories of being (that which *is*) and not-being (that which is but illusion). There, however, the similarity ended. Eastern Monists could use their definition to demonstrate that even death was illusory, that the killer who imagines he has murdered is just as confused as the murdered man who imagines he has been killed. Never mind that the dead man is no longer possessed of a consciousness with which to ponder the status of his nonexistence, this is the sort of retreat into abstract hogwash that has always made philosophy the refuge of intellectual hair-splitters, rather than a functional tool to provide man with a viable schematic which can put the forces operating around him into some sort of logical perspective. There is no doubt that much can be gleaned from the Eastern variety of Monism, and it is indeed fascinating; but I mention it here only to demonstrate the divergent outcomes resulting from the same basic premise of non-dualism.

Monism experienced a resurgence of popularity in the West toward the latter part of the 19th Century, when the Deutche Monistenbund became one of the most powerful and influential organizations in Germany. Its founder, Ernst Haeckel was a renowned zoologist and Social Darwinist who authored numerous best-selling books blending emerging biological theories and social philosophy. Under Haeckel, Monism evolved into a Pagan nature-religion, in which God lived in (and through) *all* of life and the natural world, as well as the soul of man. Though imbued with a heavy dose of Germanic mysticism, Haeckel's Monism was essentially a modern, more refined version of that postulated by Heraclitus. As a Social Darwinist, Haeckel could no doubt concur wholeheartedly with Heraclitus' dictum that "War is universal and justice is strife." And Heraclitus would no doubt echo Haeckel's conclusion that, *"Alles ist natur, natur ist alles!"* ("All is nature, nature is all!").

Perhaps unsurprisingly, a huge fan of Haeckel's philosophy was none other than Carl Gustav Jung (student of Gnosticism and one of the fathers of modern psychology). Both Jung and Haeckel were passionate about restoring the West to the equilibrium that centuries of Christianity had left devastated. For Jung, Christianity was "one-sided," for Haeckel it was anti-life. It not only resulted in "a sickly aversion to nature," but brought "death to freedom of mental life, decay to science, [and a] corruption of all morality." Christianity belonged, Haeckel concluded, "to a period of human degeneracy that is long since past but whose ideas still rule today, although they are clearly antagonistic to life." Man could only advance (or if you like, *evolve*), he felt, after recognizing that he was "not *above* nature, but *in* nature," and that, "civilization and the life of nations are governed by the same laws as prevail throughout nature and organic life."

In accordance with their exaltation of nature (and renunciation of Christianity) the Monists announced that, "Heaven and Hell are fallen," and called for a new form of *evolutionary ethics*, insisting that, "objective good and evil in nature are nowhere to be found." Monism ceased to be a mere philosophy, mutating instead into an *evolutionary religion* in which all was one, God was synonymous with nature, and man could feel the pulse of both resonate within his soul. If all was one,

and man was synonymous with nature – and nature synonymous with God – then it followed that *man* was synonymous with God as well. What had started-off as a philosophy based on the laws of the organic world had evolved into a very potent form of mysticism.

This might all sound very "new age," were it not for the logic which arose as a natural byproduct of devotion to Darwinian Law, and the dispensing with mores considered obsolete within the context of the natural world. Not only was Christianity considered an anti-life doctrine by the Monists, but so too was liberal Democracy, since it lead to, "the submission of quality by quantity, the best by the majority, the fit... by the unfit..." and so on. "Brutal reality has awakened us," declared the Monists, "from the pretty dreams of good, free, equal and happy people." It also awakened them to such truths as, "diversity stands higher than equality," and the acknowledgment that man is at times, "a predator." If it seems strange that a sect promoting the ideal of a transcendent cosmic unity should embrace a worldview so harsh as to border on the Fascistic, it ought not. After all, nature itself is a vast hierarchy of living creatures whose totality comprises an organic whole, and the laws which govern *it* are far harsher than those concocted by man to regulate his behavior.

Editor's Note:

This is a fragment from a lengthier essay, the remainder of which has been lost.

Power, Nature, God & Man

(Excerpt from *Physiosophy*, previously unpublished, 1996)

The essence of life is not to be found within the context of any existing religious doctrine, philosophy, or political system. In all the annals of human history one cannot find even so much as a single example of any dominant paradigm that reflects, in its essence, the true character of life or nature's laws. I defy anyone to locate one that even comes close. There aren't any. Is it any wonder then that the history of man reads like one long, protracted fall from grace? Man, no doubt, instinctually understood more of life's essence before he even began to *try* to comprehend it; and his intellectual attempts at doing so have only served to distance him from that once inborn knowledge.

Paradigmatic belief systems not rooted in tangible reality are, by their very nature, false constructs and antithetical to life. Such models of thought and belief are naturally cursed, and carry the seeds of not only their own destruction, but of all those who pay them allegiance. The only paradigm rooted in reality is that which both defines and constitutes the physical universe of which man himself is a part: the natural world. Nature is the only model which exists separate and distinct from the ideas and beliefs constructed over millennia by man; ideas and beliefs that have been the sole agent of his estrangement from, and opposition to, the forces which shape and govern life.

Religious, philosophical and ideological abstractions and idealisms are not functional tools for understanding and adapting to the laws that govern the primary world; in fact, they constitute the fundamental roadblock to such goals. By far the most longstanding abstractions clung to by man have been his notions of God. Traditionally, man's gods have not been gods at all, in any real sense. They have been human constructs, created by man in his own image, and in the image of his own misunderstanding. They have, at best, been attempts to understand what God *is*... attempts which have failed miserably.

What is most noteworthy about man's various attempts at understanding God, is not to what degree they have either succeeded or missed the mark, but rather what they reveal about the soul of man. All these attempts, however misguided or ill-conceived, pay tribute to an instinctual yearning that springs from the deepest recesses of the being of man. They are a testament to the fact that he is possessed of an overwhelming desire to experience God. To know, understand and be at one with the all-pervasive power that shapes and organizes the cosmos; this is the desire, the necessity, which dwells in the soul of man and motivates his search for God. That man has failed to ever achieve his aims reflects poorly only on the means he has chosen, and in no way diminishes the reality of the need which compels his quest.

In view of the fact that religion has, in the modern era, become synonymous with superstition, many might question whether or not the concept of God has become so debased that it is no longer any more than an empty term, stripped of any tangible meaning. Intellectually this may be so, but instinctively and at the most primary level, man understands it still. Man's past mistakes have arisen from *looking for* God rather than *recognizing* God. They've arisen from his inventing the attributes of God, rather than simply acknowledging them. Because man has visualized God as an anthropomorphic being, enthroned in a distant Heaven, he has failed to consider that God might exist as a palpable, all-encompassing force; a force that pervades all of life, death, nature and the universe.

There was never a need to invent God, for God is the fundamental reality of life on earth. A reality once perceived in the long distant past, but long since forgotten. Ironically, it was man's God-consciousness that put him at odds with the world of nature, the very realm in which, had he not been so thoroughly estranged from it, he may have found the full measure of what he was seeking: God as living entity of which man himself is a part. God as an *impersonal force*, not a personal savior.

Man's relationship to God is determined by the degree to which he understands God as an impersonal force, and consequently to the extent to which he is aligned with that force. It is determined by the degree to which he either adapts, or does not adapt to that force. There is no moral or spiritual evolution, only differing degrees of awareness, alignment and adaptation. To understand this, to come to terms with it, to *embrace* it, is to walk in the path of God.

Attributes Of God

(Excerpt from *Physiosophy*, previously unpublished, 1996)

God is power. Power can be creative *or* destructive, positive *or* negative, good *or* evil. So too can God, because God in essence *is* power; that power which is the force-motive behind the workings of all life on earth. What constitutes that power to each individual (or creature) differs from one to another, and their ability to harness it exists within certain strictly defined parameters. But within that context there always exists the potential to maximize one's power. The more power an individual possesses, the closer they are to God. Not worldly power expressed as mere control per se; but the soul-oriented power that increases in direct proportion to the interface between inner truth and outer truths.

God is nature. Nature is not an amalgam of isolated life forms each existing separate and distinct from one another. Nature is an organic whole, a superorganism whose only laws are the eternal laws of God, and whose totality constitutes God. God is not a spirit, nor a mere abstract concept. God is a manifestation of power at its most fundamental level, a power which pervades all life and all creation. God lives in and through the forces that govern every aspect of the physical world. God is power in its being, its form and its function.

God is order. Not just any order and certainly not some form of order arrived at arbitrarily (or mistakenly) by man, but the hierarchical inter-connectedness of the natural world; from the laws of physics and gravity, to the laws of natural selection. The order inherent in nature is a pattern repeated endlessly, from the smallest circle of life up to the largest and most all-encompassing circle of life. The same lifecycle that applies to the smallest plant applies with equal precision to the life of man and the lives of civilizations. Each follows the cyclical patterns of becoming, flourishing, decline and eventual death that is the destiny of every life form (except, of course, those for which death comes sooner due to some intervention in the process). The same law that applied to living things a million years ago still applies today, and still shall tomorrow and as long as life continues.

God is war, and even in the midst of peace there is war. The ongoing struggle for existence is an undeclared war which never abates. It wages incessantly at every level of the organic world, even in times of seeming peace – even the state of peace is yet another face of war, since peace invariably leads to stagnation, entropy and death, all of which are part of the life process, and likewise all a directed byproduct of the war which precipitated the peace.

God is antagonism, the antagonism that creates a balance between forces in conflict. And this antagonism is harmony. Within the context of the eternal, the only constant is change. One might as well accept the notion of constant change, because it will never abate or go away. Change necessitates adaptation, which in turn creates the precondition for further change, and so it goes. The primal laws which govern all life are immutable, but within their framework, all else is in a state of constant flux, be it evolutionary or devolutionary.

God is compulsion. The concept of so-called "free will," is pure hubris. Men are compelled to action or inaction by factors and forces over which they have no control. Overt aggression or pacifism, selfishness or altruism; these are usually considered the product of a conscious choice on the part of the individuals who display such characteristics. But have such individuals in fact *decided* to behave in these ways, or are their actions rather the inevitable outcome of their innate character? Can anyone really *choose* whether or not they are instinctual or contemplative, driven or complacent, productive or unproductive, civilized or sociopathic? Of course not. Men can no more choose the nature of their own character than they can decide whether to be interesting or boring. All men are slaves to their own inner character, and within the context of that slavery, the only decisions over which they can exercise full control are the most thoroughly trivial, if even that.

God lives in and through inequality. Given that inequality is the basis of the self-regulating balance that orders life on earth, it must be recognized as the engine of survival. Understating inequality is important because it's the fundamental condition of life on earth. One can't come to any sort of conclusions as to one's own place in the universe before first grasping precisely how pivotal a role inequality plays in absolutely everything. There can be no real understanding of history, humanity, the natural world, or the hierarchical nature of things, unless one first comes to grips with this single,

simple concept. Belief in the idealistic superstition of equality puts people on the path of ignorance and confusion. Acceptance of life's primary inequality puts people on the path toward wisdom and understanding.

God is hierarchy, the natural byproduct of inequality; an ordering of the universe based on differing levels of innate attributes, both physical and mental. Within the context of hierarchy, the dichotomy of superiority and inferiority is revealed to be a meaningless abstraction, since each individual is deemed to be occupying the place ordained for them by nature, and thus judging individuals by any subjective, absolute standard would be both illogical and inappropriate.

God is balance; the mechanism by which all life was set into motion, and by which all life is maintained. From negative ions and positive ions, to creative force and destructive force, all of life evolved from the interplay of elemental counterbalanced forces. This balance is the pivotal point around which all of life is ordered.

God is all, and all is one. This is a thesis reiterated down the ages (even by those incapable of grasping it in its totality or applying it to the working of life), and it is also an actuality, demonstrable in the operation of the natural world. The chain of being is an interdependent, hierarchical superorganism that constitutes all, and whose totality is one.

God is the Eternal. All those things which exist separate and distinct from the will of man, governing all that defines him and impervious to his influence.

My New Roommate

(Originally published in *Rollerderby*, 1996)

The apartment I live in, in Denver, had at one time been a girls' school attended by Mamie Eisenhower, Buffalo Bill's daughter and wealthy young girls from all over the country. When I moved in, people said, "You know that building's haunted, don't you? A couple of young girls hanged themselves on the premises." The people who said that to me had known people who had lived in the building and had odd experiences – felt areas of cold air – things like that. I didn't pay much attention to it, because I was never a believer in life after death.

For the first three years I lived here, nothing out of the ordinary happened. Then one evening I was sitting in my room reading when something caught my eye. I looked up, and there was a little girl standing in the corner of my room. She was maybe 12, but it was hard to tell because her hair was odd. And her clothing was odd – she was wearing a sort of nightshirt. She could be 16 or 17 , I just don't know. I began to formulate the words in my mouth to ask, "Who are you? How did you get in my house?" As my lips moved to form the words, she vanished as I was looking at her. I thought, "That was really weird. It must be my imagination."

Nothing else happened until Lisa [Carver] moved in with me. I was sitting in the back bedroom one evening watching television and thought I saw Lisa in a nightgown walk past the door. And I thought, "Where did she come from? There's nothing there. There's only the boarded-over stairwell." I got up and found Lisa, who was in front of her computer in her office, and asked her if she just walked by. She said, "No, I've been here for an hour." Again I convinced myself it must have been my mind playing tricks on me.

The next time, I was lying on the bed in the back bedroom and I didn't have any clothes on, and I felt a pinch on my butt. I thought it was Lisa and I turned around to look, and saw that there was nobody in the room. I got up and again Lisa was in front of her computer, and again I thought, "Hmm. That was strange."

After Lisa moved out, I was going through some wild emotions, and a lot of these experiences happened right in a row. I was lying in my room, trying to go to sleep, and there was that girl standing at the head of the bed, looking down at me. I sprang-up out of bed, and she wasn't there. I thought maybe I wasn't actually awake and that it was just a weird little dream.

Another time, I was in bed asleep and I felt hands on me, pushing and shaking me, and I could hear a voice saying, "C'mon, c'mon, c'mon." Frankly, I was terrified. I could barely speak, but I said, "Who are you?" I could clearly hear a voice say, "It's Nola." A chill went up my spine. I was wide awake and scared, and I thought, "Okay, *that* was real. That was not an hallucination. This is something that I experienced. If that happened, then all the other times happened too."

I've always trusted my instincts and intuition, and the judgment of my senses. If I trust my senses so implicitly in every other case, why can't I trust them in these cases that don't seem probable? So I decided there was definitely the ghost of a little girl named Nola living in the apartment with me. I called up some girls I knew who did Ouija board and asked them to have a séance in my house to contact Nola, and I went to do research in the library to see if Nola was one of the girls who died by suicide. These things I will do when I'm back into the country. [This text was written and published while Rice was in Australia filming *Pearls Before Swine*.]

The majority of the sightings occurred in my bedroom. Something I've always noticed about that room is there seems to be an intensely high electricity in the air that I don't see in the other rooms. When you move the bedspread, there are sparks. When I pet the cat in that room, I can see a wave of sparks in her fur.

I felt a little weird being alone in this big, huge, quiet place, feeling that there was a little girl in here. A few days after Nola told me her name, I was in the back room thinking about her when a picture that had been hanging calmly for a year literally flew off the wall and landed at my feet. I was several feet away from the wall. It was a picture of Lisa in an angora sweater.

I haven't gone off the deep end, getting books about earthbound spirits or anything. In fact, I've only told two people about this, and I really thought long and hard on whether I should tell anybody; but it was a very real experience, so I figured, "Why not tell it?" And so I have.

I'll Call You Abraxas
Conversations With Charles Manson

(Previously unpublished, 1997)

It was 1987 and I was on my way to see Charles Manson for the first time ever. From San Francisco I'd crossed over the Bay Bridge and headed north, through Mill Valley, when I came over a hill and caught a glimpse of San Quentin Prison, situated on the other side of a vast bay. I suddenly remembered a prediction that someone had made not long before: that I would soon meet a very powerful man who lived on the other side of a large body of water...

A few days earlier I'd found a Tarot card lying face-down in the gutter as I was waiting for the light to change, while crossing an intersection in downtown San Francisco. The card was submerged in a puddle of water, but for whatever reason I dried it off and carried it home with me. That evening, a girl who'd come to interview me for a music magazine spotted it in my apartment and, being a Tarot expert, gave me a rather detailed interpretation as to the significance of the fact that I'd found this particular card. While doing so she held the card to her forehead and closed her eyes, telling me that I would soon meet a man who was physically small in stature but very powerful and wise; and that she also saw a fortress, or castle involved in the encounter. I'd always viewed Tarot cards as being fascinating, but found it hard to take such things seriously, so I dismissed the girl's prediction and didn't think of it again until San Quentin loomed into view just a few days later. It certainly looked like some sort of science-fiction fortress or castle. Was Charles Manson the small, powerful man across the water? As the magic 8-ball says: signs pointed to "yes"...

I'd initially written to Manson with an offer to get his music released and distributed, after some of the guys from the band Black Flag had reneged on a similar deal they'd made with him. To my surprise, I got a response from him almost immediately and could hardly believe it when I saw the name "Charles Manson" on the return address of the letter in my mailbox. At the time, Manson's *LIE* album was my favorite record, and for as long as I could remember I'd read everything I could about the guy. In my late teens I'd spent countless hours soaking up the vibes at the Spahn Ranch, The Manson Family's compound in Southern California. I'd taken friends of mine from bands like Monitor and Throbbing Gristle out to visit the ranch, and there discussed at length the subjects of Manson, The Family and how it all went wrong. I even lived there for a time. Needless to say, Charles Manson – or at least the mythos surrounding him – had impacted my life, and thus I was mildly thrilled at receiving a personal letter from him.

Following our initial contact regarding his music, Manson and I soon began a correspondence, and after some time spent in getting acquainted as pen-pals, he eventually wrote saying that I seemed like a good guy and that I should come over and visit him at San Quentin sometime. Of course I was *more* than interested in the possibility of finally meeting the man, face-to-face.

Shortly after receiving Manson's written invitation, I made the short drive up to San Quentin and filled out the forms required to get on his list of official visitors. The guards there basically laughed at me as I filled out the forms, and gave me the impression that my chances of getting approved for visiting Charles Manson were about as good as a snowball's chance in Hell. Nonetheless, a month or so later I received a letter from Manson informing me that I had indeed been approved, and that I ought to come on over sometime. Now, after years of interest in the man, I actually stood at the threshold of meeting Charles Manson, in the flesh. As excited as I was at this prospect, I couldn't help but wonder, "Would he live up to his PR?" The answer was forthcoming...

Sitting on the edge of Point Quentin, looming over Mill Valley's sizeable bay, San Quentin looks like the sort of place Ming the Merciless might call headquarters in an old *Flash Gordon* serial. It has a futuristic aesthetic to it, in a 1930's science-fiction sort of way. To get inside the high security prison, one must pass through an incredibly thorough system of checkpoints; an unnerving experience to someone as anxious as I was on my first visit. At the first security checkpoint, I had to sign a visitor's list and present my identification, then be patted-down, gone-over with metal detectors – the works. Once past this first checkpoint, there was then a near-endless sidewalk that eventually ended at a

second checkpoint. Here I was required to present my identification again, sign-in again, submit to another search and then finally pass through a gate and into the building proper. Once inside the building I then entered a tiny room in which I was asked to pass my identification, *yet again*, to a man behind thick bullet-proof glass. After inspecting it, he passed it back to me and I was buzzed through a heavy metal door and into the visiting area. Once inside, I had to show my paperwork to yet another guard, who, after inspecting it, finally directed me to where I was to sit in the visitation room. The visitation room was long and narrow, and filled with convicts and their visitors, all seated around tables. There were vending machines with coffee, cigarettes, candies and snacks, and toward one end of the room was an elevated console where two guards could keep a watchful eye on everyone inside. Just beyond this was a roped-off area for high risk, top-security prisoners. It was in this roped-off section that I was instructed to wait for Manson. So there I finally was; waiting for the appearance of the notorious Charles Manson, deep within San Quentin prison.

After what seemed like an eternity, a huge metal door swung-open and a guard ushered Manson in, then removed his handcuffs. At first Manson seems perplexed upon entering the room, gazing around as if he wasn't sure why he was there – but then his eyes fixed on me, he smiled and said, "You must be Rice." Following this he approached the table I was seated at and shook my hand, saying it was good to finally meet me. He sat down across from me and the two of us began the first of what would become many lengthy conversations.

At first glance, Charles Manson seemed diminutive and altogether unimpressive; but then he started talking and all of that instantly changed. "First off," he said, "let's get one thing straight: there's only *one* person at this table. I'm here lookin' at you and you may be there lookin' back at me, but there's *only* one person here – one thought, one mind." He held up a single finger to emphasize the point. I thought to myself, "This is perfect. I've only met Manson a few seconds ago and he's already giving me his I-am-you-and-you-are-me rap." He then asked me if I could do him a favor and buy him a cup of coffee and a pack of Pall Mall cigarettes. "Sure thing." I came back with the smokes and two paper cups of coffee. The cups had several playing cards printed on the sides and each cup was different. Manson tells me that the bottom of the cups also bear the image of another card – the card that completes the poker-hand on the cup's side. He then says, "Let me see if I can guess what's on the bottom of *your* cup. Uh, let's see... is it the King of Spades?" I hoisted the cup up into the air to glance underneath and sure enough, it was the King of Spades. How the hell did he know? If the cups were all identical in their card-combinations, a serious coffee drinker could probably memorize each combination after a while, but it seemed to me that the very process of constructing the cups would, by necessity, make the joining of each particular bottom to each side-panel a random process, without rhyme or reason. So Manson's correct identification of the card on the bottom of my cup was unlikely an act of applied memorization, but either a lucky guess or something else entirely. Another odd thing about this scenario was that, in retrospect, I'm now aware (I wasn't then) that the King of Spades is the common playing card that correlates to the Tarot card I'd found in the street, The King of Swords. The King of Swords is supposed to represent law, power, strength and authority, as well as one who holds the power of life and death. It's also supposed to represent a man with powerful thoughts, a man with dark hair and dark eyes.

That day Manson told me that everything he ever knew he'd learned from old men in prison. He explained that if you spent enough time locked in a room with someone – almost anyone – eventually you'd come to know about their entire life. You learn all their secrets and absorb their knowledge. He'd spent his entire life behind bars, and in so doing, he claimed that he'd soaked up the lives of hundreds of criminals. Indeed, Manson seemed to have gathered more knowledge by his thirties than most people accumulate in a lifetime. He contended that this was because all this knowledge had been passed on to him by people who had accrued experiences, not only of their own lifetimes, but also those of an earlier generation of old men who had once tutored them. "And now I'm an old man," he told me, "it's my turn to pass this knowledge on to you, to do whatever you want with. I'm sure I'm not going to tell you anything you don't already basically know, or anything you wouldn't come to on your own, sooner or later, but maybe I can make the trip to your final destination faster."

Manson and I talked for hours that day and he told me stories that have never appeared in any of the various books about him. In fact, one could easily write an entire book based around the

tales of even a single visit with Charles Manson, so numerous and varied were his anecdotes. I'd gone to visit him early in the morning and we'd talked all day, until visiting hours were over. The parking lot had been packed when I'd arrived in the morning and it was nearly empty when I finally left the prison that evening. Despite the literal *hours* we'd spent talking, there were still so many more things I wanted to ask him and talk to him about. Before I left that day, he told me to come back whenever I wanted, saying, "If you wanna' come every single day and stay all day, you can." As I drove back across the Bay Bridge, toward San Francisco, my head spun as I recollected all the details of our meeting. It would be the first of many...

A lot of the things Manson had imparted to me were very straightforward sort-of rules that seemed related to jailhouse protocol and basic survival tactics. Others were fundamental psychological truths that he seemed to take to a much further extreme than most people; things relating to human nature, a topic on which he seemed to be an expert. In fact, he seemed to be an expert on many things, as I would eventually come to learn. Every point of reference I mentioned, he could speak of at length. He knew about ancient history and current history, and the forces that shaped both. He seemed to possess a comprehensive overview of the history of the whole world; not just the events as they're presented, but of all the unseen factors that preceded and resulted from those events. It was all very organic and logical, and he would always somehow factor in the human element; how people behave a certain way in a given circumstance and *why* they behave that way.

Although Manson's judgment of humanity was often cold, harsh and pragmatic in the extreme, at times it was hard to reconcile his "no bullshit" judgments concerning human nature with his own famously flawed track record regarding it. As I listened to him relate innumerable truisms about humanity, I couldn't help but wonder how someone who knows so much in that regard could have exercised such execrable judgment in his own past. It was also difficult to reconcile his sense of bottom-line realism with what seemed an equally predominant disregard for realism. I quickly came to learn that he was just as paradoxical as he was insightful.

For instance, Manson once told me that as soon as he got out of San Quentin, he and I could steal a helicopter and go visit the Ayatollah Khomeini, Iran's spiritual leader at the time. Now, as a realist I knew that Manson *wasn't* getting out of San Quentin (it's hard enough just to get in) and that flying to Iran in a helicopter was logistically impossible; but nonetheless, the very idea of it was so exciting to me, and he spoke of it with such absolute conviction, that the realities involved seemed unimportant. This, to me, seems almost emblematic of Charles Manson; that he's a unique balance of brilliance and self-delusion, and that the two blur together so much in his world that one often finds it difficult to distinguish where the reality ends and the fantasy begins. Of course even if most people *could* tell which was which, they probably wouldn't care (as I didn't), because ultimately both are equally entertaining.

When Manson was brilliant, he was so brilliant that it seemed to lend a credibility to the things he expressed, such that if anyone else had said them you'd dismiss them out of hand; but not when *he* said them. You definitely never get a sense of this facet of his personality when seeing him on camera. His filmed interviews, even the best of them, don't do him justice. They don't convey his essence. Moreover, the intensity of his voice doesn't come across on recordings. In person, Manson's voice is like none I've ever heard; it seems to have three octaves at once. It's very high and nasal yet has a very deep frequency as well, and a kind of mid-range in which the others blend. He once explained to me that his voice evolved that way through years and years of yelling in prison, saying that, "In the desert, the loudest donkey gets the most female donkeys and in jail the loudest person has the final word." So being that he'd basically spent his entire life in prison, he'd also spent his whole life *yelling*, just to stay on top.

Of all the stories Charles Manson told me during my first visit to San Quentin, the one I remember most vividly was his tale of training a cockroach in his cell. As it goes, he'd spotted a cockroach one day, coming out onto his sink from a crack in the wall. He'd clicked his fingernail on the sink, and the cockroach looked at him and started in his direction. He then put a crumb of food on the sink and continued to click his fingernail next to it. The bug came right over and ate the crumb while he was sitting right there next to it. Manson talked to it as he sat, and the cockroach looked back, as if listening. The next day, when Manson saw the creature's antennae appearing out of the crack, he repeated the process. Again the cockroach came right over. Eventually Manson was able to

get the bug to walk right up onto his finger and sit there. A month or so later, a guard stopped to peer into the cell, "Oh," said Manson, "I've got something important to tell you." "What's that?" asked the guard. Manson turned and clicked his nail on the sink. Responding to the sound, the roach appeared in a few seconds, walked directly to Manson and crawled up his finger. Manson held his finger out saying, "See this guy here? This fella's a good partner of mine. So if you see him around here someplace, *don't fuck with him!*"

Around the same time I was visiting Manson, I came across a story in the newspaper about a talking parrot that had gotten out of a house near San Quentin and had flown into the prison. After weeks of searching by the staff, the bird was finally located within the prison's walls and returned to its owners. When they got the bird home they found it had learned a new phrase; its new mantra was, "I can talk, so why can't you fly?" This is *exactly* the sort of thing I could imagine Manson doing; hiding a bird in his cell, teaching it an absurd phrase, then turning it loose again. Upon hearing his cockroach-training tail, I related the talking parrot story to Manson, who found it funny, but made no indication that it was his doing. I also asked him about a weird tale printed in *The National Enquirer*, about a guard who was afraid to venture near his cell because he'd heard screams coming from inside, as well as Manson pleading to be left alone. According to the story, the ghost of Sharon Tate would regularly appear in Manson's cell to torment him. I'd assumed it was just a prank Manson was playing to keep a superstitious guard as far as possible from his cell, and thereby insure his privacy. But when I asked him about it, however, he became very somber, quiet and serious, saying, "Yeah. That's true... I seen her a number of times in here."

On my second visit to San Quentin the guards remembered me and began to inquire as to why I was visiting Charles Manson, of all people. I tried to explain my motivations as best I could – that I found him both fascinating and amusing, and that I felt I could learn a thing or two from him – but they didn't understand. One motioned towards me and said that I was obviously a smart guy and that people who ended up in San Quentin did so because they *weren't* smart, they were losers. In retort I offered the observation that there was a class of people who, in ancient times, had a place in society as warriors – they would have been centurions, or gladiators, or soldiers – but that in the modern world this class didn't have the same outlets. If this class of person could cooperate with the modern world they might end up as cops or GIs, but if they couldn't, they'd probably end up as criminals; but regardless, there was something one could definitely learn from this rare class of people (and I believed Manson to be one of them). The guard smiled, nodded in agreement and said that I made a good point. "But the thing with the guys in there," he said, motioning toward the prison, "is that 99 out of 100 of them wouldn't understand the point you just made, much less be able to put together that kind of thought themselves." I assured him that Charles Manson certainly could, and that was what interested me in him; that I could discuss things with him that I couldn't with most other people. This the guard seemed to understand, and we left it at that.

The prison's second checkpoint was being guarded this time by an obvious lesbian who'd gone over me with the metal detector on my first visit. Her face sort of lit-up when she saw me approaching. "Coming to visit Charlie?" she queried. Before I could answer, she told me she loved the hat I was wearing and asked where I got it. It was a West German army cap, based on a design originally used by the Nazis. I told her I'd gotten it at a gun show. She asked if she could try it on and I handed it to her. She slipped it on and smiled broadly. Then she leaned toward me conspiratorially and, glancing around, told me in a hushed voice that she'd just scored a Nazi motorcycle helmet for four dollars at a garage sale, and it was in mint condition. "You know the one," she said, "all leather with the eagle and Swastika on the front." The find had made her year. Imagine that: a lesbian Nazi prison guard! It's like something out of a 1950s men's adventure magazine. This woman who had been so officious and aloof just last week, began to gush with enthusiasm, sharing private thoughts with me that her coworkers probably had no clue about. We chatted for a while, falling silent when other guards reached the checkpoint and resuming our talk after they'd left. As I went in to see Manson she called out after me, "have a nice time." *A nice time?!*

The cap was also the first thing that Manson commented on. "Wow, Rice! I love your hat. Can I try it on?" He grinned a huge grin as he put it on, then stood at attention and gave the Fascist salute, still smiling. He said, almost hintingly, that he'd really like to have a hat like it. I offered to get him one but he said it was no use, they wouldn't allow him to have it. "I can't have anything in here," he

grumbled. "If I wanted a cardboard box fulla' turds they wouldn't let me to have it." He complained about how they'd taken away his guitar and how much he missed it because music was his very life. It was a big part of mine as well, and so, we talked about music at length. "It has the power to transform the soul," he said, "but most music these days is only fit for the soul of a 12 year-old girl." I told him that I was still anxious to release his music and have it distributed, because that's where I felt his thought was communicated most directly; not in books or interviews, but in his recordings. I felt that when people had the chance to hear his music, then they would begin to understand him.

"People?" he shouted, "Understand?! People don't understand a fucking thing. They have less awareness than turds. If this table were the world, and it was covered with turds representing humans, and you exercised complete control over them, it would still be the same world and the same people. You could move the turds from here to there – do anything you want – and it wouldn't make a bit of difference. Not one bit. They have no souls. No intelligence. You could flush three fourths of them down the toilet and the planet would never miss them. Do you want to know what people *understand*? And I mean the *only* thing they understand? Fear. All this peace and love garbage doesn't work and never will work. You can't change the world through peace and love, no matter how many years you try. But if you have the right *fear*, people would change overnight."

To illustrate his point about the power of fear, he then related to me the tale of how he cut Gary Hinman's ear off. "I used to have this sword I carried everywhere with me. Now this sword had *power* in it, ya dig? But, the power *wasn't* that I used it as a weapon to threaten everybody I met. No, I never took it out, never brandished it, never intimidated people with it. I only had to use it *once*. I cut off that guy's ear, and I *never* had to use the sword again after that, because there's more power in fear than in weapons. If your power is in weapons, you have no power. If your power is in fear, you never have to resort to weapons. That's the only thing that will return this world to order: *fear*." He was intense and adamant about this, and continued, fervently, "When the person finally comes along to restore the balance in this world, it'll make Nazi Germany look like *Mr. Rogers' Neighborhood*. There will be more blood, more death, more destruction and more suffering than has been seen in the whole history of life on earth. And I don't say that just because it's what all those worthless fuckers out there deserve – and they do – but because that is what will be *necessary*. It'll take a whole hell of a lot of evil to set the world straight; not peace, not love. Because you know what, Rice? Good holds no power over evil. None. Good holds *no* power at all over evil."

He shook his head and sat silent for a period, staring at me. I just stared back at him, not really reacting to his tirade. There was an awkward silence. Perhaps reacting to this, Manson began to smile, and as he did, he started to sing a few lines from an old Doors song, "there's a killer on the road... his brain is squirmin' like a toad... there's a killer on the road." He laughed and then abruptly fell silent. We sat there, silently staring into each other's eyes. He smiled and kept staring. Soon we both became aware that the staring had lasted a bit *too* long, and that what had started as a simple lull in conversation had evolved into a staring contest. I could hardly believe it; I was actually involved in a *staring contest* with Charles Manson! It wasn't like some overt battle of wills or anything, yet it was obvious that neither of us harbored any intention of being first to blink. So on it went. Manson leaned forward and narrowed his eyes, stroking his scraggly beard. This seemed to go on for ages, though it was probably really only a few minutes. Eventually Manson laughed and glanced away, "How about a cup of coffee, Rice?" As I walked off to get it, he yelled after me "and maybe a *Butterfinger* too."[i]

Believe it or not, despite all his comments about people being worthless turds, Manson was at other times still very much into the idea of world peace, and of love. In his darker moments he'd dismiss such concepts as weak idealistic hogwash, but the few years he was out in the 1960s (and the ideas popular then), seemed to have had a lasting impact on him. But Manson was always more fun when he was in a bitter mood, or angry about something. That's when he seemed to be in his best form. And really, the only times when Manson's sincerity seemed beyond question was when he was pissed-off and was venting his rage about something.

I recall one particular day in which his mood was dark and it took no coaxing on my part for his misanthropy to come out. "Those fuckers out there will tell you how they want to be saved," he said, "They keep prayin' for Jesus to come back again, and all I have to say is; how many fuckin' times do they expect him to come back? They killed him the first time at Golgotha. Then he came back in

Germany in the 1930s and the whole world gathered together to destroy him. And now they want him to come back again? Fuck no! It don't work that way. If he comes back again, he'll come as Satan and destroy every last one of 'em." "But surely," I said, "you don't actually *believe* in Christ or Satan, do you?" To which he responded, "I believe in the *spirit* of Christ, and the *spirit* of Satan. It's *all one*, and it has different faces at different times. That's Abraxas." Now he was getting into something I wanted to talk about.[ii]

Abraxas is an ancient Gnostic deity representing the intertwined duality of existence – it embodies the idea that light and dark, good and evil, creation and destruction are intrinsically interwoven, and exist in balance with one another – and it was an idea that I'd been heavily interested in for quite some time. Manson's Abraxas-rap was totally non-linear, however. There is no way I could put it into words or remember his words accurately enough to do it justice. It was pure symbolism, totally abstract yet totally clear and precise. When speaking of it, he stood up and made symbolic gestures with his hands, writhing around wildly as if to embody the concept of which he spoke. I've only ever met a handful of people who've been familiar with Abraxas or understood the principal it embodies, so this particular conversation was shaping up to be one of the most worthwhile I'd ever had with Manson. It went on for hours, ending only when the visiting time was up. Later Manson would write to me, "Rice, I'll call you Abraxas, because you stand in two circles at once."

As the two deputies attempted to put Manson's cuffs on that day, he was in a jovial mood and joked so much that they were both doubled-over with laughter. The second they'd begin to gain their composure he'd start joking again and soon they were laughing so hard that they could barely breathe. They began pleading with him to stop, "Stop it Charlie, please. I can't breathe!" Still, they were laughing so hard they could barely speak. It seemed to me that if Manson ever wanted to escape, he could *joke* his way to the front gate; and if he ever got out he could make a fortune as a standup comic.

By the end of my second visit, I'd come to realize that Charles Manson was in fact a far more complex and multi-faceted character than even I'd imagined. One of his defining characteristics was his overt contrarianism. He was always very contrary. He was moody, in the sense that he would switch from preaching about peace and love to ranting about the worthlessness of humanity; but even beyond this, his desire not to be pinned-down or labeled lead him to want to talk about brotherhood if you wanted to talk about violence, or violence if you wanted to talk about brotherhood – to say "no" if you said "yes." It didn't take me long to recognize this trait, and dealing with it was not unlike using a bit of reverse child psychology, which I often did. But generally Manson's mood seemed to set the tone of things, and most often I just sat back and enjoyed the wild ride...

As amazing and insightful as Manson could be at times, it always seemed to me that there was a higher level of bullshit running through his world than was either necessary or healthy. I could never quite tell why it was there – was it a deliberate dissimulation on his part, or was he merely delusional? Was it a way of testing a person's degree of cleverness or gullibility? Was it some sort of deliberate tactic to see how much faith others had in him? I couldn't tell. I could only perceive that he seemed to dance around the truth at least as much as he *told* the truth, if not more. "Remember those nuclear subs that went missing," he queried of me once, "Well, *I've* got 'em. They're loaded with fully-armed nuclear warheads and one word from me would launch a nuclear holocaust in every major city in the world." He went on to imply that he was holding the entire world hostage and soon, very soon, the leaders of the most powerful countries on earth would be petitioning him. Then *he* would be calling the shots, and nothing on earth could foil the plan because the subs were hidden where no one would ever be able to find them. At times like this I found myself fighting the urge to tell him that if he really believed that, he was completely full of shit, or crazy. In retrospect, I don't really know why I didn't say just that. Probably because I wanted to hear what was coming next, and if I'd told him to cut the bullshit, I might've missed some wild stories.

Perhaps the most outstanding example of Manson's capacity for flip-flopping bullshit was during a visit in which I got a firsthand experience of his legendary antipathy towards Blacks. He was evidently having some sort of difficulties with a Black prison guard and launched into a whole scenario that was hauntingly similar to the "Helter Skelter" theory he's claimed D.A. Vincent Bugliosi, had wrongfully tarred him with at his trial. At one point he leaned as close to me as possible, and in a near-whisper said, "Rice, you don't even *talk* to a nigger. If a nigger asks you a question, don't even

answer. Because every time you talk to one, your words and thoughts are going into his brain." He continued, "See, when you talk to a nigger, you're giving him a little bit of your soul. And each time you do, you're dragging him up the evolutionary ladder. You're bringing him a little bit further into your world. And he has no place in your world. He should be locked out of it." Having said this, he sat back in his chair and stared into my eyes as he shook his head, so as to emphasize the gravity of the remarks he'd just made. He then fumbled for a cigarette and lit it, inhaling long, slow drags. Almost as if on cue, a Black man walked up to him and said, "Well, if it isn't Charlie Manson. How are you doing today my friend? You are looking very fine indeed!" The man had a jovial, almost childlike voice. He sounded African to me, and spoke English in a high-pitched, sing-songy sort of way reminiscent of the comedian Andy Kauffman when he did his Hindu-Pakistani voice. Manson told the guy he was doing great and had no complaints. The two joked back and forth, then the man asked if he could have a cigarette. "Sure, no problem." Manson replied, giving him one and lighting it for him. "Thanks a million, Charlie!" the guy said, then turned and walked off. "Hey wait a second, man," Manson called after him, "why don't you take another smoke for later." "Okay," the guy replied, "another for later. Thanks again!" "Oh, don't mention it, man." Manson responded, turning back toward me, all smiles. Then a strange look crossed his face as he realized he'd just contradicted the very point he'd been making so fervently a few short seconds before. "I'm sure you're probably wondering why I was talkin' to that particular guy just now. Well see, it just so happens that guy there is a *revolutionary*, and he's got a thousand people down in South America who'll do whatever he says do. And he'll do whatever *I* say do. Ya see?" The needle on my bullshit-meter went all the way into the red.

During one of my subsequent visits to San Quentin, Manson's friends T.J. and Anson arrived to see him as well. T.J. was well over six-feet tall, and had been with Manson since the days at the ranch in the 1960s; he'd even been there when Manson had shot a Black drug dealer, before the Tate-LaBianca murders had transpired. T.J.'s nickname was T.J. "the terrible," but he didn't seem too terrible to me. His female companion, Anson, was a homely, redheaded, freckle-faced little girl who Manson called "The Spooky Witch Thirteen" – but she wasn't a witch and she sure wasn't spooky. They seemed tedious at best – a pair of burnout hippies – but it was they who had custody of 13 hours of Manson's unreleased music, so I knew I'd have to try to work with them if I was to release the recordings in question. Manson asked them to give me the tapes, and after a good deal of hemming and hawing, they finally agreed to do so. Earlier that same day, while I was alone with Manson, he'd told me he could easily get out of San Quentin if he'd desired to. But he didn't *want* to, he claimed, because it was a matter of principle. He'd leave only after the president of the United States came and personally apologized for the injustice done to him by the government. Then, and only then, would he leave. But now, talking to T.J. just a short while later, he'd evidently had a change of heart.

"Could you do a big favor fur me, T.J.," he asked. "You know I will Charlie, anything." T.J. didn't even have to think about it. "I need you to switch places with me." Now T.J. was about six-eight, and Manson came-in diminutively at just over five feet himself; but he was nonetheless explaining how he was simply going to walk out of the prison in T.J.'s place. It would be easy; all he'd have to do would be to shave the top of his head so as to look like T.J.. He'd leave his hair long on the sides and back, and comb forward the hair in the back, disguising the bald spot as he came into the visitation room; then when visiting hours ended he'd brush aside the hair and simply stroll out to the truck with Anson, leaving T.J. behind. Charlie gave T.J. a long, sincere, searching look and asked, "Will you do that for me, man?" Again the answer was instantaneous: "Of course. You know I will." "There's one thing though that you should probably consider," Manson said, seeming to have an afterthought. "What's that?" T.J. replied. "If you do this for me you'll definitely get caught. You might get some years... and one thing's for certain... I *sure as fuck* won't be coming to visit you!"

We all laughed at this, Manson most of all. I found myself wondering whether this was a real plan being hatched, or if Manson was merely testing T.J., or if this had all been staged for my benefit. I found the latter two possibilities far more plausible, as the plan seemed hopelessly incapable of succeeding. T.J. was so very tall and distinctive-looking that the prison officials had actually departed from official policy in terms of dress code. They'd allowed him to visit the prison in jeans and a t-shirt, what the prisoners wear, because the likelihood of him being mistaken for any of the inmates was simply beyond the realm of possibility. T.J. was also a veritable fixture there, known to all the guards and staff members. So too was Manson. Even without the crude Swastika tattooed on his forehead

there was no conceivable way that even a near-blind person could confuse the two. Nonetheless, months later I would see Manson on TV with a strange new haircut. It appeared that his hairline had been shaved away and that his hair was sticking to the top of his head as though combed straight forward from the back...

The breakout scenario involving T.J. had been amusing, but now Manson turned his attention to "The Spooky Witch," Anson. "You know what I'd really like to do to you if I weren't in here and could do anything I wanted?" he asked. It was clear that she worshiped Manson, and she giggled nervously (presumably expecting to hear some explicit sexual fantasy). "No Charlie, what?" she asked. "Well, first off," he said, pausing to look up and down her body, "I'd shave off all that ugly red hair." She looked crushed, disbelieving. "Then," Manson continued, "I'd piss all over you, take a shit in your mouth, spit in your face and kick you down the side of the mountain." Manson sat smiling, while she just stared blankly, obviously confused by the whole deal. He gave her a few seconds to ponder the scenario and then continued on with a perfectly friendly, normal conversation, as though nothing out of the ordinary had ever been uttered. Curiously, Anson seemed to take the incident in stride, joining in the conversation again after a few minutes, seemingly happy that things were on an even keel once again.

When I later talked to Anson and T.J. in the prison's parking lot about getting the tapes from them, Anson threw a tantrum. "It's not fair!" she shouted, "we've had those recordings for three years and *we* were going to put out Charlie's album." I tried to reason with them, explaining that they were really in no position to actually *make things happen* in the music business, and had no connections that could get this thing actually manufactured and distributed, but that *I did*. "If I'd had the recordings for three years," I told them, "Charlie's album would have been out two-and-a-half years ago." I argued that if what they really cared about was getting the music out there, then wouldn't it make sense to work with someone who'd had experience doing just that? "No" said Anson, "it's not fair." This was absurd. Was it "fair" for an immature, inept, hippie fuckup like her to sit on Manson's recordings when I could have them released into the world in maybe three short months or so? Attempting to illustrate this to her somewhat tactfully, I asked her, "Would you try to repair your car if you didn't know how it worked and had no tools, or would you take it to someone who was familiar with what needed to be done, an expert, and had the tools to do it?" She conceded that she wouldn't, but didn't see the parallel. She wouldn't budge. It was like she was a backwoods hillbilly who saw me as some sort of fast-talking city slicker trying to grift her, and no amount of logical reasoning on my part would sway her.

Frustrated and increasingly aware of the futility of the situation, I tried another tactic. In an attempt to diffuse the hostility of the situation and win over Anson, I suggested that we go out for coffee and discuss the matter; but she and T.J. protested that they couldn't because they had no money. So I offered to buy them coffee. "Can we have pie and ice cream too?" asked Anson, suddenly showing signs of life. "Sure, let's go." I replied. But then suddenly T.J. piped in saying that they probably shouldn't, because they had to go into Mill Valley to bum spare change for gas money. Their tank was empty and they had to drive all the way back to Mendocino or someplace – and it would take hours to bum that much change. I only had 15 dollars in my pocket at the time, but as a goodwill gesture I handed it to T.J. and said, "This is all I have, use it to buy some gas." Suddenly they were both happier and friendlier. "So now are you going to take us out for pie?" Anson asks. Trying not to sound *too* indignant, I said, "Uh, no. I don't have any more money for pie because I gave you all my money so you could buy gas, remember?" At 17 Anson was evidently getting senile (short-term memory is the first thing to go, apparently). So I bade farewell to the tedious twosome – who couldn't afford *a fucking cup of coffee* and had to beg alms to put gas in their vehicle, yet somehow imagined that they were going to produce, manufacture and distribute an album – and returned to San Francisco.[iii]

At some point during the period in which I was visiting Charles Manson, I also got in touch with another member of his inner circle, Lyn "Squeaky" Fromme, whom he called "Red." Manson had suggested I contact her, and evidently also wrote her a note saying that I was a good guy and that she should talk to me. We began corresponding and soon she was calling me collect from prison in West Virginia. I'd written to her maybe 10 years earlier and tried to get in to see her when she was being held at San Diego's Metropolitan Correctional facility, following her 1975 faux-assassination attempt on then-President Gerald Ford in Sacramento, but it wasn't until Manson personally

intervened that I got a response from Lyn.

I really liked Lyn Fromme; she was at once both childlike and wise, and seemed like a very genuine person. In a way, she seemed purer to me than Manson. He was sincerely devoted to the ideas he espoused, yet at times it seemed to me that certain things he said were just for effect, or that he could (and would) say exactly the opposite if the mood struck him. Lyn wasn't like that at all. At first she was openly suspicious of me and my motivations, but when I finally won her trust it seemed boundless. Her admiration for me would eventually cause friction between her and Manson, however, and he would eventually accuse me of "scammin' on his pussy." He'd later ask me if I was trying to "steal his old lady," and then dismissively say, "Well I got thirty wives, and that's just in the kitchen." A strange statement coming from a man who argued that jealousy was just a barometer for insecurity.

One subject that'd come-up during my correspondence with Lyn was that she'd warned me about a woman who I'd later meet while visiting Manson; a woman whom she described as "a little bit crazy." This woman had something like eight children and evidently thought that Manson was Jesus Christ. But if Christ ever treated his disciples the way Manson treated this woman, I've never heard tell of it. Manson treated her like absolute shit, and the poor fool was sweating bullets constantly.

Once, this woman and I visited Manson on the same afternoon, and during the visit the three of us discussed music. Manson stated in no uncertain terms that this woman "didn't know a fucking thing" about what constituted good music. "That's not so," she protested. "Okay," said Manson, "who do you think makes good music?" There was a long silence and she sheepishly said, "Elvis." Manson retorted that he had "been Elvis before Elvis even existed," and the real Presley was just an actor pretending to be *him*. "But he wrote some good songs," she offered. "Really, Elvis wrote some good songs? Elvis *wrote* them? You name a single song that Elvis Presley *wrote*. A single fuckin' song. Go on." The woman stared down into her lap, silently. "You go home and put on an Elvis record," Charlie snapped at her, "and then you put on the London Philharmonic playing Wagner, and you come back and tell me which is *real* music." The woman was totally browbeaten, but Manson wasn't finished. "Let's give you a little test to checkout your musical I.Q." he said, "Now, I'll give you names of musicians and you tell me which ones are for real, and this oughta' be easy, because one's going to be a musical genius and the other one is total fucking bullshit. Okay? Let's go. Who's the real deal, Barry Manilow or Neil Sedaka?" The woman seemed panicked. She glanced toward me imploringly, as though she thought I knew the answer and could somehow tip her off. "Remember," he said, as if to clue her in, "one has *true soul* and the other's a complete phony." She didn't even venture a guess, afraid she'd choose the wrong one. He continued coming up with even more absurd combinations. "Okay, this is an easy one. Even you should be able to get this. Who's coming straight from the soul, Shaun Cassidy or Leif Garrett?" It went on and on; it was a hilarious spectacle, the woman's fear of making a wrong choice and Manson's parings of mediocre musicians. But it seemed like such a waste of time to me. He obviously had no respect for this woman whatsoever, and she was obviously totally stupid, so it was really a frivolous exercise. Here was a man who held all of humanity in utter contempt, and yet he was allowing this pathetic woman to be a part of his life. She was far less worthwhile than the mass of people he so vocally dismissed as worthless. It was absurd. Could anyone be so lonely, even in prison, that having someone like *this* come to visit would seem preferable to solitude? It hardly seemed likely.

I asked Lyn Fromme about the foregoing scenario and her reply was that Manson has so few people that are willing to do things for him that he has to, in effect, "play with whatever hand he's dealt." But the cards analogy didn't wash; or at least it didn't make sense in terms of explaining how this woman might be an asset to Manson. It might, however, make sense in terms of explaining Manson's *situation*. An astute card player dealt a poor hand, would probably fold. Someone as tricky as Charles Manson might stack the deck so as to insure success. But what sort of person would wager everything on a losing hand? Manson was smart, brilliant in fact, when it came to understanding human nature, but had never seemed to exercise good judgment in regard to his own life. And who dealt him the hand that he had in 1969? In a game of cards, if you can rid yourself of the weak cards in your hand, the odds are that you'll be dealt something better; but in '69 Manson wasn't dealt a poor hand, he chose it for himself. The flakes, fuckups and losers he surrounded himself with – some of whom committed the murders of Sharon Tate and her friends – are the very people he *chose* to

surround himself with. Manson bet his life on the fact that he could trust these people 100 percent, and he lost, because they *were* flakes and losers. He still blames them for putting him in jail, but given his understanding of human nature, he really should have seen the shadow of disaster coming down the road, so to speak.[iv]

Of course, Manson ultimately claims that he had nothing to do with the murders for which he's imprisoned. And the truth is, he never actually killed *anybody* at either the Tate or LaBianca households. He also wasn't allowed to testify before the jury at his trial, because the prosecution managed to convince the judge that if were to do so, he'd have some sort of Svengali-like ability to hypnotize them. His trial was a sham, to say the least. Regardless, from my point of view, if it really is in fact the case that Manson *didn't* order the Tate-LaBianca murders, then the crimes aren't interesting and neither is Charles Manson. If, as he claims, "the kids" did it to stop the war in Vietnam, one can only say that the gesture was a wildly inappropriate means of trying to achieve that end.[v]

Naturally, while Manson most often claims total innocence, being the contrarian that he is, he will at other times boast that he'd orchestrated the murders as part of a Holy War. Having spoken with him at length on the subject through his various seesawing moods, I'm personally convinced that that *is* indeed how he actually felt at the time (and still feels), and that's also what "the kids" felt, regardless of how often he's since attempted to change his story. Manson still seems to think that a race war between Blacks and Whites in America is inevitable, but just when he starts to get carried away with the idea, he censors himself and tries to put a sort of pseudo-liberal spin on it; like rationalizing how the poor, oppressed Black man has so many centuries of hostility in him that it wouldn't be unnatural for it to boil over sooner or later and, "hey, it's got to go *somewhere*."

I was only to see Manson a few more times after I began to seriously doubt his credibility. My name was removed from his visiting list when I was discovered coming into the prison with a bullet in my pocket. The lesbian Nazi guard was going-over me with a metal detector and found it. She was clearly sad about having to handcuff me and turn me in. For her co-workers, however, it seemed the happiest day of their lives. One guy was on the phone to the warden a split-second later, exclaiming that they'd just taken some guy into custody who had attempted to smuggle an *explosive device* in to Charles Manson. I was placed under arrest and charged with "the smuggling of an explosive device into a state penitentiary." I won't even bother to explain what I was doing with a bullet in my pocket, since I've explained it at least a thousand times in the decade since my arrest, both in interviews and in conversation, and clearly not a single person seemed to believe my story. Not Lyn Fromme, not even my best friends.

As a result of my arrest, I spent some time in the Marin County Jail in nearby San Rafael, which is part of a structure designed by the legendary architect Frank Lloyd Wright (a fact all but completely lost on those it housed). The details of this escapade do not bear recounting, aside from the fact that much of the jailhouse wisdom that Charles Manson had imparted to me suddenly became relevant not only figuratively, but quite literally as well. Upon my release from jail, I was surprised to learn that there'd been no mention of the bullet incident in the press. I'd almost anticipated it to be on the nightly news, and fully expected to get the maximum sentence possible for the offense. But the district attorney, for whatever reason, decided not to press the charge filed against me and the press never picked-up the story. Instead I was simply removed from Manson's visiting list.

In retrospect this is probably a good thing. I'd heard from Manson insiders that he'd told a number of people that *I* was going to be the guy who'd break him out of San Quentin. That's a pretty large task for someone who can't even smuggle in a single bullet, but the fact is, if Charlie had asked, I'm sure I would have tried in some way or another. Not because I had so much loyalty to the guy that I'd be willing to lay my life on the line if there was a chance I could win his freedom, but because – like so much of what made Manson appealing – the very *idea* was exciting.

After my arrest, officials of San Quentin blamed Manson for the bullet incident, and without evidence of any involvement on his part they put him in solitary confinement. They'd always been nervous about our interaction with one another and as a result of my oversight, they now had Manson right where they wanted him. They withheld my correspondence from him and after a short time he began writing to me, angry that what I'd done had resulted in his being punished unjustly, and that I hadn't even cared enough to write him afterwards. Of course I couldn't exercise any control over

how paranoid bureaucrats interpreted (or misinterpreted) who was to blame for the bullet incident, anymore than I could exercise control over whether or not they gave him my mail. Since I had no way of communicating with him, I couldn't even let him know that they were withholding my mail from him. Before I could make any attempts to demonstrate to prison officials Manson's non-involvement in the bullet incident, he took apart his mattress and threatened to cave-in the skull of a guard. Following that, they were then able to keep him in solitary confinement, and did. My friendship with Charles Manson was over, and I haven't communicated with him since.

I could easily claim here that I'd had my fill of Manson and planned to cut him off cold before the bullet incident, but that wouldn't be entirely true; I still felt crushed at being removed from his list. Even with his obvious flaws and all the disappointments, he'd still been one of the most amazing people I'd ever met. He was part con-man, part shaman and a total paradox. He had the ability to convey a quality of life larger than 999 out of 1,000 people were capable of digesting or comprehending – and when he was in top-form, he was downright electric. The fact is, I still found him an inspiration, lies, flaws and all.

I realize, of course, that conceding to this reveals the same sort of poor judgment on my part which I've accused Manson of possessing. Perhaps even more so, since by that point my faith in him had been shot to hell, and in the process my faith in general had been left in shambles. I was very disillusioned by the experience of getting to know the real Charles Manson, but actually considered it a development altogether enlightening. After all, consider the word itself: *dis*-illusioned. In a way, my experience with Manson helped rid me of certain illusions I'd held about him and those like him, and that was hardly a negative thing. It'd helped kill my idealism and left me far more cynical and realistic. It drove home the fact that a person can be brilliant but lack common sense; that they can be wise, yet lack the ability to incorporate that wisdom into their life in any meaningful sort of way. "Words are only words," Manson had once told me, "and have no reality beyond words. Words can say anything but truth needs no words." My experience with Charles Manson would have taught me that, even if he hadn't actually uttered it aloud. Words, after all, are only words. I've always known that, but it was then that I came to understand it.

As I write this today – a full 10 years after I first started visiting Charles Manson – benefiting from the perspective of 20/20 hindsight, things naturally seem much clearer than they did back then. In the last decade I've answered dozens upon dozens of questions in interviews relating to my relationship with Manson, and I've grown thoroughly bored of the subject, so I hope that this essay will suffice as my final word on the matter.

Addendum (2007):

It is impossible for anyone who didn't live through the 1960s to fully comprehend the iconic purport of such figures as John F. Kennedy, Andy Warhol or Charlie Manson. Today such figures seem like cultural clichés, their very larger-than-life status having condemned them to over-exposure on such a grand scale as to reduce them to seeming caricatures.

I must admit that the Manson who inspired me as a teenager, while not being a caricature, was nonetheless an abstraction. He was a counterculture icon who came to symbolize a tangible incarnation of values that were the precise inverse of the liberal humanist dogma set into motion in the hippie era. For decades, he was one of only a few such figures.

At the end of the day, Manson the man was far more interesting and complex than the myth that has become attached to his name and persona. In a lot of ways he seems a larger personage than even his larger-than-life image. Even now, it still seems bizarrely surreal that our paths should have crossed one another's, however briefly. Warts and all, I'm confident that I'll never again encounter the equal of Charlie Manson. Ever.

i Whenever I tell people this story about winning a staring contest with Manson they invariably try to hook me into a staring contest with them, thinking, I suppose, that if they can out-stare me it somehow implies that their willpower is then greater than that of Charles Manson. The reality, of course, is that such contests probably have more to do with how moist or dry your eyes happen to be on a given day than how much willpower you possess – so I'd advise people wanting to demonstrate their strength of will to instead try beating G. Gordon Liddy's

record for holding his hand over a lit candle. As of this writing, I haven't had any takers on *that* proposition.

ii Manson's pronunciation of the word "Abraxas" was quite odd; he'd say, "Abba-rax-us" bringing in his own idiosyncratic phonetic butchery of the word, instead of pronouncing it correctly.

iii Since this scene took place some 10 years ago, that means T.J. and Anson have had those tapes of Manson's recordings for 13 years and haven't managed to do a single thing with them. If these were the kind of people Manson was counting on to man his armada of nuclear submarines, he was clearly fucked. I could only hope for his sake that those South American revolutionaries had their act a bit more together...

iv Church of Satan head Anton LaVey actually knew murderess Susan Atkins previous to her involvement with Manson and his "family," and described her as "an accident waiting to happen." She worked for LaVey as a topless-dancer and would do things as moronic as call-in sick with a temperature of 108 degrees. She wasn't even smart enough to know that anyone with a temperature that high would be dead. LaVey eventually had to fire her. "Susan was someone I wouldn't trust to show up for work," he once told me, "much less commit a murder for me." So if Manson was such a good judge of human nature, why couldn't he too see this? It didn't make sense.

v Manson actually claims that the Tate-LaBianca murders *did* in fact bring an end to the Vietnam war, but of course there's no cause-and-effect connection between one and the other, and he's never elaborated on this claim to me. Given the nature of his personality, however, this isn't the least bit incongruous for him.

April In Paris

(Previously unpublished, 1997)

I'm not even sure what year it was – sometime in the early 1980s. I was on a train bound for Paris, coming from who knows where. My traveling system at the time was that I'd get a bottle of wine, board a train at sunset and arrive at my destination at sunrise. A good system; it saved on hotels. As I sat sipping wine, taking in the view of the French countryside passing by, a girl entered my compartment and virtually collapsed across from me. She looked odd somehow; pale complexion and wearing clothes from some other era. It was as though she was a ghost, an apparition. I offered her some of my wine but she didn't drink. Fab – more for me.

The girl told me of the small town she came from – and was going to. A place "near of Paris." Soon she was telling me of her hopes and dreams. Generally, when people start regaling me with their aspirations, I inform them that that I wipe my ass on their irrelevant hopes and dreams, but this girl had a certain forlorn charm about her. Though I was sure her dreams might never be realized, I wished they could. Suddenly, in mid-sentence, her eyes rolled back in her head and she nodded off. As I sipped my wine into the night, I was struck by her eerie beauty. She looked for all the world like a cadaver... too peaceful, too made up and too pale.

I awoke with a start as the train pulled into the station. It was my companion's destination, so I got down her luggage and gave her a few taps on the shoulder. No response. I shook her a bit and shouted in her ear. Still, no response. Fuck. My mind raced: "This girl is dead. She doesn't just look like a corpse, she *is* one. I'm drunk in a train compartment with a dead girl. This looks just great." Suddenly she let out a moan and opened her eyes. "Are we here are already?" "Yeah, we're here." I carried her bags to the platform for her and fetched another bottle of booze for the remainder of my journey. I needed it.

Arriving in Paris, Gare du Nord is a culture shock. It is maybe France's principal train station, and when I was there it seemed the last bastion of sexual differentiation; glamorous women who looked like models (or porn stars) and men who looked like clerks. I took in this passing panorama of life as I sat down and imbibed a trifle more wine. I then ambled out to the station's taxi queue and in perfect "Ugly American" form demanded that the driver "take me to McDonalds." The purpose of this junket was partially gastronomic, but mostly fetishistic. I wanted to consume American fast food in the shadow of the Arc de Triomphe. I wanted to revel in the irony of munching French fries in a country where they're called *pomme frites*; all the while contemplating just who history will decree as having had "the bigger dick," so to speak, Napoleon or Ronald McDonald? (Despite my reverence for the little general, I put my money on the clown.) Back in my early twenties, three or four glasses of wine was enough to kick my ass – and at the McDonald's on the Champs-Élysées, you could get a glass of wine with your Big Mac. I had one... then another... and another.

As I drunkenly stumbled out of McDonald's I saw a hapless family of American tourists. Though stone-cold sober, they were in more of a haze than I, hopelessly out of their element and wandering Paris' ancient streets like zombies, dazed and confused. The father seemed to come to life at the sight of the Golden Arches. "Thank-God-to-Christ," he hollered, pointing at the restaurant's sign. "At last we can get a decent meal in this goddamned place!" The rest of the family lit up as well – Mecca. These sad sacks of shit were smack dab in the middle of the culinary center of Europe, perhaps the world, and they couldn't find a *decent meal*?! Throw a dirt clod in Paris and it's likely to hit a plate of Eggs Mornay or Oysters Rockefeller. Go 10 seconds in any direction whatsoever and you can purchase the most decadent pastries in the history of mankind. Hate the politics of France all you will – these fuckers really know how to live. I crossed the street, leaving the family, but in my heart I was saying to them, "Have your Royale With Cheese, dickwad, then get on the plane back to Wyoming. Plenty of good food there."

I made my way to The Tuileries Gardens, to check my map and take a respite. The sense of history was a bit much in my drunken state – I was in the shadow of Louis XIV, "The Sun King," and pissing distance from The Louvre. And, altogether unwittingly, I'd plopped down on a bench in front of a fountain lovingly described by Surrealist leader André Breton in his novel *Nadja*. Great. This was

just the sort of quiet, contemplative break I needed before continuing my journey. Next thing I knew, however, all hell broke loose. Two men's dogs had broken their leashes. The dogs were obviously expensive and well bred, but were attacking one another with a degree of savagery such as I'd never borne witness. The dogs were ripping one another to shreds as the owners looked on helplessly and barked orders in French, ineffectually. I decided I needed another drink, at least.

So I had a bit of a buzz on when I entered the Musée Grévin, one of the great wax museums of the world and a favorite haunt of the Surrealists. Ostentatious changes had been made to the high profile annexes of the museum, but happily, much seemed to remain unchanged since the 1920s. (Having not been back in several decades I have no idea if this remains true today.) At the time of my visit there were tableaus of Zulu "savages" tarted up in gingham miniskirts. There were dioramas depicting the French Revolution with a forced perspective so extreme it could make spectators dizzy; add to this the aspect that one was drawn into a darkened underworld labyrinth to view such scenes and the museum seemed like some Western recapitulation of the ancient mysteries. At the time, as I recall, there still existed the scene of a French prostitute adjusting her garter. This particular tableau, so beloved by the Surrealists vanished shortly thereafter, I'm told. A damned shame. However, also by this time, the "life imitates art" thing had come full circle and the grand gallery had waxwork figures of Charles de Gaulle posed alongside Salvador Dalí and Jean Cocteau. Would the Surrealists have loved such a bizarre juxtaposition or despised it? I can't say.

The Chamber Of Illusions (or whatever the hell it was called) was very odd indeed. Though lined with mirrors intended to give the false perception of infinite space, the reality was that it was claustrophobic. I was herded in with a bunch of other visitors, and just as the door slammed shut, the lights were cut and I was in a room of strangers and absolute blackness. There was a loud, clicking mechanical sound, then – just before collective panic kicked in – the lights came back on and the room was filled with luxuriant foliage. It was as though we were in the midst of a vast rain forest. In any direction one looked were perfectly symmetrical rows of trees, stretching out to infinity. Above them hovered a roof, thick with leaves and vines. Here and there, eerie luminescent serpents were entwined on the trees' branches. It was as though we'd been transported from the 20th Century to a scene from some fairy tale, a locale enchanted, yet menacing. It was a simple gimmick, really, but altogether mesmerizing.

When this attraction first opened in the late 1800s it must have seemed like the mechanical marvel of the age. Even now, the crowd was utterly awestruck. But before the *oohs* and *ahs* of the spectators could die down, the room was cast into darkness again. Once more the sound of machinery kicked into gear. Folks tensed up a bit, but again the lights came on and the scene had been transformed. Now we were in a vast palace with columns made of light. I was still more than a bit drunk, but getting hip to to the drill nonetheless. When – predictably – the lights went out again, I shrieked as though being murdered, made gagging and choking sounds, then stepped off to the side of the darkened room. When the lights came back on, my fellow visitors didn't seem to notice the new vista presented them – they seemed a bit terrified. I pretended to share their consternation and confusion. I could see genuine fear in their faces, as though the next time the lights went out the maniac in their midst might truly strike. I can't really say why so much of my youth was dedicated to fucking with people – all I knew then was that I'd ruined their experience of the wax museum, and that was enough. I was filled with a boundless joy. When this *experience* finally ended, the other participants exited running.

Next, I somehow navigated to Père-Lachaise, a famous boneyard that's the final resting place of any of a number of personal favorites of mine. Almost upon entering, a young French girl right out of central casting (wearing a beret, even) came running towards me. "Are you here to see Jim Morrison's grave?" "No, I'm not. I'm here for the likes of Oscar Wilde and Tristan Tzara." She knew where they were located, but insisted on showing me Morrison's grave first. It was a tawdry affair, strewn with candles, old Doors albums, incense and horrid, moronic graffiti. (It's not bad enough that the poor fucker died in a bathtub, silly shits have to desecrate one of the world's coolest cemeteries in misguidedly honoring him.) She lead me to the final resting places of my favorite poets and libertines, then subsequently informed me that the only way to truly experience the cemetery is by night. "This is a city within a city," she told me. "When the sun goes down, it's peopled by the strangest individuals on earth, and hundreds of stray cats." Stray cats and strange people – it sounded like my

cup of tea. I decided that maybe I needed to spend the night there and forego the nearby hotel. I repaired to the local shop and purchased some bread, cheeses and a bottle of wine that was large and cheap. My choice of fare wasn't based upon some romanticized ideal of French cuisine, but was rather functional, as I was still (believe it or not) a vegetarian at the time.

Later, as darkness descended on Père-Lachaise, I heard a thunderclap and rain began to fall. I was fucked. The place had been locked up tight – with me in it – I was drunk and was beginning to be drenched to the bone. Thankfully, I was blissfully naïve as to what actually transpired in the place at night. The "interesting people" who appeared as from nowhere were in fact junkies, prostitutes and thieves. Some, cutthroat killers. I'd only seen the hundreds of feral cats, so far...

Luckily, I had procured a length of pipe from a trashcan, and used it to break into a tomb that was spitting distance from the grave of Tristan Tzara. Small and oppressive though it was, it offered shelter from the rain that was soon coming down in buckets. The wine comforted me and perhaps distracted me from the notion that I might die there amidst my literary heroes; a victim of pneumonia, exposure, or whatever. My thoughts went to the overly romantic French girl who'd suggested spending a night in the land of death. In my mind's eye, my hands were around her throat, throttling her.

I awoke well before dawn, frozen to the core. The rains were such that they entered the small sepulcher and I was laying in a pool of water, an empty wine bottle at my side. The storm had subsided but I was soaked. Somehow or other I managed to scale one of the cemetery's walls and exit the place. Though I'd seen shadowy figures moving about, I never quite encountered the denizens of this degenerate half-world. Probably a good thing. I hailed a cab and headed off in search of a hot bath and a warm bed... and more wine.

The Devil's Dandies
Sir Francis Dashwood & The Hellfire Club

(Originally published in *Modern Drunkard*, 1997)

Most modern drunkards are undoubtedly aware of The Rat Pack, the group of entertainers who swore fealty to booze, broads and the pursuit of pleasure. Few people, sadly, are aware of the so-called "gentlemen's clubs" that were The Pack's precursors. Although these groups were generally little more than secret societies that elevated drinking and debauchery to the level of religious doctrine, at least one such club essentially controlled the fates of nations and dictated the course of history.

Sir Francis Dashwood's Hellfire Club started modestly enough as a group that met in a pub to drink and indulge in every conceivable form of revelry. When their desire for pleasure began to far exceed the day's mores, they decided to acquire some property far from the prying eyes of the public. Sir Francis purchased a disused abbey in High Wycombe, a site that could be easily accessed from London by sailing up the Thames on a barge.

Dashwood spared no expense in turning his new property into a garden of earthly delights. A landscape artist was commissioned to design topiary shrubbery depicting obscene acts, and hedges were sculpted into huge erect penises. A series of loveseats (literally) were scattered willy-nilly about the property so couples who suddenly became aroused while taking a leisurely stroll could be assured of the most immediate gratification possible. The ground beneath the abbey was honeycombed with a series of caves that became the scene of countless orgies and unspeakable rituals. The caves were decked-out lavishly with couches of silk and velvet, and the walls were festooned with tapestries and oil paintings depicting every conceivable sexual proclivity. Signs bearing libertine maxims and witticisms were posted throughout. The participants imbibed cocktails laced with brimstone (sulfur) and had sex with women beneath signs proclaiming, "Do what thou wilt shall be the whole of the Law" – all this a century before Aleister Crowley.

Prominent members of Parliament began to show-up for the notorious late-night ceremonies, and even that swinging U.S. founding father Ben Franklin found time to become a member during his visit to London – all the while promoting the virtues of clean living back home. Rumors began to circulate in the town of Wycombe about the goings-on in the Hellfire caves and abbey. The cries and moans of drunken revelry and sexual abandon issuing from the caves were interpreted as human sacrifices and it was whispered that animals set afire were seen running from cave entrances. Whether such rumors were true or not, the effect was that superstitious villagers kept their distance, leaving members of The Club to pursue their vices in peace.

The Hellfire Club soon became something of an institution. Its membership not only included leaders of the British aristocracy, but also foreign power-brokers whose combined influence impacted the entire civilized world. The club's roots, however, were in a far more unsavory underworld, taking its inspiration from a series of "gentlemen's clubs" that were headquartered in various London pubs and were responsible for what was essentially a sustained reign of terror. The credo of these groups was, "Wine, women, song... and violence." They were generally composed of libertine aristocrats who wanted to drink excessively, fuck excessively and create havoc; and create havoc they did. When drunk, these gentlemen would rove the streets of London, molesting fair damsels and burning down buildings as a lark. On the infrequent occasions in which these pranksters were caught in the commission of such crimes and brought before a magistrate, their punishment would be something negligible, like a fine of three shillings. They were, after all, the ruling class.

Such clubs had been around since the 1600s. The most notorious of the period were The Hectors, The Nickers, and The Mims. Later, in the early 1700s, it was the Mohawks who kept Londoners in a constant state of terror with their favorite pastime – "tipping the lion." This was euphonious for smashing-in someone's nose with a huge piece of iron and gouging their eyes with thumbs. Few Londoners ventured out at night for fear of "being mohawked."

The leaders of these groups bestowed exotic titles upon themselves, such as "Rape Master General of England" or "Patron of Blasphemy." If their names were a frontal attack on public decency, their deeds certainly lived-up to the hype. A group called the She-Romps would abduct women from

the street and whisk them off to their pub, whereupon such ladies would be made to walk on their hands until such time as their dresses fell down, following which their behinds would be viciously whacked with riding crops.

When the libertines tired of sex and drink, their fancy often turned to pranks. Not the type of fellows to commit small pranks upon the scale of, say, exploding cigars or whoopee-cushions, their idea of humor was putting old ladies in barrels and rolling them down the side of a hill. For a real laugh they'd capture a hapless vagrant and nail his hands to the side of a shed. It's a safe bet that at no time in history did practical jokes have as violent an edge as those practiced in 16th Century England.

Each successive generation saw the coming of new groups and the fading-away of old groups, and of course the younger generation wanted to take things just a bit farther. The old-timers disparaged the young breed of libertines, saying the kids today were just going soft. They maintained that in *their* day they drank more, fucked more and committed more daring crimes. The younger generation, for their part, turned the focus of gentlemen's clubs away from raw violence and toward new levels of decadence. The last of the great clubs, such as The Mollies, The Sharps and The Sons of Violence, actually donned women's clothing while embarking on their drunken escapades. They elevated the practical joke to a fine art and wielded insults with an inspired degree of wit and cruelty.

The later groups also began to incorporate black rites and the committing of blasphemies into their repertoire. Some libertines started claiming to have pacts with Satan, while still others said the devil himself presided over the soirees. Unfortunately, the groups' dalliance with Satanism proved to be their undoing; the proverbial straw that broke the camel's back. A God-fearing public that had long tolerated every excess and indignity was simply not prepared to suffer the existence of groups so stridently anti-Christian. A public outcry forced the government to crack down on gentlemen's clubs, and in time members of Parliament and the House of Lords who belonged were publicly exposed and expelled from office.

The clubs, of course, didn't disappear; they simply went underground (in the case of the Hellfire Club, they went *literally* underground, into the caves beneath the abbey) and ceased activities that would bring any unwanted attention from authorities. They continued to flourish as secret societies and no well-known rakes' clubs existed publicly again until the advent of The Rat Pack.

Though The Rat Pack was a Vegas lounge version of a gentlemen's club, it did possess most of the classic characteristics. In order to attain status as a Rat, one had to be a hard drinker, a cad to women (*lots* of women) and a master prankster. And if, at first glance, The Rat Pack seems to lack the darker aspects of its predecessors, think again. Sinatra was one mean son-of-a-bitch. A surly drunk stepping out of a Vegas elevator once discovered this firsthand – after calling Sinatra a scrawny little wop, Frank took him out with a single punch in the gut, then proceeded on to his hotel room. If someone *really* pissed him off, a single phone call could arrange for persons unknown to break the offending individual's legs.

Frank's fellow Rat Packer, Sammy Davis Junior, was a member of The Church of Satan, and was known to wear the organization's Sigil Of Baphomet lapel pin on stage (hail Satan, baby). Sammy hosted wild orgies at his Hollywood Hills home, attempting to lure Hollywood's most illustrious names into The Church. Many joined, though most kept their membership a carefully guarded secret. Not Sammy. He remained very vocal in his advocacy of Anton LaVey's brand of Satanism until some years later, when he did a 180° turn and converted to Judaism.

If there is a lesson to be learned from these fragments of history, it would seem to be that Western man has really forgotten how to party. Dean Martin was a drunk's drunk. Francis Dashwood was a libertine's libertine. Who today can hold a candle to either of them?

As we advance into the new millennium, every true rake should turn the clock back several hundred years and draw inspiration from those golden days of yore. Never do anything halfway. Moderation is half-baked and half-assed. This new century will offer us more of everything; we need but be willing to reach out and grab it with both hands. More drinks. More debauchery. More. More. More!

Ponder that as you leave your house and head to the bar. Remember the likes of Dashwood, The Sons of Violence, and The Mohawks, and tell yourself, "Tonight we're going to party like it's 1699."

<u>Addendum</u>:

The Hellfire caves and abbey are now maintained as a historical landmark, and can be visited at High Wycombe, about an hour's drive from London. Scandal and blasphemy had little ill effect on Francis Dashwood's standing as a well-respected gentleman, and to this day his portrait still hangs in the National Portrait Gallery in London. A wooden throne which once graced the Hellfire abbey was purchased by Sammy Davis Junior's pal, Church Of Satan founder Anton LaVey, and now occupies a place of honor in his ritual chamber (wedged between Rasputin's sled, Jane Mansfield's grand piano and a coffin once used by murderess Susan Atkins in the Topless Witch's Review). Along with these other relics, it constitutes a link between history's great swingers, past and present.

They Stole Mussolini's Brain
(well, almost)

(Originally published in *PANIK*, 1998. Republished in *Live In Osaka*, 2003)

This is a tour diary documenting a period of five or six weeks in which I played a series of concerts as NON, with the Austrian one-man band Der Blutharsch, in various parts of Europe. The text which follows consists of notes jotted down between intense periods of drinking, sight-seeing, sex, visits to various holy sites (some ancient, others more modern), and any number of ill-advised escapades. And – oh yeah – we also gave 10 concerts or so along the way (only a few of which are mentioned in passing herein). Our journey begins in picturesque Austria...

Vienna, Austria:

The last time I was here, while on tour with the band Death In June, there were six undercover cops in the audience of our show and military police with machine guns stationed outside the club, as well as at the nearby subway exits. A car filled with police was parked across the street from the venue and a paddy wagon circled the block in preparation for the event that riots might break out. There were none, but the attendant fear that there might have been made for a very exciting evening.
Members of the German government had informed the Austrian government that our show was taking place and that they should expect trouble. They also brought the show to the attention of the Austrian media, who denounced it each and every day for a week straight in the major newspaper, labeling me as "the foremost leader of right-wing extremism in the world today." What?! Little *me*?
Prior to the show I was informed by Austrian police that if I gave the Fascist salute on stage I'd be jailed instantly. This hardly presented a problem for me, since giving the Fascist salute was something I'd never done on stage or had even considered doing that particular night. Despite all the excitement, the show went off without incident, as did most of that tour. Now I was back for another tour, this time with my friend Albin, of the band Der Blutharsch, whose home base was Vienna.

Albin met me at the airport and from there we went almost immediately to the city's amusement park. I'd wanted to ride on the old Ferris Wheel, on which Orson Wells gave his famous soliloquy in *The Third Man* – the one in which he says that the people down below look as small as ants and that crushing them would be of no more significance than stepping on insects. It was Wells' finest moment, or at any rate, certainly one of them. I'd wanted to visit the place so badly when last I was in Vienna, but time constraints hadn't permitted me to do so. In fact, I drove right past one amazing site after another on that previous visit, never having a spare moment to stop and inspect any number of places I'd wanted to visit my entire life. But I had determined that this trip would be different; this time around I'd arranged to have two or three days off between shows. No more 18 or 20 hour days, no more nights of only four hours sleep or two hours sleep, no more unwieldy entourage; just me, Albin and our tour manager, Sven. When you're touring with seven or eight people you can't have two or three days between shows, because the cost of hotel rooms alone would eat up all your profits. But two one-man bands and a tour manager/driver is a whole other story. Three has always been a good number for me.

Zagreb, Croatia:

The drive to Croatia was like traveling back through time: every border we crossed seemed like traveling back yet another century. Soon we we're sharing the roads with wagons drawn by cows. There were old peasant women wearing babushkas, standing in fields and shooting squirrels with ancient rifles. The roads had been repaired since I was last in Croatia – the marks left by tank treads were no longer visible. The bombed and burnt-out remains of rusting vehicles had been cleared off the roadside. The scars of war were no longer quite so apparent. The scars left by Communism, though, were still evident everywhere.
On entering the city of Zagreb, one is confronted with apartment blocks that must at one

time have been the pride and joy of Marxism. On our arrival however, they looked as though they'd needed a fresh coat of paint since 30 years prior to the fall of that regime (though it hardly seems that a fresh coat of paint would help mask the seeming soullessness of these monstrosities). Despite it all, there was something about Zagreb that was very, very appealing. I liked the place – liked it a lot. We had several days to hangout here, and spent most of our time drinking at outdoor cafés.

Our host, Dinko, was gravely ill and had been confined to bed. Even talking on the phone seemed to take more energy than he could muster. So, in Dinko's stead, we went out to dinner with some of his "business partners," men who we were told could get us anything that might be "hard to find." They'd been leaders of the Communist regime in the old days, but under the free enterprise system had since turned their talents to dealing in arms, munitions and various other sought-after commodities. They were a fun bunch to dine with, loud and gregarious. The restaurant owner knew them and personally made sure that we were well looked after, bringing bottle after bottle of wine to our table. The restaurant we dined at was perched on a hillside overlooking the oldest section of Zagreb, and as I stared out over the rooftops of the city's ancient buildings and listened to the laughter of our new underworld friends, there was no place on earth I'd rather have been. This was the good life.

Our show went well. The crowd was roughly as large as when I'd played there previously (with Death In June), which was a good turnout for a place like Zagreb. It was Albin's first live show as Der Blutharsch, and his performance went over extremely well. We spent most of the next day drinking at an outdoor bar across from the town's main cathedral. The cathedral features two huge towers, upon which falcons gather, flying from one spire to the other; a phenomenon that Douglas Pearce (of Death In June) references in his song "Rose Clouds Of Holocaust" when he sings about the falcons of Zagreb. Later, in search of an eatery, Albin and I wound our way through streets and alleys plastered with large posters for our show. We ended up at an Italian place.

Partway through our meal the restaurant put on some rather annoying music, which we asked them to turn down. They told us they would, but didn't. Taking matters into our own hands, we decided to deal with it ourselves, and went to the men's room with the intention of sabotaging the place's electrical system. In the men's room, we bent and altered a fork – until it had only two prongs which would fit neatly into the positive and negative slots of an electrical outlet – then shoved it into an empty plastic container to protect ourselves from the current. As I slid the fork into the outlet, sparks flew all over the place – but the lights remained on. We were both perplexed as to why the sabotage had no apparent effect. When we went back into the restaurant, however, the whole place was plunged into darkness. Unfortunately, the music must have been on a different circuit, as it was booming away, as loud as ever, in the pitch darkness. We left.

The next morning found us back at the sidewalk bar across from the cathedral, having some drinks while waiting for some Croatian friends to arrive. When they finally showed up we then took a series of trains out to a huge old cemetery. The place seemed endless. We visited a monument to the Ustasi, Croatian ultra-nationalists who fought in World War II. Then we visited a huge new addition to the boneyard, made up entirely of those killed in the recent war. Seeing the thousands of headstones put the recent hostilities into sharper perspective. Doug Pearce had friends who'd fought in the war. He'd known people who'd died in the war. In the West no one seemed to have any idea what it was even about. Few seemed to know, and fewer still cared. It was an abstraction, something one heard reference to on the news. Yet Doug had felt so deeply about it that he'd nearly volunteered to join the army. Instead he donated huge sums of money to local hospitals to buy equipment to treat the casualties. When last he and I were there, a grateful surgeon sent Doug a bouquet of roses in appreciation. As I looked out over the sea of tombstones, I was grateful that there were none among them marked "Douglas Pearce."

Back at the bar we wiled away the rest of the day. The next morning we left for Fiume, "City Of The Holocaust."

Fiume, Croatia:

Between the two World Wars, Fiume was occupied by the Italians and ruled as a city-state by Gabriele d'Annunzio, an Italian warrior-poet who slept in a coffin, had his own private army and planted a

battleship in the garden of his estate (among other things). My kind of guy. D'Annunzio was the first of modern Europe's dictators, and in Fiume he created the archetype that would later be hijacked by Benito Mussolini and used as the foundation for his Fascist movement (the black-shirted Arditi and Roman salute, for instance). Later still, Adolf Hitler would borrow these elements from Il Duce for his own take on Fascism. However, despite d'Annunzio's staunch nationalism and his undeniable influence on the evolution of Fascism, his politics were more like something out of Plato's *Republic* than what would become later manifestations of Italian and German Fascism. Fiume, under d'Annunzio, was a city-state ruled by a philosopher-poet and was, undoubtedly, the most libertarian dictatorship of the 20th Century, if indeed it can be called a dictatorship.

Gabriele d'Annunzio is one of my personal icons and I'd wanted to visit Fiume forever. The locals knew the city by its Croatian name, Rijeka, and none of them seemed to remember d'Annunzio or know the whereabouts of what was once his palace (though there was a photo of it hanging on the wall of the local McDonald's). Some wandering about the steep cobblestone roads eventually lead us to the place, which had since been converted into a museum of history and nautical memorabilia. It was closed. The hours were something ridiculous, like 10:00 in the morning 'til 1:00 in the afternoon. Going around back we heard an opera singer practicing inside to piano accompaniment (very strange!). Albin spotted a huge marble slab leaning against the structure; it was maybe five-and-a-half feet by eight feet. Upon closer examination we discovered that the side facing the wall was inscribed with the names of important people who'd lived in the building at one time or another – among them Gabriele d'Annunzio and Benito Mussolini. This would've made a great souvenir; unfortunately it wouldn't fit in my luggage.

Part of the palace had been transformed into a nightclub called The Python. It was closed at the time of our visit but we resolved to drive up the coast and get a hotel, then return later in the evening. We adjourned to an outdoor café in a square beneath the palace. From where I sat I could look up a narrow cobblestone street and see the balcony where d'Annunzio had once addressed both the citizens of Fiume and members of his private army. In my mind's eye I could see him on the balcony, amidst the banners bearing his revolutionary slogan: "I don't give a damn." For a brief moment I felt as though I was actually being transported back in time and witnessing the event as it actually occurred.

After driving to Opatja and checking into a hotel called The Imperial (just our style!), we returned for drinks at The Python. The previously closed palace was now lit up brighter than a Christmas tree and its doors were wide open. It seemed that there was a classical music recital that night, so we got to see the interior of the palace after all. It lived up to the title of "palace," easily. The place was utterly lavish – all marble, gold leaf and full-on opulence – all that I'd imagined and more. A domicile fit for a king – or a dictator.

After exploring the palace we retired to The Python for some drinks. The bar had outdoor seating on one of the terraces that overlooked the palace's garden, and we drank there until late at night, surveying the scene where d'Annunzio must have spent hours; later we returned to Opatja and The Imperial, for more libations on its terrace as well. At the end of the evening, back in my room, I gazed out the window for a view of the Adriatic Riviera. Fog hung low upon the tree-lined hills, a full moon shimmered off the surface of the sea. This was what a tour should be.

The next morning we visited The Imperial's breakfast room, which was like a grand ballroom. One could easily picture Wolfgang Mozart or Richard Wagner giving piano recitals there. We were alone, but for one other couple. After a walk along the beach we headed north, toward Italy.

Predappio, Italy (Day One):

Nestled in the hills of Northern Italy is a small town inhabited by the friendliest people I've ever met in my life, bar none. If one evinces any interest in the topic of Benito Mussolini, they become friendlier still. The place is Predappio, the town where Il Duce was born. The town's tourist bureau directed us to a nearby hotel that just happened to be but half a block away from Mussolini's Casa Natale, the house where he was born, and for which the town is famous.

Predappio's main street is dotted by souvenir shops devoted to Mussolini memorabilia. Here one can buy Mussolini wine, champagne, aftershave (called Nostalgia), cigarette lighters, t-shirts,

posters, marble busts, snuff boxes, letter openers... you name it. Any conceivable product to which the image of Mussolini can be affixed is available for purchase. For those wanting to beef-up their collections of Fascist march music there's a nine-volume set of CDs to cater to the taste of even the most demanding completist (the songs sound like a cross between Italian opera and '30s movie music). After exploring the local stores, we sat down for a beer at a sidewalk café. Without prompting, an old Italian gentleman informed us that he hated Americans for having destroyed Mussolini's dream. Another old man sitting nearby nodded vigorously, obviously in agreement. Even after discovering that I was, in fact, an American, the old men were still cordial, gregarious even, and gave me a hearty handshake before ambling off.

Having learned that Predappio is also the site of Mussolini's crypt, we resolved to break into it, and late that same night, under cover of darkness, we made our way to the town's cemetery. After scaling a wall we wandered through the boneyard in search of Il Duce's grave. The place was like a ghostly fairyland, with each grave lit up by small light bulbs and flickering candles. The object of our quest was to steal Mussolini's brain, which was interred in a marble box inside a small glass case, separate from his body (after the war, the Allies had Mussolini's brain removed and shipped to the U.S., supposedly for a series of tests to determine his level of intelligence). We found the tomb, only to discover that it was – for all intents and purposes – impregnable, especially without the proper tools. We decided to return in the morning, when the crypt would be open to the public.

Predappio, Italy (Day Two):

Mussolini's tomb was now open, but filled with a coterie of reverent visitors. They spoke in hushed whispers as they gazed at the massive stone sarcophagus lined with fasces symbols. Above the repository for the coffin was a huge marble bust of Il Duce, and to either side a series of glass-fronted cases, inlaid within the wall. In one, a black shirt once worn by Benito was displayed. In another, his ceremonial hat rested. In a third were the items he had with him when he was captured and killed by partisans: his boots, his backpack, some maps and a crucifix. In a final display case, just to the right of the massive bust, sat the marble box containing the bisected remains of the fallen dictator's grey matter.

I no longer wanted to steal the brain. Seeing the look of awe on the faces of those elderly onlookers at just being in the same room as Mussolini's earthly remains made me rethink my plans. These folks nearly had tears in their eyes as they placed their wreaths and bouquets about the mausoleum, lit candles and signed the guestbook. In Italy, "nostalgic" is a euphemism for those who miss the times of Mussolini, and these folks are obviously *molto nostalgico*. I was touched by this exhibition of loyalty; one that hadn't faltered even after the passing of more than half a century. Moreover, I had to marvel at the thought of the kind of personality capable of inspiring such a longstanding faithfulness and affection; and that a man who had long since turned to dust should still live on so palpably in the hearts and minds of so many. We met these sorts of people at every turn of our journey. Old shopkeepers, spotting the black paramilitary clothing that Albin and I were always dressed in, ran out of their shops to drag us inside and give us gifts or show us pictures of themselves from the war. It was like visiting some parallel world where Italy never lost the war, and Mussolini's mutilated cadaver was never hung upside-down and spat upon.

After visiting the cemetery, we headed to a very strange little bar located in an equally strange modernist building (the only one of its type in Predappio). A massive tower thrust skyward from the building, visible throughout the small village, but (except for the bar), this building stood vacant. It's a shame, because it looked like the work of a futurist architect; some long forgotten, neglected masterpiece. After finishing our drinks at the bar, we then wandered around the building's perimeter, gazing into huge, dusty, empty rooms. The place didn't look as though it'd been used in decades.

Remembering a potentially substantial sum of money due me in the near future, I decided that this disused futurist building would be a nice place to live. I could really imagine residing in a structure like this and in a town like Predappio. It seemed a million miles away from the rest of the world. The place was so huge that, were I to become the owner of it, friends could visit for extended stays to escape the hectic pace of living in cities. I could build a recording studio there, put in video

editing facilities, a darkroom, you name it. The idea started to seem more and more attractive. When I later mentioned to a shopkeeper that the modernist building would be a nice place to live, she said, "Oh, you mean the old Palace Of Fascism?" I could just imagine giving visitors instructions on how to get to my new home: "Just ask anyone to direct you to the old Palace Of Fascism. It's right on the main square, you can't miss it." So if I ever come into a large sum of money, you'll know where to find me. For the moment, however, it was onward to Rome, "The Eternal City."

Rome, Italy (Day One):

We stopped at a large square to meet our hosts and have some drinks. When our hosts arrived they asked if we knew where we were. "What do you mean, do we know where we are?" "That balcony," they informed us, "is where Mussolini gave all his speeches." Sure enough, I recognized it from the pictures. The synchronicity continued...

Rome, Italy (Day Two):

After breakfast we were off to the site of the ancient Roman Circus Maximus. It had been turned into a park; green and peaceful. People were walking their dogs there, picnicking, jogging, and sitting in the shade of small trees, reading books. Here and there, lovers embraced and kissed. Few traces remained to remind modern visitors of the brutalities once enacted at that spot. Part of the original structure sat crumbling behind a chain-link fence at one end of the park, and along its length on one side were the cells which once held slaves, lions and Christians. I retrieved a brick from the ruins of the original edifice – a souvenir that *would* fit in my luggage – and we were off to Mussolini's Imperial Forum.

We were told that the Olympics were to be held there four years later, but not, I assumed, before some major changes were made. At the time of our visit, on entering the large promenade leading to the forum, one passed a gargantuan marble obelisk with "Mussolini" inscribed along the length of its front. Below his name was *DUX* (Latin for "leader"). Along the length of the promenade were elaborate mosaics depicting the history of the Olympic games – and of Italian Fascism. Small black tiles formed the images of legions of saluting blackshirts, rows of fasces, and Fascist slogans like *Molti nemici, molto honore* ("many enemies, much honor"). It was hard to believe that this place still existed in 1998, and harder yet to imagine that it still would in four years time. Imagine athletes from the four corners of the globe walking over mosaics proclaiming *Viva Il Duce*, en route to their competitions. Welcome to Italy.

That night our show was packed and the crowd was nothing short of Fellini-esque: men in military uniforms and women in fishnet body-stockings or g-strings and little else. We used so much fog that the audience couldn't see us onstage. They were lost in a sea of sound, smoke and strobe light. The response was great and after the show we stayed there at the venue, drinking 'til the small hours.

Rome, Italy (Day Three):

It was Sunday morning, and less than half a block from the restaurant where we had our breakfast was a church housing what were supposed to be the largest remaining fragments of the true cross of Christ. As we arrived, a Latin mass was going on. We went to the reliquary to discover that besides the cross fragments, the church also had on display two other supposedly authentic Christian relics: two barbs from Christ's crown of thorns and the bones from John the Baptist's index finger (which once touched the side of Christ). Good stuff, but not nearly as compelling as Mussolini's brain. Following this, en route to Germany, it was off to Lake Como to spend the night.

Como, Italy:

In Como we met our friend Marco, in a pizzeria. He asked if we'd like to see one of the most important

Italian works of architecture from the early 20th Century – the Como Palace Of Fascism. "Sure, where is it?" "Not far." As in Predappio, we walked but a half block to see an ultra-modernist building occupying a whole block. Built by a prominent futurist architect in 1936, this building would still have looked contemporary – even futuristic – in the '60s. In fact, it still looked modern as the end of the century drew near.

I'd seen enough of Mussolini's buildings by then (in Predappio, Rome and then Como) that I'd begun to get a sense of how Italian Fascism differed from its German counterpart. Whereas Hitler had tried to invoke the spirit of a glorious German past (by means of architecture, art and ritual), Mussolini had attempted to summon the spirit of a glorious Italian future. Mussolini had wanted to create a new world, whereas Hitler had tried to recreate an old one; one that perhaps never existed. I still find it very curious that no one (to my knowledge) has ever drawn this distinction before, especially considering that when you see the byproducts of what both men created, the differences are rather glaring and would seem to speak for themselves. Both bore about as much resemblance to one another as either did to Gabrielle d'Annunzio's state, though superficially all three would appear to have been one and the same.

Marco suggested that we continue the Il Duce "stations of the cross" by visiting the site where the dictator was executed by partisans. Unlike the previous locale, however, the next "station" was more than a mere half block away; it was 15 minutes, by car. But, he informed us, the site was marked by a huge block of stone bearing the names of Mussolini and his mistress, Clareta Petaci. So we decided to give it a shot. The 15-minute car ride stretched into an hour as we drove along the banks of Lake Como and later the hills just above it. We began to suspect that perhaps Marco had never really gone there before. After asking directions of locals, he finally located the site of Mussolini's execution. Instead of the huge stone monument we were expecting, there was just a small iron cross affixed to the entryway of someone's house, with Mussolini's name and date of death welded across it. According to the locals, the new story of Mussolini's death was that he was shot when he attempted to prevent partisans from raping his mistress, Clareta. They then shot her and staged his execution so that it would look like a political act rather than a gangbang gone awry. Apparently, a new "eyewitness" comes forward every year or two, and the world will probably never know with exactitude what really happened, or so they claim. Next it was off to Lake Garda, to visit Gabriele d'Annunzio's estate, Il Vittorialle.

Il Vittorialle, Italy:

After his "liberation" of Fiume, Gabriele d'Annunzio was one of the most revered men in Italy. So much so, legend has it that Mussolini bought him Il Vittorialle and supplied him with a princely stipend in order to keep him distracted from any interest in further pursuing a career in the realm of politics. It's said that the black-shirted fascisti, ostensibly there to serve as d'Annunzio's bodyguards, were in fact stationed there to keep him from leaving. Regardless, if Il Vittorialle was indeed his prison, d'Annunzio was the world's most privileged prisoner. He lived in a lavish, closed world of his own design, and the place was nothing if not excessive. Priceless antiques were crammed into every square inch, actual airplanes hung from the ceiling, there was a personal amphitheater, and, of course, the battleship Puglia (captured at Fiume) planted in the garden. Although on some evenings a chamber orchestra would perform on the ship's deck, a scaled-down version of d'Annunzio's private army actually lived aboard the ship as well. They fired-off 21 gun salutes when important visitors arrived (which was virtually every day), and he spent thousands of dollars a month just on the ammunition used for such salutes.

Less a home than a cross between a palace and a museum, Il Vittorialle was a shrine to the man who'd lived there: his fetishes, obsessions and excesses. On his death, D'Annunzio was buried there, surrounded by the Arditi who'd helped him conquer Fiume. Above the garden where d'Annunzio planted the battleship Puglia, the warrior-poet's mausoleum was made to survey his estate and the ship below. If ever there was a tomb befitting a warrior-poet, this was it. The interior of the house was just as impressive as its exterior and grounds; dark, yet luridly colorful. There was a d'Annunzio museum, replete with first editions of his written works, personal correspondence, portraits and

various bits of nostalgia. The site also featured a medal commemorating the triumph of Fiume (I have an identical one at home; on one side is the date of the liberation, on the other a sea of upraised hands brandishing daggers). I was particularly struck by one room in the building; it was empty but for a bed and some opulent statues, the walls covered by very dark-toned wood, and the ceiling a deep, lustrous blue illuminated by recessed lighting. This was where d'Annunzio's body was displayed at the time of his death. I couldn't resist the urge to leap over a small barricade and lie down on that very same bed; to rest my head on the same pillow that his head had rested on, both in life and death. Albin snapped a picture and then he too laid on the deathbed while I photographed him. I could have easily moved into Il Vittorialle and stayed forever, but our schedule dictated that we had to move on.

Hotel Fiordellichi, Italy:

A few minutes down the coast from Il Vittorialle is Hotel Fiordellichi, where d'Annunzio lived after conquering Fiume but before settling down at Il Vittorialle (1921-'23). Its front faces Lake Garda. We entered the hotel's lobby, which – much like Il Vitorialle – was like a palace. The tables bore old books: biographies of Claretta Petacci, and of Benito Mussolini (or Claretta and Benito), books about the Salo Republic, and so on. We wondered what the deal with all the Mussolini-themed books was, but soon discovered that while d'Annunzio had indeed lived there for a few years, the place was really famous for serving as home to Il Duce's mistress, Claretta. In fact, she and Benito lived out the last weeks of their lives there. It had begun to seem as though Albin and I were either blessed by a magic touch of some sort, or that every square meter of Italy is somehow tied into the life and legend of Mussolini. Because the place is still a hotel, one can rent Claretta's suite for $500 a night; the very room in which Mussolini and his mistress once fucked. And as if that weren't enough, for a few bucks less one can also opt to flop in d'Annunzio's old quarters, still a world historical place to call it a night. I decided that if ever I have a honeymoon (which I doubt), Hotel Fiordellichi will be the place. I was beginning to develop an intense affection for Italy, but alas, we had to leave, and headed north toward Germany.

Schloss Neuschwanstein, Germany:

We drove north towards Mannheim. En route we stopped off at Bavaria's Neuschwanstein Castle, the picturesque neo-romantic retreat of "Mad King Ludwig." Richard Wagner had stayed there for a time, and Walt Disney used it as inspiration for "Sleeping Beauty's Castle" in Disneyland. Ludwig was considered "mad" because the extravagant sums of money he poured into creating Neuschwanstein Castle threatened to destroy the economy of his Bavarian kingdom; and this is still the common wisdom regarding his legacy today. It's quite self evident to the casual observer, however, that by constructing the castle Ludwig vouchsafed a booming economy for this region for all time. People flock from all over the globe and pay money just to look at the place. While there they patronize hotels and restaurants that have sprouted up solely to accommodate visitors to castle. There are nearby souvenir shops dedicated to Ludwig and the Neuschwanstein, hawking every conceivable "Mad King" doodad (beer mugs, plates, busts; you name it). In short, Ludwig is a major industry for the region. But he wouldn't be generating any sort of economic prosperity if he hadn't left behind his castle. So who then is mad: a man who left posterity a monument of enduring grandeur and beauty, or those who continue to earn a comfortable living from it yet are incapable of recognizing his genius?

Heidelberg, Germany:

After spending the night in Mannheim with our friend Claus, we got up early and headed out to Heidelberg and Der Heilige Berg – The Holy Mountain. This is the site of one of the most famous pagan "Thing Places" created just prior to World War II. Built for the celebration of heathen holidays, as well as for various outdoor concerts and festivals, the site was designed to have perfect acoustics and seating for 8,000. One could easily imagine the sort of meetings that once transpired here under the stars, lit only by torches and bonfires. Though it had been long since overgrown with tall grass and weeds, the place still emanated a quasi-religious vibe. Even today, it would lend itself quite well to a

number of outdoor concerts I could think of right off the top of my head. Yes, it would be the *perfect* place for a concert. From this modern German pagan site, we proceeded to an ancient German pagan site.

Die Externsteine, Germany:

The Externsteine is a natural rock formation that looks strikingly unnatural. It is comprised of several stone towers thrusting many stories into the sky, looming ominously above the surrounding countryside. By means of flight upon flight of steps hewn from the very stone of the tower, one can climb to the top and see the high holy place (no pun intended) – a small cubicle with a sort of altar, carved from solid rock. Directly above the altar is a small round window, and at sunrise on the vernal equinox the sun shines through the aperture and directly onto the center of the altar. This is said to definitively prove that the ancient Germans possessed advanced knowledge of astronomy. The site has been a holy place for as long as anyone can remember and viewing it today one can still see why it has stirred feelings of awe and reverence for so many centuries.

Kenneth Anger filmed a movie at the Externsteine, in which he laid out Marianne Faithful in a sarcophagus carved into the solid rock (in the shape of a body). On finding the same sarcophagus, I couldn't resist the impulse to lie down in it myself. In ancient times it had been used for sacred rites of death and resurrection, but I was just as excited to know that Anger and Faithful had been there. After visiting the Externsteine it was off to Hannover and another show.

Hannover, Germany:

Great people, miserable sound system. Our hotel rooms looked like McDonaldland. White rooms with bright purple bunk beds and furniture. Off to Belgium for another show.

Belgium:

Great venue, great people. I gave an interview to Belgian National Radio before the show. Albin performed behind a huge curtain of camouflage netting, which looked great, but the audience couldn't really see him. After the show we hung out drinking 'til very early in the morning. There was a Lufthansa stewardess named Jania in attendance who was a friend of Tony Wakeford's (of the band Sol Invictus), and we had a good discussion about German schlager music. Next stop, Denmark.

Denmark:

My Swedish friend, Veronica, traveled six hours by train and ferry to see me, as had another Swedish friend, a fellow who goes by the name Mortiis. After the show, the club was closed down so we could have our own private party. We drank 'til dawn. Mortiis – already drunk from the mead and whisky we'd plied him with – began proclaiming his love of pain, and to prove it put out 10 or 12 cigarettes on his arms and stomach. At dawn, we headed back to our lodgings and Veronica and her friends headed for the ferry. Mortiis had met some girl and decided not to return to Sweden with the others. The two ended up at The Ritz, where Mortiis got a $300 suite. After going up to the room with him, the gal promptly informed him that she had to go to work. She left.

Dresden, Germany:

Dresden was a gas. Claus and his gang showed up. Albin and I met a couple of wild women from Munich and, tentatively, made plans to see them there later on the tour. After the show we went to a party in a castle. As we entered, one of my songs, "Embers," was being played. We soon tired of the castle and left.

Berchtesgaden, Germany:

En route to Munich we stopped to spend the night at the Hotel Turken in Berchtesgaden. The hotel was a stone's throw from the ruins of Adolf Hitler's old house, and was one of the only buildings in the area not reduced to rubble by Allied bombing during World War II. The hotel's foyer contained a gigantic heroic painting of a toiling peasant, no doubt dating back to the '30s or '40s. More recent pictures lined the hallways; depictions of kittens and puppies woven from yarn, undoubtedly the work of the hotel's elderly proprietress. Across from the front desk were photos documenting the hotel and surrounding area as it was during Hitler's time, along with aerial photographs of said area being destroyed by Allied bombs. The old gal behind the desk was ultra-friendly. She informed us that the refrigerator in the lounge was stocked with beer; to just mark down on a sheet of paper what we drank and we'd be charged at checkout time. I was a bit flabbergasted by how trusting these people were, the polar opposite of what you'd expect back in the U.S.. It was almost like traveling back in time to the 1950s, or perhaps the 1940s.

After stowing our luggage we went for a walk and took in the sights: the ruins of Hitler's house, the ruins of Martin Bormann's house and the ruins of Hermann Goering's house. At the ruins of the headquarters of the S.S. regiment that had served as Hitler's bodyguards, a farmer passed by, walking his dog. "Hitler isn't home today," he told us, "nothing much to see." He wandered off, chuckling to himself. We returned to the hotel for a lovely meal, then decided to have a bottle of wine and watch the sunset. We ascended a hillside that was once both Goering's front yard and Bormann's back yard, but had since been turned into a cow pasture. Sitting there was like sitting on top of the world. The view was spectacular, Wagnerian in its grandeur. The village in the valley below seemed so tiny that it could've been a thousand miles away.

The sun slowly vanished behind the craggy peaks in the distance and the twilight seemed to last for hours. Dark clouds gathered in the half-lit sky. There was absolute silence, but for the clinking of bells around the necks of cows grazing just up the hill from us. I began making mooing sounds to the cows and one of them started walking in our direction. Then another, then another... soon we were surrounded by cows. We fed them some apples and they began to rub their heads against us, like family pets requesting attention. As we petted them and scratched their necks, they held their chins out and closed their eyes, not unlike a cat would. These cows were as friendly and trusting as the old lady who ran the hotel. When total darkness fell and we left, the cows followed us right up to the gate at the edge of the field. Albin commented that this was typical of our trip; everyone liked us wherever we went – even the cows. Back at the hotel lounge we drank several beers (dutifully marking down our consumption on the sheet provided) and then retired. As we drifted off to sleep we could hear the distant clinking of cowbells from the hillside across the road. Our friends.

The next morning, after breakfast, we checked out the hotel's downstairs attraction: Hitler's Führerbunker, an echoey labyrinth of seemingly endless hallways and staircases. Great acoustics. Hitler's sealed off quarters – walled up behind bricks and cement – were lined with marble and fine hardwood, or so we were told. The rest of the place was cold, damp and somewhat moldy. From there we took a bus up to the top of the hill and The Eagle's Nest, Hitler's personal tea house. To get to The Eagles Nest, one must enter via a long tunnel carved through solid rock, then take a huge brass elevator up. Once on the terrace the view seems endless; the horizon stretching forever and vanishing into mist. Looking down at the hillside where just last night we'd watched the sunset, it appeared tiny below us, as if it were at the bottom of an abyss. Just the night before it had seemed like the top of the world.

Munich, Germany (Day One):

In Munich we checked the tourist bureau at the train station for hotels. The place we got happened to be a block from The House Of German Art (built by Hitler), and a stone's throw from a massive monument called the Feldherrenhalle. But what excited me was that it was only a few blocks away from the Englisher Garten, the park where my super heroine Unity Mitford shot herself in the head. I'd always wanted to visit the park and had driven by it on past trips, never having enough time to stop.

Mitford was an eccentric British aristocrat who, as debutante in the 1930s, dreamed of learning German, going to Germany and meeting Hitler. Remarkably, she did just that. She'd been

conceived in a small town in Canada called Swastika, and at birth was christened Unity Valkyrie Mitford. She believed that her name spelled out her destiny; that she was in fact a Valkyrie preordained to create unity between England and Germany, two nations she loved dearly. She would parade the streets of cities in both nations dressed in full Fascist regalia: black shirt, black necktie, black skirt or trousers, Fascist pins and Swastika badges, and black leather gloves. Talk about making a bold fashion statement!

Unity was so well liked by Der Führer that she often dined with him at The Reich Chancellery and Berchtesgaden. She even accompanied him on holidays at Wahnfreid, Wagner's house. She did her utmost to convince Hitler that he should ally himself with England, but when war between the countries was declared, she went to the Englisher Garten and despondently attempted to blow her brains out. She lived, but eventually died from her wound when the bullet (which couldn't be removed) shifted and caused hemorrhaging.

Unity's sister married British Fascist Oswald Mosely, whose grandson I once met in London, at a performance by The Jim Rose Circus Sideshow. When I expressed an interest in Unity he offered to introduce me to her sister, Lady Mosely, his grandmother. Alas, the meeting never took place and I regret having missed out on the chance. I also regret having missed out on the chance to meet Unity herself, for reasons that go beyond merely her excellent fashion sense. She was a woman unlike others of that time. One story about her relates how the people who lived in her boarding house returned from church one Sunday morning to discover that Unity had relocated every radio from the premises, put them all in the garden, tuned them all to different frequencies, and had the volumes turned up full blast – a full 40 years before industrial music. Wow! My kind of gal indeed.

Albin too was anxious to see the Englisher Garten, having wanted to visit the oriental tower there since childhood. He'd made plans for us to rendezvous there with the girls from Dresden, at a beer garden near the tower. We dined at an outdoor café, strolled over to Feldherrenhalle, and then onto the garden. The girls arrived before us and had already half-finished their beers, drinks that could most succinctly be described as a six-pack in a glass. Massive great things they were. We sat around all day drinking, talking and laughing, until the place closed down, the lights finally went out and most of the clientele stumbled off. I was soon to learn of a charming German folk custom I'd never heard tell of: when the beer garden closes down it becomes transformed into a sex garden, with the couples left behind having open sex on benches and atop picnic tables. Say what you may about the Germans, they certainly know how to have a good time. We stayed there 'til 4:00 in the morning, long after everyone else had left. Afterwards, the girls were scared, as people were frequently murdered in the park, so we accompanied them to a main thoroughfare where they set off in search of a taxi.

Munich, Germany (Day Two):

The next morning it was off to The House of German Art. Since Hitler's day it had apparently been converted into a permanent exhibition of *entarte kunst*. Oh well. We hit the road to Bayreuth and Wagner's house, Wahnfried. Located on Richard Wagner Strasse, right off of Franz Liszt Strasse, the place had been converted into a Wagner museum, and having just missed its closing by minutes we contented ourselves with wandering around the grounds. Just contemplating the various historic figures who'd passed through there, both before and after Wagner's death, boggled the mind. The house looked smaller than I'd imagined from seeing pictures of it, yet it radiated a sense of stern dignity. On to Leipzig.

Leipzig, Germany:

We arrived at a hotel Albin knew and it turned out that I'd stayed there before with Doug Pearce, David Tibet (of the band Current 93), and Tibet's ex-girlfriend "Thorn." The next four days were a blur of non-stop activity. A goth music festival was taking place and the city was packed-out with 12,000 black-clad visitors. Albin and I weren't playing there, but had V.I.P. passes and so got into everything for free, as well as free meals, free booze, everything. Mortiis was there and so were a lot of other friends and people who we'd met on tour.

We saw Tony Wakeford play twice and sat in as he gave a press conference. I unintentionally

created a disturbance at one of Tony's concerts by walking atop an awning that was falling to pieces and then scaling a tower to get a better seat. The awning looked so dangerous and unstable that people thought I was going to fall through at any second. As I made my way across it, the crowd turned away from the stage to watch me and started snapping pictures. Tony glanced up to see what they were looking at and when he spotted me he simply shook his head and rolled his eyes. By the time we left Leipzig people were already circulating the rumor that Albin and I were running around nude on the roof and dancing nude atop the towers.

Throughout the course of the tour Albin had begun to notice that whenever he became involved with females there was bound to be friction and trouble. He noted that when it was just us fellas everything went smoothly, but the presence of women seemed to create lots of unnecessary problems. Albin and I both like girls, but we both also dislike problems. When people give us too many problems in proportion to the amount of fun they provide, it's our natural instinct to simply walk away. On tour it's usually easy to walk away from anyone who's boring or annoying; we just go backstage or back to the hotel, and the next day we're off to another town. But the festival in Leipzig lasted for four days, and it was there that two women began to stalk us – literally. They'd first shown up knocking on our doors at 4:00 in the morning; we sent them off, but when we left at noon the next day, they were still sitting on the hotel's front steps. Everywhere we went in Leipzig these two women would appear. I stayed at the hotel the last day of the festival but Albin went off to see some friends from Sweden. He and the Swedish boys formed some sort of organization for men only. No women allowed. It was kind of a joke, but he seemed to be taking it quite seriously. However, I doubted that anyone as girl-crazy as Albin could live up to the ideal of this anti-woman creed for any substantial length of time.

Prague, Czech Republic:

We arrived in Prague to find huge posters for our show completely covering the walls of some buildings. Across from the venue was a hotel offering free beer with the rental of a room. I decided that was where I wanted to stay for the evening.

A local band had been added to our show's bill without our consent. It had about nine or 10 members, not including their dogs. We always hate it when there's a dog in the venue. We especially hate it when the dog is wearing a bandana around its neck. These people had two dogs with bandanas. We knew just from looking at these assholes that they were the type of folks who would go on for hours once they got on stage, so we refused to play unless they went on last, so we could leave and not have to watch them. But that wasn't enough for Albin. He took the fuse out of their synthesizer and smashed it beneath his heel. As it turned out this band was so offended by the two of us that they packed up their stuff and left of their own accord. I still wonder how long it took the band's synth player to figure out what was wrong with his instrument.

Our soundman was late, but we were told that he was the best in Prague. He had his own industrial band and understood all the ins and outs of avant-garde music. As it turned out, he was totally worthless and we almost canceled our show because of him. For some stupid reason half of the sound system equipment was at his mixing desk and the other half was behind the stage. He kept running back and forth between the two halves of the system, trying to figure what to turn up to get sound to come out of the speakers. At the last possible second he somehow figured it out and, to our great surprise, it turned out to be the best show of the tour.

After the show, our driver, Sven, wanted to head straight back to Vienna. If we drove all night we could be there by dawn, he assured us. I wanted to go the hotel with the free beer, as did Albin. Albin and I had also planned to checkout the cathedral where the partisans who'd assassinated Reinhard Heydrich were gunned down (you can still see the bullet holes in the wall), but Sven was anxious to get home, so we left. For some reason or other, I always end up leaving Prague prematurely.

Vienna, Austria:

As we pulled into Vienna, having finished our tour and driven all night from Prague, the sun was rising; and we found Albin's ex-girlfriend Alzbeth in the process of moving out of the apartment

they'd shared. She and Albin had been in a band together called The Moon Lay Hidden Beneath A Cloud. When the two broke up, so did the band. Now Alzbeth was carting off all the equipment the two had purchased together, as well as a lot of things that had belonged to Albin before they'd even met, let alone dated. Albin had hoped that they could eventually work out their difficulties, but now things were turning acrimonious and ugly. Virtually every single day for two weeks following Alzbeth's departure Albin would discover another several items of his that were missing (that she'd stolen). Albin even changed the locks on the door, but she somehow got back in to take things that she'd initially overlooked, such as the master tapes to their former band's CDs.

Alzbeth had called everyone we knew to inform them that Albin had come home early, caught her leaving, and had beaten her severely. It never happened. She'd also called Albin and told him that I was just a loser who was using him to "advance myself." She further claimed that Doug Pearce was doing the same thing; that Doug was just an alcoholic homosexual who'd run out of ideas years ago and was recording with Albin not because he liked him or respected him, but to use him. She'd always really liked Doug and I while she was dating Albin, but all of a sudden we'd apparently become the scum of the earth; "losers."

Looking at what little remained in his empty, ransacked flat, Albin couldn't believe his situation. Alzbeth had taken everything but the toilet paper. It was as though everything Albin had said about women creating problems earlier in the tour had been a kind of self-fulfilling prophesy, far truer now than when he'd begun expressing the idea. I told him that this was the kind of *tabula rasa* he needed: a clean break and a new beginning. Sure enough, he got a far nicer apartment, in a nicer part of town, in only a few days time. By now he probably has nicer equipment and, perhaps, a nicer girlfriend as well.

My last few weeks in Vienna were nothing if not idyllic. In showing me around the town, Albin went to places he'd never been to before or hadn't visited in years. We saw the Spear Of Destiny. We took in the War Museum and saw the flyers that Gabrielle d'Annunzio had showered on the city from his plane. We saw the crypt in Saint Michael's Cathedral, with its ancient, shriveled cadavers, its stacks of skulls and piles of bones. We went to the flea market and I scored a record I'd wanted for years – a 45 of German pop star Heidi Bruhl doing a song called "Mr. Love" (it's a classic). The flea market also had an Italian Fascist uniform that fit me perfectly (which is remarkable since I'm six-three and most World War II era stuff was made for people not nearly so tall). Nevertheless, I passed on the uniform, despite its perfect fit. Olive drab just isn't my color.

I could get used to living in Vienna. When we weren't sightseeing, Albin and I spent afternoons at sidewalk cafés and evenings at beer gardens. You don't really get sidewalk cafés and beer gardens in Denver, Colorado. In Denver I'm a recluse; I cherish my solitude. At home, solitude is always luxurious compared to going places, doing things and seeing people. Strangely enough, when I'm on tour I quite enjoy going places, doing things and seeing people. It's a real study in contrasts, being around people 18 or 20 hours a day – every day for a month or six weeks – versus being totally alone most of the time. It's the best of both worlds, really, and each seems a good counterpoint to the other.

Addendum:

In reviewing these notes upon my return to Denver, I can see that an awful lot has escaped documentation. I've failed to note a number of visits to the graves or birthplaces of people either famous or infamous. I could have written pages on the amazing Park Of The Monsters in Northern Italy, or Lanz von Liebenfel's castle for The Order Of New Templars in Austria. What I've written here is little more than a thumbnail sketch of what we did and where we went. But then again, I could have written page after page more about any one of these places. Nonetheless, it's a pretty representative overview. Even now, as I write this, I'm making plans to return to these places sometime soon, and to go to all those sites I missed out on during my previous visits. It'll be even better next time; and who knows, maybe next time we *will* steal Mussolini's brain.

Paradise Lost

(Originally published in *Taboo: The Art Of Tiki*, 1999)

Every man, whether he knows it or not, feels some primordial attraction for the allure of paradise. After all, down the centuries the world's major religions have all been formed on some intangible paradise or another being promised as a reward for earthly toils. I grew-up in the 1960s, a time when that notion of paradise became a pop culture phenomenon, manifesting itself in music, film, television, cocktails, fashion and so on. Inspired by the recent statehood of Hawaii and bolstered by returning World War II G.I.s' tales of adventure in the tropical paradises of the South Pacific, Americans' fancy turned toward a simpler, idealized time and place; one far-removed from the stresses of modern life in the Cold War era. In the 1960s a phenomenon known as "tiki culture" or "exotica" offered Americans a respite from modern living, if only for the time it took to play a Martin Denny record or sip a Mai Tai at a tiki bar.

The re-emergence of tiki culture in the 1990s serves basically the same function today as it did when I was growing up, except that today, people's yearning for a long-lost paradise is also coupled with a desire for that long-lost golden age when tiki bars studded the American landscape. For modern youth, the late 1950s and early '60s now represent that simpler time and place; an era that, perhaps, is *their* version of paradise lost. Many of today's tiki-hounds don't actually have roots in that era; they grew up in the 1970s and 1980s. I grew up in the late 1950s and '60s, and remember it all as though it were yesterday.

In Southern California, where I spent my formative years, tiki culture was inescapable: the suburban landscape was dotted with backyard barbecues, fake waterfalls, life-size carved tikis, tiki torches and strings of brightly-colored party lights shaped like the massive stone heads from Easter Island. This was a time when, for every paranoia-inspired concrete fallout-shelter built in a suburban backyard, it seemed there was also a faux-Polynesian tropical paradise constructed just next-door.

More definitive of the exotica craze, however, were the era's tiki-themed restaurants. In southern California alone, there were dozens of them, and they were all amazing. The Bali Hai, an expensive spot on the San Diego bay, featured a gigantic thatched roof, at the center of which was a massive carving of a Polynesian man with a bone through his nose, and the restaurant also boasted of having The Arthur Lyman Group as its live house-band for a number of years. The Kona Kai, another classic tiki joint, supplemented its exotica cuisine and décor with an actual stream that flowed through the restaurant; and at The Reef Lounge one could dine on Polynesian cuisine whilst observing half-naked "mermaids" dance an underwater-ballet behind glass walls. It was a great time for suburban Southern California; even Disneyland had "The Enchanted Tiki Room" in answer to the trend.

But it wasn't just backyard tiki bars and exotic restaurants that made the early 1960s a modern tiki-hound's wet dream; tiki culture abounded and ersatz paradise was everywhere. My favorite TV show at the time was *Hawaiian Eye*, a program about a private investigation agency in Hawaii. Many of the on-location shots for the show were filmed in Waikiki's International Marketplace, where exotica music pioneer Martin Denny had first made his mark, but it was Arthur Lyman, Denny's California-based exotica contemporary, who provided the music for the program. I also loved *Adventures In Paradise*, a program about a tiki-necklace-wearing adventurer (played by Gardner McKay) who sailed his yacht, The Tiki, from one exotic port to another, and found himself involved in an exciting new mystery each week. Tiki culture also made its way into the world of film, and the period saw the release of a number of exotica-themed movies, including: *Donovan's Reef, Bali Hai, South Pacific, Goin' Coconuts, Paradise Hawaiian Style, Beach Party*, and Elvis Presley's *Blue Hawaii* (yes, even the king of rock n' roll answered the call of the exotic).

Near my hometown of Lemon Grove, there was even a chain-store called Robert Hall that sold exotica-wear for kids, and each pseudo-Hawaiian shirt they sold came with a matching tiki necklace. The shirt I got was colored lime-green and avocado, and had three-quarter-length sleeves; the tiki necklace that came with it had lime-green rhinestones for eyes, to match the shirt. When I wore this outfit to school, I felt like the hippest kid at Bancroft Elementary. In short, exotica and tiki culture were simply *all-pervasive* in the late 1950s and early '60s. It was a strange time in American

pop culture.

As the years passed, the cultural landscape changed and exotica faded from prominence, eventually making the transition from hip to kitsch. My childhood enthusiasm for tiki culture also shifted into teenage years occupied by other interests, and I too all but forgot about it, until (in the latter part of the 1970s) a bit of serendipity brought it back to me full-force.

I'd traveled to Los Angeles with two friends to see a concert, and near the venue a strange apparition caught our eyes: the legendary Hawaiian barbecue, Kelbo's. The building looked positively *wild*. It was surrounded by large tikis and tropical foliage, and its walls were decorated with murals that dated back to the late 1950s. These depicted native chiefs and topless maidens amid scenes of tropical paradise, and in one such mural, native men were running toward a canopy of jungle-trees carrying naked women on their shoulders, while creatures seeming to be half-ape, half-man, chucked coconuts at one another. It was compelling stuff! Could a mere dining experience truly live up to the kind of idyllic primitivism that these murals seemed to promise? We had to see.

Inside, Kelbo's was more excessive still. The place was very dark, and as our eyes slowly adjusted to the darkness it seemed that every square foot of the restaurant's available space was occupied by some garish trinket or display. The ceiling was covered with plastic foliage and fishing-nets bearing various shells and starfish, and in places was even further festooned with dried puffer-fish converted into lamps, each of which had a different colored-light inside, which emitted a soft, eerie glow. On a bamboo platform behind the cashier there laid a mannequin in a diving-suit which had been stabbed in the chest with a knife. There was an entire wall made of Lucite, and embedded in it were hundreds of doodads from 1963, the year the wall had been made. This vertical time-capsule contained a nonsensical assortment of items, none of which seemed to bear any relation to the others: Barbie dolls, lipstick, cap-guns, children's toys, even two fried eggs. How any of this related to the theme of the restaurant I couldn't figure then (and still can't), but it was stunning and mind-boggling, and in a lurid Pop Art sort of way, beautiful.

The restaurant itself was much like a jungle; made-up of a series of dark labyrinthine passageways lined with enclosed booths. The booths were almost like small grottos, and seemed like self-contained total environments representing someone's fevered dream of what tropical paradise *might* be like. The booths' tables had tops of thick resin, which were embedded with shells, seahorses, gold coins, and other assorted seafaring paraphernalia, and each table also featured a kerosene lamp in the shape of a tiki. The passageways connecting these microcosmic booth-environments appeared to snake around endlessly, and it almost seemed that a customer who left their booth in search of a restroom might never find his way back.

Kelbo's drink menu featured cocktails with names like "The Skull & Bones," (which came in a skull-shaped mug and arrived at your table *on fire*), and also included commentaries such as, "this one's Johnny Carson's favorite!" or, "this is the big artillery here, better watch out!" The restaurant's napkins bore a drawing of a strange ape-like creature holding a coconut and staring at a sign that read, "IITYWIMWYBMAD." When I asked our waitress what this meant, she retorted, "If I tell you what it means will you buy me a drink?" I told her that I would, and she informed me that – no, she wasn't asking for a drink – that was what it *meant*: "IITYWIMWYBMAD" was an anagram for the phrase, "If I tell you what it means will you buy me a drink?" Bar humor.

The Kelbo's concept for what constitutes Hawaiian food was a simple and straightforward one: just add pineapple to everything. Even the burger I had came with a slice of pineapple on it. Although unusual, the food was actually pretty good, but that didn't really matter either way. What you were paying for at Kelbo's was obviously the experience of spending an hour or so in a kind of anachronistic parallel-universe, a thousand miles removed from the modern world that existed just outside its doors.

My friends and I all realized that we'd stumbled onto something important at Kelbo's. The hokey imagery of paradise-lost that at first appeared kitschy, started to seem like a really potent kind of *primal symbolism*. Being in Kelbo's was actually like experiencing paradise. The fact that it was all false didn't lessen its impact at all. It was evocative. It was like eating a meal at Disneyland.

After having this epiphany, my quest to seek-out and discover the last remaining vestiges of exotica and tiki culture began in earnest. Returning home from my visit to Kelbo's, I dug-out my old Martin Denny albums, which a biker-friend of my father's had turned me onto years earlier, when I

was just an adolescent. He'd passionately claimed that Denny's exotica music was, "the best music on earth," and virtually forced me to sit down and listen to both sides of Denny's *Exotica* album on headphones. He'd further posited that this music was the only music on earth capable of bridging the generation-gap, because it managed to be beautiful and mellow enough to appeal to older people, yet psychedelic enough to appeal to the young as well. I can still picture this particular bearded, leather-jacketed, hard-ass biker character extolling the virtues of exotica music in my parents' living room. It's certainly an incongruous image; a burly guy with Swastika tattoos holding a 1950s record cover that featured Sandy Warner peering out from behind a bamboo curtain. But his argument made perfect sense, and his proselytizing of exotica sure had an effect on me.

Back in those days, every thrift-store had multiple copies of Martin Denny's albums, and in no time I had a few dozen; before long I was a devoted exotica fan, with a record collection that included almost everything by Martin Denny, Arthur Lyman and the few others who'd followed in their wakes. Visiting Kelbo's with my friends had inspired me to revisit my collection of Martin Denny records, and this too rekindled my fascination for tiki culture in general. A couple years later, a friend informed me that Martin Denny was still playing on the island of Kauai, and upon learning this, *that was it* – I was off to the islands on a pilgrimage to see the high holy man of exotica music.

I went first to Honolulu, to visit what constituted exotica's "stations of the cross": Henry Kaiser's Dome Theatre, The International Marketplace, The Shell Bar, Trader Vic's and so on. The Shell Bar no longer existed (the victim of remodeling a decade prior), but at The International Marketplace I came across the very tiki next to which The Martin Denny Group had posed for a photograph which appeared on the back sleeve of their definitive album, *Quiet Village*. It was a peculiar tiki, which – unlike most – had an almost human-looking head (when I came back to revisit this tiki a year later, it had been removed). After hitting all the requisite Honolulu tiki sites, I spent a few days leisurely soaking up paradise; lounging on the beach at Waikiki by night, drinking daiquiris and listening to Annette Funicello sing her rendition of the song "Waikiki." It was idyllic; a paradise of perfection. But I was anxious to see the father of exotica music, and so I soon made-off to the island of Kauai.

When I walked into the room where Martin Denny was playing at the Weilea Beach Hotel in Kauai, it was pure magic. Seated before a piano in the corner of a darkened room, Denny was brilliant at the keys. I immediately ordered a cocktail that came in a hollowed-out pineapple. *This* was the way to properly experience Martin Denny's music; in a lavish Hawaiian hotel, sipping an exotic cocktail. It was definitely one of those peak, perfect life-experiences, and I savored every moment of it.

The highlight of the evening came when Denny played "Quiet Village," his hit. While performing "Quiet Village," he switched-on a tape-player and the sound of squawking birds filled the room, just like on the album. Many of the tourists present, unfamiliar with Denny's early work, seemed a bit perplexed and stared around the room in confusion, seeming to think that a flock of birds had somehow flown into the hotel and were now trapped in the lounge.

When Denny took his break between sets, I approached him with my stack of his albums for him to sign, and also gave him a copy of Throbbing Gristle's *Greatest Hits* album, which had just been released and featured a mock Martin Denny album-cover, as well as a dedication to him. Denny was excited to learn that young people were still inspired by work he'd done 20 years previous. After chatting with him for a while, I made arrangements to return when his performance was over, to conduct an interview, and as he began another set at the piano, as I headed-out to see the sights.

I came back later that evening and caught the end of Denny's final set, following which the two of us stood in the hotel's lobby talking until nearly four in the morning (this despite the fact that he had to rise early for an important appointment that day). The interview I conducted with him that night would see print in an exotica 'zine called *Ungawa!*, and would so further incite my interest that I would again interview him in later years for the New York-based music magazine *Seconds*.

Martin Denny was quite aware of the irony that his music is intrinsically associated with Hawaii, yet isn't the least bit Hawaiian in origin. Hawaiian music is played on ukuleles and steel-guitars. Denny's exotica music is piano-based with accompanying vibes, percussion and sundry ambient sound-effects. Nonetheless, by creating a lush ambience that's evocative of paradise, Denny's music is perhaps truer to the *spirit* of Hawaii than anything ever to come out of the island's more authentic musical tradition. Over the years Denny's met thousands of visitors to Hawaii who've informed him they'd wanted to visit the islands ever since first hearing his music. If he saw even a

small percentage of the business he's generated for the islands he'd be a very rich man indeed. Regardless, for Martin Denny, the idea of paradise was not just an empty concept, but a way of life. He *lived* it. He spent his days at the beach and on the golf course, and passed the evenings playing piano. He was clearly a man who was getting exactly what he wanted out of life, and this too was inspiring.

Back on the mainland, after my visit to the islands, any traveling I did henceforth became a pretext for my ongoing exotica pilgrimage. Throughout the 1980s, I crisscrossed the western U.S. from tiki bar to tiki bar, and at the time nearly every place still had some remaining vestige of tiki culture left. I was amazed by the sheer amount of variation that seemed to exist from one tiki bar to the next, and the degree of excess and extravagance seemed over-the-top in even the most subdued tiki bar. They were seldom disappointing, and even the most tasteful examples seemed possessed of a garishness and naïve romance seldom found in modern life. They all seemed to embody the spirit of another time, if not another place.

Phoenix, Arizona, had a tiki motel called The Kon Tiki, which I visited in the course of my travels. Its slogan was, "a little bit of Honolulu in Phoenix." Except for the heat and humidity, Honolulu and Phoenix couldn't be more dissimilar; and yet the motel looked like it had been plucked from Maui and unceremoniously deposited in the desert.

Hunting through oddities in a thrift-store I came across a tiki mug marked "Harvey's Sneaky Tiki, Lake Tahoe." The mug looked to be from the 1950s, so I assumed that the place it advertised must long-since have vanished, but when later visiting Lake Tahoe I was pleasantly surprised to find that Harvey's Sneaky Tiki still existed (on the top floor of Harvey's Hotel and Casino), and it looked as if it must not have changed in 20 years.

In nearby Reno, Nevada, I discovered a place called Trader Nick's that was much smaller, but equally lavish. A lot of bars had tried to cash-in on the success of the well-known Trader Vic's chain, as the name had become so synonymous with tiki bars that even those sounding somewhat similar could communicate to potential customers exactly the sort of exotic ambiance they could expect within. So, I've been to Trader Nick's, Trader Mick's and Trader Dick's.

Traveling down California's Pacific Coast Highway, I once spotted an ancient-looking sign for a place called Trader Ric's. The huge tiki on the sign looked so faded and weather-beaten that I doubted the place even still existed, but at the outskirts of Pismo Beach, I spotted it: there were tikis and a catamaran out front. The parking-lot was empty, but I drove-in anyway, and miraculously, it was open. The restaurant's main dining room overlooked the ocean, and as you ate you could watch the waves crash against the rocks on a cliff below. There were no other customers during my visit and thus the atmosphere was unnervingly haunting. It genuinely seemed as though I had walked into a scene from another time; a remnant of a past world. The world of which it was once a part obviously no longer existed, and it seemed that it, in fact, couldn't much longer survive in this world either. I felt a sense of melancholy and a heightened awareness that I was experiencing one of the vestigial remains of a phenomenon whose day had come and gone; and I knew that even this last bastion of it would soon vanish too. I was quite saddened at being faced with this realization, as I knew only too well that I'm usually correct in predicting these sorts of things.

It didn't take terribly long to see my worst fears were indeed well-founded. In the early 1980s, a few girls and I went to The Reef Lounge to check out the topless mermaids and found that the restaurant had closed a few months previous. Similarly, a friend of mine went to visit a tiki palace he'd often viewed from a train, and arrived just in time to see the building being demolished. One after another, the great old exotica places began to vanish. Even Trader Vic's closed its San Francisco location after some 30 years in business at its Cosmo Alley location. Kelbo's lasted until the 1990s, but like most of the others, finally shut its doors to make way for a strip club.

But while the bad news is that a lot of the great tiki places are nothing but a memory, the good news is that one of the very best of the tiki bars has managed to survive and prosper. I'm speaking of course of San Francisco's Tonga Room at The Fairmont Hotel. The Tonga Room began its life as The Fairmont's indoor swimming pool, but when the exotica fad hit, the management decided to turn the space into a tiki lounge. They scattered the pool's bottom with various shells and starfish, thereby converting it into a sort of ersatz lagoon, and surrounded two sides of the pool with thatch-roofed huts for patrons to drink and dine beneath. In addition to this, management painted the

ceiling black so as to give the illusion of being out-of-doors, under a night sky; but it was the final touch that was sheer genius – they installed an elaborate sprinkler system above it all to replicate the experience of a tropical downpour. That's right, every 20 minutes or so the restaurant is filled with the sound of prerecorded thunder, there are flashes that appear to be lightning and then streams of fake rain pummel the pool for a minute or so. It's a low-tech spectacle that never fails to enchant even the most jaded of viewers. Not only that, but at a certain time each evening, a small boat containing a live band floats out into the center of the lagoon and plays for the remainder of the night. The Tonga Room may well be the last fully intact bastion of a once-booming phenomenon which has since gone the way of the dodo bird. If it is one of the few remaining vestiges of what exotica was at its apex, we can at least take some joy in the fact that it's also one of the best manifestations of the trend.

William Butler Yeats once said that there is something essential in the nature of man which causes him to feel a deep affinity with (or yearning for) another time or place, whether real or imagined. In the 1960s, exotica was a large-scale manifestation of that impulse; and the remembrance of that bygone era in today's latest exotica renaissance is no doubt only the most recent incarnation of that same timeless impulse.

Remembering LaVey

(Originally published in *The Black Flame*, 2000)

"Dead people belong to the live people who claim them most obsessively."
– James Ellroy

I was in New York City when I got the news. I'd just given a concert and was at a post-show party being thrown in our honor at a local club called The Bank. A half-dozen or so Church Of Satan kids were gathered around my table, full of questions about the organization's legendary founder and figurehead, Anton LaVey.

"What's he really like?" they queried, and I responded, "Like no one I've ever met before or probably ever will meet again." The questions came fast and furious, until one fellow asked, "Who's going to take over The Church when Anton dies?" "He's too mean to die," I shot back. "He's told me that he can't afford the luxury of death, because his passing would please too many assholes. So he's just going to have to tough it out and will himself to live forever." This response brought chuckles all around. "Besides," I continued, "no one could fill those shoes, *ever*."

By and by, a girl approached me and informed me that I had a telephone call. The phone was in the basement. On the line was fellow Satanic magister, Peter Gilmore, and he sounded strange. His voice was hoarse, strained. "I'm afraid I have some bad news," he started, and a chill ran through me; I knew the rest. In the milliseconds before he continued, my mind raced to reassure itself that the bad news couldn't be *that* – Anton LaVey couldn't be dead. My mind raced, and I thought to myself, "But he's still so young... but I just saw him." But this, but that.

Peter's words left me numb. I had just seen LaVey in San Francisco not so long ago and interviewed him for *Seconds* magazine while I was there. He'd seemed so hearty and vivacious. He'd recently received the transcript of the interview and the intro I'd written for it, and had called me up, thanking me profusely (he was always very grateful for any little thing you did on his behalf). We'd had a great conversation on the phone that day; he was in high-gear and sounded ready to take on the world. His energy and enthusiasm were so infectious that at the end of a meeting or conversation, you'd invariably be so charged with adrenaline and so stimulated by the exchange of ideas, that you yourself felt ready to take on the world. The Doctor (as he was called by friends) signed-off that day with a gruff, "Hail Satan!" and little did I suspect that those would be the last words he'd ever speak to me.

Though I seriously thought he would be around for many more years yet, I had nonetheless considered the notion of LaVey's mortality on a few recent occasions. Shortly before his passing, my friend Giddle Partridge had called to tell me of a recent dream she'd found disturbing – in it, she'd been someplace-or-other and bumped into LaVey, and he asked her if she was going to be seeing me anytime soon. "Sure, I see Boyd all the time," she replied. "Well," he said, "the next time you see him, let him know that I'm planning my funeral." The following night, LaVey appeared in another of Giddle's dreams – "Have you seen Boyd yet?" he asked. No, she hadn't. "Well, be sure to give him my message. It's important."

Giddle was haunted by the macabre dreams and called me as soon as she awoke from the second one. I dismissed them offhand as just dreams, yet can't deny that I was disturbed. So much so, in fact, that I squeezed in a trip to San Francisco a week before I was due to leave the country, just so I could see LaVey. I'd initially thought it would be far less hectic to interview LaVey after my return from Europe, but (in part inspired by Giddle's dreams) decided to squeeze it somehow into my schedule. Seeing LaVey during that visit, he seemed so hearty and fiery, that all thoughts of Giddle's creepy dreams vanished... only to return on the train journey home.

Back in Denver, transcribing my interview with LaVey, my thoughts drifted to Tiny Tim and how I had interviewed him less than a week before his death. I thought about how much I missed him and what a great loss it was. There was no one else quite like Tiny, except – in an odd way – Anton. Ruminating on this, the image of Giddle's morose dreams returned to me. I stared down at the yellow legal-pad on my lap, its lines covered with LaVey's words and ideas. Suddenly, a terrible thought crept

into my mind. Was it possible that I would lose LaVey as suddenly and unexpectedly as Tiny? After all, Tiny had a heart attack recently before his demise – sure – but he'd sounded so strong and vibrant when last I spoke to him, that I never would have expected him to *die* shortly thereafter. He, like LaVey, was only in his sixties. I didn't want to think about it anymore; I wanted to put such negative thoughts out of my mind completely. But still I wondered, could it be possible? The answer, unfortunately, was forthcoming.

I must confess a bit of shock on my own part regarding my personal response to LaVey's passing. The sense of profound loss and overwhelming sadness that I'd expected would plague me, never quite reached the severity that I'd always assumed. They were there, naturally (and still are), but were overshadowed by something far more intense. I can't think of Anton Szandor LaVey in terms of what I, or any of us, have lost in his passing; I can only think of him in terms of what he has meant to me as a vital part of my life during the last decade or so. To be accepted into the inner-circle of this great man has been perhaps the most rewarding event in my life thus far. I've never lost the sense of awe I felt at being accepted by this man as friend, confidante and acolyte.

Although I didn't come to see him as a mentor until the end of the 1980s, Anton LaVey has, in one capacity or another, been part of my life for 27 years. At the age of 13, I cut his pictures out of magazines and displayed them prominently on my bedroom wall. These few, simple images spoke to my soul – they conveyed volumes to me. They told me of a man who enacted his fantasies in reality and pursued his obsessions to their utmost. They spoke of a man who lived by his own inner-law; a man whose will was so strong that he could bend the world to it. They spoke of a man who prospered in the real world, not despite being an outsider, but *because* of it.

Going through my teens in the early 1970s, I lost track of Anton LaVey and of Satanism, but the early conclusions he caused me to draw stayed with me nonetheless. Arriving in San Francisco in the late 1970s, I would find my mind drifting back to LaVey often. My friends and I would occasionally drive past a particularly dark-looking house in the city's Richmond District and I'd ask, "Is that the Church Of Satan?" I'd invariably be told, "Anton LaVey only deals with millionaires and movie stars, not the general public anymore." And I'd think to myself, "Good for him." On one occasion, I'd spotted a shiny, black Jaguar bearing the license plate SZANDOR, parked in a Cala Foods lot at 3:30 in the morning, and I'd hung-around for a while to see if it indeed belonged to The Man. I had to run off before the driver appeared, but I thought, "What's a guy who only befriends millionaires and movie stars doing at a supermarket at 3:30 in the morning anyway? It's probably not him." I would later learn that the vehicle was indeed LaVey's.

Eventually, through my connections in the local underground art and music scenes, I met Jim Osborne, an artist who was a countercultural legend of sorts. Osborne was the kind of guy who knew everything. He wasn't a know-it-all, just someone who *knew it all*; and it turned out he knew Anton LaVey. Jim and I were discussing I-don't-know-what one evening, and he said, "You know who you should meet? Anton LaVey. He is into exactly what you're into, and I mean each and every single thing, from Ed Gein to Tiny Tim." (Mind now, this was at a time when absolutely *no one* was into Ed Gein or Tiny Tim.) I said, "Sure, I've always wanted to meet him," and since I'd met virtually every other celebrity who'd ever interested me, I assumed our paths would cross sooner or later – in fact it seemed inevitable that LaVey and I would meet eventually, especially in a city as small as San Francisco.

My already well-established interest in LaVey was even further piqued by the fact that I kept hearing amazing rumors about the guy. I heard that he had put his wife into a hypnotic trance, which he could reactivate at any time, simply by uttering some short, post-hypnotic phrase. Whenever the woman's presence began to grate on his nerves (which was evidently quite often), he merely had to say the phrase. She'd abruptly fall silent, exit the room and go recline on the bed – and she'd remain there in a state of hypnotic slumber until such time as he saw fit to return her to the land of the living. It sounded like something right out of an episode of my favorite childhood TV show, *Dark Shadows*. The more I heard about this guy, the more I wanted to meet him.

We finally did meet at an "Incredibly Strange" film festival I was involved with. He'd come to meet T.V. Mikels, a polygamist of sorts who'd made the films *Astro Zombies* and *The Corpse Grinders*. LaVey was interested in polygamy (and exploitation films) and was eager to spend time with this man who seemed to be such a kindred spirit.

As he strode into the theatre, LaVey looked for all the world like a figure right off the big

screen; a film noir crime boss, an arch-villain. He was impeccably dressed, and exuded a presence that was larger than life. I stood and stared dumbfoundedly. As I gawked, I wondered to myself, "Should I approach this man and tell him how profoundly his works affected my early development, or should I pay him respect by honoring his privacy?" I was torn between the two options. So, I stood watching him, trying not to stare, but staring nonetheless. Suddenly, he glanced around and his gaze met mine. He walked over to where I was standing and said, "Is your name Boyd? I think we share some mutual interests." As he introduced himself, I was stunned. Anton Szandor LaVey, talking to me! And not only that, but he knew who I was! He said he was impressed that someone my age was so passionate about Little Peggy March, whom he also greatly admired. We immediately launched into a discussion about girl groups. I remember him saying, "This is *dangerous* music, Boyd. Songs like 'Johnny Get Angry' and 'I Will Follow Him' could never be done in today's climate. But people like us have to bring back this sort of thing." We talked at length and I was indeed stunned to see how closely our obsessions mirrored one another's. As the "Incredibly Strange" film screening seemed to be on the verge of starting, he asked for my number, saying, "We should continue this conversation some time. I'll have my Gal Friday, set up a meeting with you." True to his word, he did, and I went out to see him at his home not long after.

It was, befittingly, a damp, foggy night. San Francisco's foghorn moaned in the distance. As I was buzzed through the security gate to LaVey's infamous "Black House," the door swung-open and Blanche Barton, LaVey's secretary and paramour, stood in the doorway holding back a snarling wolf-dog who was straining at its leash. "Calm down, Bathory," she admonished the beast, who was clearly in attack mode. Once inside, I was ushered into an elegant purple-colored room, and Blanche left to fetch some coffee. I was alone in the dimly-lit room, filled with strange paintings, stuffed animals, demonic doodads and a gynecological examination table. The bookshelves still bore the warning label I'd read about in *Man, Myth & Magic* at age 13: "Anyone caught removing books from these shelves will have their hands amputated." It was great – everything I'd expected and far more. Better, in fact, than I could have imagined.

I'd arrived at LaVey's house at 8:00 in the evening and didn't leave until well after sunrise the next day. I came back the following week, and continued to return every week for the next few years, until I moved to out-of-state, to Denver. Those nights at LaVey's place were truly magical. His house was like some hermetically-sealed alternate reality that exists separate and distinct from the rest of the world. LaVey's personality was so thoroughly imbued in every square-foot of the place that it seemed almost an extension of him; a part of him. And he too felt a deep sense of interconnectedness to the house. It was like a work of art that he'd created over the course of a lifetime. He felt so close to the place that he referred to it as affectionately as one might refer to a dear, old friend.

I remember returning from a restaurant one evening and seeing LaVey's pained expression as he noticed in the light of the full-moon that the paint on the front of the house was beginning to crack and peel. "That's just awful," he commented. "This house has been so good to me that I really owe it to it to hire someone to put on a coat of paint." His sentimentality toward the house was such that I could sense he felt almost as though the place *was* an old friend, and the friend was in ill health. I too had a longstanding love-affair with the house. As a kid I'd dreamed of traveling to San Francisco to visit the notorious Church Of Satan. I'd gaze at a picture I had of Karla, LaVey's daughter, standing in front of it, and I'd try to imagine how amazing the interior might be. So I told LaVey in no uncertain terms that I wanted to paint the place myself. I had to really twist his arm to get him to agree, but finally he relented and said, "Well, okay, if you're sure you really want to." An artist friend named Harvey Bennett Stafford helped me and we completed the task in several days. When The Doctor inspected the job, he was as joyous and enthusiastic as a child. His eyes sparkled and a huge grin spread across his face. Contrary to what many might assume, Anton LaVey was able to take the greatest pleasure out of the simplest little things like that; which is why I relate this episode. It's one of his qualities I admired the most.

LaVey never allowed his cynicism to get in the way of that pure, childlike enthusiasm. Most people with his level of scorn allow it to sour them on all of life. Not LaVey. He was able to get extremely passionate about the sorts of things that most people either take for granted or don't even notice: a favorite brand of cookie, an old hat-store in the neighborhood, a faded advertising slogan

painted on the side of a brick building, a certain alley that he liked the look of. Here was a man who'd fucked sex-symbols, hung-out with the rich, the famous and the powerful, had founded his own *bona fide* religion – and he could still get excited by something as simple as a cookie or an alley. The people who imagine him to be brooding, gloomy and dour have no idea of the vast scope of his personality, or his complexity – and LaVey was nothing if not complex. The different aspects of his personality were like a puzzle, formed of many interlocking pieces; and although a lot of the pieces seemed to be diametrically opposed to one another, he made them all fit and he made them work.

Most people are either sweet by nature, or cruel; serious or goofy, and so on. In LaVey these things seemed to exist side-by-side, and in greater quantity than you'd find in most people. When he was angry he was *really* angry. He'd fly into a rage and you'd swear he was ready to reach for his gun and murder someone. When he was tender he was intensely so, and anyone who didn't know him would be lead to believe he was the sweetest man on earth. He seemed to experience everything far more deeply than most people do.

I don't know which I'll miss more about LaVey: his great kindness, or his greater meanness. He would often speak at length (and in great detail) of unspeakable acts of cruelty and violence, and I would be left wondering whether he was sharing a dark fantasy with me, or a cherished, secret *memory*. The old man spoke of hunting humans in such vivid, exquisite detail, that I was often transported to the scenes he described. He'd often, for example, explain the logistics of waiting in some bushes, alongside a trail in, say, San Francisco's Golden Gate Park, or the nearby Presidio, and wonder aloud, "No telling how long you'd have to wait, so you'd want a jug of water and another empty jug to piss into. You'd want a weapon of stealth, like a garrote, a knife, or an ice-pick..." Such were his descriptive powers, that I could almost feel myself crouching in the shadows, the cold night-wind sending a chill through me, as I lay in wait for a passing victim...

Ex-police officers and journalists had phoned me from time to time, to inquire as to whether or not I thought it was possible that Anton LaVey was possibly the notorious Zodiac Killer, who'd operated in the San Francisco Bay Area at the end of the 1960s and had never been apprehended. At hearing his lurid fantasizes about hunting humans, I almost wondered. LaVey had actually been interviewed for one of the books on the Zodiac Killer, and asked by the author what he imagined the killer's motives might be. "Maybe," he replied, "he just likes hunting humans."

LaVey had also suggested that the book's author check out an old film called *The Most Dangerous Game*. In this film, a reclusive, ex-big game hunter lives alone on an island. He's no longer satiated by merely killing animals, so he engineers shipwrecks near the island so that the passengers who end up stranded on his shores can be hunted-down and killed as sport. The film was a favorite of LaVey's, naturally. He screened it for me once, and afterwards we discussed some plot changes that would make it even better.

If ever he was feeling out-of-sorts, conversations about killing people (especially *who* to kill and *how* to kill them) would cheer The Doctor right up. He'd take fiendish glee in describing some incompetent person he'd had dealings with, and what – ideally – he thought should happen to them. "If you were looking for the perfect candidate for human sacrifice," he'd say, "you wouldn't have to look any further."

Those of us who knew The Doctor are aware of just how dearly he cherished humor. Unfortunately, however, judging by 99 out of 100 Satanists I've come across through the years, most seem never to have heard about his oft-repeated observation that a Satanist without a sense of humor would be a tedious *pain in the ass*.

One of LaVey's "Necronomicons" was the Johnson-Smith catalog, a turn-of-the-century mail-order guide which featured a countless selection of gags, tricks and novelties. He could thumb through this book for hours, reading the various blurbs and descriptions corresponding to the products it advertised, laughing uproariously. His favorite gags, of course, were those which preyed upon people's foibles and frailties, or in which humor was derived through causing discomfort and humiliation to an unwitting victim. He liked one ad so much, he had it enlarged and framed to hang on the wall of his kitchen. It depicted an "Anarchist Stink Bomb," a small vial which, when broken, released a airborne chemical that produced "a most disagreeable odor." One dropped in a room was said to produce, "more consternation than a Limburger cheese." The ad's illustration depicted a crowd of people grimacing and holding their noses, exclaiming such things as, "Wow, *pee-ewe!*" and, "That's

an awful smell, boys!"

In a brief aside, I'm reminded of the time LaVey in fact gave me a huge chunk of Limburger cheese. "We were going to throw this out," he told me, "but then I thought, 'Hey, Boyd can do something *funny* with this.'" He unwrapped the foil surrounding the cheese and a foul odor began to pervade the entire room. I winced and tried not to breathe. I can still picture him, standing there laughing heartily with that hunk of Limburger in his hand. After staying-up all night with LaVey, I left his house at dawn (with the Limburger stowed in a bag), boarded a bus full of early-morning commuters and positioned myself towards the rear of the vehicle. As I unwrapped the cheese, people looked over their shoulders and craned their heads, disturbed by the sudden, overwhelming smell of *shit* on the bus. Those who could, moved as far forward as possible. I hid the exposed cheese on the hot wheel-well at the back of the bus, and as it heated-up it began to melt and smell even *worse*. As the bus got closer to downtown it was packed so full that at least half the people on it were incapable of doing anything to escape the awful smell, except to simply get off before their stop. More than a few did. The only word that can possibly describe the scene, is right out of Johnson-Smith: consternation. When I described the scene to LaVey the following week, he laughed non-stop, from start to finish.

One week, LaVey informed me he'd seen a copy of the Johnson-Smith catalog at a bookstore near his house, and anxious to have a copy of my own, I went to the store the moment I awoke the following day. Alas, the book had been sold only an hour or two before. Relating my sad story to The Doctor the following week, he reached down next to his chair and picked up something... "I didn't want this to fall into the wrong hands," he told me, "here, this is for you." It was the Johnson-Smith catalog. Since we both stayed up all night and went to sleep at dawn, he too must have gone to get the book the moment he got up. I was touched by the gesture. LaVey must have known a few dozen people (probably more), who'd have given their eyeteeth for a copy of that catalog, and yet he gave it to me; and every time I crack the pages, I am transported back to the nights we spent chuckling in the Black House. I can still hear his gruff voice every time I read the descriptions for itching powder, sneezing powder, or "the dying pig" – and that rich, hoarse, full laugh of his.

LaVey was an adept mimic, and would occasionally take on the personalities of different characters he'd invented. One was an old Asian man who took trips to Reno, Nevada, to see a particular prostitute. One was a film noir mob-boss. Another was a German movie director *à la* Von Stroheim; and yet another was a Yiddish fella' whose name was Rudi something-or-other. LaVey would go into these characters without warning and sometimes the charade would last for hours. And when such did occur, it was like you really *were* talking to another person; after a few minutes you'd find yourself forgetting it was Anton LaVey you were talking to – he'd been replaced by a thoroughly convincing persona.

LaVey called me up late one night and the moment I heard him bark out my name, I knew that the film noir crime-boss was on the line. "Boyd, it's the Old Man. I hear some of those New York hotshots are tryin' to blow smoke up your ass. Well, you just tell 'em that the old man says 'No dice.' If they start to piss and moan about it, just pass the buck. Never put your ass in the fire if you can pass the buck." He had a rule about not giving advice unless it was asked for, and this shtick was a roundabout way by which he could give me council pertaining to an awkward situation I was in with some New York media folks. The details of the situation escape me now, but they're unimportant anyway. I accepted his council and extracted myself from the situation, explaining, "If it was up to me, I'd help you guys out, but the old man said I shouldn't." Couldn't I just run it by him, they queried, try to *reason* with him? Nope, I passed the buck: "You have no idea how difficult Anton LaVey can be to deal with. Downright impossible. I'm afraid it's hopeless." Dejected, they hung up the phone and never bothered me again.

Anton LaVey was not what you'd call a "people person." He hated people – despised them, in fact. He'd been disappointed by people big time, and yet he never lost his ability to trust in the people who merited his trust. He was so soured on humanity – on the entire human race – that he seemed to cherish those he was close to in a way so passionate and intense that it more than compensated for all those who didn't (couldn't) measure-up to his standards. Sure, LaVey was authoritarian, autocratic (his term) and a harsh taskmaster; but he was also one of the most loyal and supportive people I've ever met. To LaVey, loyalty was not an empty term – it was a way of life.

I remember a time when things were looking terribly bad for me. People were demanding that my records be banned, literally pulled from the shelves. They were saying I was just an asshole; too harsh, far too extreme. I had no desire for my bad PR to reflect negatively on The Church Of Satan, so I suggested that I could tender my resignation from the organization, rather than single-handedly cast an unpleasant shadow over the entirety of it. LaVey's response: "Bullshit! You aren't an asshole, Boyd, they are. You aren't too harsh, they aren't harsh enough! You aren't too extreme, they aren't extreme enough!" "Dammit, Boyd," he exclaimed, "You're an iconoclast! Satanism is *about* iconoclasm. It's about stepping on people's toes every now and then, because anyone who remains true to their vision has got to step on some toes along the way. Trusting your vision – your instincts – means following them to wherever they lead you, and let the chips fall where they may. Sometimes they take you to some pretty ugly places; places that piss people off. So be it. They deserve to be pissed-off. It may not be my intention or your intention to piss them off, but more often than not that's a byproduct of what we do. And, hell, if you're not pissing-off someone, you must not be following the right path."

LaVey was a true leader, and when one of his own was under attack, he took it very personally. Rather than worry about the very real possibility that I might be a liability to him, he instead sought to bolster my morale, encouraging me in the very things other people discouraged. When everyone I knew was counseling me to calm down and be more moderate, LaVey would say, "Never calm down. Give it to 'em with both barrels." He was the only person who was there for me – there to fan the flames when everyone else wanted to douse them – and I appreciate that more than words can say. Like I said, loyalty was more than just a word to him.

And I pride myself on the fact that I was there for *him* in turn, when not a whole hell of a lot of other people were. Not that he wanted a throng of people around – quite the contrary – but I was a very vocal proponent of LaVey at a time when the S-word was *very* uncool. It was seen by many of my peers in the late 1980s and early '90s as "some sixties thing," and LaVey was often dismissed as a phony, a con-man, a hack and a has-been. Many even thought LaVey was dead! ("Anton LaVey?! Is *he* still alive?") But I could see that a whole generation was slowly starting to come around to the ideas that LaVey had been promulgating all along; ideas I'd never lost sight of. I also knew that it was inevitable that those ideas would grow, spread and flourish; and that in the end, the naysayers would eat their words.

It doesn't surprise me that Anton LaVey has suddenly become hip again, at the dawn of a new millennium. Or that there are probably more people now who think he's a wise man than there are who think he's a con-man. I knew it would happen, but the aspect of it that I derive the most joy from is not the fact that it did happen, or that I was right, or even that I had the privilege to be "along for the ride," so to speak, but that Anton lived long enough to witness it happening. A lot of great men don't live long enough to see such a massive resurgence of interest in their work. Poor Ed Wood, for example, died a few short years before his works were rediscovered and finally embraced as something truly marvelous. I know that LaVey took great pleasure in the fact that a whole new generation looked to him for inspiration, and more so that it was a generation who could really grasp his ideas and apply them, not just part-time dabblers and half-assed occultniks. Like The Doctor always reiterated: timing is everything.

LaVey lived long enough to enjoy the sweetest vengeance one can exact upon one's detractors: success. Of course, he had always been a success; anyone who lives on their own terms and by their own law is a success. Even during LaVey's self-imposed exile (a time when he cut himself off from practically everything), his books stayed in print and continued to sell, and his name was still good copy. The media was still hounding him and Geraldo Rivera was offering him six figures to show his face on camera. But LaVey's success of recent years is really the "fuck you" variety of success; the sort that definitively says to any remaining detractors, "I'm right, you're wrong. I win, you lose." LaVey departed the arena a winner. He was a very happy, extremely satisfied man; and never more so than since the birth of his son, Xerxes LaVey. I'm only sad that he didn't have more time with the boy, and vice versa.

Over the years I've heard a lot of horrible things about Anton LaVey. Some of them were true, and some of them weren't. I won't bother to confirm or deny any of the rumors, gossip, hearsay, or other assorted speculation about the man. Instead, I'll simply say this:

There are certain historical figures around whom a myth evolves, and by its very nature the myth constitutes a far greater truth than any actuality ever could. It's been said that history is truth that eventually becomes a lie, and that myth is a lie that eventually becomes truth. I feel lucky to have known Anton Szandor LaVey. I experienced him as both an actuality and on the level of myth – and I can truthfully say that the actuality of LaVey was far beyond anything his myth could ever be, no matter how wild or lurid. I miss the old man.

To learn about Anton LaVey's Satanism, read:

The Satanic Bible, by Anton LaVey

The Satanic Rituals, by Anton LaVey

The Devil's Notebook, by Anton LaVey

Satan Speaks!, by Anton LaVey

The Church Of Satan, by Blanche Barton

For more on Anton LaVey's life, read:

The Devil's Avenger, by Burton H. Wolfe

The Secret Life Of A Satanist, by Blanche Barton

Dystopia

(Abridged version originally published in *Apocalypse Culture II*, 2000)

dys·to·pi·a: *n.* – A society characterized by human misery, as squalor, oppression, disease and overcrowding; An imaginary place or state in which the condition of life is extremely bad, as from deprivation, oppression, or terror; An imaginary place where people lead dehumanized and often fearful lives; an imaginary place where everything is as bad as it possibly can be, or a vision or description of such a place.

"Hope is a lack of information."
– Heiner Müller

We are told that the function of evolution is to perfect the species. Like all other creatures in the animal kingdom, man slowly adapts and mutates, constantly discarding physiological characteristics that hinder his survival and assimilating those that strengthen it. Given such a premise, the human race could theoretically evolve into the much-heralded Nietzschean *Übermensch* (the overman) – superman. In other words, a *living god*.

Look around... and think again.

Nearly a century ago, Charles Fort, an eccentric thinker and chronicler of the unexplained, rejected Darwinian evolutionary-theory precisely because it didn't seem to bear out the foregoing assumption about its nature – in fact he felt the very opposite was true. Rather than witnessing man's evolution, Fort observed man stagnating, or worse; devolving. Looking around today, long after Fort's death, one can't help but agree with him. Are we presently seeing the survival of the fittest individuals, or could it be survival of the *un*-fittest multitudes? Do we still operate under the Divine Right of Kings, or a modern simulacrum thereof – do people at the top of the social and intellectual food-chain still call the shots for the whole of the social order – or did idealism of rule absolutely collapse, favoring only those who find ways to leech off of the rest of society and bring it down with them? What do *you* see?

Here in the United States, everywhere I look I witness the steady decline of intelligence, year after year, accompanied by a radical increase in numbers. The clever and gifted seem to grow fewer and fewer, while the unfit herds multiply at an astronomical rate. In short, it is my contention that we are presently witnessing rampant dysgenics and ever-increasing *dystopia*.

Never mind the emotionally-seated, retrogressive counter-arguments desperately clung to by the delusional idiots of the modern Christian Right; Darwin's theory of evolution is a tangible reality – a cold, hard fact – visible everywhere in the physical world around us. But where, in mankind itself (as Fort first questioned), is the evolution which we've so often heard touted since Darwin first discussed the idea? Where indeed...

The Illusion Of Progress:

The concept of human evolution is often erroneously linked with so-called "progress" – the idea that man's upward-evolution can be demonstrated by his continual social and technological advances. People in the West generally assume that progress is proceeding at an ever-increasing rate because they can, after all, see its superficial proliferation all around them. An obvious example would be modern man's means of mass-communication, which have grown astronomically in both speed and depth, in just the past two decades (a miniscule measure of time, in the grand scheme of things). Modern man's access to seemingly limitless information is now all but instantaneous, and the average person not only has more information at his fingertips than would have been reserved for the most privileged and educated classes of antiquity, but more so even than ever before in the entire history

of mankind. To most Westerners, this alone serves as definitive proof-positive of man's progress; and by extension, also of his upward-evolution... but it isn't.

The truth is that as mankind's means of communication evolve to ever-stratospheric heights, the content of what people communicate has devolved almost proportionately. Via the Internet-connected personal computer, modern man now has access to the equivalent of the lost libraries at Alexandria, many times over (in his own home, no less) yet rather than endeavoring to actually *learn* anything, he most often occupies himself in the downloading of football scores, pornography and short video-clips of other people hurting themselves. It is indeed true that for the first time in history you can sit in the privacy of your own home and talk to a total stranger on the other side of the world – but if that person has a room-temperature I.Q. (as the vast majority of people do), it's still a waste of your time.

One of the more deceptive aspects of mass-communication (and thus the idea of progress) is that few seem to realize the fact that raw information in and of itself is worthless (no matter how much of it you have) if you don't know how to process it, or what to do with it. Note that the word "information," is decidedly *not* synonymous with *ideas*. Having access to limitless information at the speed of light does not make one wise, let alone intelligent, and modernity's emphasis on technological progress and information accumulation has, in its haste, ignored the value of *thinking*.

As universal access to disseminating and receiving information increases, it often has much more in common with *mis*-information and *dis*-information than it does with thought. With the increasing communalization of modern mass-communication, every brain-dead moron now has his own personal, digital soap box through which to contribute his personal borderline-retarded view of life and the world to the growing informational cacophony. As modern man gradually buries himself in an ever-increasing deluge of information, he undermines the very value of communication itself. Gone (or soon to be gone) are the days of bona fide journalists, experts, pundits, academics, and others who've put in the time and effort to assure the credibility and reliability of their information – now, *everyone* has an opinion on everything; and everyone's opinion is seen as valid. The fact is, genuinely innovative ideas are extremely few and far between in the digital-age, and until "progress" comes to mean *better ideas* that result in a *better living* of your life, it is foolish to simply assume that technological advancement represents any sort of progression whatsoever.

Rather than strengthen him, technological advancement has made modern man lazier and weaker with each passing epoch, and further divorced him from the tangible, hard-and-fast realties of the world around him. Moreover, for every advance in technology, people at once seem possessed by far less common-sense than even their immediate ancestors and, in fact, can be shown to be demonstrably more stupid – yet each generation smugly assumes itself to be more advanced than its progenitors, when in fact the very opposite is often true.[i]

Modern man's growing detachment from even the most basic of factors that keep him alive – such as the production of his food – has cumulatively made him utterly incapable of surviving on his own, outside the safe-haven of his technologically advanced society. Thus we must conclude that the result of man's ever-increasing technological modernization – his so-called progress – is not, in the final estimation, correlative to his evolution per se. In fact, I'd argue that the very opposite holds true. Technological advancement has made man both mentally feeble and physically unfit. Sluggish and benumbed by his own technologically-facilitated comfort, he is thus increasingly tolerant of frailty and rampant dysfunction in his midst, corrupting him from within; a tolerance that will eventually usher-in his ultimate downfall. As technology increasingly makes man both physically and mentally lazy, it also contributes to the unraveling of the very fabric of his social structures.

The Divine Folly Of Serfs:

In the distant past, people in the West believed in the Divine Right of Kings as a given. The orders came down from the top. When a King made a pronouncement, everyone fell into line and followed in lockstep. Although its been centuries since those days, most Westerners still assume that a somewhat similar process is in operation today. They simply take for granted the idea that the people at the top are calling the shots, dictating the course of civilization and society – "manning the ship's wheel," so to speak – when, in fact, today the inverse is true. In nearly every sector of modern life, it's

today's bottom-feeders who are actually setting the agenda, because everything now has to be dumbed-down and idiot-proofed in order to accommodate them; and the large-scale detrimental effect of this phenomenon upon modern society cannot be overstated.

Today, incompetent people set the agenda for competent people, since the latter have to constantly compensate for the former's screw-ups. Lazy people set the agenda for industrious people, who are expected to take-up the slack for them. Unproductive people set the agenda for productive people, who are taxed more, so as to subsidize those who see no reason to make the effort required to subsidize themselves. Slow people set the agenda for quick people – it's as if the quickest, smartest and most capable are stuck behind the slowest in a proverbial traffic-jam, when they rightly belong at the front of the pack. I could go on at length, but you get the picture; as bottom-feeders set the agenda, everyone is reduced to being treated no better than those at society's lowest rung, by a dumbed-down, idiot-proofed, coddling nanny-state.

We've all, at one time or another, witnessed a mentally-unbalanced person on some form of public transport, babbling, hollering violently and gesticulating wildly. Regardless of whatever such individuals' alleged mental "illness" may be, these people are clearly functional enough to operate outside the confines of a mental institution – in the real world – yet obviously feel no compunction whatsoever to adapt their behavior to the standards of others. No, it is others who must adapt to them – it is others who are expected to suffer their transgressions, to be accepting of their obtrusive idiosyncrasies. The allegedly mentally-unbalanced aren't supposed to try to behave normally, it's the other passengers who are expected to pretend that such individuals aren't lunatics; and if it is acknowledged that such individuals are indeed somehow abnormal or subnormal, it isn't their responsibility – it's not their fault.

When everyone pretends long enough, when everyone learns to tolerate even more ever-increasing indignities, a funny thing begins to happen: pretty soon such aberrant behavior loses its sense of abnormality and makes the transition into being simply another part of the normal urban landscape. Visit any major U.S. city and try to convince yourself otherwise. Everyone has adapted to this – sanctioned it, even – and having become acclimated to it, they're ripe for the next indignity, and the next step downward on the path towards large-scale dysgenics, devolution and dystopia.

The foregoing thumbnail-sketch of a moronic troublemaker on a bus or a subway train is but a microcosmic example of what's happening on a far larger scale throughout Western civilization. It's not so much that the lunatics are running the asylum, it's that the lunatics are calling the shots for everyone else, while those who should really have *better sense* are accommodating their slightest whims. With modern Western Democracy's current deification of victimhood, lunatics and failures of all varieties are coddled and subsidized, and the productive are made their de facto slaves. This – *this* – is the modern world in a nutshell. The Divine Right of Kings has seemingly been replaced by the divine folly of "victimized" serfs. The people who are setting modern society's agenda are not those at the top of humanity's pecking-order; they're the world's fuckups, and their dominance is now so ubiquitous as to have altered our very semantics:

Crazy people aren't *crazy* anymore – they now suffer from "emotional problems" and "mental illness." The mentally retarded aren't *mongoloids* anymore – they suffer from a "cognitive impairment." The crippled and physically-handicapped aren't *disabled* anymore – they're "differently-abled." Prostitutes aren't *whores* anymore – they're "sex workers" (who prefer to work in a "sex-positive" environment). Alcoholics are no longer just *drunks* – they suffer from the "disease" of alcoholism. The homeless aren't idle *vagrants* anymore – they're "unemployed," or "under-employed." And those who receive a monthly unemployment-check from the government aren't lazy, deadbeat welfare-bums – they're receiving "government assistance" for any number of pseudo-justified reasons (read as: excuses). So on and so forth, *ad nauseum*.

It is said by those who bemoan its iniquities, that the state (the system, the rich, the status-quo, "the man") inflicts upon these and other self-identified "victims" a hideously poor sense of self-esteem. It's not *their* fault. After all, why should an innocent victim feel any shame whatsoever over any circumstance of his life, when all his misfortunes are somehow construed as the result of his victimization by everyone else around him; and ultimately result in his own poor self-esteem? *Poor self-esteem?!* These folks don't suffer from too little self-esteem, their problem is *too much* self-esteem; far more, in fact, than their accomplishments or capabilities would seem to merit. This is why

they experience no shame whatsoever over their glaring ineptitude and uselessness; in fact, they flaunt it. They think it's okay. They think they're okay. But the reality is that today's enshrined victims are yesteryear's fuckups. They believe that their very status as a socially-sanctioned failure entitles them to a life of state-sponsored comfort, at everyone else's expense.

At one time there was an element of shame attached to being lazy, stupid, irresponsible, incompetent, unproductive, et cetera – not so today. Rather than suffering great humiliation over their lowly status, today such status is the very source of social power for those who luxuriate in failure. In the prevailing modern dystopia, delusions of entitlement are accommodated and what was once the humiliation of failure is now the self-righteous zeal of innocent martyrdom. The dystopia motivates all who wear the thorny-crowns of victimization, in all its myriad dysfunctional forms. Within the dystopia, emotions enshrine the status of victimhood, and in so doing slay logic and reason, winning every battle of the dystopia's self-perpetuating downward-spiral of debasement.

The Decline Of The West:

It has been my longstanding conviction that any idea carried to its furthest logical conclusion will inevitably become the embodiment of the very values to which it is diametrically opposed. For instance, modern Democratic nations such as the United States declare "diversity" to be one of their most esteemed values. And yet, under the aegis of Democracy, we can clearly see tangible diversity disappearing; perceptibly vanishing before our very eyes. The various cultures gathered under the banner of Democratic diversity within the U.S. can be seen to be withering and fading – perceptibly losing their individual contours and content – becoming more like one another in multifarious ways than they ever were different. In short: modern Western Democratic societies seek diversity and ultimately attain homogeneity, its polar opposite.

The same principle likewise applies to the pernicious notion of so-called "equality." By treating everyone the same – by dumbing things down to the lowest common denominator – is humanity, as a result, becoming more equal? Well, if you associate equality with dimwittedness and debasement, with having less sense of both individual and cultural identity and with being more homogenized in general, then yes, perhaps humanity *is* becoming more "equal" as a whole. But if becoming alike in dumbness and lack of character is synonymous with equality, then is equality really a value that humanity wants or needs?

Equality simply does not exist in nature. Beyond the microscopic level, no two organisms are ever "equal" – period. Modern man's only hope for ever seeing something akin to genuine equality would be to allow himself to devolve over the course of eons, so far as to become – once again – the ape-like anthropoids who may have been his long-distant ancestors; and even *that* is utopian idealism. First of all, it's certainly unlikely to happen, and secondly, even if it did it still wouldn't represent the triumph of equality, as some apes would inevitably be stronger than others and would lord over their weaker brethren by force. Oh well...

Nearly a century ago, Charles Fort could already perceive the downward-flow of history, even in his time (an age admittedly far less debased than our own). A short while later, German philosopher Oswald Spengler released the definitive exposition on the downward-tide of history, his two-volume magnum opus, published in English as *The Decline of The West*. Much like Fort, Spengler, while accepting the basic premises of Darwinian evolutionary-theory, nonetheless rejected the popular conclusions drawn from it. He surmised that if every living organism conformed to the laws that governed all of life and nature, then all organisms would also have to go through the mandatory cycles of becoming, flourishing and decline, within their own lifetimes. Taking a cue from *Leviathan* author Thomas Hobbes, Spengler pushed Darwin's primary thesis one step further, positing that nations, cultures and peoples were, in fact, *living organisms* – super-organisms – subject to the same laws that define every other manifestation of living creatures. In short; according to Spengler, civilizations are born, rise, fall and die, just like individuals. And the historical record would certainly appear to support such a thesis.

You won't find any Pharaohs in modern-day Egypt; you won't find a single soul there contemplating constructing larger pyramids or a better Sphinx, either. In Russia you can't purchase the latest model of exquisitely-crafted Faberge eggs. These days, in Italy's once-glorious Florence,

you'll find no modern equivalent of the Medici family, Leonardo Da Vinci, Dante Alighieri or Niccolò Machiavelli. Like the rest of the world, each of these once-great cultures is today but a shadow of its former glory. To Spengler, each of these civilizations had simply gone through its own natural lifecycle, much like any other organism. If this were indeed true (as it indeed appears to be), Spengler further felt that the evidence revealed conclusively that Western civilization was in the midst of the final stage of its lifecycle; that of decline.

Due to Spengler's brutal realism, his gloomy conclusions about humanity's inevitably dour collective prospects, and the fact that he was writing in Germany just prior to (and during) Adolf Hitler's Third Reich, he is often dismissed as a Nazi philosopher. The reality of the matter, however, is that Oswald Spengler's conclusions about Western civilization's inevitable decline didn't sit well with the leaders of the Nazi state at all – in fact such ideas stood in diametric opposition to the Nazis' starry-eyed idealism about the glorious future of their "1,000-year Reich" and the nascent Aryan supermen who they imagined would populate it. Hitler and the Nazis held-fast to a warped version of Friedrich Nietzsche's utopian ideal of the *Übermensch*. They agreed with Spengler's basic premise that the world was on a downward path, yet they still harbored the naïvely romantic dream that they could somehow turn the tide of history around (after all, they were – or so they believed – supermen). It's not necessary to detail here what the Nazis' idealism ultimately lead to, as it's well-documented and universally recognized as being quite far from "utopia," to say the very least. Let's suffice to say that their "1,000-year Reich" lasted a bit more than a decade; and the West's larger downward-spiral continues, unabated.

Dysgenics, The Death Instinct & Evolution:

If Oswald Spengler were alive today he could write another several volumes chronicling the decline that has occurred just since the 1960s. If Charles Fort were alive, he'd think his musings about the proliferation of the unfit had reached such a point of critical mass as to constitute the definitive, living refutation of Darwinian theory. Indeed dysgenics – the gradual genetic degeneration of man – is a demonstrable fact. Every 10 years or so the population of the United States as a whole loses an I.Q. point or two while the country's obesity epidemic grows ever worse conjunctionally. Despite their so-called progress, collectively, Americans are becoming both dumber and fatter; we are witness to the ongoing process of dysgenics and devolution, before our very eyes. Instead of walking on the path that leads to superman, we seem to be heading down one that leads to its opposite, *untermenschen*.

So where in all of this (as Fort first wondered), is the oft-lauded theory of evolution, as applied to mankind? In answer, I submit the following: simply put, it is *all* evolution. Every ugly, contemptible, wretched detail of modern dysgenic decay and ever-snowballing dystopia is a byproduct of, and factor towards, evolution; just as the extinction of certain species has been a product of evolution in the past.

Modern man's all-pervasive anti-life bent – the extremes to which he carries it and its myriad manifestations – boggles the imagination. This would seem to defy all logic (emblematic, perhaps, of modern schizoid neurosis, writ large) unless, of course it's possessed by its own *inner-logic*, the patterns of which exist on a scale so massive as to be beyond man's own nearsighted comprehension. To arrogantly assume otherwise (as most have), simply because it suits one's sensibilities to do so, is to become the victim of self-deceit.

One of the most controversial psychoanalytical theories put forth by the father of modern psychology, Sigmund Freud, was that which he referred to as *Der Todestrieb*, or "the death instinct." This was a term Freud employed to describe that part of the psyche which counterbalances man's intrinsic will to live; namely, his dormant (yet rarely acknowledged), urge towards death. Though it may seem illogical on the surface, I venture that perhaps every single example of modern dystopia might, in fact, be symptomatic of a kind of Darwinian response to what seems to be man's *collective* death wish. Further, that the growing dystopia is both a symptom of said death wish and at the same time a means of its fulfillment.

Modern man's all-pervasive folly may actually represent an instinctual, wholly unconscious attempt to create a culture so geared to self-destruction that it would, in effect, act in a manner similar to chemotherapy; taking humanity to the brink of death in order to purge the impurities that

pollute man's world, brain and soul. This is by no means an abnormal concept. In forestry, fire is often used to fight fire; in toxicology, venom is used to create anti-venom; and in virology, viruses are employed to immunize against more powerful viral strains. Likewise, it could very well be that through his own seeming dysfunction and discord, man is engineering (albeit unconsciously) the end of the modern world, to ensure his ultimate survival.

Certainly, one of the more commonly overlooked aspects of evolution is that of attrition. When there are too many animals of a certain kind to be sustained by the available resources in their habitat, something miraculous often occurs: a disease materializes (seemingly out of nowhere) and kills-off vast amounts of the creatures, restoring the balance between what is left living and what they require of their environment to survive. If this occurs on an island over the course of a season, the cause-and-effect relationship is clearly self-evident, even to an untrained observer. But if that species is *humanity itself* and the island the planet Earth – and the season is stretched-out over millennia – then the cause-and-effect nature of the attrition taking place would be far more difficult to discern, even to the highly-trained observer.

The Path To Hell Is Paved With Good Intentions:

Perhaps it is not, as Charles Fort surmised, the mechanism of evolution that has gone amiss, but man's assumption that he understands evolution which is off. Man has always labored under the delusion that evolution always proceeds along an upward path, when clearly, its manifestations fail to bear this out. Rather than view evolution with an unbiased, detached objectivity, man has always subjectively assumed that evolution will somehow better him, and that the endpoint of evolution is the creation of a *better* man - but even the premise of this assumption is faulty. After all, what does "better" mean? Better in what sense?

As discussed earlier, it isn't necessarily a given that the man who lives in a modern technological society is in any qualitative way *better* than one who lives in a hunter-gatherer society. The technological society is supposed to provide modern man with a life of ease and comfort, yet the reality is that he is often neurotic, unhappy, unhealthy, overworked and underpaid, and suffering from any variety of stress-related disorders. His so-called "primitive" counterpart may hail from a culture that has no written language and hasn't invented so much as a simple wheel (and thus is assumed to be inferior); but this subjective value judgment ignores the fact that primitive cultures have no *need* for written language or wheels. Primitive man may live in harsh conditions, but he also has 80 percent leisure time, and his problems (when he has them) are rooted in hard realities and don't issue-forth from such insubstantial sources as *lack of self-esteem*.

I'm not attempting here, *à la* Jean-Jacques Rousseau, to exalt the qualities of the so-called "noble savage" over that of civilized man; not at all. I'm just saying that man's present view of evolution isn't terribly unlike his antiquated views about Heaven. He's analogized social evolution with moral and spiritual evolution, and (as with Heaven) has further equated this with salvation; a vague, undefined salvation that exists above him somehow, always just beyond reach.

Modern man has made the grievous error of assuming that the results of evolution will be exclusively "good" in content, ultimately benefiting him. He's made the further mistake of assuming that anything he deems to be good in its intent will therefore also be inevitably good in its result. But alas, he doesn't even understand, in the larger sense, what "good" means. He thinks he knows what *isn't* good: people dying, war, disease, strife, struggle, social ills, et cetera... in short, anything he finds harsh and unpleasant to his own, subjective sensibilities. As a result of this, in the name of "good," man tries to eradicate whatever he deems to be "bad." Although he's been far less than successful in the quest, he has succeeded to the degree that the human population is expanding at an exponential rate.

Eradicating disease is good, right? People suffer less and live longer. Less wars are good, right? Wars are never just, and always result in human suffering and vast numbers of dead; and death is *never* good right? Wrong. Death, whether considered in large-scale or on an individual level, is as normal and necessary as any of nature's evolutionary processes. Nature, unlike man, is utterly indifferent to subjective judgments such as "good" and "bad," and views death as but a mechanism of evolution. Evolution has but one imperative, which cannot be understood in terms mankind would

consider good or bad, positive or negative; its results are always purely *evolutionary*, nothing more, nothing less.

Man's pursuit of "good" moves slowly, inexorably onward; and yet from man's own perspective, things go from bad to worse nonetheless. New diseases appear, seemingly from nowhere (remember that island?). Social malaise and unrest increase almost in tandem with population growth. According to the dictums of progress, people now have it better than ever, but crime shows no sign of going away any time soon... so perhaps it would be of benefit to take pause for a moment to consider the probable evolutionary outcome of what man has deemed to be "bad": crime has always been considered bad, especially violent crime. Statisticians tell us that things are getting better – that violent crime is on the decrease – but I remain skeptical. Why should violent crime be in decline, especially since (for those of us who don't happen to live behind electrified gates) it has certainly appeared to be on a steady increase, even as the conditions thought to give rise to it have supposedly become less and less pervasive? A possible explanation, in a purely Darwinian sense, is that it could feasibly be argued that crime has statistically decreased because at some point it reached a state of *critical mass* in such as way as to become a threat to its own continuance. It's perfectly possible that crime itself may have created the conditions and basis for its own emerging attrition rate. Conceivably, members of the population most predisposed to criminality and violence have, over the past few decades, been engaged in killing one-another off, thereby removing themselves from the gene pool. Many of those left alive presumably found themselves in prison; to be released at a more advanced age, when the hot-headed ways of their youthful criminality have simmered-down. The result: a perceptible drop (albeit small) in violent crime, at least statistically. So, if it thus keeps itself in check, is crime really all bad? Such speculative value judgments, of course, are purely the domain of man, not nature.

War is generally considered very "bad" by man, yet the Futurist theorist Filippo Marinetti once dubbed it, "The World's Hygiene." Marinetti saw war as a Darwinian cleansing process, whereby the human population was pruned-back from time to time. Those who emerged from warfare intact, Marinetti felt, were hardened (like steel) by the process, and were left more well-equipped to do battle with life, thus conforming to a larger evolutionary imperative. Perhaps, in a sense, he was correct. As busy, overpopulated and hectic as the modern world is today, can you imagine what it would now be like if World War II had never happened, and the *fifty-two million* people killed therein had all lived? Imagine that those people each had two or three children, who each in turn produced another two or three... If you think it's difficult to find parking *now*, imagine how hard it would be if World War II hadn't happened!

I'm not saying that we should necessarily encourage war or criminality, but if, as I hypothesize, what man most commonly considers to be "good" often results in what are ultimately *negative* evolutionary effects, then what is typically viewed as "bad" can be shown to sometimes have *positive* evolutionary effects in the long-run. Humanity, despite the arrogance of its modern intellectual conceits, lacks real perspective, especially when it comes to itself.

The result is that all this collective "good" seems to have had an equal and opposite impact on humans as individuals. So many manifestations of what man assumes will benefit the greater good, are but softening him up for slaughter. Slowly, incrementally, the altruistic pursuit of "good" is building man up for a big fall. It is the slow, imperceptible evolutionary calm that precedes the coming storm of attrition. An attrition that, in fact, has already arrived on some fronts.

The Murky Future Of Man:

When one mentions the word "eugenics" these days, people often assume it's a euphemism for *euthanasia*. Even the use of the word "genetics" implies a level of biological determinism that most people find difficult to come to terms with. The concept that intelligence, character, or indeed *any* aspect of man's nature could be rooted purely in the realm of biology, today invariably evokes the knee-jerk response that such ideas inevitably lead only to the construction of concentration camps, or putting the elderly "out of their misery." It is, unfortunately, generally further assumed that any discussion of eugenics whatsoever is little more than a camouflaged espousal of *racial hatred*; that any concerted attempt to stem the growing tide of dysgenics in the West would invariably entail some

sort of racist agenda. This, of course, makes little sense.

The hysteria attendant to any discussion along these lines is simply that: hysteria. It is a reaction of emotion against reason; of feelings against facts. Unfortunately for humanity, reason hasn't got much chance as a tool against generalized hysteria, and nor do facts. People today find feelings far more comforting than facts, and they mistrust reason as being far too tyrannical a basis for formulating their ideas about the world.

The fact of the matter is, if the whole population of the United States is declining by a few I.Q. points every decade, and that population is predominantly White, then any concern about the overall deterioration of the populace cannot logically be based on race alone. While the eugenic concerns of the past have, on occasion, certainly led to some unsavory consequences (especially in Europe), we should nonetheless endeavor to learn from the past, not simply be completely soured by it outright.

Like it or not, in today's West, it is the case that people who are stupid or poor outbreed those who are intelligent and of favorable means; and of course people who are stupid are also likely to be poor as well (big surprise there). If the dysgenic tendencies continue (and there's no reason to believe that they won't), it naturally behooves us to ponder what the probable outcome of such a trend would be for humanity in the long-run, evolutionarily speaking.

The most likely scenario would be the eventual division of society into two separate and distinct classes, estranged by a genetic abyss. Not unlike the sort of scenario presented by H.G. Wells in his 1895 science-fiction novel *The Time Machine*, the class on the top would evolve ever-upward, while the class on the bottom would devolve ever-downward, until such time as it reached a leveling-off, or bottoming-out. Naturally, the middle-class would vanish in such a polarized scenario, most being absorbed by the ever-increasing numbers of the underclass; literal *untermenschen*. Such a biological reality would render ideals *vis-à-vis* humanity obsolete. Any and all social engineering would have to be abandoned. Men (at least those who still fit the definition) would have no alternative but to proceed in whatever avenue was left open to them that might be functional to their immediate needs. The age of Democracy will have vanished and the "equal" and "individualistic" hordes will have been replaced by new classes of lords and serfs; masters and slaves. In essence, man will have gone full-circle, so to speak.

Our current dystopia is a unique historical interlude. It is not the culmination of centuries of civilization and progress, nor is it the end of the world. It is a prelude to an evolutionary transition-point; the beginning of an end, to which nature and evolution are utterly indifferent. All those aspects of the modern world that seem so alarming are but the outward symptoms of an evolutionary process which is grinding from one phase to the next. We presently exist in a dystopia poised between two worlds; and the death-throes of one world are naught but the birth-pangs of the next.

The Joy Of Schadenfreude:

A lot of the people who are perceptive enough to be cognizant of the fact that we're living in a dystopia lack the detachment necessary to put it into perspective. Their reactions to it are, well... reactionary. They think that if enough other people come, somehow, to the awareness that things are fucked-up, putting things straight will automatically follow as a natural consequence. This is like thinking you can erase stupidity by simply "wising people up." Unfortunately, the world is not like a disorderly apartment that you can simply tidy-up at will. When the disarray exists on a superficial level it can be dealt with by simply exercising more control; but when it is so vast and all-encompassing that it pervades every aspect of every manifestation of modern life, trying to deal with it by fighting it is like taking an aspirin to fight full-blown AIDS. Sadly, the flow of history has now advanced too far for simple curatives. The dystopia is definitely going to get worse before it gets better. So what is an intelligent, conscientious, diligent citizen of the modern West to do?

Well, it's easy to hate the dystopia, and frankly there's a lot about it to hate. But hating it isn't going to affect it and hating it just makes things hard – in fact, it drives some otherwise bright people downright crazy. At the risk of sounding Christ-like, it is my view that the best way to inoculate oneself against the prevailing dystopia is to simply decide to love it. That's right, *love* it. You might as well try, as – after all – stemming the downward tide is all but hopeless anyway.

If you're naturally inclined toward misanthropy like I am, loving the dystopia isn't as difficult as it may sound at first. I don't suffer fools well, but I certainly don't mind seeing fools suffer – and neither should you. Dystopia can be your friend – you need only learn to luxuriate in the misery it engenders around you. The self-inspired misery of other people can be one of life's simple pleasures, one need only remember that that which makes others weak makes *you* strong. It's no longer about taking the time to "stop and smell the roses" – it's about stopping to smell the *neurosis*. Try to take pleasure in the misfortunes of others; savor their suffering. Become the proverbial one-eyed man in the kingdom of the blind.

A lot of people say that the nightly news is depressing. *Au contraire!* The nightly news is like a sitcom about the end of the modern world – all it's missing is a laugh-track. Those who find such a notion appalling forget that one man's meat is another man's poison; that one man's kitsch is another man's living room décor; and that likewise, one man's misery is another man's entertainment: mine.

I'm certainly not alone in this view, although I often feel as though I'm one of the few who's consciously aware of it. It often seems as though immersing oneself in the suffering of others has, in fact, become the new national pastime here in the U.S.; we *all* do it, whether we're conscious of it or not. We listen to the testimonials of endless parades of victims, marketed as entertainment in all its multifaceted forms – and judging from the all-pervasive presence of such material in the media, the demand seems to fit the seemingly endless supply. As mobs of masochists listen, they feel the pain of the victims and identify with them; but as the sadist listens he takes solace in it. He loves it for what it is; the attrition phase of man's evolution.

In view of the West's spiraling dystopia, the sort of things that most people consider great national tragedies seem to me cause for celebration: Mobs of angry Blacks are burning down Los Angeles? Great! Outsider teens are hunting down jocks in a local high school? It's about time. A Buddhist monk has immolated himself in protest against some perceived injustice? Break out the weenies and marshmallows. A crazed gunman opens fire in church on a bright Sunday morning? Praise the Lord!

If every dark cloud has a sliver lining, rejoice! Storm season is at hand. So turn your frown upside down... don't bother to question why bad things happen to "good" people. Maybe, just maybe, they *deserve* it. As the world crumbles around you, understand that the streets are paved with gold...

> "Time does not suffer itself to be halted; there is no question of prudent retreat or
> wise renunciation. Only dreamers believe there is a way out. Optimism is *cowardice*."
> – Oswald Spengler

i <u>Original publisher's note</u>: In the February 6, 2000 *New York Times* magazine, in an article titled, "Incompetence Is Bliss," author David Rakoff Writes of a recent study called "Unskilled and Unaware of It" by Justin Kruger of the University of Illinois and David Dunning of Cornell, that maintains, "few people have any idea how incompetent they really are... Those who scored lowest on the objective tests scored highest on in their own self-evaluation. The same held true in reverse: high-scoring subjects underestimated their skills and how well they compared with others."

And To The Devil They'll Return
A Personal Quest And A Brief Genealogy

(Originally published in *Dagobert's Revenge*, 2000)

I awoke to the sound of a ringing phone. I groggily grabbed it and put it to my ear. "Hello," said a voice on the other end, "this is Tom Bodette." I recognized the man's voice – he did radio ads for the motel I was staying at. "Congratulations," he continued, "you've just won a million dollars! Just kidding. This is your wakeup call." As I slammed the receiver down, I visualized pistol-whipping Tom Bodette. I was in a Motel 6 somewhere in North Carolina, en route to Durham. I'd taken this trip to visit an aunt, meet a half-sister I'd never met before and stay in the ancestral home of the Rice family; a old cabin dating back to the days of slavery, now a national landmark. Joe Rice, the man who now owned the cabin (yet another relative I'd never met), was a family historian and genealogist, and I was anxious to meet with him and gather some information on my family's history and roots.

Upon my arrival in Durham, my aunt Eloise (my father's sister) took me on a guided-tour all over town. To my surprise, I could remember much of it from when I was four or five years old, and it looked hauntingly familiar. As I now drove through the area at the end of the 1990s, I recognized motels I'd seen back in 1961 or '62, when I was just a kid. At that time they were way out at the outskirts of town, in the middle of nowhere, but by now they'd been surrounded by malls, fast-food restaurants and various other businesses. The town had grown enormously in four decades and yet vast sections seemed relatively untouched by the passage of time. It was kind of amazing seeing places that I'd remembered, or half-remembered, all my life without quite recalling when or where I'd seen them: the old bus station, now closed; a certain park; a certain lake; a dilapidated old bridge. There also seemed to be evidence of our family scattered all over Durham and its neighboring environs. We passed a number of businesses owned by the Rices: jewelry stores, machine shops and so on. It looked like there were still a lot of Rices in these parts, and they'd been there a long time.

I couldn't look at my aunt Eloise without seeing her as she looked back in the early 1960s. She must have been the most glamorous girl in Durham; blonde and beautiful, and always dressed in flashy clothes. As a child I'd thought she looked like a movie starlet. Eloise soon introduced me to my half-sister, Beverly, whom my father had sired with a woman he'd married (and subsequently divorced) before meeting my mother in the '50s. Beverly was a devout Catholic, and wanted to see the church where she'd been baptized or christened (or whatever it is that Catholics do) as a baby. Like me, she'd moved away from Durham as a child and had now returned to pay a visit to the ancestral home, to learn something about the history of our father's family, the Rices. Once acquainted, the three of us then met-up with Joe Rice, the current owner of the family's ancestral home. Joe was an affable old gent who looked something like Dave Thomas from the Wendy's commercials on TV. We followed him out of town to the Rice-Pettigrew house, or as he called it, "The Old Place."

The Rice-Pettigrew house lies at the end of a long, winding road way out in North Carolina's strange and hilly countryside. In the old days, many generations ago, it had been a modest, small-scale plantation that had grown cotton, tobacco and various other crops. The Rices who'd lived there raised hogs, cattle and sheep, and seemingly had everything necessary for a totally self-sufficient lifestyle, out there in North Carolina's hilly woodlands. They'd even had their own private cemetery on the property, where generations of Rices found their final resting place, in plain sight of the dwelling in which they'd both lived and died.

Although the house is actually a cabin built of logs, it's not what you'd think of when the phrase "log cabin" is mentioned. The building includes: a living room with a large fireplace, an adjoining kitchen and three bedrooms (two upstairs and one downstairs). Portraits of Rice family ancestors adorn the walls and the bedrooms are further decorated with various period antiques (spinning wheels, butter-churns and so on). These days, Joe rents the place out as a bed-and-breakfast, and he's done an incredible job of maintaining its historical feel while thoroughly modernizing it (there's even a whirlpool tub in one of the bathrooms). The front of the house features a huge, roofed porch, and the back of the place has an even larger screened porch. One can sit on the

back porch at sunrise or sunset and watch herds of deer wander by – it's quite picturesque. While we were there, huge, ugly birds soared about overhead, making a god-awful racket. I asked Joe what exactly they were, and with typical southern humor, he said, "down here we call 'em buzzards, but out in California they're referred to as condors."

Old Joe Rice really did exude an aura of the Old South. He seemed to evince a mistrust of "northerners," and managed to still retain some vestigial hostility over what had happened to the South back in the Civil War. Although the Rices had lived in North Carolina (technically a Union state), they'd fought on the side of the Confederate army. Among other assorted historical artifacts he'd brought with him for our visit, Joe showed us a an old letter from the Civil War era, yellowed with age, which one of the Rice boys had sent home to his parents during the war. It had been mailed from a field-hospital where the boy was recovering from a *peculiar* injury, and ended with the phrase, "until death, I remain your son." Theatrically regaling my other relatives and I, old Joe read the contents of the letter aloud...

It seems that just before the letter's author had left for the war, his mother had given him a small New Testament Bible, which he afterward always carried in his left breast-pocket and would read during lulls in battle. One day, while charging at the Union enemy, this young Rice was shot. The bullet was meant for his heart and would surely have killed him, but... it was stopped the Bible in his pocket! The slug nearly went through the volume, but came to rest toward the last few pages, sparing the boy's life. As Joe related the story, he paused a long while for dramatic effect, and then solemnly declared, "That Bible *saved his life!*" As a result of the shot, the boy only suffered some broken ribs, but was incapacitated enough to end-up in a field hospital, from which he'd sent the letter home. To Joe, this was a miracle, plain and simple. The hand of God had personally reached-out to save this devout rebel lad, my ancestor. And indeed, the story would have truly been amazing, but then Joe added, "and 21 days after he wrote this letter, he was killed in the Battle of Gettysburg." *Whoa!* Now hang on there just a minute. Why the fuck would God personally reach out to spare the life of this soldier in a true-life miracle, then turn around and allow him to be killed less than a month later? This addendum to the story rendered the whole "miracle" episode utterly meaningless. But perhaps I'm overly cynical...

After offering this sentimental episode in Rice family history, Joe further showed us around the old homestead and spun more tales of the place's past. Since the house dated back to the days of slavery, I asked the obvious question: did the family own any slaves? "They owned 27 slaves at one point," he answered matter-of-factly. "That's the most we're aware of at any given time. They could have owned more." This certainly explained why the family had fought on the side of the Confederacy, rather than the Union with which their state was affiliated. "Where the hell did they all sleep?" I wondered aloud. "As a matter of fact, the room we're now in was the slave-quarters," he informed us. "They entered and exited through that window, going up and down a ladder. I'm sure they didn't all sleep here though. There were probably shanty-shacks scattered throughout the property." The room we were in was actually quite large and thus it was easy to imagine that 27 people could indeed sleep in this single room. I know I'd certainly prefer sleeping inside, on the floor with 26 other people, to sleeping in a shanty shack in the woods – except perhaps, during North Carolina's muggy summer months. As it so happened, that night I did sleep in the room that was once the slave-quarters. When the lights were out, I gazed around in the darkness, taking in the same sights those slaves saw every night, centuries ago (except I was in a huge, four-poster bed, rather than on the floor, so I imagine it was a bit different). My eyes eventually came to rest on the window. I tried to visualize people entering and exiting through it as I drifted-off to sleep.

When I awoke the next morning, I lit a cigar and wandered over to the small cemetery on the property. As I surveyed the grave markers it was hard to believe that the odd, old names on the tombstones each represented a forebear of mine; that the blood that flows in my veins had once flowed in theirs. Now they were all dust, and had long been dust. Eloise, Beverly, Joe and I later drove several miles down the road to another cemetery comprised entirely of Rices, this one even older. Some of the graves were, in fact, so old that they weren't even fitted with proper tombstones, just huge misshapen rocks bearing neither names nor dates. One aging tombstone bore the name of a woman who'd married a Rice; a woman from a family with the surname Boyd. I naturally wondered, "Is this where my father chose my name from; a grave in the family cemetery?" It certainly seems so.

After all, Boyd is generally a last name. In 40 years I've only met and heard of very few people with Boyd as a first name; it's pretty rare. Cemeteries have always played a big role in my life (I've even lived in them, at times), as well as in my family's, so it's fitting to think that my name may likely have been inspired by one.[i]

At any rate, when we returned to the Rice-Pettigrew house, Joe produced stacks of genealogical materials. They contained documentation that traced our family line back to a Thomas Rice, who'd come to the then-colony of Virginia from England. Thomas was the descendant of an ancient prince of South Wales, Griffith Ap Rhys. Rhys is the original Welsh spelling (changed to "Rice" in the colonies, like so many other European surnames), and the prefix Ap denoted distinction or nobility. Not only was Griffith descended from a prince of South Wales, but his wife, Catherine Howard was descended from William the Conqueror, Kings Henry I and II, King John and King Edward I. Thus, according to the documents, our branch of the Rice family could claim royal descent from the Plantagenets. Furthermore, an unrelated article I later encountered makes the claim that Griffith's father, Rhys Ap Thomas was the "natural son" (bastard son?) of Geoffrey Plantagenet; and if this were indeed the case, then there would seem to be Plantagenet blood on *both* sides of Griffith's parentage. In addition, Griffith's mother Mary Howard (daughter of Thomas Howard, Duke of Norfolk), is said to be yet another Plantagenet connection to the family. This got me to wondering; what, if any, was Mary Howard's relation to Catherine Howard? Were they from the same family of Howards? It all starts to seem more than a bit incestuous, somehow, albeit thoroughly royal (a phenomenon not uncommon in Europe's noble lineages). I was left wondering, for the time being...

I further learned that day, that while the story of the Rices' ancestors in England and Wales was certainly intriguing, their time in the New World was not without interest. Early American Rices were Indian traders, plantation owners, gunfighters, vaudevillians and in great frequency, priests. Thomas, the descendant of Griffith Ap Rhys, who'd first journeyed to the colonies, owned a plantation in Hannover County, Virginia and sired nine sons and three daughters. Later in his life he returned to England to collect what was said to be a large inheritance, and on the voyage home he died at sea. It is assumed that he was assassinated and that the inheritance he was carrying home with him (which was never recovered) was stolen. Of his nine sons, one was named Thomas Junior, who in turn had a son named Thomas III, and it was he, I believe, who built the Rice-Pettigrew house (thus beginning the Caswell County, North Carolina, branch of the Rice family). The family, having survived the loss of its first American patriarch (and his inherited fortune), managed to prosper nonetheless, throughout the economic ravages of the Civil War and the abolition that followed it, only to lose everything in the great New York stock market crash of 1929.

Upon returning home to Denver, I sent old Joe and his wife Avis a note of thanks, along with an copy of the album *Seasons In The Sun*, which I'd done with Rose McDowall as the band Spell (they'd wanted to hear some of my music and up to that point, *Seasons In The Sun* was the only easily-accessible thing I'd done that average folks like them might possibly be able to relate to). They wrote back saying that they'd enjoyed the album, but that it was a shame that someone with my obvious talents wasn't using his gifts in the service of God. I didn't respond, but I couldn't help thinking to myself, "But Joe, that's exactly what I *am* doing... "

Back at home, pondering all I'd learned about my family's genealogy during my trip to Durham, it seemed hard to believe that six or seven-hundred years back the Rices had connections to William The Conqueror, or had once been royalty in Wales. In spite of my initial surprise at discovering this, however, additional reading and research further turned-up the amazing factoid that King Edward III has over *100 million* living descendants – which certainly helps put the whole matter into somewhat clearer perspective. Nonetheless, my interest was piqued and I subsequently read everything I could put my hands on that dealt with these people to whom I was distantly related.

From the documents Joe had shown me (as well as a few others I came across in my own research), it appears as though Thomas Rice, who'd first brought the Rice line to America, was connected to the Plantagenet bloodline via several genealogical routes. If speculation concerning the earlier Rhys' Plantagenet parentage are true, then this opens the door to the fascinating possibility that all subsequent Rices may in fact not have so much as a single drop of Rice blood in them; that for centuries my family has gone by the name Rice and we aren't even Rices, but Plantagenets, by blood if not by lawful name. The possibility certainly fascinated me and I began to research the history

and lineage of the Plantagenets in earnest.

The Plantagenets were kings of Britain during the 12th and 13th Centuries.[ii] Under the Plantagenets, the British Empire stretched from Scotland all the way down to the Pyrenees mountains which separate France from Spain; at one time constituting the totality of the westernmost end of Europe. The first of the Plantagenets was Count Geoffrey of Anjou, whose father, Fulk of Anjou, had been King of Jerusalem and had fought to drive the Saracens out of Europe. The subsequent counts and kings of his bloodline came to be known as the Angevins, and as their influence and control grew, so too did the fear they inspired. According to legend, the Angevins were descended from the daughter of Satan, and it was said of them, "From the devil they come and to the devil they will return." In later years, the English King Richard the Lionhearted would refer to his family's supposedly Luciferian pedigree, citing it (perhaps humorously) as being responsible for the fact that they seemed to "lack the natural affections of mankind."

Though the Angevin men were indeed feared throughout Western Europe, the women were said to be far worse, and histories of the period relate colorful rumors which were, at the time, accepted as fact. One of the more notorious Angevin women was named Melusine, and according to one legend, she was said to have been taken by surprise one night by her husband, who was shocked to discover that she had shape-shifted into a form in which her entire bottom-half took on the appearance of a blue-and-white serpent. As the tale goes, she keeled-over dead at the horror of being discovered, but her ghost (in half-serpent form) haunted the site thereafter. Another tale relates that an Angevin woman known as "The Witch-Countess" had apparently gained local disrepute, owing to the fact that she refused to attend Mass on Sundays. Her husband had four of his knights take her forcibly to services one day, and during the consecration she dematerialized, leaving only her gown and the overpowering smell of brimstone behind (in another version of the tale, she leapt screaming through the window, never to be seen again).

These tales come from a time in European history when stories were used to frighten the superstitious local populaces into willful submission to authority. It wasn't an uncommon practice, for instance, to let it be known that the devil lived in your wine-cellar, as a means of keeping local peasants from stealing bottles of wine.[iii] From what little I know of European history, it seems most likely that the Angevin nobles in the preceding tales simply had their wives murdered, spreading the wild supernatural tales to frighten off superstitious locals and keep the disappearances from being scrutinized too closely. Unfortunately for the Angevins, tales such as these would eventually prove to be a PR nightmare. In Thomas B. Costain's 1949 study of the Angevins and Plantagenets, *The Conquering Family*, he writes, "The counts of Anjou and their lovely but wicked wives gained such an unsavory reputation over the centuries that the people of England were appalled when they found out that one of them was to become King of England." The English needn't have worried, however, as the Plantagenet years were the glory days of the British Empire. It's certainly been all downhill ever since they came to an end.

I soon came to realize that virtually any book that even vaguely pertained to the Plantagenets contained some passing reference to either Rhys, the Angevins, or both. I felt certain that I'd only scratched the surface thus far in my research and in repeatedly coming across the assorted Luciferian connections to the Angevins I couldn't shake the feeling of some strange sort of déjà vu – that this all seemed oddly familiar for some reason. On a hunch, I dug-out an old book I hadn't read since the early 1980s – *Holy Blood, Holy Grail*, by Michael Baigent, Richard Leigh and Henry Lincoln – and sure enough, the Angevins were featured prominently throughout it. According to the text, Fulk The Black's father-in-law, a man by the name of Godfroi de Bouillon, had also been King of Jerusalem. De Bouillon, it is said, could trace his genealogy back to Dagobert II, further back to Parsifal, and beyond that to the family of Jesus Christ.

Central to *Holy Blood, Holy Grail* was its authors' revolutionary theory that rather than simply dying on the cross and then subsequently ascending to Heaven, Jesus Christ had fathered children who went on to found a *Holy bloodline* that later became the royalty of Europe. The authors postulate that Christ fathered children by either surviving his crucifixion, or by impregnating Mary Magdalene prior to being crucified; and that either way, the Magdalene took Christ's children with her to France, where his bloodline was begun in Europe (via Dagobert II, De Bouillon and their subsequent connections to the Angevins and Plantagenets).

It was a wild theory, bordering on the conspiratorial, yet despite its controversial contention, *Holy Blood, Holy Grail* was extremely well-researched and its premise had always seemed quite straight-forward, logically-presented and plausible to me (certainly more so than the idea that Christ was the son of God, had died on the cross for humanity's sins and then miraculously rose from the dead on Easter). Now, in light of the implication that I might possibly be a descendant of Christ's family – the grail bloodline – via the Plantagenets and Angevins, I reread *Holy Blood, Holy Grail* with a far more critical eye. In rereading the book some 15 years on, its premise still seemed sound; it was based on solid scholarship, and tried to steer well clear of unfounded speculation. In short, it presented what I found to be an altogether convincing scenario of what could possibly be an alternate history of Europe.

In both *Holy Blood, Holy Grail* and other sources I was to later come across, I learned that besides being King of Jerusalem, Godfroi de Bouillon is also supposed to have founded both the Priory of Sion and the Knights Templar. I'd never known quite what to make of legendary groups like the Templars or Cathars. Everything I'd read about the Templars had been utterly contradictory and seemingly predicated more upon the biases of particular authors than on anything tangibly provable. Were the Templars knights of Christ, as some authors alleged, or worshippers of the demonic entity Baphomet, as others posited? Or could they, in fact, be *both*? Much of the information relating to various members of the grail family seemed equally paradoxical. For example, if Dagobert II was a purported descendant of Christ, then why was the capitol of his Merovingian dynasty located in a place called Satanicum?[iv]

Many of the references I gleaned from *Holy Blood, Holy Grail* provided points of departure for further research, and almost without exception what I uncovered in other texts relating to the grail bloodline was just as strange and rife with paradox. To give just one example: Italy's Catherine De Medici later became Queen of France (her son Francis wed Mary Queen of Scots), and while queen she reportedly stated that she was interested in "neither Heaven nor Hell, but only magic." Catherine is further known to have performed what is said to be a "black mass," which purportedly involved a nude altar, the consumption of blood and *dual hosts* (one white, one black) representing the coequal powers of good and evil. Further, a woman named La Voison (who was reported to have been a student of Catherine's and practitioner of her Medici black mass), later became the leader of an all-girl crime syndicate that very nearly succeeded in toppling the government of Louis XIV in France.[v] If this seems to be wandering far afield from the grail bloodline, please bear with me... because two of La Voison's most noteworthy patrons and avid supporters were the Duke and Duchess de Bouillon, heirs of the aforementioned Godfroi de Bouillon. I could go on at length, citing similar cases, but you get the idea: the grail bloodline interweaves itself throughout the royal families of Europe, and wherever it is found, so too are a host of paradoxes, eerie coincidences and enigmatic riddles.

The foregoing connections I've cited aren't just a few isolated examples which standout in contrast to all the rest of the Plantagenet, Angevin and Merovingian histories, but rather a small sampling of incidences which seem to me emblematic of the sort of paradox that typifies the whole saga. Some readers will no doubt surmise that I've scoured the historical record with a fine-toothed comb, focusing fetishisticly on any oddities that I could conceivably interpret according to my own predilections; but such is not necessary. All those elements which might, at first glance, seem to be the perplexing inconsistencies that plague this tale are, in fact, so inescapably consistent that they seem to constitute the defining ethic of it all. If this persistent dual-vibe is representative of the secret gnosis which is the unique inheritance of the descendants of the grail bloodline, then – given my own nature and past – I can't help but feel as though I've been there all along...

i My grandmother was actually *born* in a cemetery, and on Halloween no less. How did it happen? Well, the house where my great-grandmother lived was situated in the middle of a graveyard, and on the night of Halloween she was walking home (through the graveyard) in her ninth-month of pregnancy. As she neared the house, some holiday mischief-maker leapt out at her from behind a tombstone and screamed at the top of his lungs. My great-grandmother was so terrified at this, that the shock sent her into premature labor and my grandmother was born right there in the boneyard. Or so the story goes anyway...

ii It is widely reported, even in scholarly works, that the name Plantagenet came about due to the fact that the earliest member of this line made it a habit to wear a sprig of a broom in his hat; and the name derives from the French word for broom. In fact, what he wore in his hat was a *bloom*, the bloom of a plant called the *planta genesta*. This is a small yellow flower that grows wild in the fields of Europe, where it is commonly known as the "rape flower" (as in the Death in June song, "Fields of Rape").

iii In fact, there is still a South American wine available today, whose name translates from Spanish to "The Devil's Cellar."

iv The same territory in question was later ruled by René d'Anjou, Duke of Lorraine. René, also a Merovingian descendant, designed the Cross of Lorraine, an emblem said to signify both the arms of Christ and the arms of Satan. René d'Anjou was alleged to have been influential in helping Lorenzo De Medici create Europe's first library. It is rarely mentioned, however, that most of the books contained therein dealt with alchemy, the occult, hermeticism, Gnosticism and related esoteric doctrines.

v La Voison, known as "the witch-queen of Paris" was an abortionist, fortune-teller and purveyor of rare poisons who moonlighted by conducting the Medici black mass for France's richest and most powerful families. Louis XIV's mistress was a member of La Voison's inner-circle and, as the story goes, was about to participate in a plot to poison the monarch when police intervened at the 11th hour. Upon her arrest it was discovered that many of Paris' leading clergymen were playing an active role in her criminal activities and dozens were burned at the stake alongside her.

Savitri Devi, The Externsteine & The Pagan Ritualism Of The Nazis

(Previously unpublished, 2001)

Savitri Devi was a paradox; born of mixed European stock in early 20th Century France, as an adult she tested as having a genius level I.Q., was deeply religious, and extolled violence as an absolute necessity for achieving the ideological aims she sought to see fulfilled in the world. Throughout her adult life she wrote prolifically in fervent support of both National Socialism *and* Hinduism, and even made an attempt to synthesize the two (in so doing, hoping to encourage Hindus to embrace nationalism, and warn them against the spread of Christianity and Islam in India). In the course of pursuing her National Socialist aims she made several pilgrimages to Germany, and on one such visit actually did jail-time for promoting National Socialist ideology in the post-World War II occupied nation. She believed that Adolf Hitler was an avatar of the Hindu god Vishnu, but also that he shared a destiny with the Egyptian god Akhenaton. All told, Ms. Devi was quite a character indeed.

To those who disagree with Devi's views, her works nonetheless provide a revealing glimpse into the prevalent worldview of a people who – in but a few short years – allowed an obscure artist like Adolf Hitler to transform into a messianic figure who exercised power without limit on one of the most technologically advanced nations of the time. Those who would be supportive of Devi's ideas will no doubt glean much the same significance from her writings, despite her other, seemingly incongruous interests and endorsements.

Like her or hate her, agree or disagree with her views, Savitri Devi was surely one of the strangest figures standing in the wings of 20th Century history. She was a self-admitted French Germanophile who moved to India because (unlike Germany) she felt it still had an uninterrupted "Pagan tradition," based on Indo-European (or Indo-Aryan) precepts. This sounds fine in theory, but in all practicality, India was (and is) still a place where pilgrims immersing themselves in the "holy" water of the Ganges river might well expect to see pieces of garbage, sewage, *corpses* and other assorted detritus floating by. There is certainly much to be said for the value of ancient civilizations, cultures and creeds; but there is also much to be said for plumbing, indoor-toilets, hygiene, sanitation and the civility of modern first-world living. If there is a balance factor at work in Devi's life-choices, I am at pains to find it; nonetheless, her writings are often strikingly profound, and explore a wide variety of intriguing themes and concepts.

Among such is Devi's conception of a prevalent pre-Christian, Pagan culture in ancient Germany, and its spiritual centralization in a sacred site called the Externsteine. Located in the Teutoburger Wald region of northwestern Germany, the Exernsteine is a distinctive rock formation which consists of a collection of large, narrow columns of rock which rise abruptly from the surrounding woodland. It is widely assumed that this locale served as a center for the religious activity of ancient Germany's Teutonic peoples and their predecessors, prior to the encroachment of Christianity upon northern Europe (the region remained in Pagan hands until Charlemagne finally defeated the Saxons in the 8th Century). In the chapter "Rocks Of The Sun," from her book *Pilgrimage*, Devi says of the ancient holy site:

> "These Rocks, I knew, had been the center of Germanic solar rites in time without beginning. [Upon seeing them] I felt like a person who has walked a long way and a long time – who has come from a very, very distant country – with a definite purpose, and who, at last, reaches the goal... I had reached the Source where I could replenish my spiritual forces for the eternal Struggle in its modern form: the Struggle of the Powers of Light against the Powers of Gloom, experienced by me as that of the National Socialist values against those both of Christianity and of Marxism... I knew that, at the top of that rock is the sanctuary from which the wise ones of old used to greet the Earliest Sunrise, on the morning of the Summer Solstice Day... I thought of this, which I had read, and which I had been told by

modern Germans faithful to the old solar Wisdom; Germans who had gone back to it, in an unexpected way, through that modern Faith in Blood and Soil – that Aryan Faith: National Socialism – that binds me to them. I thought of this, and imagined, or tried to imagine, the solemn scenes that have taken place, year after year, upon this rock, for centuries, nay, millenniums; scenes of which the regularity had seemed eternal like that of the reappearing of the sacred Days. And I thought of the abrupt end of the Cult of Light; of the destruction of this most holy place of ancient Germany by Charlemagne and his fanatical Frankish Christians [who]... stamp[ed] out every spark of the old solar Wisdom – of Aryan wisdom – in its main European Stronghold."

When I first read Savitri Devi's writings, nearly 20 years ago, I was an ardent Pagan. In many ways I still am today. But the intervening years have lead me through a labyrinth of research and study, and two decades on, my conclusions about the Externsteine are at variance with Devi's in a number of ways. Devi, like many of her age, was of the opinion that Germans were Nordic and had come to Germany from Finland, Sweden and so on. In fact, the Germans seem to have migrated upwards from Sumeria; namely, from locales now known as Iran and Iraq. These Sumerian-descended peoples possessed the type of astronomic knowledge exhibited in the Exernsteine, and certain of their cuneiform letters are identical to symbols in what became the Germanic runic alphabet. In fact, many words still extant in the German language can be directly linked to a Sumerian prototype (and over half of the words in the modern English tongue also have roots in Sumerian as well). In contrast, Devi's contention of Nordic roots, although prevalent at the time, is far less substantiated.

That the Externsteine was considered sacred from time immemorial is unquestionable. That it represents an ancient Germanic holy site is altogether less clear-cut. In truth, no one knows who created the most ancient of the odd formations and stonework of the Externsteine, and *when* they were created is even more open to question. Since carvings upon solid, exposed stone cannot be dated by any means now known, definitively determining the antiquity of the site's creation is (at present) impossible. What nonetheless remains intriguing and fascinating about the site to the modern mind, however (as well as what inexorably links it with Devi's interpretation), was its immense symbolic importance and occult utility to the Nazis, specifically, Reichsführer Heinrich Himmler's Schutzstaffel, better known as the S.S.

The time: The early 1940s, just hours before dawn on the winter solstice. In a subterranean chamber located in the north tower of Himmler's "Grail Castle," Wewelsburg,[i] a group of black-clad men stand in a circle and solemnly intone runic mantras. The scene is lit only by the flickering flames of a bonfire, blazing in the chamber's center. This room, called "The Chamber Of The Dead," lies directly beneath a great hall, the floor of which is emblazoned with a massive Black Sun symbol; emblem of the esoteric doctrine of the Nazi S.S. and the central focus of the warriors' rites and ceremonies carried-out in this place.[ii] Standing before the fire, an S.S. initiate contorts his body into various postures and shapes, echoing those of specific ancient European runes; and in so doing hoping to manifest and awaken within himself the primordial forces those runes represent. As he maintains each stance (for hours at a time), those around him solemnly utter such chants as correspond to the runes he is invoking.

The chamber has been designed to exact harmonic specifications, and each sound intoned is magnified and extended by the acoustic dynamics of the room itself. The chants echo and reverberate throughout the space, creating an ongoing harmonic drone which seems to emanate from everywhere and nowhere at once. At key points of the ritual, a low-pitched hum mingles with the drone of the chanting, and grows ever louder and higher in tone. At such times, the bonfire almost seems to shrink, the chamber appears to darken and the air seems to grow so thin that the participants can barely breathe. They become lightheaded and feel as though they're upon the verge of collapse – or death. Suddenly, the humming subsides and the fire leaps back to its original state. The black-clad men are collectively in a kind of trance-state, and come to feel a mystic bond both with one another and the fire itself. To them, this fire is symbolic of the light of the eternal sun, and it is a fire that burns within their very blood.

The elements of this ritual are both wholly ancient and completely modern. Ancient, because

the ritual encompasses symbols and concepts central to the solar cults that predated Christianity in the region; modern, because it makes use of what was at the very cutting-edge of experimental Nazi technology. At the central apex of the chamber's ceiling was an air-vent constructed in the shape of a Swastika, putatively installed there to remove the bonfire's smoke from the room. In truth, however, on the other side of this vent an experimental jet-engine had been installed, which could – in a matter of seconds – remove virtually all the oxygen from the room. This then, was the source of the strange ever-present humming noise described earlier, and why the fire in the room's center could suddenly shrink, as if on cue. It is also the reason why this, the Nazi's most secret occult ritual, was known as "The Stifling Air." By way of this jet-engine and air-vent assemblage, the chamber could likewise be infused with massive amounts of *pure oxygen*, with the result that the fire would leap to great heights and the participants would experience a mental state every bit as heightened and trance-like as that caused by oxygen deprivation.

This cyclical initiatory process could go on for hours, often lasting from midnight until just before dawn. As sunrise approached, the group of initiates would begin chanting a mantra based on the *eiwaz*, or Wolfsangel, rune; an ancient symbol representing the union of life and death. At length, the telltale low-pitched hum would be heard to mingle with the chanted drone, and the black-clad brethren would file-out, as the initiatory chant blurred into the deafening roar. At this time the fire would be extinguished, and as the initiate was suddenly swallowed-up in darkness, he would collapse in a heap upon the floor, unconscious. Almost instantly, uniformed men with flashlights would flood into the ritual chamber and carry the initiate's body to a waiting limousine. Taking-off at breakneck speed, said limo would race along curving streets in the predawn dark, towards Germany's most ancient sacred site: The Externsteine.

When the car carrying the still-unconscious initiate arrived at the Externsteine, the man's body would be swiftly placed into "The Chamber Of Death & Resurrection." This is a tomb-like enclosure in the Externsteine, carved out of the site's solid rock. Inside, a sarcophagus-like shape (mimicking that of the human body) is carved into the rock as well, adding to the tomb-like effect. A solemn ritual would follow the initiate's symbolic burial, and as the sun's first rays began to illuminate the dawn sky, the initiate would invariably start to regain consciousness. He had essentially undergone an ordeal that in the modern vernacular would most likely be called a *near death experience*, if only ritualistically and symbolically. This was, after all, a ritual connected to the Black Sun; an emblem of death and rebirth.

Upon exiting his "tomb" the initiate would ascend a flight of steps carved into the rock of one of the Externsteine's tower formations, and upon reaching its top, cross an arched bridge leading to an adjoining tower. Here he would be confronted with an altar also carved out of the stone. Above the altar – in its center – was incised a small, circular aperture, etched straight through the solid rock. Through this hole, the S.S. initiate could glimpse the first rays of the rising sun – but only on *this particular day*. As the sun rose in the heavens, it cast its ray through the hole and onto the center of the altar; the spot thus illuminated was only so lit on a *single day* each year – the winter solstice. In other words, the shortest day of the year. From this moment forward, the days would grow longer, until the summer solstice was finally reached. The approach of spring would not be far off now, and the cycle of life would begin anew.

So, the ceremony in which the S.S. initiate had participated had a dual meaning; it was both a rite of the Black Sun, and a rite of the *invincible sun*. Both celebrated death and rebirth. As evinced by the forgoing tale, such was the extent to which the Nazis took ancient Pagan symbolism seriously.

By contrast, modern German nationalists seem largely to have lost touch with the esoteric side of things, often now claiming that the Black Sun merely symbolized, "mourning for the defeat of National Socialism." That's simply preposterous. Particularly foolish in that the symbol of the Black Sun is ancient – like the Swastika, predating Nazism by eons – and was rich with meaning long before Himmler discovered it. After all, the symbol of the Black Sun appears in the story of Jesus Christ. Was the king of the Jews mourning the defeat of Nazi Germany, 2,000 years prematurely? Of course not. Christ, in utilizing the Black Sun, was invoking a symbol ancient even in his own time; a symbol central to the mythology of Egypt, and to Sumer before that. In fact, ancient Babylonian inscriptions reference the Black Sun as well, and describe it as an "unseen sun that shines within is." You simply can't get much more antiquated than that.

In ancient mythology, when the king dies, he descends into the underworld. Following this, the sun turns black for three days, and at the end of that time, the king is reborn... as God. This, of course, is the Egyptian story of Osiris. Echoes of it recur also in the story of Christ. It represents the perennially retold tale of a dying and resurrected God. We see it in the Babylonian god Tammuz (Dumuzi to the Sumerians) and so on, *ad infinitum*. Himmler had the Black Sun symbol installed in the marble floor of Wewelsburg Castle's great hall at a time when the regime of which he was a part had accrued only victories; no losses. Ergo, in so doing, was Himmler invoking an ancient occult tradition as many had done before him for eons; or was he merely prophesizing his own inevitable downfall, and somehow clairvoyantly mourning it aforehand? The idea is ridiculous.

While much of the afore-discussed subjects may indeed be speculative, we do know that when the Nazis occupied Prague, their "final solution" co-architect Reinhard Heydrich, took-up residence in a royal palace located at the end of the legendary "Alchemists Way." There is a famous house on this same street called "The Place Of The Black Sun," and it is marked with an image of the Black Sun symbol. Is it mere coincidence that this street is also known as "Heaven Street," and that a thoroughfare leading to the ovens in that most notorious of Nazi concentration camps, Auschwitz, was also subsequently dubbed "Heaven Street"? I'll leave the reader to draw their own conclusions regarding such questions, but posit that the Nazi's obscure esoteric obsessions with both the Black Sun and the Externsteine have yet to be fully understood by most mainstream scholars, least of all by people who make wildly un-substantiated claims about the black sun symbolizing nothing but a preemptive, "mourning for the defeat of National Socialism."

I have offered the foregoing tale relating to the Externsteine for two reasons. Firstly, because the specific details of the secret S.S. ritual above-detailed have never been publicly disclosed (so far as I'm aware), and reveal the extent to which mundane politics often took a backseat to what seem to have been more overriding esoteric preoccupations by the Nazis. Secondly, because Savitri Devi's mystical, occult interpretation of National Socialism in "The Rocks of the Sun," might not at the end of the day be as much in variance with the Nazi hierarchy's worldview as one might first suspect.

Regardless of Devi's theories and their validity (or lack thereof), what we *can* say with certainty is that the Externsteine exhibits a knowledge of geometry and astronomy presumably unknown in ancient times. However, that this knowledge was somehow specifically *Germanic*, as Devi asserts, seems questionable. Why? Because it accords precisely with other sacred sites scattered across the globe. In Egypt, the Orient, South America and England, there also exist ancient monuments built to map the equinoxes, just as the Externsteine does. That said, the Exernsteine *may* be one of the earliest examples of this sort of engineering, as other (perhaps later) worldwide monuments exhibit a complexity of design not to be found in the German model.

One need not agree with Devi's view of the Exernsteine as a pre-Christain spiritual center to realize the importance of that fact that Heinrich Himmler certainly *did* see it that way; and that much of the occult tradition appropriated and morphed by the Nazis played a far more important role in what they were doing and what they were about, than is often surmised by historians today; and Devi certainly realized that.

Whether you find Savitri Devi's writing and theories fascinating and compelling or misguided and contemptible, the fact remains that the man with the funny moustache (who took center stage in the drama of which Devi was so passionate an observer), still continues to exercise a peculiar fascination over the public; and (ironically) especially to those who hate him most. Not a few people have observed that today's History Channel could well be rechristened "The Hitler Channel," because of the fact that one can tune-in to *der Führer* almost any time – morning, noon, and night – and never be want for more material on the subject. Savitri Devi died some years ago, but one thing is certain: if she were still alive today, she'd definitely have cable.

i It is presumed that Himmler chose the Wewelsburg castle as his elite S.S. headquarters because of its close proximity to the Externsteine. He'd intended to make the Wewelsburg the sacred, "center point of the world," just as the Externsteine had been the center point of solar worship, not just for ancient Germans, but for all Europe. The two seem to have been conjoined in his mind, and presumably, he hoped his posterity would make the same connection. All world religions have a place – a building, a monument, or a locale – which they proclaim as the

center point of the world. For ancient Mesopotamians it was Babylon; for Jews, Jerusalem (or Solomon's Temple); for Muslims, Mecca; for Egyptians, the Pyramid at Giza; and so on. For Himmler such a place was the Externsteine.

ii It is interesting to note that although the Black Sun featured on the floor of the great hall appears to be black, it is in fact a very dark shade of *green* – the color of initiation.

The Persistence Of Memory
Ancestral Recall & Blood Mysticism

(Previously unpublished, 2002)

Though each organism represents a totality, it is at the same time part of a larger *whole*. Sometimes in nature the part carries with it a memory of the whole – an inner longing for a union with the whole – and so it can also be with certain human beings. The journey to bridge the abyss that separates the past from the present is a quest to transform the present; and thus the future. It is not political in nature, nor could it ever be. It is defined by eternal values and divine principles. Nothing about it is determined by the temporal. It is not a quest for everyone, but for the elect who feel its calling in their very blood.

The self seeks union with the soul and the soul yearns to regain its lost and forgotten territories. The instinctual awareness that such things are possible has served as a fundamental driving force for certain men down the centuries, nay, *millennia*. Poets, philosophers and mystics have searched for the means to somehow achieve these goals, and awaken in man the ancestral memory that might serve as a nexus between the earthly and the divine. The memory is there. The quest to awaken it follows a path that leads through fire and water, forests of symbols and initiatory ordeals not written of in books. That memory is possessed of a power, a hunger, *a will*; as can be witnessed in the realm of nature and certain of its creatures.

Take as a splendid example, the simple starfish. At times, during the harsh struggle for existence far beneath the waves, the starfish will lose an appendage. Although adrift on its own, the lost limb retains a longing somehow to become a part of that which was once the whole. Within the millions of cells of the seemingly dead member, longing is translated into *growth*. Cell by cell, the limb remembers that of which it was once a part; cell by cell, it reconstructs itself into the shape, function and pattern of that to which it once belonged, until finally, memory becomes reality. A new starfish has been created. Clearly, this process can be achieved by a very common creature, so are we to imagine that human beings are exempt from this same longing – the instinctual yearning to be reunited with the primordial whole?

Much lies buried in the blood, in the genes. If you take a common spider, for example, and place it in a box at birth – with no contact from other spiders – it will nonetheless weave a perfect web, purely from genetic memory. While certainly complex, the common spider is a tiny creature whose brain is literally one-tenth the size of a peanut; yet it harbors in its genes an entire array of dynamic survival mechanisms including the ability to weave webs of astounding intricacy. Human beings are far more complicated than spiders. Do you imagine that we only inherit the color of our eyes and the shapes of our heads, or is there a deeper memory that dwells within us, in every cell: a genetic memory? Of course there is. It is a memory that can be awakened – cell by cell – soul by soul.

The word "religion" comes from the Latin *religio*, meaning "going back to the source." The quest for the grail is a quest to return to the source. It is a quest to reunite the part with the whole, the descendant with the ancestor, the temporal with the primordial... and in so doing, recreate the missing nexus between our past and our future.

Booze vs. Baghdad

(Originally published in *Modern Drunkard*, 2003)

The current "War On Terror" is being touted as a war of good versus evil, by both the U.S. and Al-Qaeda – and it is – but to define it even closer to the core, it is a war between cultures that drink and those that don't. Muslims routinely bullwhip people who drink in public, and foreigners unfamiliar with local customs in Muslim countries often find themselves tied to a post and receiving fifty lashes. Therein lies the paradox of Islam. I mean, consider it – they live in an arid and difficult environment, are forced to ride around on donkeys, camels and other vulgar beasts while wearing extremely unstylish garments, and feel lucky if they get a public glimpse of a woman's bare ankle, for crissakes. They're trapped in a world where strong drink is needed the most, but alas, none is to be had. Their Koran forbids having a civilized cocktail, so is it any wonder that they lash out at the least opportunity?

Our allies in this war, on the other hand, are mostly people whose national characters are intimately connected to drinking. For example:

The British:
An empire (albeit fading) built on gin, ale and grog. They conquered the Indian subcontinent just so they could invent the gin and tonic. Their greatest contemporary leader, Winston Churchill, not only withstood the Nazi army, he probably could have drank the lot of them under the table.

The Japanese:
In Japan it is not uncommon on weekends to find businessmen in three-piece suits passed-out on Tokyo's sidewalks. Passersby respectfully refrain from disturbing the businessmen, assuming they must be very dedicated workers, who no doubt richly deserve this restful respite from their labors. During World War II, before sealing their kamikaze pilots into their cockpits, they *didn't* send them off with a cup of green tea and a hearty "Good luck!" – no, they sent them off with a strong shot of sake and a, "Tell your ancestors hello for me."

The Russians:
In the 1970s it was thought that the only thing that could end Communism was to stop vodka and trigger a popular rebellion in the USSR. In the 1990s, Russian Fascist Vladimir Zhirinovsky's chief political platform was lowering the price of vodka. Could you imagine an American president publicly pounding as much booze as Boris Yeltsin?

The French:
The average Frenchman drinks more wine than a wino resident of Denver's Colfax Avenue and reaps powerful health benefits because of it. During World War II they craftily let the Germans overrun their country and get drunk in their wine cellars, so the Americans could defeat said Germans and build Euro Disney.

The Israelis:
Though not renowned as boozers, the bars in Tel Aviv never close. A nation with no last call comes pretty close to living up to the title of Holy Land. Honoring the Sabbath to the Israelis means staying at home, having sex and drinking wine. No wonder the Muslims hate these guys.

The Germans:
A country whose holidays and *putsches* all take place in beer halls can't be all bad. Okay, they keep invading France, but maybe they were looking for some good wine? And they heard so much about how good Russian vodka was, they had to check it out as well.

Whoever thought we'd live to see it, a war with all the good guys on the same side? Easterners and Westerners, Germans and Jews – even the French, who seem to be hated by everyone. A lot of odd

bedfellows putting aside their differences to crush into oblivion a common teetotaling foe. We're living in truly marvelous times. We're witnesses to history.

As I write this, Osama bin Laden is on the run and Iraq is on the verge of being carpet-bombed. Those Muslims will be clear-minded and sober as their world falls down around them. Meanwhile, here at home, I'll have another cocktail; and I'll raise my glass to the pilots who are dropping those bombs; and to England, France, Japan, Germany, Israel, Russia and the rest of this coalition of magnificent drunks. *Chin-chin!*

One Night In Barcelona

(Originally published in *Modern Drunkard*, 2004)

Douglas Pearce, Albin Julius and myself all sat in the shade, finishing our double-bourbons, as the matador delivered the *coup de grace*. Less than twelve feet in front of us the massive bull collapsed, convulsing and belching-out what seemed like a river of blood onto the sand of Barcelona's bull-fighting arena.

I turned to Doug and asked if he wanted another drink. He smiled and said, "Do you really have to ask?" As I got up and headed off to get us another round of cocktails, a team of horses was lead into the arena to haul away the bull's carcass. As I returned, lost in thought, I became aware of a strange, far-away sound not unlike bells jingling. Men around me started shouting in Spanish, gesticulating wildly and pointing. I turned to see what they were so excited about and discovered to my shock that the team of horses dragging the dead bull was bearing-down upon *me*, at full-gallop. I literally ran for my life – narrowly avoiding being trampled to death – and somehow managed to spill not a single drop of the two double-bourbons on ice I was carrying. Oh, running with the bulls is fine, but if you want a *real* thrill, try running from a team of horses with a fat pair of bourbons in your paws.

Doug, Albin and I had been drowning in sangria and bourbon since early that morning, but another fellow in the arena that day had clearly dived-in far deeper than we had. He stood swaying like a pendulum, shouting insults at the matador until nearly everyone in the arena swore they would murder him. Our native guide translated his colorful language for our amusement: "Hey, matador! My little sister could kill a bull quicker than you! I'd rather take a shit than watch this farce!" Just as it seemed a homicidal riot centering on this fellow was imminent, two policemen appeared and dragged the angry gentleman away. He didn't go willingly, instead kicking and shouting while loudly insisting that the day of the angry bull was long gone; and soon, so was he.

When the last bull had died its inevitable, bloody death, we retired to a bar near our hotel for a brunch consisting mostly of more sangria. The thing about sangria is that it sneaks-up on you, and once you start, it's difficult to stop. Just when our food arrived, a man began hollering from the other end of the room. The voice seemed strangely familiar and – sure enough – it was the same vocal gentleman from the bull-fighting arena. I had to meet him.

Translator in tow, I walked over to shake the surly fellow's hand and buy him a drink. I told him I'd enjoyed his spirited discourse on the state of bullfighting, earlier at the arena. He shook his head sadly and affirmed, not unfamiliarly, that the angry bull was long gone, and had been notoriously replaced by lazy and shiftless bulls. It wasn't like the old days, he said; a real bullfighter like El Cordobes would never have sunk so low as to kill a lazy bull. Where had the real men gone? Like the angry bull, they were a thing of the past. As we parted ways, the fellow grasped my hand firmly, telling me I was a great guy, for a tourist.

Following our brunch, Albin, Doug and I moved to an outdoor café on the Ramblas – the huge boulevard that runs through the heart of Barcelona – to swill sangria until our friend Cela arrived. No ordinary friend was Cela; she was our key to Barcelona's hidden subculture. She'd promised to take us to secret bars frequented only by locals; mysterious dives unbeknownst to travel-guides and tourists, which bore no signs and were hidden both above and below twisting side-streets. These were places that wouldn't let a stranger cross their thresholds unless accompanied by a known patron.

Upon Cela's arrival, Albin and I bid adieu to Doug and followed her down countless narrow alleys and dramatically under-lit cobblestone streets, finally arriving at a stout wooden door. She knocked on said door and a small window opened, just like a speakeasy in the movies. The man on the other side eyed us suspiciously for a moment, then the door swung wide. We were greeted by what seemed to be world's longest and steepest staircase. The steps were treacherously narrow, twice as high as they were deep and made of unforgiving cement – one misstep and you'd careen head-over-heels into a strange world, undoubtedly gathering a broken neck along the way. And it *was* strange; one of the most bizarre layouts I'd ever laid eyes on. This odd club was divided into perhaps 10 levels, each consisting of nothing more than an alcove carved-out of solid rock and fitted with a booth. It

might once have been a crypt, employed during a more ancient time and populated by those who lived and died in the dwellings above; one can only imagine. We secured a booth near the bottom of the stairs and I immediately realized that none of the booths were in sight of each other; each group of patrons was shut-away in their own tiny, claustrophobic cell. The barkeep was stationed in an alcove near the middle, and to get service one needed only to shout up the stairwell and the man would appear with alarming alacrity. He leapt up and down the treacherous staircase like a mountain goat high on methamphetamines. As fascinating as this place was, after a couple of beers, the cryptic ambience became overbearing and we ascended back out into the night.

Another darkened alley led us to a faded green door, just like in the song. Again we knocked, yet another tiny door at eye-level slid open, and we were quickly ushered inside. Here we were greeted with a scene straight out of a Fellini film, or perhaps Isherwood-era Berlin. The room was dense with smoke and on its tiny stage a midget wearing too much pancake makeup labored over an accordion. The walls were lined solid with vintage photos and posters of a glamorous Spanish singer and movie star; the woman in the photos was none other than the club's owner and hostess who, eerily enough, appeared suddenly before us, clasping our hands with a warm welcome. She was much older and somewhat plumper than in the faded photos (which were from at least the 1940s), yet she still exuded an tangible aura of glamour. Her hair was dyed jet-black and her eye-makeup hadn't changed a bit since her days of fame and glamour. The club's clientele looked as if someone had sent to a Hollywood studio's central casting department for an assortment of decadents, eccentrics and prostitutes. Aristocratic older men in evening-dress mixed with transvestites, and yet more midgets. It was quite a scene.

Following our introduction to the club's proprietress, the accordion music abruptly ended and our hostess took the stage. After addressing the adoring crowd, a small band joined her and she began belting out a song she'd made famous decades earlier. Her voice was still incredibly powerful and the song was punctuated with a series of dramatic hand-gestures as she pantomimed each line. The crowd ate it up, though they'd probably witnessed the routine dozens of times before. For us first-timers however, it was a mind-boggling spectacle, the sort of fare typically found on the pages of pulp fiction, playing out before our very eyes – a faded star trying to hold on to a long bygone glamour – a dramatic struggle to keep the faded dream alive, if only in a tiny cabaret hidden away on a lonely unlit street in Barcelona.

Cela informed us this was Marc Almond's favorite bar in the city. I didn't doubt it. We stayed for three rounds and I could have sat and drank in the atmosphere (and the booze) for an eternity, and would have, if Cela hadn't mentioned that our next stop was a secret absinthe hideaway...

For all intents and purposes the absinthe bar looked like any other bar in Barcelona. Unlike the previous two locales, we didn't even have to speak to a doorman through a tiny opening to get in. There were windows, for crissakes, through which passersby could gaze in with impunity. Some "secret."

The waiter approached us and rallied his limited command of English, sounding not unlike Ricky Ricardo from TV's *I Love Lucy*. We shyly asked for absinthe and he acted as nonchalantly as if we were asking directions to the Brooklyn Bridge. Cela leaned in to have a quick word with him in Spanish and his demeanor immediately changed. He then ushered us into a small room in the back, well out of public view. He departed to a side-room, then quickly returned with a tray bearing a small carafe of absinthe, a large carafe of ice water and a box of sugar cubes. After preparing our drinks in the traditional manner, he then hustled off and left us alone with "the green fairy." It wasn't our first meeting with absinthe, but this particular brand seemed stronger and more god-awfully bitter than usual. After an hour of hacking through the wormwood jungle we decided to move on.

At this point in the evening, Cela led us to a part of town we were vaguely familiar with and there abandoned Albin and I to our own devices. It was quite late by now and the streets were deserted, save for prostitutes and burly doormen guarding flashy nightspots full of tourists. We began to wander aimlessly, and naturally we soon found ourselves in an extremely sleazy sector of the city, which was crowded with strip clubs and garish neon signs flashing that universal siren-call, "SEX, SEX, SEX." Albin's eyes lit up and he somehow managed to convince me the night was, in fact, quite young. Now our only problem was option anxiety – which of these wicked places would deliver the most lurid behavior? Albin spied a neon sign several blocks down flashing, "SS Club." "What could be this?" he

inquired in his childlike Austrian accent, "a place where strippers are taking off German uniforms?" It *would* surely be the ultimate in kink; so our decision was made. As we approached, however, we were gravely disappointed to discover the sign actually read "KISS Club," the devious K and I were burned-out. Still, we figured fate had lured us there for a reason, and we determined to find out what that reason was.

As we crept into the KISS Club's red, velvet-lined antechamber, we were met by a woman who appeared the archetypical brothel madam. She explained that we must purchase at least two drinks, then led us to a table in a room that was pitch-black but for the light reflected off a silvery curtain at the back of a stage. After whispering something in Albin's ear, she departed. He quickly related that if we found ourselves particularly enamored with one of the girls, we need only give the madam some money to earn the right to take the girl in the back and shag her. Now *that's* hospitality.

Our drinks arrived as a Spanish girl wearing blue eye-shadow and thick mascara climbed on stage and began writhing about to deafening techno music while losing possession of her clothing. She eventually stopped writhing, gathered up her garments – shed for naught – and schlepped off stage. Shortly thereafter, a loud thumping began and all eyes returned to the stage. We sipped our cocktails and patiently waited, but no one appeared. After 20 seconds or so of gazing longingly at the empty stage, I found myself suddenly overcome with the overpowering notion (I blame the absinthe) to leap on stage myself. So I dashed to the front of the club and did just that, much to the audience's approval.

Not being much for dancing as such, I instead seized a chair and held it aloft as I marched about the stage like a majorette leading a marching band. I did this for what seemed like ages, until a movement stage-left caught my eye. I turned to find the tardy stripper dashing toward me. She slid to a stop, confused by my presence, then smiled and walked toward me like it was all part of the show. She began to dance circles around me evocatively, caressing me rather theatrically. After a warming me up, she removed her top and gave it a toss. She then began slowly unbuttoning *my* top and it went the way of hers. She then kicked-off her heels, sending them spinning off into the darkness – following which she pushed me onto the chair, then knelt to unlace my boots. The audience roared with laughter as first the boots, then my socks were tossed into their midst. The lovely Latina then stood to jiggle her breasts an inch or so from my face. When she finally got around to removing her g-string, she did so slowly, teasingly, before swinging it like a propeller over her head and letting it fly. I was pretty sure I knew what was coming next – in my mind's eye I could see her twirling my pants high above her head and letting them sail into the darkness...

I didn't have to wait long to find out. The stripper danced off to the side of the stage and then came to a standstill, placing her hands on her hips and staring into my eyes. She turned to the audience, then gestured toward me. They hooted and hollered, and she came toward me in a stylized crouch, like a panther stalking its prey. She took me by my hands and pulled me from the chair to my feet. Now she ran her hands down the length of my body until she was kneeling before me. With professional speed and dexterity, she soon had my belt unbuckled, my fly unbuttoned and my pants around my ankles. She seemed surprised I wasn't sporting any underwear and turned to the audience feigning Macaulay Culkin-esque shock, her mouth open wide and her hands to her cheeks. She pushed me back down into a sitting position, pulled my pants off and (much as I'd prophesied) they too vanished into the darkness. I blurrily remembered that as I'd hopped onto the stage, Albin had yelled-out, "Boyd! You should get totally naked!" And there I was – naked.

Pushing me back into a seated position, the stripper straddled my legs and sat on my lap, pressing herself tightly against me. It began to appear as though we were about to kick off the live-sex portion of the show, but it was just at that moment that my mind flashed to my pants, sailing away into the darkness... with my wallet and a rather large sum of money still in them. Panicked, I lifted the stripper off me, determined to rescue my trousers from the grasp of what I imagined would surely be a gang of desperate degenerates. Before I could leap off the stage, my stage-partner seized my forearm with both her hands. Smiling, she leaned-over and gave me a kiss on the cheek. I don't care what you might think about her earlier behavior, the girl had class.

Despite my earlier concerns, the audience was very helpful in reuniting me with every errant article of clothing. Someone had even folded my pants and placed them on my table, with nary a single peseta missing. As I pulled my boots on, the hostess came over with a round of free drinks; a

gesture which is very indicative of the nature of Barcelonans. Nearly anywhere else in the world, the sort of sordid behavior I'd just engaged in would have gotten me physically ejected, arrested, or worse. In Barcelona it was rewarded with a complimentary cocktail.

Following our escapades at the KISS Club, Albin and I retired to the Cosmo Bar on the Ramblas, an outdoor joint just a stone's throw from our hotel. Our friends, Doug and Ken Thomas were already on-hand, watching the teeming eccentrics, musicians, bizarre street artists and common folk parading down the boulevard. As we reviewed the day's events over a drink, Albin concluded that he was incredibly fond of Spain and the Spanish people. "They know how to live here," he declared. I agreed that they certainly did. Contented with our misadventures, we sat beneath the streetlights until the bar closed down, enjoying life's passing parade, the warm night air and cold Spanish sangria.

Whenever anyone asks me what I did in Barcelona, I tell them, "I worked there. As a stripper in an all-nude show. They paid me in drinks... and I was happy."

Disneyland's Club 33
Beyond The Green Door

(Originally published in *Modern Drunkard*, 2004)

Disneyland is billed as "The Happiest Place On Earth" – and it's happier still when you've had a bottle or two of fine wine. Growing up in southern California, I was a frequent visitor to the theme-park, and even in my youth I heard whispered rumors about a secret restaurant built by Walt Disney above the "Pirates Of The Caribbean" ride. It was ultra-elite, I was told, and only millionaires and movie stars were allowed inside. My youthful imagination went into overdrive. Disneyland was my idea of a garden of earthly delights, and if there was a secret place inside that garden – one so special that the general public was denied access – then that place had to be *out of this world*.

An Invitation Into The Inner Sanctum:

Over the years I queried many people about this restaurant, getting a wide variety of responses. Some said it was an urban legend. Others said that it was an eatery for Freemasons and masters of industry. Eventually I met a fellow named Tom who worked for W.E.D. (Walter Elias Disney Corporation) in the capacity of "imagineer." When I inquired about the restaurant, he unhesitatingly said, "Oh, you mean Club 33."

So, it was true; it really existed. It's also true that Walt was a master mason of the 33rd degree – the highest degree to which a Master Mason may rise – which is why I believe it was named Club 33 (there are many other competing theories). Tom regaled me with strange and humorous anecdotes about the club and, noting my obvious enthusiasm, he eventually asked, "Hey, would you like to go there?" "Yes," I immediately informed him, "I *would*."

At the time (1980) reservations had to be made months in advance, to allow for the attention to detail that made every guest feel as if he were a god entering Valhalla. When you were led to your seat, a shiny black book of matches sat at your place-setting with your name embossed upon it in silver. Though this may not be your idea of Valhalla, it's undeniably highfalutin' and I've never heard of another restaurant to go to this extreme in personalized courtesy.

Secrets Of The Pirates:

Since the entrance to Club 33 is secreted away near the exit to "Pirates Of The Caribbean," we went on the ride prior to visiting the restaurant, a ritual I've repeated to this day. As a student of the occult, I've come to appreciate the Masonic influences of many of Disney's rides. "Pirates Of The Caribbean" in particular recapitulates the symbology of the ancient mystery religions. First, you are advised to turn back by a talking skull, warning that death may be imminent. Then you descend into a fantastic underworld. After enduring various trials and tribulations, you experience absolute destruction and finally ascend into the light. What better prelude could there be to entering the fabled Club 33?

Exiting the ride, you'll wander onto a faux New Orleans street named Rue Royale and to your left, behind an apparently fake door with the innocuous marker "33" is the entrance. Even if you've been to the club a dozen times and think you remember clearly where it is, you can still miss it. It seems almost invisible; and for good reason. Disney's imagineers have scoured the color spectrum and discovered the shades least noticeable to the human eye. The color which ranks the highest they call "No-See-Um Green." If you look around the park with a critical eye, you'll find many things hiding behind this shade, including the door of Club 33.

Beyond The Green Door:

In the old days there was a secret panel near the door concealing an intercom that would allow you to get buzzed in. Nowadays you need a keycard to access the doors to Valhalla. Once inside, you'll enter a small antechamber where a hostess verifies your reservation, then directs you to an

antiquarian 19th Century elevator that will lift you to an eatery which replicates the fineries of a bygone age. The club as a whole possesses an understated sense of elegance. When first I dined here, a harpsichordist played Mozart tunes.

Stepping off the elevator and into the Gallery, you'll find a wooden telephone booth with leaded glass panels identical to the one used in the Disney movie *The Happiest Millionaire*. Other interesting-looking pieces of antique furniture abound, and the walls are decorated with a vast array of original (and undoubtedly invaluable) works of art by Disney artists.

The Gallery leads you to Lounge Alley, the buffet room for the main dining room and the trophy room. The main dining room is an elegant remembrance of the Napoleonic era. Lit by three glimmering chandeliers, fragranced by fresh flowers and populated with antique bronzes, it emanates warmth and dignity.

The trophy room is a bit less formal. Wood-paneled and rustically refined, it brings to mind the den of a 19th Century sportsman of no small means. There was a time when it was less refined and much more macho, with big-game trophies, Fijian war-clubs and even a mastodon tusk adorning the walls. But alas, these items went the way of the wooly mammoth and were replaced by sketches and paintings. A few birds remain, notably an animatronic turkey-vulture lurking in a corner. Walt envisioned the vulture conversing with guests (microphones were planted in the chandeliers to collect personal information) while they dined, but he died before he could put his strange and brilliant plan into operation – which is a pity. What could be more exciting than – while digging into a steak – having a mechanical vulture start hassling you for a cut of the action? And, what's more, the cheeky bastard would hassle you *by name*.

And as you might expect, the food at Club 33 is fabulous. The pasta bar dishes out everything from gnocchi to fettuccine al pesto, all cooked to order. There's beef briquette, chicken fricassee and mushrooms stuffed with crab meat. It's a flabbergasting buffet featuring every delicacy a condemned man (so long as he was a man of taste) might wish to enjoy as his last meal.

Above and beyond all this gastronomic majesty, of course, is the restaurant's greatest allure – it's the only place in The Magic Kingdom where alcohol is served.

Drinking In Disneyland:

When I stopped-in a year ago, my pals and I waded through several bottles of a very nice chardonnay before our meals were finished. Bottles of wine start at around fifty bucks a pop, but how can one put a price on the experience of getting drunk in Disneyland? Following our wine, we proceeded to some serious drinking that day. The club assembles an excellent martini, and I lost count of how many I consumed before we realized the restaurant was empty save for us gin-guzzlers. We'd arrived at noon and it was presently dark outside. The tab was twice as much as I pay for a month's rent, but hey – I was in *the happiest place on earth* and I know what makes *me* happy.

We stumbled out into the warm California night and made our way to "Mr. Toad's Wild Ride." This has always been a favorite of mine, and is another simulated occult rite of death and resurrection. During the ride, you are nearly killed, half a dozen times, consummating with a head-on collision with a train, then you ultimately end-up in Hell, before being cast back out into the park. Under any circumstances the ride is a laugh riot, but after having consumed four hundred bucks worth of gin and chardonnay, it's damn near a religious experience.

And so it was with the other rides in Fantasyland. In "Snow White's Scary Adventure," the last tableau you see is the witch about to launch a gigantic boulder down a path, to crush the hapless seven dwarfs. Immediately afterwards you travel through a set of doors and note a huge sign reading, "And they lived happily ever after." This odd mix of death and happiness pervades Disneyland. There are 999 happy ghosts in "The Haunted Mansion," but, "there's always room for one more." "Hurry back!" the little wraith at the ride's end entreats visitors, "and be sure to bring your *death certificate*." It's all too easy to imagine that this morbid humor is indicative of a more innocent age in which people could still smile about death and destruction, but even the newest rides are imbued with a sense of the macabre. "The Temple Of Doom," as the name indicates, is one such example. It's a rollercoaster ride past a fiery abyss, death-doting Kali worshippers and mountains of human skulls. If you're looking for a celebration of mass death and fetishistic danger, look no further than "The

Happiest Place On Earth."

Penetrating The Green Door:

Over the years I've been lucky enough to visit Club 33 about a dozen times. I say lucky because I've always had the great fortune of knowing people who knew people who could get me in. I say *great* fortune because the rules governing access to the club have become increasingly stringent. Disney employees, such as Tom the imagineer, are no longer allowed in. I recently met a high-level Disney employee whose jaw dropped when I mentioned I had reservations at the club. "I've worked for Disney for over ten years," he exclaimed, "and I've never been allowed inside."

If you're Michael Jackson or a high-powered CEO, the red carpet is rolled-out for you at Club 33. If not, there's a $7,500 membership fee, plus $2,250 in annual dues; and there's only room for 400 members on the club's rolls, so you can expect a three-year waiting-list. Despite the obvious appeal such elitist and exclusionary tactics lend to the club, it's sort of a shame. Disneyland and drinking go together like Peter Pan and Tinkerbell.

In a better world, they'd serve daiquiris as you waited to get into "The Enchanted Tiki Room," and Bloody Marys while you languished in the line for "The Haunted Mansion."

Disney's rationale for not serving booze in the park is that it might detract from the wholesome atmosphere. Which is ridiculous, of course. What could be more wholesome than a belt of rum while watching crazed pirates raping, pillaging, and burning a village to the ground? Or a shot of schnapps while a vengeful witch attempts to crush dwarves with a boulder? And what better than a mint julep to make a trip through Hell more pleasant?

Woody Woodbury
High Holy Man Of Hooch

(Originally published in *Modern Drunkard*, 2004)

In the early 1960s, Woody Woodbury reigned as the High Priest of Liquor Culture. His headquarters was a famous watering hole in Fort Liquordale (Fort Lauderdale to you teetotalers), where he performed a comedy routine based almost entirely on booze and boozers. He was such a devotee of drink that he founded a religion based on alcohol consumption called BITOA, an anagram for Booze Is The Only Answer. The members of this creed called themselves Bitoans and were organized to such an extent that they would travel from cities across the U.S. for group holidays at luxury hotels known to have superior bars.

There was even an official Bitoan publication called *Woody Woodbury's Party Magazine*. It included essays on booze, how to throw wild parties, and details of events celebrating the Bitoan lifestyle. There was a regular feature called "Booze Nooze," a humor section called "Booze, Babes & Bars," and a consumer information section called "Shopping With The Booze Hound." The Booze Hound was the official mascot of the Bitoan movement, an iconographic representation of a tipsy canine meant to convey the spirit behind the sect.

Dedicated Bitoans could order plastic wall plaques of The Booze Hound for five bucks (a lot of money in 1961), so their home bars could, in effect, be transformed into shrines. They could also purchase small pendants shaped like martini glasses which bore the inscription "Member Bitoa," as well as framed parchments outlining the creed. When visiting Florida to see Woody perform at The Bahama Hotel, members received a 10 percent Bitoan discount on their rooms.

Woody Woodbury may well be the only lounge performer to ever successfully make the transition to cult leader. Though today we might perceive cocktail comedy as a marginal phenomenon, in Woody's day it was nothing of the sort. It's appeal was so widespread it is almost impossible to comprehend in terms of the current culture. Woody's records sold so many copies they went gold, and in the 1960s it seemed like every household with a record player had at least one of his albums. He was a frequent guest on The Tonight Show, and an occasional guest-host as well. He even appeared in movies, playing himself in *For Those Who Think Young*, a comedy about teenagers on Spring Break in Florida.

Woody's albums are essential live documents of him holding court at his headquarters at The Bahama, complete with the sounds of catcalls from drunks and the clinking of cocktail glasses. The albums so effectively capture the atmosphere of the proceedings that one can almost smell the cigarette smoke and cheap cologne. In ads for his LPs, Woodbury claimed that playing one of his records would, "Turn your house into a night club," and indeed it does. When the record starts to spin it becomes a genuine time-traveling experience – you feel as though you're back in 1961, the golden age of boozers and bars, a time when albums of cocktail comedy go gold and Mecca was a place called Ft. Liquordale.

I urge every serious sybarite to seek-out those recordings and see for yourself why Woody Woodbury was, and still is, the High Holy Man of Hooch.

Nectar Of The Gods

(Originally published in *Modern Drunkard*, 2005)

As local legend has it, when Viracocha ("The White God") mysteriously appeared in South America, he taught the native people he met there all the "arts of civilization": astronomy, geometry, agriculture and architecture. He also taught them how to make wine from honey. When he finally left these people, they slowly returned to their huts and gradually forgot most of what they'd learned from him. But to this day they still brew an alcoholic beverage called *balche*, based on the same recipe Viracocha taught their ancestors millennia ago. And who can blame them; I mean, those other arts are great and all, but what are they compared to a well-prepared gourd of honey wine?

Not surprisingly, there are many myths from around the globe in which the figures credited with founding the regional religion are also said to have been the inventors of alcoholic drinks. In northern Europe, the heaven-sent bringer of the booze was the Norse god Odin. More than willing to suffer for his art, Odin sacrificed an eye for wisdom, and hung himself on a tree for nine days and nights to come-up with the runes; an early form of written communication, but also powerful magical symbols. After he got the requisite magic tricks and wordy stuff out of the way (probably after boring the hell out of the natives), Odin got around to bringing them something they could sink their tongues into: mead, another alcoholic beverage made from honey.

Now, if you've ever tasted real mead before, you have to know these savages must have *really* wanted to get liquored-up. These early Vikings felt that hitting the mead brought them closer to their gods, and would regularly drink to gain Odin's blessing before battles, as well as to heighten their fearlessness (something that would later be referred to as "Dutch courage"). Oftentimes "berserkers" (the old Viking version of the Japanese kamikaze – only with axes instead of airplanes) were not the bravest and most suicidal, but rather the most *loaded*. Unfortunately, the practice of boozing before battle sometimes led to less than favorable results – on the eve of one key battle, the Vikings decided they wanted to be *really* sure they had Odin's blessing, and drank to such excess that the next morning they had such horrible hangovers that their enemies were able to demoralize them by merely rattling their swords against their shields. The whole lot were then promptly massacred (if you've ever experienced a mead hangover, you'll know they were probably grateful.) So the next time your wife complains about you coming home drunk, tell her you were merely out getting Odin's blessing (but don't blame me if you get massacred).

For the early Greeks, it was Bacchus who coughed-up the wine recipe, and wine played a central role in his worship. Worshipping Bacchus essentially took the form of a drunken orgy, so – as you can imagine – it was a pretty popular religion in its day. The behavior of Bacchus' followers (Bacchantes) was so notorious that to this day any sort of excessive hedonism is called "Bacchanalian." Bacchus' cult outlived the Greeks, surviving into Roman times, where he changed his name (probably for legal reasons) to Dionysus. The followers of Dionysus became so frenzied in their drunkenness, that for party tricks they would sometimes behave like crazed animals and rip passersby limb from limb. So, it was the equivalent to a modern-day frat party, essentially.

Even a religion as tame as Christianity is not without its booze lore. Surely, of all of Christ's miracles, turning water into wine is the most impressive (and back in the day, was probably the most popular). With Christ possessing the power to turn a pond into a party, it's no wonder Christianity spread like wildfire. You can almost hear the apostles saying, "Hey, J.C., bringing that guy back to life was awesome and all, but... uh... could you do the water-to-wine thing again? The boys are getting thirsty."

No teetotaler himself, Christ was much-abused by his detractors because of his fondness for wine. At a time when most holy men made an ostentatious show of their piousness by fasting and depriving themselves of worldly pleasures, Christ was known to have a healthy appetite for good food and drink. His opponents might not have thought much of it, but it no doubt endeared him to the chaps down at the wine pub. And to prove Christ liked to spread the joy around, he made wine an enduring part of orthodox ritual, in the mock-cannibalism of the Eucharist ceremony (still the central ritual of Catholicism.)

Oddly, in biblical lore it was that perennial black sheep, Cain, who's credited with the invention of wine. While his uptight brother, Abel, was out sacrificing animals, Cain, the "man of the field," busied himself with inventing the plow and cultivating both grains and grapes; from which he created the first form of vino. Early depictions of Cain portray him as a bearded man, holding a sheaf of grain in one hand and vine-bearing grapes in the other. Though it's popular these days to suppose the figures of Cain and Abel were purely mythological, a good deal of evidence exists to indicate they were in fact historical figures. Many cultures in the Mideast recount in their legends the appearance of a man who taught early communities how to build a plow, plant grain, enjoy music, cultivate grapes and – yes – make wine. Though the name of this figure varies from region to region, all the names do phonetically echo titles held by Sumeria's second king, Kan, a figure thought to be the historical prototype of the biblical Cain. How'd Kan get to be king? I'll bet the wine thing had a little to do with it...

Ancient people drank to get closer to their gods; to achieve a temporary state of ecstasy in which they could rise-above their mundane daily concerns and catch a glimpse of something timeless and otherworldly. Native Americans did this with peyote; across the Atlantic they used booze. But you don't have to want to get close to God to appreciate the wonders of alcohol – you don't even have to be a believer. The effect is still the same – worldly cares and woes shrink away, one sip at a time. And we owe it all to that old villain Cain.

In a better world Cain wouldn't be regarded as the villain of biblical lore, he'd be the first hero. Okay, so he smited his brother with a rock, but perhaps he had a valid reason? Maybe Cain was a violent forerunner of P.E.T.A., or maybe Abel was riding him for "getting close to God" every night? Or maybe he just had a hangover and simply couldn't *deal* with his teetotaler brother anymore? Who's to say? But regardless, would you rather live in Cain's swinging scene of agriculture, wine and music, or in Abel's creepy world of killing sheep and setting them on fire? If you ask me, Cain got a bad rap.

The Holy Land Experience

(Originally published in *Bizarre*, 2005)

If you've ever wished to make a pilgrimage the Holy Land, but were less than thrilled at the prospect of flying bullets and suicide bombers which might be attendant to such a journey, read on.

Now there's a theme-park in Florida which offers a Disney-esque glimpse of the Holy Land, *sans* the specter of Holy War. It's called The Holy Land Experience, and its creators claim that it's not so much a theme park as a total-environment, meant to transport the visitor back to the Jerusalem of biblical times. Though its close proximity to both Disneyworld and Universal Studios might lead one to expect rollercoaster rides replicating such stories as "Jonah And The Whale" or "The Parting Of The Red Sea," such is not the case. In fact, there are no rides to speak of.

The park's creators stress that it's not merely a Christian amusement park, but a serious attraction where visitors can learn more about biblical history and experience a deeper understanding of some of the places described in the bible. You can visit Herod's Palace, for instance, or the Wilderness Tabernacle. For most guests, the high point of the park is a chance to stroll through the Garden of Gethsemane and check out the empty Tomb of The Christ.

The park was already controversial before it even opened last year, and "freedom from religion" advocates protested that it was merely a clever plan to indoctrinate and proselytize to unwary atheists. But the park's creators pride themselves on the understated nature of The Holy Land Experience and counter that it is simply a family-oriented tourist attraction meant to educate and entertain. And speaking of entertainment, actors in period costumes perform Vegas-style routines on the steps of Herod's Palace, belting-out gospel tunes via wireless headset microphones; or appear outside the Tomb of Jesus, singing songs celebrating his life – and death.

Of course, even Christians get hungry and thirsty after trudging through the caves of Qumran, *et al*, for hours in the humid Florida heat. And as would be expected, the park offers biblical-themed fast food. You can chow down on Goliath Burgers and other tasty treats, the likes of which probably *weren't* on the menu at the Last Supper. For desert there's King Solomon's Shortcake, or if you'd prefer, milk and honey ice cream.

As you can see, The Holy Land Experience offers a wide variety of sights, sounds and culinary fare above and beyond what's available in the *real* Jerusalem, either ancient or modern. So if the perennial problems plaguing the Mideast peace process have caused you to put your plans for a visit to Jerusalem on permanent hold, The Holy Land Experience may well be the answer to your prayers.

Cold War Cocktails

(Originally Published in *Modern Drunkard*, 2006)

Try to imagine a bar frequented only by star-crossed lovers. A watering-hole inhabited by couples doomed never to share each other's lives – only a few stolen moments over cocktails. It sounds like a place that could only exist in *The Twilight Zone* or the imagination of William Shakespeare, right? Wrong. I've been there, even bought a round for the house; but to tell my story I must first describe an era in which the Cold War was still very chilly indeed...

Berlin, East Germany, 1978:

"Checkpoint Charlie," the famous crossing-point in the Berlin Wall that separated East and West Berlin, was manned on the Western side by American servicemen stationed there and on the Eastern side by East German Communist soldiers. Upon my arrival into the Eastern sector, my first impression of it was that the East Germans hadn't evolved much since the Nazis were running the show. The uniforms and attitudes seemed the same, the only apparent difference was these guys were commies.

I was hoping to spend a few days in East Berlin, but the militaristic hard-asses at the border-checkpoint clearly didn't want me there. They tore apart my luggage and tossed out a Blondie LP I'd brought as a gift for a friend. The commandant stared me down. "Is there any reason you are bringing this sort of *cultural material* into East Germany?" he demanded. I laughed. "It's not culture," I told him, "it's just pop music." He slammed his fist down in indignation, snatching the record at the same time. "We'll see exactly what it is! Sit down and wait." I sat down, terrified that my destiny seemed to be resting upon whatever counter-revolutionary significance a Blondie record might possess. An hour elapsed, and then another. At length, the hard-ass reappeared with an entire commie posse in tow. His demeanor was brighter and friendlier. Grinning, he handed me back the record and asked, "Are you a friend of Blondie?" "I've seen them in concert," I told the man, "but I don't really *know* any of them as such." "No, no, no," he protests, he has heard them often on the Radio Free Europe, he is a "large friend" of the group, as are his fellow inspectors. His pals grin broadly. For the first time I realize that these fellows have the number-one sweetheart gig in Communist Germany. They'd kept me waiting because they'd been listening to the LP over and over again. These seemingly spit-and-polished stormtroopers, who I had initially feared might be my firing squad, appeared even more corrupted by Western decadence than those they guarded from it. They certainly had better access to it.

I was duly informed that I was free to proceed as soon as I purchased a visa and exchanged a sizable amount of American dollars for East German Deutschmarks. Needless to say, the exchange rate was utterly insane. The East German mark was all but worthless, and yet I had to exchange for *a lot* of them in order to enter the country. After I'd traded currencies, *Das Commandant*, who by this point imagined me to be some sort of kindred spirit, stepped outside and confided in me. There was no human way, he informed me, that I would be able to spend all that money in the three days I'd planned on spending in East Germany. He gestured toward a building a half-block away. "That's a bar, down there," he informed me. And not just any bar, it was a kind of nexus between the East and West. It was a place where lovers drank before one or the other went back to the West, through Checkpoint Charlie. "Go there early in the day," he advised me, "and attempt to drink-up all your cash. If you can't, then buy a round for the house. Seriously."

Of course, the bar was my first stop. After Checkpoint Charlie you *need* a drink. If the place had a name, it didn't gleefully advertise it the way Western bars do. I admit it didn't make a large impression, this first visit. I didn't drink-up all my marks – though I made a fair start – and was soon in an excellent condition to explore East Berlin...

I quickly discovered that the area around the checkpoint was a devastated no-man's land; block after block of oblivion punctuated by towers peopled with snipers, making sure no one tried to circumvent Checkpoint Charlie. Amidst this landscape, which had undoubtedly changed little since World War II, I came upon a phone booth. It squatted in the rubble and desolation like an artist's rather broad attempt at surrealism. Endeavoring to make contact with my local friend, I inserted coins

into the phone and it sounded as though they were tumbling down a massive echo-chamber, into the underworld itself. He gave me instructions on how to navigate to Berlin's central square and traffic intersection, Potsdamer Platz, and which train I needed to catch from there. En route I noticed a massive cement structure and a semi-collapsed tower, thrusting forth from the gravel. Intrigued, I ventured down the structure's stairwell, entering a small, dank room filled with pools of rank, murky water, broken bottles and the unmistakable debris of teenage parties. The stairway continued downwards and I wondered what lay down in that darkness; but *sans* matches or a lighter, it was a mystery I had to pass on.[i]

Dominated by a massive statue of a gesticulating Vladimir Lenin, casting its shadow across the square, the once-sprawling Potsdamer Platz was now as jarringly surreal as any Salvador Dalí painting. It should have been choked by congested traffic, but it wasn't; quite the opposite in fact. It was completely empty; no cars and no people. The divvying-up of the city and the massive wall which had since bisected it, left this once-central square redundant and useless. An eerie silence hung in the air. I felt like I was in one of those episodes of *The Twilight Zone* in which a man wakes up to find that he's the last person on earth. Being somewhat drunk only made it better, of course.

The square's subway station presented the same scenario. It was a vast complex of endless, marble-slab hallways, each stretching out to a vanishing point. All empty and lifeless. There were no ticket-takers or sales people, just a pole festooned with hundreds of train tickets and a plastic box in which to insert your fare before taking a ticket. I could easily have just grabbed a ticket and not paid, but this was a police state and I didn't want to tempt fate, so I paid for mine.

When the train arrived at the platform I was pleasantly surprised to see other human beings aboard. As the vehicle emerged from underground and onto an elevated track someway down the line, I was struck by the fact that there was no color anywhere here, only shades of gray. The sky was gray, the buildings were gray, the streets were gray, et cetera. Rusted signage from the pre-Wall era was the only proof that the city was once part of the 20th Century. These few weathered remnants from the 1950s looked downright futuristic in 1978 East Berlin. The place was perhaps fascinating on one level, but mostly depressing.

I got off the train a short while later to find my artist friend waiting for me at the station. I demanded we go to the nearest bar, just to drink away the gray, but was told it would be better to drink at his house. Heading back to his place, we walked through a terrain so bleak and soul-destroying, that the posters and billboards of burly revolutionary workers brandishing tools and firearms only seemed to accentuate the vast abyss between the harsh realities of daily life and the long-decayed Communist ideal. Nevertheless, I must confess to a certain excitement at being in the midst of a totalitarian regime. Yes, it was total bullshit, ideologically, but the constant reminders that the populace were revolutionaries involved in a magnificent struggle was, uh, almost *cool*. I paused to take a picture of a billboard in which a White man, a Black man and an Asian were embracing and – presumably – advancing toward a glorious Communist future, united by Communism and unencumbered by their differences. "Does anyone here really buy into this stuff?" I asked my host. "No," he said. "Not for many decades, I think."

The next few days were a bleak whirlwind, a protracted nightmare softened only by the large amount of alcohol I used to paint the otherwise bleak world around me. My gracious East German hosts attempted to offer me the best of their world, but I encountered situations that would make the most hardened contestant on TV's *Fear Factor* gag. Finally, in an attempt to perhaps salvage their national gastronomic reputation, my host took me to East Berlin's fanciest restaurant, where I was served the finest dish on the menu. Confused at the sight of it, I asked what it was that I was fearfully gnawing on. It took a while, but at long last they divined the proper English words for it: bird hearts. Fabulous. I required no less than a bottle of industrial-strength wine to wash it down.

When I finally made it back to the inconspicuous bar near Checkpoint Charlie, at the end of my visit, I was more than ready for it. There, my East German host gazed into the depths of his beer and told me tales of a girl from the West he'd been in love with. They'd drank together regularly, at that very table, and when the bell for last-call rang, she would return to her world. But after a while, she never came back. A friend of his had met his own Western girl at the bar and longed for her so much that he attempted to go over the wall. He was machine-gunned to death.

It began to dawn on me that this was perhaps the most Wagnerian watering-hole in Europe,

if not the world. It was then that I remembered the advice of the border-guard commandant; that I should "buy a round for the house. Seriously." Just as the guard had foretold, I still had plenty of East German marks left; largely because there was nothing to *buy* in East Berlin. So I took out my wad of bills and asked the bartender if I had enough to buy everyone a beer and a shot. Indeed there was, and then some. He began filling beer mugs as his partner poured schnapps into shot glasses. For a brief while, the gloom dissipated as the smiling patrons bellied-up to the bar for free drinks. I emptied my remaining East German coins into the bar's ancient jukebox. The selection was mostly German folk songs, a few Heino singles, and a 45 by an early-1960s Polish girl group called Filipinki. Certain of the folk songs hit a real nerve with the customers, who began singing along the moment the songs began. It was as though I'd stepped into a scene from *Cabaret*, and the effect was both stunning and eerily disconcerting.

As the night wore on and the collective consumption of alcohol increased, so too did the sense of melodrama. Lovers held one another's hands and gazed into each-other's eyes in absolute silence. Others wept. Some couples were very young, others perhaps in their late fifties. The atmosphere in the bar was such that many a lone tourist stopping in for a drink on the way back to the West would take one step inside, scan the scene and turn on their heels. The place was literally suffused with a palpable sense of tragedy. And as the hour grew later, the vibe only intensified. I had no desire to hang around and see what last call might bring, so my host and I exited into the night. As we said our farewells into the cold night air, my friend said I could stay at his house anytime I visited East Berlin. I thanked him and said I would, but after shaking his hand and walking away down the wet cobblestone road, I knew I'd never go there again.

Exiting Checkpoint Charlie, I was waved-through by the American guards. I stepped over a line painted on the pavement and passed into an altogether different reality; West Berlin... and Capitalism. Suddenly there was color everywhere. Neon lights flashed and garish ads screamed for attention. Vast columns of cars zoomed past with their radios blaring, and I caught snippets of the latest ABBA song. For obvious reasons, the West is certainly more to my liking, but I couldn't resist romanticizing, ever so slightly, the sense of melancholia that I'd experienced in the East; the doomed lovers who perhaps even at that moment were sharing a final last call cocktail before parting ways and returning to their separate worlds.

In a better world, that unremarkable Checkpoint Charlie bar would be preserved as a great monument to Melancholy. A place where two worlds as different as night and day came together. A place where East and West reached out for each other over a drink. I often wonder whether it still exists, or if the star-crossed lovers from the Cold War era ever return there to transverse memory lane. I'd certainly like to imagine so.

i Decades later I discovered that this place was the Führerbunker, the place where Adolf Hitler and his Nazi cronies spent their last weeks on earth. That's how bad the kids in East Berlin had it – they had to party in the anteroom of Hell.

Hitler In Zimbabwe

(Previously unpublished book proposal, 2006)

Western intellectuals enjoy promulgating the image of indigenous peoples as being that of the Rousseau-esque archetype of the "noble savage" – a natural man unencumbered with the conceits of Western civilization which define his debased modern counterpart. In reality, this view is in itself one such conceit, a politically correct bit of self-delusion concocted by the Western mind to avoid dealing with inconvenient – at times seemingly *inconceivable* – truths. Though such elaborate self-delusions might be seen to border on outright insanity, they can't hold a candle to such insanity as still holds reign in certain parts of the world, even today. For your approval, we offer a series of vignettes, all real, all true. Thumbnail sketches of the human condition, gleaned from a file labeled "keeping it real."

Hitler In Zimbabwe is compiled from literally thousands of honest-to-God reports from agencies as legit as the BBC and Amnesty International. Unbelievable true tales from the dark underbelly of the Dark Continent, such as:

A man calling himself General Butt Naked leads an all-nude army. His troops are invincible, he claims, because "their nudity makes them invisible to the bullets of the enemy."

A man in a town square proclaims that his penis has been "stolen by a witch." He points out the woman who he claims to be the thief of his member, who is subsequently beaten to death by an angry mob.

Three children arrive at a local schoolhouse, claiming that a fourth classmate has been "turned into an eggplant" by a witchdoctor. Local authorities take possession of the eggplant, placing it under "protective custody" pending capture of the witchdoctor.

The right-hand man of Zimbabwean leader Robert Mugabe changes his name to Adolf Hitler. When a flabbergasted *60 Minutes* reporter asks Mugabe if he isn't worried that people in the West will find this horrible, he simply smiles and responds, "Hey, what's in a name?"

A rumor that telephone lines have been cursed results in a superstitious populace refusing to answer any phone calls, effectively shutting down an entire nation.

In the midst of a murder trial, a snake and two brightly-colored birds simultaneously appear in the courthouse. The room is evacuated and the trial postponed for weeks, pending fear of witchcraft afoot.

The bodies of a male and female are found dead at the foot of a cliff – a local Lovers' Leap. The man's fingers are still intertwined with those of his beloved; an orangutan.

On an almost weekly, perhaps even daily basis, nearly identical tales appear; seldom, if ever, reported in the Western press. We'd rather not even conceive that scenarios of such a degree of absurdity – or unmitigated barbarity – occur with the level of regularity that they do. But indeed they do. What follows is the introduction to *Hitler In Zimbabwe*...

Try, if you can, to envision a far-distant land where women accused of stealing penises are beaten to death by angry mobs and militias attired in wedding-gowns, high-heels and blonde wigs, murder with *impunity* and dine on the barbequed hearts of their victims. It's a world as different from your own as night is to day. Believe it or not, this world exists. It is called *Africa*. Not the Africa of Joseph Conrad, or even of such recent despots Idi Amin or Jean-Bédel Bokassa – it is modern Africa, the Africa of today.

The events which will be described in this volume are all real, all true. Though mind-

bogglingly bizarre in nature, such incidents are happening today and will undoubtedly be repeated tomorrow, and the next day... and the day after that. But before exploring such events in greater detail, allow me to backtrack a bit...

As a child, in the year 1963, I was taken – for some inexplicable reason – to see the film *Mondo Cane*. The movie was a documentary highlighting humanity's collective madness and inhumanity (*Mondo Cane* translates from Italian to "world gone to the dogs" – and that's *exactly* the vision of the world presented in the film). It was considered so shocking in its day, that as a promotional gimmick theatres offered *mal de mers* (seasickness pills) to any members of the audience nauseated by its content. Part of the appeal of *Mondo Cane* was that it allowed its audience to be *in on the joke*. It provided them with an opportunity to laugh at flabbergasting displays of human stupidity (such as a group of matadors lining up in single file to approach an angry bull, who in turn charged them and knocked the lot of them over like so many dominoes). Once the viewer accepted the film's obvious premise – that man's idiocy knew no bounds – the directors then began to introduce examples of such behavior that were far less amusing in nature (thus the need for seasickness pills). Though highly entertaining, *Mondo Cane* undoubtedly had most of those leaving the theatre questioning the very nature of the world in which they lived.

Needless to say, seeing this film at such a tender age may well have been a life-altering experience for me. It was only later, while researching the subject of "Mondo Films" for a book I was collaborating on, that I discovered that one of the makers of *Mondo Cane* had purportedly made the film as a misanthropic indictment of mankind after his girlfriend had been killed by a drunk driver. Consequently, many dismissed the film and its content as merely the bitter testament of a grieving man who'd suffered great loss. Though this may have explained the filmmaker's *raison d'être* in making the film, clearly he couldn't have documented scenarios of barbarity and insanity had they not existed to be filmed. Regardless, what fascinated me about *Mondo Cane* was the *a priori* presence of that barbarity and insanity. The film spoke to me of something ongoing in the human condition that might, perhaps, never completely go away.

For a few years, filmmakers Gualtiero Jacopetti and Franco Prosperi, the creators of *Mondo Cane*, continued trying to exploit the format they'd pioneered, but after the film's huge success, they found themselves competing with a crop of imitators trying to cash-in on the shocking reality genre. Deciding to up the odds by taking an exceedingly less lighthearted approach to the format, Jacopetti and Prosperi turned their mutual gaze toward the continent of Africa. Here was a bastion of brutality, be it in the corrupt regimes that ruled by violence, or in the rebel "freedom fighters" who rose up to oppose them; both seemed equally savage and horrifying to Western audiences. That the film's U.S. title was changed from *Africa Addio* (Farewell Africa) to *Africa, Blood & Guts* doesn't even begin to hint at the true severity of its contents. As if the human carnage wasn't gut-wrenching enough, it also included footage of warehouses stacked high with the tusks of slaughtered elephants and the hides of zebras and lions (sold for pennies on the dollar) – all of which sickened Western moviegoers. Even today, when African poachers kill an animal on the endangered species list, its hide fetches maybe $2.50 – a dollar or so more than the going rate for a female child in the same region.

Toward the end of *Africa Addio*, the film's narrator makes a sobering forecast relating to the ongoing battles between Africa's corrupt rulers and so-called rebels:

> "The victors have no sympathy for their prisoners. Today it's the rebels turn to suffer. But tomorrow, when the mercenaries move on, other rebels will return. Then it will be someone else's turn... it's an endless cycle, a dance of death... Black against White, East against West, Black against Black. No one ever wins, no one finally loses; except the dead. Under the pitiless sun and swarming ants and flies, they rot together, with absolute equality."

As bleak and bereft of hope as such a prediction may sound, it was nonetheless very accurate. Still, it fell far short of the mark, even in its somber fatalism. In the decades that have elapsed since this dire forecast, Africa has gone from bad to worse... and then to worse still. The malaise of modern Africa is not something that can be attributed to a few corrupt governments, flawed economic systems or despotic tyrants. It is an endemic, *decentralized* manifestation of brutality so commonplace in its occurrence that it has become a sort of cultural wallpaper or muzak. It is a condition so pervasive and

defining that one parish priest in The Congo described the region as "the waiting room for Hell."

<u>Summary Of Chapter Titles</u>:

The Waiting Room For Hell
Magic, Murder, Madness
The Devil Made Me Wear This Dress
Rapeland
Absolute Power
Cops / Criminals
Man Eats Man
Children For Sale
Life Is Cheap

After Hours With Boris

(Previously unpublished, 2007)

In the year 1987 I was still working the last job for which I had to punch a clock, as an armed response agent for an alarm company. I patrolled the fog-drenched streets of San Francisco all night in a security vehicle, from just before midnight until just after dawn. If an alarm went off in one of our company's accounts, my job was to respond to the location ASAP and check the doors, windows and perimeter of the premises to make sure it was secure. More often than not it was a false alarm, set off by rats inside the building or a heavy truck rolling past. On occasion I'd have to hold an intruder at gunpoint 'til the police arrived, or wrestle a trespasser to the ground to 'cuff him, but this was rare.

One morning, at around 4:00 a.m., I was dispatched to a liquor store in the city's Haight Ashbury district. I turned off my headlights mid-block and slowly pulled up a distance from the shop. The streets were empty. I got out and performed my perfunctory check of the store's doors and windows. Probably a false alarm, no visible signs of entry. But as I pulled at the metal trap door on the sidewalk, used to deliver stock to the store's basement, I was surprised to discover it unlocked, and it easily opened wide. I shined the beam of my heavy Maglite into the depths of the subterranean chamber and (try to imagine the sound of an angelic choir here) saw before me a treasure trove of sorts. My beam illuminated shelf after shelf of hard alcohol. Boxes stacked to the ceiling. Bottles filled with dusky amber liquid. I closed the door and radioed the dispatcher, advising her to wake the owner and tell him to come to the site to secure it. She got the fella' on the phone and he wasn't happy about being awakened. I explained the situation and when details were relayed to the man, his response was "Don't worry about it." I was told to leave it alone, and that he'd tend to the problem first thing the next morning.

Two weeks later I found myself with my friend Boris and another guy exiting a Haight Street concert venue late at night, and the club was a block away from the liquor store in question. Curious, I wandered down to confirm that the lazy shit who owned the place had indeed resolved the problem with the sidewalk delivery doors. Nope. Again, the metal trap doors opened without hesitation. My friends' faces lit up, and with even less hesitation they made a mad dash to the basement, quickly reappearing with armfuls of liquid booty. Some readers may question whether or not I paused to consider the appalling lack of ethics that would permit me – a person paid to protect this place and its goods – to stand by while friends pilfered those same goods. Simply put, I didn't worry about it. When I was hanging out with Boris, this kind of thing was just par for the course.

I first heard about Boris from my friend Thomas Thorn, with whom he'd formed a band called Slave State. He told a story about drinking with Boris and running out of beer late at night. Emptying out the last several cans at 3:00 in the morning, he was naturally horrified at the realization that the liquor stores had all shut down hours earlier. Nonchalantly, Boris rose and said he thought he knew where to locate some booze, then exited. Considering the lateness of the hour, those in attendance may have thought him crazy, or a bit too drunk, but a few minutes later they were shaken to their feet by the ear splitting sound of a nearby burglar alarm. They peered out the curtains to see Boris approaching, brandishing two cases of beer. He'd kicked out the door of a liquor store almost right across the street with his steel-toed boots. And, sure enough, he had indeed known where to "locate some booze."

I think I first actually met Boris at Lefty O'Doul's, a bar founded by some famous San Francisco baseball player. One end of the place was an honest-to-gosh piano lounge, the rest a working class cafeteria where Corned Beef & Hash was a big menu item. We hit it off immediately, and after a night of drinking at O'Doul's, we stumbled into the misty night air. It was trash day the next morning and the street was piled high with garbage taken out to the curbside, awaiting pickup. Before us was a pink Cadillac convertible – the type awarded as a prize to high dominance Mary Kay saleswomen. The top was down. Our gazes met and we smiled. Not a word was exchanged. We scurried up and down the block and filled the Caddy to the brim with every last sack of refuse. The vehicle's owner was no doubt just inside, hugging the piano bar.

We were hanging out with folks who most people might classify as "hooligans," and this

relatively innocent bit of mischief set our companions off. One of them repeatedly head-butted a massive glass window fronting the Union Square Neiman Marcus. Though he eventually produced a small crack, the damage to his prefrontal lobe may have been greater (or so I'd hope). By noon the next day the window had been replaced. My pals' admonitions to "go do something" fell on deaf ears and I wandered back down Geary street to my apartment, to sleep and dreams. I awoke the next morning to a phone call from Boris: "You won't believe what happened last night, right after you left." "Um... everyone did something stupid and got arrested?" Sure enough. It was always the same story with those fuckers; they were super smart and amusing, but couldn't quite see the shadow coming down the road, somehow lacking in the faculty of foresight.

At the other end of Geary Street is some Scottish bar, another haunt of this particular group of fellas. I went to the joint because it was exactly next to a place where I took fencing classes. For some inconceivable reason, the jukebox was stocked with Marlene Dietrich singles, such as "Ask What The Boys In The Back Room Will Have." There was always a fight in the place – always. And my friends were always kicked out or denied more booze – always. Boris and I were there one night when a mutual friend tossed his jacket on a barstool and a .45 fell out. The sound of the gun slamming down on the tile floor reverberated through the bar. "The cops have been called," we were told. Big fucking deal; we kept drinking. Next thing I knew a few drunken idiots among our group were trying to remove the massive wooden tabor from the wall so they can have some sort of traditional *old school* Scottish competition in the bar. The owner wasn't really freaked out by guns in his place of business and turned a blind eye to most of our excesses, but this was maybe a bit much. I left. Unsurprisingly, a call came the next morning: "You're never going to believe what happened exactly after you left last night." Again, mayhem and arrests.

After yet another night of drinking, last call was bearing down and we didn't wanna' stop. Rather than have Boris kick in the window of a booze shop, we hit the Safeway supermarket at Market and Church streets, and exited with two cases of beer. Boris was behind the wheel and drove us all up to a fog-ensconced mountaintop on Twin Peaks. It was a sort of Lover's Lane and make-out spot. (Did that sort of quaint crap really go on in cosmopolitan San Francisco? Evidently not. We were the only ones there.) An hour or two later we saw a cop car heading our way and chucked our beer down the mountainside. Their spotlight cut through the fog and fell squarely on us. They exited their vehicle, brandishing their batons. "What are you guys doing up here at this hour?" "Just hanging out." "Yeah? Really? Well, we'll be coming back again half an hour from now, and if we see you shitheels still up here you're spending the night in jail." There's something you just gotta' love about folks who don't mince their words. They got back in their car and zoomed off into the fog.

I wanted to climb down the hillside and retrieve the half case of beer we'd ditched. Boris wanted to get gone. He was my ride, so I climbed in. In a meaningless show of bravado, he decided to exit the tiny hilltop parking lot at 90 miles per hour. There was a massive crashing sound and the car veered to a halt. In the dense fog, he never even saw the cement abutments he slammed into. Getting out, we soon saw that his tires were destroyed, his shocks were ruined and his car was fucked. Boris didn't have Triple A, but even if he'd had, it would have been hopeless, given the circumstances. Soon it dawned on us that *we* were fucked. If we stayed we'd be arrested and if we attempted to leave it meant walking miles. I still opted for relocating our abandoned beer and waiting down on the hillside. Certainly a better idea than what followed...

Lazy shits, the lot of us, we attempted to concoct a plan of some sort. All of us being fans of *A Clockwork Orange*, someone suggested reenacting a scenario from the book. "Cool, it can't miss." Soon we were at the door of a highly affluent house and Boris was pounding incessantly on it. It was 3:30 in the morning but one light after another came on inside the house. "Who's there? Who is it?" "There's been a terrible accident on the roadside, maam, I need to come in and use the phone." The lady inside sounded sympathetic and for a second or two it looked like we might've been able to at least call for a cab. But Boris was too in character. "I barely escaped alive, miss, I've got a pain in me Gulliver." That was that. "I don't know who you are or what you're up to," the woman on the other side of the door intoned, "but I'm calling the police *this instant!*" This instant? Thankfully, the police were incompetent as hell; it took *hours* to walk down off Twin Peaks and we saw nary a law enforcement type at all. We watched the sun rise on Babylon by the bay, wandering down Market Street.

A month later Boris was dead. He hanged himself. His friends were baffled. He was a happy, fun-loving guy and success was just at his doorstep. But it later came out that this was part of an ongoing pattern of his life; he'd experienced great happiness in the past, but it always preceded an even greater tragedy. Perhaps he finally consciously chose to exit on a high note. I'd like to think so. Someone once observed that life is like a banquet, an all-you-can-eat buffet. The smart people know to leave the table when they've had their fill. Those who don't get gout.

The Good Life (In Stereo)

(Previously unpublished, 2007)

For all intents and purposes, for Americans of the 20th Century, "the future" began in the mid-1940s, precisely as World War II ground to a halt. Having vanquished their foes abroad, an entire generation of young men returned home, and having done so, wanted nothing less than their own piece of the long-promised American dream. Thanks to the G.I. bill, most returning soldiers were indeed actually capable of acquiring their own piece of the dream; purchasing houses that sprang-up in the suburbs, going to college, or learning a trade. Some applied the specialized skills they'd acquired in the war to emerging fields, such as the expanding airline industry. All around, the nation's economy boomed, as did its spirits. There seemed to be a palpable sense in the air that these men (and the women that they'd left behind) had moved mountains, and that together they could create America anew. The America of the future would be molded in their own image, and everything would be bigger, better, more modern and efficient. By the mid-1950s, less than a decade since the war's end, this dream was fast becoming a reality. Prosperity and progress were the watchwords of the day and the presence of both were everywhere evident.

There's a particularly poignant image which appeared in a national ad campaign in the late 1950s or early '60s. In it, a young housewife gazes at a full-length mirror, in which she finds her reflection. The woman is attired in a simple housedress under a plain apron, her hair is pulled away from her face and wrapped-up in a bandana, and she's cradling a feather-duster in her arms – but the image she envisions reflected in the mirror is altogether different. In the mirror's reflection, she sports a *chic* cocktail-dress, long gloves and a diamond choker. Her hair is done-up in a glamorous bouffant and adorned with a shimmering tiara, and in place of the feather-duster she holds a dozen long-stemmed roses. Such an image could have been used to sell anything from dish-soap, to stoves, to bath beads; but what it really spoke to was an attitude that was endemic of that era in American culture – an overwhelming desire for *la dolce vita. The good life.*

With prosperity and progress so pervasive in the postwar era, the good life seemed for many Americans, almost close enough to reach out and touch. The aforementioned depiction of a housewife looking into a mirror could well be emblematic of that era's America as a whole, gazing at its own image and seeing the promise of possibility fulfilled. However, it ought to be noted that the 1950s idealized vision of the good life was much akin to the so-called sexual revolution of the 1960s – people were aware that it was happening, it was reported on the news and written about in magazines like *Time* and *Life*, but for those in the suburban hinterlands, it remained a distant abstraction. To them, the good life was an ideal to be dreamt of, yet was always somehow just out of the reach of their otherwise humdrum nine-to-five lives; and therein lay its incredible appeal...

Nowhere can this phenomenon be glimpsed in such vivid, *lurid detail* as in the era's album-cover artwork. The music industry was booming in the postwar era, and record sleeves reflected the dreams, hopes and hidden desires of the populace at large. Each album cover was seemingly a window, opening upon some facet of America's collective psyche; a sort of barometer of the nation's shared aspirations. The elaborate album covers of the period were not so much snapshots of *who* Americans were, but rather, who they *imagined* they were; who or what they desired to be.

For every hope, craving, or fantasy of the collective American psyche, there seemed to be a corresponding soundtrack available for purchase; albums that promised to recreate the ambience of the good life, within the confines of one's own home. For those who wished the future could come sooner, there were albums offering "the sounds of tomorrow, today." For those with lascivious leanings, "the sounds of seduction" might be just the ticket. There was even a comedy album that came with the guarantee that it would "turn your living room into a nightclub." Farfetched as such ballyhoo may seem nowadays, it fit quite neatly into the mindscape of the late 1950s and early '60s. After all, America was a place where ideas and dreams were being visibly translated into wide-scale realities with each passing year. Using the medium of music to invoke, voodoo-like, some tangible aspect of the good life, must have seemed every bit as real as walking through Disneyland's "House Of The Future" – and indeed it was.

What follows is but a brief review and analysis of the major themes presented in album-covers of the 1950s and '60s. It is by no means comprehensive, but nonetheless, may provide an overview of the era's general *zeitgeist*:

The late 1950s and early '60s were a time of transition, the last emanation of an era that was like the pop-culture incarnation of the antediluvian world. Its values and ideals would be inverted and rejected in the years to come, but for a short period, its utopian paradigm seemed to be shaping reality itself. Space-age easy-listening music promised a model of the future that was soothing and fantastic at once, and featured out-of-this world sounds created by strange-sounding instruments such as the Theremin. The concept it embodied was meant to serve as the prototype of a world as yet unborn, but one very, *very* imminent. It was felt that Americans' very ability to imagine it served as a means for ushering it into existence.

Easy-listening music "from outer space" prefigured the actual conquest of space by only a few short years, and albums such as Les Baxter's *Space Escapade* or Jimmy Haskell's *Blastoff* primed the popular consciousness for what was to come. Such albums helped to foster an ongoing belief that progress was an inexhaustible resource, limited only by human ingenuity which, in the period, seemed to know no bounds. Furthermore, by bringing otherworldly sounds into America's suburban living rooms, suburbanites were made to feel like participants in the Herculean strides being made by the nation's scientists. Of course, it couldn't have hurt that the album cover to *Space Escapade* depicted astronauts newly-arrived on another planet, being offered glowing libations by its sexy female inhabitants. The clear subtext was that the impulse to explore the unknown beyond was little different from that motivating any bachelor: *to boldly go where no man's ever gone before!*

As the cautionary axiom goes, "be careful what you wish for." In the postwar era, people wished for progress – and got it, in spades. Many at the time considered it the vehicle of their salvation, but more than a few were frightened by its downsides. Smog, congested freeways and an ever-quickening, hectic pace of life were part and parcel of it all. Modern technological conveniences meant to free the housewife from her domestic indentured servitude never quite delivered on their promises. Soon, rather than providing a life of ease, leisure and relaxation, the suburbs became but another part of the stressed-out, capitalist rat race – a hyper-competitive realm of "keeping up with the Joneses," in which acquiring status symbols was paramount and consumerism existed for its own sake.

America's acquisition of Hawaii as the 50th U.S. state had a calming effect on the nation's populace. People caught in the throes of a go-go-go modern world turned their minds toward the notion of an idyllic tropical paradise. This was just the elixir needed by many at the time; an idealized fantasy which provided a respite from the increasing tensions of modern living. The foreshadowing of this was prefigured in the novels of James Michener and the books of Thor Heyerdahl, only now it represented escapism writ large. Tiki bars sprouted-up across the American landscape. Backyard tiki gardens appeared allover suburbia, complete with fake waterfalls, wooden Tahitian gods and pagan torches.

As a soundtrack to the phenomenon came the exotic sounds of a man named Martin Denny. Denny was a young musician who'd been able to attend music conservatory thanks to the G.I. bill, and had recorded his first album, *Exotica*, in a new format called high-fidelity ("hi-fi" for short). Denny used the hi-fi format to its ultimate effect; so much so that record-player salesmen wanting to hawk this exciting new technology used Denny's vinyl-platter to demonstrate the full spectrum their hi-fi turntables could attain. As a result, they sold many hi-fis, and even more of Denny's albums. So many, in fact, that *Exotica* came to be the best-selling record in the world, for a whopping 13 straight months.

Martin Denny spawned an entire genre of *Exotica* imitators, no doubt largely due to his great success, but also in part due to the fact that he embodied the archetype of *going native* (or at least the pretense of going native). Not every dispirited suburbanite could pull a Paul Gauguin (flee to a South Sea island, drink rum on the beach and take up with native girls), but a lot certainly *wished* they could. For those who couldn't go the Full Monty, they next best thing was buying a Martin Denny album. Listening to its pseudo-tropical rhythms amidst their suburban tiki torches, fake waterfalls and pagan icons, they undoubtedly thought, "now *this* is paradise." And so it was... or as close as it needed to be.

One of the major archetypes found in 1950s TV is that of the Old West cowboy, be he marshal, bounty hunter or outlaw. The cowboy was a man who lived by his wits, surviving in a lawless land through his strength of will and character alone, and most often aided in the attempt by his six-shooter. Such figures represented a uniquely American archetypal ideal of independence, self-sufficiency and self-determination. The 1960s equivalent to the cowboy was the private eye, a man who often upheld the ideal of justice by bending the law or circumventing it. He was always the consummate bachelor, in an age when bachelorhood meant being a *bon vivant* and "playing the field" like a pro. As such, the private eye was both outlaw and hero at once. He eschewed convention, and in so doing embodied the sort of outsider figure many men dreamed of being. In purely American terms, the 1960s private eye was a rugged individualist.

The notion of the bachelor in that era implied a man who was a law unto himself; making up the rules as he went along. He always got the girl and seemed to inhabit a *demimonde* in which beautiful, willing women were in endless supply. The hedonistic lifestyle of the swingin' bachelor was probably far less evident in daily life than it was in TV shows, movies, or on album covers. Nonetheless, the swinging bachelor played a prominent role in the American mythos. With his sporty convertible, exciting career and groovy modernist apartment, men yearned to be like him, and women yearned to be seduced by him.

In the postwar era, men's libidinous nature was increasingly a topic of comment, even if the sexual revolution still seemed a long way off. The notion of the swank bachelor pad, where hapless females might be seduced by strong cocktails and romantic melodies was a concept whose allure may have been equally appealing to both sexes; and the album covers of the period reflected this and played upon it. One album-cover of the time catered to the male fantasy that the listener himself was, or could be, a sexual *predator*. Wasting no time in making its overtly blunt point, its cover depicted an elegantly attired bachelor standing at the threshold of his swingin' lair and beckoning the viewer inside; his face hidden by a wolf mask. Undoubtedly, many a nebbish purchased such records, with the intent of turning their bleak apartments into "swinging bachelor pads" (without luck, of course). But the notion of being able to purchase some portion of the good life, over the counter, must have seemed as brimming with promise as did the ideal itself.

Perhaps the most uniquely American ideal of the good life is also the most unorthodox. Frank Sinatra once told his daughter Nancy that the U.S. was so violent, "because we're a nation of rebels." And he was certainly right about the rebel aspect of that equation. Some of America's most interesting citizens have been its rebels. Sinatra was one, as were his Rat Pack pals. But whereas they epitomized the most excessive mainstream bastions of the American ideal, some at the opposite end of the spectrum were defining an altogether new expression of that ideal. They were part of the first real pop-cultural underground, and were referred to early-on as *the subterraneans*. We now know them as Beatniks.

The Beatnik phenomenon, such as it was, almost instantly devolved into a kind of bargain basement bohemianism – a movement as defined by its cartoonish depiction in movies and on TV shows as by anything offered up by its real founders. TV Beatnik Maynard G. Krebs probably influenced more people to drop out than did real Beat poets and writers like Jack Kerouac or Allen Ginsberg. For several years, nearly every show on TV found some excuse to venture into the recesses of a Beat coffee house, or write into their scripts crazed Beat poets, Beat sculptors, Beat artists – and their female models, of course. While America was at a loss to comprehend the eccentricity that seemed to be so central to the Beat scene, the menfolk seemed to intuit that *free love* might be lurking in the shadows of those basement Beat haunts. Indeed, the day's men's magazines hinted that every coffee house was rife with Beat girls ready to strip off their black turtlenecks in a heartbeat, willing to pose for any man calling himself an artist or photographer.

Sadly, the wall-to-wall presence of the Beat underworld in the media belied the fact that unless you lived in certain major cities, your access to such smoky, jazz-filled dens of iniquity was limited to what you could glean from an episode of *Peter Gunn* or *77 Sunset Strip*. Unless – of course – you had a hi-fi. Then you could score any number of platters that would bring the ambiance of bohemia straight to suburbia – complete with Beat poets, pounding bongos and the tinkling of espresso cups. Despite the Beat generation's being co-opted by the mainstream, even the silliest depictions of it are noteworthy for having a level of cynicism not in evidence elsewhere in 1950s

America. In a few short years, those who followed in the footsteps of the Beats – the hippies – would replace such attitudes with a starry-eyed idealism, albeit an idealism not consistent with the good life ideals of progress and prosperity.

It's worth noting that the dominant cultural paradigms of the period often seemed mutually-exclusive, yet nonetheless blurred into one-another in such a way as to create an odd amalgam, each facet of which complemented the others perfectly somehow. It was as though a plethora of paradoxes dominated the pop landscape, coexisting alongside one-another as though each were but a facet of some grand design. With one eye, America gazed toward the heavens and the exploration of space; with its other eye, it gazed toward more earthly pursuits, contemplating pleasure, the primitive and paganism. That Americans wanted to both explore space and at once retreat to a savage paradise didn't seem asynchronous; each divergent impulse seemed like an utterly logical reaction to the tenor of the times, and a rational extension of them. Collectively (albeit unconsciously) Americans were creating their own modern myths, entities which in turn were both promethean and primitive, hedonistic and heroic. The variant strands of the idealized good life were woven into one-another in such a way as to create a singular tapestry – one such as never had been seen before, nor is likely to ever be seen again.

Curiously enough, perhaps the most across-the-board unifying ethic of the era, was an all-out belief in booze. Alcohol seemed to be the single factor central to each and every divergent emanation of the good life. Album covers depicted astronauts on alien planets sipping cocktails, native pagan women sitting atop casks of rum, scantly-clad modern women reclining seductively within enormous martini-glasses and so forth. In the case of Jackie Gleason's best-selling *Music, Martinis & Memories*, the album cover featured a picture of just a tabletop with two empty glasses and two half-smoked cigarettes in an ashtray (the viewer was left to his own devices to contemplate where the couple who'd consumed the drinks and abandoned the cigarettes were – or what they might be up to). Despite the wildly divergent themes displayed in the era's album-covers, booze was the underlying current that flowed beneath it all.

The era's pop-culture heroes also sang the praises of booze. Beat-poet Jack Kerouac appeared on Steve Allen's *Tonight Show* toward the end of what had *obviously* been a several-day-long bender. Johnny Carson regularly sniffed co-host Ed McMahon's coffee cup on-air, then rolled his eyes and made faces indicating that more than a hint of Irish Whiskey might've be present. Members of Frank Sinatra's Rat Pack regularly brought a *portable bar* on stage with them at The Sands in Las Vegas, and consuming copious amounts of booze was central to their stage-show. And of course, Woody Woodbury made an entire career out of popularizing the worship of alcohol. Booze, naturally, goes hand-in-hand with escapism, and in essence, this was what the era's mythos was centered around: escaping into the future, outer space, the primitive, the bohemian – anywhere and everywhere but postwar suburbia and workaday modern life.

It could be said that America in the postwar era was, in essence, a vast Disneyland, wherein illusion and reality often blurred seamlessly into one-another. America and Disneyland were both, after all, idealized *total environments* and both embodied grandiose visions of the future. Some of those visions would come true and many would fall by the wayside (especially as the golden decade of the 1960s progressed). Beneath the era's glossy façade of promise and plenty, however, was an alternate, darker, reality, glimpsed in newsreels of race-riots, civil unrest and the atrocities of war. As the 1960s progressed, images of bona fide outsider groups such as The Hell's Angels, Black Panthers and The Weathermen began to supplant those of the idealized good life. The grand postwar daydream all finally came to an end in August of 1969, with the gruesome Tate-LaBianca murders. This act affirmed that even the "beautiful people" who lived a charmed life high atop the Hollywood hills couldn't vouchsafe their slice of the good life. Six short years earlier, President John F. Kennedy had optimistically promised that America would have a man on the moon by the end of the decade. But even as faint black-and-white images flickering on TV screens showed the fulfillment of his promise, the idealism of which he was so visible a symbol was fast coming apart at the seams. America's sense of hope was on the wane, even before 1969, and the nation's collective yearning for the promise of *the good life* had already begun to seem more and more like an old-fashioned fantasy.

If, in the final appraisal, the idyllic good life captured in 1950s and '60s album-cover artwork was nothing more than a beautiful dream, then we are left to ask: do not beautiful dreams hold a

cherished position in our hearts and minds? Are they not the source of ideals that inspire us to reach for the stars and transform our world, and thus our own lives? Of course they are. Even the ancients had notions of some mythical Arcadia, a golden age in which perfection reigned supreme; a place that once *was* and shall be again. For a brief period in the 20th Century, Americans dreamt of an Arcadia in suburbia. Instead of gods and goddesses, their paradise of perfection was peopled by bachelors, beatniks, primitives and spacemen. It was no less beautiful for having been a fantasy, and no less a source of inspiration, even today.

Toward The Plastic
The New Alchemy
A manifesto by Giddle & Boyd

(Previously unpublished, 2007)

Glamour is possessed of a power; those who have it dwell in Disneyland and those who don't inhabit the wasteland. Fun is possessed of a power; those who understand it are forever winning the game, those who can't are now and forever losing. Sound decadent? You bet it is. Sound frivolous? Not on your life. Glamour and fun are revolutionary principles, tools of the new alchemy and keys to a parallel reality...

In the course of human events, there have recurred time and time again, key junctures in which competing ideas or forces exist alongside one another. Ultimately, one takes precedence over the other and the result is a turning point in history. Depending upon what direction the tide of history takes as a result, everything in its wake is changed in accordance. For our generation, one such turning point occurred about 40 years ago.

In the mid 1960s two cultural paradigms were vying for dominance of the popular consciousness. On the one hand was a silvery, futuristic glam interpretation of reality, as manifested in the East coast's Op Art, Pop Art, Warhol and the fashion of Rudi Gernreich, Mary Quant and Paco Rabane. This zeitgeist was dubbed "The Silver Sixties." The second sub-current emanated from the West Coast (read: California). It eschewed glamour, formalism, futurism and fun, in favor of the more "for real," less uptight, rebellion epitomized by jeans and t-shirts. Part and parcel of this trend was a rejection of all aspects of culture deemed *plastic* (i.e. fake) in favor of models unthinkingly considered more "natural." This ideal of natural beauty, translated into real terms, equated to little more than women not wearing makeup or shaving their legs and armpits, then donning the same *de rigueur* uniform of jeans and t-shirts worn by their male counterparts. Both are slobs. Are either rendered somehow more authentic by virtue of their slovenly state? If so, the ensuing decades must have been very *real* indeed, for it was the latter paradigm that prevailed in that mid-'60s contest. Those of you born into the post-1969 era were raised in a world largely defined by the ethos central to that worldview.

But try, if you can, to imagine a parallel universe of sorts; the kind of world that *might* have existed had that Op/Pop, Silver Sixties prototype prevailed. Now stop imagining, because that parallel universe is real. It exists, right here, right now. It dwells in the imagination and the soul, and the values which live in either can be externalized and transposed onto the outward realities of one's existence. We call this principle Fabulous Alchemy and we can see the traces of its fingerprints on everything we honor and adore.

All those aspects of culture rejected in the 1960s as *plastic* – glamour, design, fashion, pop music, et cetera – were expressions of a creative impulse central to the soul of man; and man has always resorted to the recesses of his imagination seeking the means to transform both himself and his world. If others choose to deride the byproducts of this perennial impulse as *plastic*, so be it. We view the same emanations as offering a uniquely singular glimpse into man's desire to transform reality; to replace the commonplace with the fabulous and to make fun a tangible presence rather than mere abstraction. But we digress...

Suffice to say, the parallel universe to which we allude is in fact our primary universe. It belongs exclusively to those who both have the power to see it, and the desire to inhabit it. It is a realm where we live 24 hours a day, seven days a week. Please feel free to join us.

Wild wishes,
– Giddle & Boyd, September, 2006

Artworks & Photography
i) Things That Don't Exist (1974)

Artworks & Photography
ii) Experimental Photographs (1974)

Artworks & Photography
iii) Manipulated Halftones (1977)

Artworks & Photography
iv) Documentary Photographs (1978)

207

Artworks & Photography
v) Fetish Photographs (1995)

Artworks & Photography
vi) Abstract Paintings
(1975)

Lyrics
1988 – 2007

Editor's Note: Boyd Rice began releasing audio recordings in the late 1970s, and while most of his work from the first two decades of his career is instrumental, there are certain instances in which his recordings from this early period contained "lyrics" of sorts. Such instances have been omitted here, as they are usually limited to single words or phrases (the content of which is usually the same as the track's title). Also omitted here are the lyrics to Rice's more widely known cover songs, as these are readily available either online or via other print sources. Lyrics to Rice's more obscure cover songs have been included here, as they are often not available elsewhere. At various instances throughout his recording career, Rice has recorded multiple versions of the same track, the lyrics to which may differ slightly from version to version – in such instances, the earliest available version has been included and later versions omitted. All lyrics are by Boyd Rice unless otherwise noted.

Boyd Rice & Friends
Music, Martinis & Misanthropy
(New European Recordings, 1990)

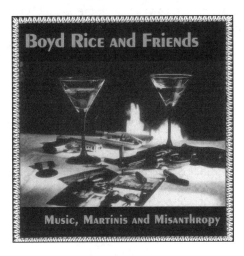

Liner Notes:

MUSIC: It hath charms to soothe the savage beast.
MARTINIS: Those exotic cocktails of American origin.
MISANTHROPY: Another word for *Love*. Put it together with music and martinis, blend well, and stand back! You're in for the time of your life ...

Music, Martinis & Misanthropy is a fun-filled romp that will propel you into a very special realm indeed. Don't be surprised if it seems as though your innermost thoughts are captured on this recording – these are songs as special as the contempt you feel for everything wretched. Thirteen tunes so catchy that to keep your foot from tapping you'd have to staple it to the floor. And these ditties don't pull any punches. Why should they? Truth doesn't mind stepping on a few toes. Nor does Love.

The selections on *Music, Martinis & Misanthropy* deal with a very special kind of Love ... one that doesn't squander itself or spread itself too thin. A precious, *vital* Love that's never wasted on the weak, the botched, or the lowly. The sort of Love that eschews the corrupt and cowardly, that they might reap the scorn they so richly deserve. Sound old-fashioned? Perhaps. But amid the hustle and bustle of today's modern world, it's nice to know that there are still folks who remember what Love really means. Boyd Rice and his friends not only *remember*, they even like to write songs about it ...

So turn down the lights, mix yourself a martini, and prepare for a joyous listening experience. This is the new contempt of the world. This is the new Love of the world.

"People"

Do you ever think about what a lovely place the world would be without all the people that make life so unpleasant? All the small, petty people. All the ugly, annoying people. It's hard not to think about it. I like to think about what could be done to these people. Something cruel. Something mean. Something just; but the meaner the better. Goodness knows they deserve it.

Have you ever dreamed of killing all the stupid people? Not just the unintelligent people but the sort that don't know anything about *anything*; but seem to have opinions about everything. They're

only too ready to offer you their advice about how to run your life; and yet look at how they run their own lives. For the most part they've accomplished nothing, they've contributed nothing; their lives are miserable. But they talk, talk, talk. At the very least their tongues should be cut out. At the very least.

Did you ever wanna' kill all the people who tell lies? Some certainly deserve it. Not necessarily the big liars, or even those who teach lies as truth. I'm talking about people who say one thing and do another, or who tell you they sent something express mail when you know they haven't.

Did you ever want to kill all the slow people in the world? The people who are in front of you ... when they should be behind you. The crime that the swift should be held back by the slow, and it's criminal that nothing is done to rectify it. And what about all the really ugly people? Add them to the list as well.

Some people try not to think about life's ugliness. I've thought about it. I've thought about it quite a lot. Something should be *done* to these people; something to make them suffer the way they've made us suffer. I say, bring back the Circus Maximus for starters. Unless these weeds are dealt with they'll poison everything. They are poisoning everything. We need a gardener. A brutal gardener. A thorough, thoughtful gardener. An iron gardener.

Whatever happened to Vlad The Impaler? Where's Genghis Kahn when you need him, or Roi d'Ys? Ayatollah Khomeini, Adolf Hitler, Benito Mussolini, Nero, Diocletian, Kitchener, Come back! Come back ...

"The Hunter"
Words: Anton LaVey

The hunter must hunt.
For as soon as he stops,
He becomes the hunted.

"Night Watch"
Words: Rod McKuen

I keep my good eye open.
Who can tell?
There might be someone in the night.

What was that?
The dropping of a leaf?
Or a footfall in the darkness?
Is someone there?
No.
Only the shaking of a leaf.

I keep my good eye open just the same.
Tomorrow, maybe ...

"Disneyland Can Wait"

Someday I'll take you to Disneyland.
Someday I'll take you to Disneyland. We'll go on "Mr. Toad's Wild Ride" ... and follow him straight to Hell. But that's not necessary just now, for now Hell's all around us. No rubber devils, no smell of sulfur, but Hell nonetheless. A Hell more grotesque than any medieval woodcut. Instead of dramatic demons, a lifeless, shuffling horde. Without souls, without imagination, without worth and

beyond redemption.

Someday I'll take you to Disneyland. I'll buy you a pair of mouse ears, tons of cotton candy and a big helium balloon with Mickey inside. But all that can wait. Today I'll buy you a .357 Magnum and lots and lots of bullets. I'll buy you a stack of AK-47s and a warehouse filled with banana clips, all loaded and ready to go. I'll buy you a B-52 loaded with neutron bombs and lots of soldiers, to do whatever's necessary.

Disneyland can wait. We have time. Someday there'll be more of us. Maybe then the world can be Disneyland ... and visiting Hell will be novel again.

"An Eye For An Eye"
Words: Adapted from the writings of Ragnar Redbeard

Lo, I hear the fighters coming,
Over hill and dale, and plain.
The battle cry of ages,
In a rebel world again.

Hate for hate and ruth for ruth,
Eye for eye and tooth for tooth.
Scorn for scorn and smile for smile,
Love for love and guile for guile.
War for war and woe for woe,
Blood for blood and blow for blow.

The natural world is a world of war.
The natural man is a warrior.
The natural law is tooth and claw,
All else is error.

Who'd forge their swords to plowshares
Shall sweat the bitter yokes.
The freeborn race of fearless
Must deal out battle strokes.

Hate for hate and ruth for ruth,
Eye for eye and tooth for tooth.
Scorn for scorn and smile for smile,
Love for love and guile for guile.
War for war and woe for woe,
Blood for blood and blow for blow.

Death endeth all for every man,
For every son of thunder.
Then be a lion in the path
And don't be trampled under.

Hate for hate and ruth for ruth,
Eye for eye and tooth for tooth.
Scorn for scorn and smile for smile,
Love for love and guile for guile.
War for war and woe for woe,
Blood for blood and blow for blow.

"Down In The Willow Garden"
Words: Traditional (with adaptations)

Down in the willow garden
Where me and my love did meet,
As we sat a-courting
My love fell off to sleep.
I had a bottle of German wine,
My love she did not know.
So, I poisoned that dear little girl
On the banks below.

I drew a dagger through her,
It was a bloody night.
I threw her into the river,
Which was a lovely sight.
My father often told me
That gold would save me somehow,
If I would murder that dear little girl
Whose name was Rose McDowall.

Now he sits in his cabin door,
Wiping his tear-dimmed eyes.
For his only son soon shall walk
To yonder scaffold high.
My race is run beneath the sun,
The scaffold waits for me now.
For I did murder that dear little girl
Whose name was Rose McDowall.

"Tripped A Beauteous Maiden"
Words: Traditional

Down a winding pathway,
In a garden old,
Tripped a beauteous maiden,
But her heart was cold.
Came a prince to woo her,
Said he loved her true.
Maiden said he didn't,
So he ceased to woo.

Came a perfumed noble,
Dropping on one knee,
Said his love was deeper
Than the deepest sea.

But the winsome maiden
Said his love was dead,
And the perfumed noble
Accepted what she said.

236

Came a dashing stranger,
Took her off by force,
Said he'd *make* her love him,
And she did ... of course.

"As For The Fools"
Words: Arthur DeGobineau

It was almost midnight, everything was quiet; the earth was asleep. The waters of the lake rippled and sparkled in the moonlight. "I wish," said Wilfred softly, gritting his teeth, "I wish that instead of this peaceful scene, we could see here properly and with our own eyes, the kingdoms of the earth in all their glory. But let's look at them in our mind's eye. Let's think of those swarming masses, whether smartly dressed in all their finery, or in rags. Exclude nobody. Do you recognize their complete barbarity? Not the brave, bold, picturesque, happy barbarity of the young, but a sinister, sullen, churlish, ugly savagery which will kill everything and create nothing.

You'll at least be amazed by their mass, for their mass is indeed enormous. Look with wonder at its neat arrangement into three parts: At their head, the motley tribe of fools. They lead in everything, carrying the keys, opening the doors, inventing phrases, wailing when they are wrong, and assuring you that they would never have believed that this or that could happen. Next look at the scoundrels, they're everywhere; at the sides, at the front and at the back. They run about, agitatedly working themselves up. Their sole purpose is to stop anything from being settled, until they have settled themselves. But what's the point of their being settled? Hardly has one of their gang declared that it has had its fill, when famished swarms of others rush up to take over. And now look at the brutes; the fools have unleashed them and the scoundrels are herding them in countless flocks.

You might well ask what I make of such pandemonium. I can make of it only what it is; stupidity, destruction and death. I can indeed perceive merely a world of insects, differing in size and species – armed with saws, pinchers, drills and other tools of ruin – intent on bringing down the morals, rights, laws and customs; all that I have loved and respected. A world which burns cities, razes monuments and now spurns books, music, pictures – substituting for all of them potatoes, underdone beef and rough wine. Would you want to spare such a rabble, if there was at hand a sure way of destroying them? That's for you to decide.

As far as I'm concerned, lend me for one moment the thunderbolts of Jupiter and I will destroy however much is necessary of this irresponsible mass of brutes. They're totally incapable of discrimination. I don't see that they have any soul, although that is scarcely their fault. Nor should we show any excessive severity towards the scoundrels; I can hardly tell you that they are the salt of the earth, but they are its brine. We can, at a pinch, turn them into something and so long as we hang a few of them from time to time, the rest can be employed; if not honestly then at least usefully. Moreover, we have to admit that our planet produces them naturally, and without excessive effort. In spite of itself, the world could never either get rid of them, nor even perhaps do without them. As for the fools, I would be pitiless. They are the vain and bloody authors, the sole and detestable agents of universal decay, and my thunderbolts would rain down mercilessly upon their perverted brains. No, such a gang do not deserve to live. Indeed, an ordered world cannot survive so long as such croaking vermin exist. The eras of splendor and creativity were those when such reptiles did not crawl upon the steps of power.

"History Lesson"
Words: Adapted from the writings of Gerald B. Lorentz and Heraclitus

History's lesson is written in the blood of the vanquished. It is spelled-out in the ruins of forgotten civilizations; in the monuments to their grandeur and the monuments to their folly. History's lesson reveals that War is the father of all and the King of all; and some he has made gods, some men, some

bond and some free.

The history of the world is a history of wars. It is the history of people preying upon people, and people resisting predation. It is the struggle of competing societies to survive in a world of natural, biological and sociopolitical strife. That is why it is difficult to turn a single page of history without reading of war, combat, strife, revolution, uprising, invasion, insurrection, strike or some other form of violence.

The great heroes of history are the mass murderers of history: Alexander The Great, Charlemagne, Genghis Khan, and on, and on ... and on. During the first three-quarters of this century alone more than seventy million people were killed as a result of wars, revolutions, insurrections, rebellions, massacres, assassinations, executions, exterminations, genocides, and so forth.

History's lesson reveals that War is the father of all and the King of all; and some he has made gods, some men, some bond and some free.

"Silence Is Golden"
Words: Rod McKuen

If I had a pistol to hold in my hand,
I'd hunt down and silence the Good Humor man.
I'd pour sticky ice cream all over his wound
And stop him forever from playing that tune.
For silence is golden, on a soft summer day.
It's a pity to let strangers take it away.

If ever I get me a license to kill,
I'll war on the jukebox and jackhammer 'til
The wind and the rain rust up all their parts,
And the worms and the woodchucks dissect their hearts.
For silence is golden and hard to be found,
And killed far too often by the jackhammer's sound.

If diesels and dump trucks and gossips were words,
I'd feed them like kernels of corn to the birds;
And then all the thumping and bumping, and pounds
Would come out forever like pretty bird sounds.
For silence is golden and soft as a tear.
The soft sound of empty is the next voice you'll hear.

NON
In The Shadow of The Sword
(Mute Records, 1992)

Liner Notes:

"That which disturbs your soul you must not suffer."
– Goethe

"Paradise lies in the shadow of the sword."
– Anon

"Total War"

Do you want total war?
Turn man into a beast once more.
Do you want to rise and kill?
To show the world an iron will?
Do you want total war?
Throw out Christ and bring back Thor.

Do you want total war?
Do you want total war?
Do you want to stand and fight?
To rip asunder this pallid night?
To smite your foes that they may die?
Spatter blood across the sky.

Do you want total war?
Do you want total war?
Yes, you want total war.
Yes, you want total war.

Do you want might to prevail?

To kick aside the weak and frail?
Do you want total war?
Do you want total war?

Do you want total war,
To see life's will return once more?
Do you want total war?
Unleash the beast in man once more.
Do you want total war?
Do you want total war?
Yes, you want total war.
Total war.
Total war.
Total war.

"War Speech"
Words: Richard Wagner

War is eternal. War is universal. There is no beginning and there is no peace. Nor could there ever be, even if the beast man desired it himself. For man is subject to the same law which governs all living things and this law dictates that every living thing maintain its existence exclusively by depriving other living things of theirs. So it has always been and so shall it ever be.

Man is a beast of prey. History proves that man is a beast of prey. The beast of prey conquerors countries, founds great realms by the subjugation of other subjugators, forms states and organizes civilizations, exclusively to enjoy his booty in peace ...

Attack and defense, suffering and struggle, victory and defeat, domination and servitude – all sealed with blood. This is the entire history of the human race.

"Eternal Ice"
(Sung by Rose McDowall, to the tune of "Silent Night")

Silent war, holy war.
Hail the blade, evermore.
Time's true current rushes down.
Time's cruel burden crushes down.
There is no birth without blood.
There is no birth without blood.

Silent war, holy war.
Hail the strong, evermore.
Prey bows down 'neath the predator's jaw.
Honor our beacon, the wheel of the law.
There is no birth without blood.
There is no birth without blood.

"Vengeance"
Words: Boyd Rice and Tony Wakeford

When the earth shakes and the dead awake
To sing us their songs.

And we hear the march of fate
And footsteps of the strong.
And we hear the call
Carried on a wing.
Arise, arise, arise,
A once future King.

Waiting for vengeance.
Waiting for vengeance to rain down.
Waiting for vengeance.
Waiting for vengeance to rain down.
Vengeance.

Broken vows
Can cut like broken glass.
Better keep one eye
On the hourglass.
I hear of a visit
From men across the sea.
Who settle scores by the sword
Just like it used to be.

Waiting for vengeance.
Waiting for vengeance to rain down.
Waiting for vengeance.
Waiting for vengeance to rain down.

The world is ruled by little men.
Too blind, too scared to see
The glory that once was
And yet again shall be.
Their gold has made them poor.
The world is sad and cold.
But through the gathering gloom,
Longboats heading toward the shore.

Waiting for vengeance.
Waiting for vengeance to rain down.
Waiting for vengeance.
Waiting for vengeance to rain down.

Vengeance.
Vengeance.
Vengeance.

(et cetera)

"Scorched Earth"
Words: Ragnar Redbeard

Might was right when Caesar bled
Upon the stones of Rome.
And might was right when Joshua led

His hordes over Jordan's foam.
And might was right when German troops
Poured down through Paris gay
It's the gospel of the ancient world
And the logic of today.

Sword-strong races own the earth
And ride the conqueror's car.
And liberty has never been won
Except by deeds of war.

For might is right when empires sink
In storms of steel and flame.
And it is right when weakling breeds
Are hunted down like game.

Then what's the use of dreaming dreams
That each shall "get his own,"
By forceless votes of meek-eyed thralls
Who blindly sweat and moan?
A curse is on their cankered brains.
Their very bones decay.
Go trace your fate in the iron game,
Is the logic of today.

That the strong must ever rule the weak
Is grim primordial law.
On earth's broad brutal threshing floor
The meek are beaten straw.
Then ride to power over foemen's necks,
Let nothing bar your way
If you are fit you'll rule and reign,
Is the logic of today.

You must prove you're right by deeds of might,
Of splendor and renown.
If need be, march through plains of Hell
To dash opponents down.
If need be, die on scaffold high
In the morning's misty gray.
For "liberty or death" is still
The logic of today.

For liberty or death is still the logic of today.
For liberty or death is still the logic of today.
For liberty or death is still the logic of today.

"Invocation"

A dagger upon the throat of the lowly.
May the wretched wreak havoc upon the wretched.
May the rotting branch fall of its own accord.

Come now the conflagration.
Sound aloud the death rattle.

An age of swords to replace an age of victims.
A scourge of swords to replace a scourge of victims.

A day of holocausts and a night of steel.
A night of order and a dawn of blood.

May the rules perish, that the law may return.
May the rules perish, that the law may return.

"Abraxas"

I am the fire.
I am the power.
I am the death.
I am the dawn.

I am the blood.
I am the order.
I am the death.
I am the dawn.

I am the beast.
I am the blade.
I am the death.
I am the dawn.

I am the last.
I am the first.
I am the death.
I am the dawn.

"Prey"
Words: Hermann Hesse

Who would be born must first destroy a world and fly to God ...
A God whose name is Abraxas.

"A World On Fire"

I have a dream ... In my dream I see a world freed from the burden of falsehood.
I see a world reborn in perfection. I see the rule of purity. And how is this dream to come true? And how is this world to be born? Only through tribulation. Only through great and terrible suffering, destruction and retribution.
Yes, I have a dream ... in my dream I see tide after tide of violent conflict. I see rivers of blood. I see death and more death – death at every turn. I see a massive de-stabilization of prevailing social structures and a populace that quickly reverts to barbarism. I see animalistic tribes struggle – doing battle for land, for food and for water – fighting just to survive. I see a huge loss of human life. Streets

littered with corpses and the spreading of pestilence run rampant. I see vast stacks of severed heads and bodies dangling from lamp posts. I see the grandeur of the days of old return, and public squares once again illuminated by crucified Christians; human torches set ablaze as in the time of Nero and Diocletian.

I see a world on fire ... and the midday sun blacked-out by flocks of ravens that descend to peck at the bloated cadavers strewn about the streets. Yes I have a dream: a dream of a world cleansed by destruction. A world purified by fire. A world in ashes. And when the last embers have died, and when the ashes have all settled, then shall the summits exist in the clouds once again. Then shall the valleys rejoice in their depths and nevermore shall the summit and the valley come to meet upon the plain.

"Love & Love's Murder"
Words: Carl G. Jung, as excerpted from *The Seven Sermons of The Dead*

In the night the dead stood along the wall and cried:
"We would have knowledge of God.
Where is God? Is God dead?"
God is not dead. Now, as ever, he liveth.
This is a God whom ye knew not, for mankind forgot it.
We name it by its name: Abraxas.
Abraxas standeth above the sun and above the devil.
It is improbable probability, unreal reality.

Abraxas begetteth truth and lying,
Good and evil, light and darkness.
In the same word and in the same act.
Wherefore is Abraxas terrible.
It is love and love's murder.
It is the saint and his betrayer.
It is the brightest light of day,
And the darkest night of madness.

NON
Might!
(Mute Records, 1995)

Liner notes:

"Christs may come, and Christs may go ...
But Caesar lives forever."
Ragnar Redbeard

Might. Brute force – power in its most elemental form. This was the basis of a book called *Might Is Right*, penned nearly a century ago by a man who called himself Ragnar Redbeard. The lyrics to this recording were taken exclusively from his tome, a work considered by many to be the definitive exposition of Darwinian law as it applies to man, his world and his nature. It is above all a celebration of force, at once both frenzied paean to its glory and cold appraisal of its inevitability.

"No Nirvana (Prelude)"
Words: Adapted from the writings of Ragnar Redbeard

This world is no Nirvana, where peaceful pleasure flows – it is a gruesome butcher-shop, where slain men hang in rows.

The surface of the soil is a lethal chamber – the bottom of the sea a charnel house. Both are littered from pole to pole with the ruins of forgotten "civilizations" that men and nature have delighted to destroy. Everywhere and always the debilitated have perished, everywhere and always the mightiest have won. As it was in the beginning, is now, and ever shall be. Power, slavery, pain, joy; side by side, forever.

"Ye Who Fall"
Words: Adapted from the writings of Ragnar Redbeard

Upon the island of Java there is a remarkable valley of death. It is literally strewn with the bones and skulls and skeletons of innumerable dead animals and creeping things. In the due season giant turtles, five foot by three in diameter, travel upward from the sea to lay their eggs. En route they are set upon

by packs of wild dogs, and these dogs roll the turtles over upon their backs, then devour them alive by tearing out their unprotected entrails. When the dogs have gorged, they in their turn fall easy prey to the ambush of tigers; then hunters kill these tigers with a variegated scale. Bright grass springs up after the rainy season through the skulls and bones that litter this tropical Golgotha and droves of cattle gather there to fatten. Again the cattle are hunted for there hides, horns and flesh and their bones are also left where they fall, to manure the valley and prepare it for new generations of hunters and hunted. Such is in miniature a picture of the everyday world as it actually is. All living beings are pursuing and being pursued. Woe unto those who stumble. Woe unto ye who fall.

"Credo"
Words: Ragnar Redbeard

Blessed are the strong, for they shall possess the earth.
Cursed are the weak, for they shall inherit the yoke.

Blessed are the powerful, for they shall be reverenced among men.
Cursed are the feeble, for they shall be blotted out.

Blessed are the bold, for they shall be masters of the world.
Cursed are the humble, for they shall be trodden under hoofs.

Blessed are the victorious, for victory is the basis of right.
Cursed are the vanquished, for they shall be vassals forever.

Blessed are the battle-bloodied, beauty shall smile upon them.
Cursed are the poor in spirit, they shall be spat upon.

Blessed are the audacious, for they have imbibed true wisdom.
Cursed are the obedient, for they shall breed creeplings.

Blessed are the iron-handed, the unfit shall flee before them.
Cursed are the haters of battle, subjugation is their portion.

Blessed are the death-defiant, their days shall be long in the land.
Cursed are the feeble-brained, for they shall perish amidst plenty.

Blessed are destroyers of false hope, they are the true messiahs.
Cursed are the God-adorers, they shall be shorn sheep.

Blessed are the valiant for they shall obtain great treasure.
Cursed are the believers in good and evil, for they are frightened by shadows.

Blessed are they who believe in nothing – never shall it terrorize their minds.
Cursed are the "lambs of God," they shall be bled "whiter than snow."

Blessed is the man who hath powerful enemies – they shall make him a hero.
Cursed is he who "doeth good" unto others, he shall be despised.

Blessed is the man whose foot is swift to serve a friend, he is a friend indeed.
Cursed are the organizers of charities, they are propagators of plagues.

Blessed are the wise and brave, for in the struggle they shall win.
Cursed are the unfit, for they shall be righteously exterminated.

Blessed are the mighty-minded, for they shall ride the whirlwinds.
Cursed are they who teach lies for truth and truth for lies, for they are abomination.

Blessed are the unmerciful, their posterity shall own the world.
Cursed are the famous wiselings, their seed shall perish off the earth.

Thrice cursed are the vile for they shall serve and suffer.

"Ultimatum"
Words: Ragnar Redbeard

Under natural conditions, there is no haven for the wretched, no hope for the weaklings, no resting-place for the weary, no quarter for the beaten. Nature loathes infirm ones. Every organism, every human being must conquer or serve. This is an ultimatum.

"Deletion"
Words: Adapted from the writings of Ragnar Redbeard

When the kindly Roman Emperor imagined that peace had settled down permanently on the ancient world, even then, the dissimulating assassin's dagger was sharpening for his throat. And now, while lower organisms dream of a "world of lovers" – of arbitration instead of hostility, of conciliation between rival carnivores – the mechanism of deletion is silently under construction: that (when completed) will sweep them off the face of the earth.

Foolish and blind (or mad) are they who think the struggle for existence has ended. It has only begun. This planet is in its infancy, not in its decrepitude. The "end of all things" is far off. The kingdom of heaven is *not* at hand. Incessant is the rivalry for supremacy among men, and manifold are its metamorphoses. Not for a single hour, for a single second, is there an armistice. Night and day the combat rages, and with renewed virulence on Sundays. When we fall asleep and when we wake up, the clashing of weapons and the crunching of bones is sounding in our ears. Everywhere "the sword is uplifted on man." Everywhere Cain's bludgeon is cracking skulls. The hands of "congregations of the faithful" are red with the blood of the innocent; yet how they boast of being washed clean in the blood of their brother – the lamb.

Eternal battle is the main condition upon which man holds his life tenure. When the brand is shattered in his hand, that is death ... or slavery. When his enemies are beneath his heel, that is life, honor, success. Indeed the struggle between men is more pitiless and more unmerciful than among brutes.

The brute beasts do not enslave, but permit the unfit to die off. Man enslaves his "brother man" on business principles and makes fuel of the widow and the fatherless. The "failures in life" may be counted by millions and everyone knows their horrible fate – their living death. Behold them being whirled into the blazing maw of the great iron furnaces.

Overt action is not always needful for the drastic removal of lower organisms. Very often, if left alone, degenerates cremate themselves. If given control of governmental mechanisms, they immediately commence to grind one another into mincemeat (that is to say, into dividends). Mentally, physically, morally, they are past redemption. Doomed souls are they.

Nature having already condemned them, they provide each other with palatable poisons – for slow, but sure, suicide. They build Gehenna-fires and cast themselves headlong into blazes.

"Evolution"
Words: Ragnar Redbeard

In evolution there is no finality. It is operating always in some form; endeavoring to blot-out inferior organisms and perpetuate more perfect types. Like the gods of antiquity, it is both a destructive and a creative. The powerful of the past were overthrown by the more powerful of the present, and in strict sequence the powerful of today must be overthrown by the more powerful of tomorrow.

"No Nirvana"
Words: Adapted from the writings of Ragnar Redbeard

This world is no Nirvana, where peaceful pleasure flows – it is a gruesome butcher-shop, where slain men hang in rows. This old earth is strewn to the very mountaintops with the fleshless skulls and rain-bleached bones of perished combatants in countless myriads. Every square foot, every inch of soil contains its man.

Skyward or hellward, man moves on and on, and on. If there are barricades in his way, he must surmount them or blast them aside. If there are wild beasts ready to spring upon him, he must destroy them or they will destroy him. If the highroad leads through hells, then those infernos must be besieged, assailed and taken possession of – even if their present monarchs have to be rooted-out with weapons as demonic and deadly as their own.

This world is too peaceful, too acquiescent, too tame. It is a circumcised world. A castrated world. It must be made fiercer before it can become grander and better – and more natural. Terror, torture, agony and the wholesale destruction of feeble and worn out types must mark in the future, as in the past, every step forward or backward in evolution.

The soil of every nation is an arena, a stomping ground, where only the most vigorous animals may hope to hold their own. What is all history but the epic of a colossal campaign? The final Armageddon of which is never likely to be fought, because when men cease to fight, they cease to be *men*. The normal man is the man that loves and feasts, and fights and hunts – the predatory man. The abnormal man is he that toils for a master, half-starves, and "thinks" – the Christly dog. The first is a perfect animal; the second, a perfect monster.

The flow of destruction is as natural and as needful as the flow of water. No human ingenuity can destroy the immolation of man, nor prevent the shedding of blood – and why should it? Majestic nature continues on her tragic way, caring naught for the wails of the agonized and panic-stricken, nor the protests of defeat; but smiling sadly, proudly at the victor's fierce hurrah. She loves the writhing sword-blades – the rending of tradition – the crunching of bones and the flap of shredded, shot-torn banners, streaming out savagely (in the night, in the day), over the battle-weary, the mangled dying and the swollen dead. Christs may come and Christs may go, but Caesar lives forever.

"The Logic Of The Spheres"
Words: Adapted from the writings of Ragnar Redbeard

(Right channel)

Born of neither love nor hate, right – like water – finds its own level. Man's consent is not necessary to the operation of natural forces. It is not required. It is not even asked. He is like unto a patient strapped firmly upon a dissecting table. He may feel the surgeon's lance sinking through his quivering flesh – he may shiver in terror and break out into a cold sweat – he may groan in convulsive agony and pray to his idol – but, he cannot escape.

Knowing all this, why not let nature alone work out her own silent ends? Why should communities of creeping things try to safeguard their incapables? Why obstruct the drastic and significant removal of corrupted organisms? The Jesus type of men were clearly made to be crucified and flogged. The Buddha type were (evidently) born to die of pestilence and famine – poor weak

cowardly swarms of rotting vermin that they are. Behold them in the distance there, with their ribs sticking through their hides, accepting with doleful thankfulness the alms of their conquerors.

Let the cowardly and the vile die off – let them annihilate themselves: that is the logic of the spheres. The atmosphere of this terrestrial ball will be purer when these "heavy laden souls" are gone, and there will be elbow room on its surface, for the regeneration of purity, and cleanliness of mind and body.

At the banquet of life, let no seat be reserved for those who cannot win it – who cannot *break into* the enchanted circle, by force of character and force of deeds. The impotent and the brainless, who call themselves "the righteous" are better dead anyhow – better for themselves, and better for their successors. Is it not the height of madness, for communities to deliberately nourish and foster the bacteria of hereditary degeneration?

(Left channel)

Beyond love, beyond hate – encompassing both – nature is eternal. Nature is cruel and merciless to men, as to all other beings. Let a tribe of human animals live a rational life, nature will smile upon them and their posterity; but let them attempt to organize an unnatural mode of existence, an equality Elysium, and they will be punished even to the point of extermination.

There are certain higher laws, which no one can even try to rebel against, without being quietly executed. The transgressor of a natural ordinance may think he has escaped, even while the noose-knot is under his chin and the bolt about to be sprung. Nature has a very long arm and a vengeful one. Many a "city of the plain" has been incinerated, besides Sodom and Gomorrah. Individual transgressors of nature are always driven mad and nations that organize defiance to the nature of their being become regimented hordes of incoherent manlings, sootily perspiring downward to their "Heaven" – dancing the dance of death, shrieking the songs of "progress."

When not thwarted by artificial contrivances, whatever argument nature promulgates is – right. The further man gets away from nature, the further he departs from right. To be right is to be natural, and to be natural is to be right. The sun shines, therefore it is right that it should shine – the rain falls, therefore it is right that it should fall – the tides ebb and flow, therefore it is right that they should ebb and flow.

Darwin's law exists – may be seen in operation – therefore it is also right. It is not a dream like "religion," it is not an invention like "morals," it is not an assumption like "God." It is a cosmic fact, like the sunshine, the rain and the tides.

"Great Destroyers"
Words: Adapted from the writings of Ragnar Redbeard

Mankind is aweary. Aweary of its sham prophets, its demagogues and its statesmen. It crieth out for Kings and heroes. It demands a nobility – a nobility that cannot be hired with money, like slaves or beasts of burden. The world awaits the coming of mighty men of valor, great destroyers; destroyers of all that is vile. Angels of death. We are sick unto nausea of the "good Lord Jesus," terror-stricken under the executive of priest, mob and proconsul. We are tired to death of "equality." Gods are at a discount, devils are in demand. He who would rule the coming age must be hard, cruel and deliberately intrepid, for softness assails not successfully the idols of the multitude. Those idols must be smashed into fragments, burnt to ashes, and that cannot be done by the gospel of love.

The Boyd Rice Experience
Hatesville!
(Hierarchy, 1995)

"Hatesville!"

You won't find Hatesville on any maps. It's easy to get to, but you can't go by train, a plane, or car. You need a ticket to get there from here and you're listening to that ticket this very minute, dad. A one way ticket – first class. See, Hatesville exists partway between the heart and the mind. It's that place in the soul where hate dwells –and we're here to point the way.

Why? Because hate is groovy. Because it's fun and it's necessary, and it lives inside you every second of every day. And you know what? You need hate – and we need to let you hate. Because we're your friends and we want to see you happy, and healthy ... and just a little bit angry So don't hold back or hesitate. Sit back, smile, relax ... and hate. Everyone needs a scapegoat. Everyone needs a whipping boy. When you find someone to hate, it fills your heart with joy.

"How God Makes Little Girls"
Words: Boyd Rice and Adam Parfrey

To make a girl,
God takes sweetness and lace.

Adds ribbons and dimples,
And a smile for the face.

A carefree laugh
And a winsome wink.

Some giggles, some curls
And a touch of pink.

Then he stirs in more love
Than there is tea in China.

And to round it all out
He includes a vagina.

"Mr. Intolerance"

I'm not a tolerant person. In fact I get more intolerant by the day. I just find it more and more difficult to tolerate assholes. As my tolerance decreases, their numbers seem to increase. Every day there's more and more of them, and every day I have less and less patience. I'm not a mere bigot, but I certainly don't cut any slack to anyone on the merit of their status as an oppressed minority. Your people were enslaved? Tough luck. The White man stole your land? Too fuckin' bad. Your fair sex is plagued by date rape? Grin and bear it.

These days everyone has a sob story, and frankly, I don't care. It's no excuse for being an asshole. We live in the age of the excuse. We live in the age of the asshole. They're everywhere. They come in all shapes, all sizes, all colors: There are Black assholes, White assholes, women assholes, men assholes, queer assholes, straight assholes, smart assholes, stupid assholes, suburban assholes, inner-city assholes, homeless assholes, upwardly-mobile assholes, lazy assholes, incompetent assholes, sloppy assholes, anal assholes, and so it goes *ad nauseum*. Why should I tolerate any of them? Why should I tolerate anything I don't care for, for any length of time? Why should I pretend it's okay?

I don't like assholes. Don't like talking to them; don't like talking about them. Don't like knowing them; don't like knowing about them, or their thoughts, or their deeds. Assholes are like bad ideas; if you let even a single one into your life it can begin to ruin things. It can destroy what's good and foster much that's bad. Why tolerate that? Tolerance was a virtue once. No more. There aren't enough hours in the day to tolerate all the assholes, to tolerate all the indignities hurled your way and still be able to live a decent life. Perhaps Goethe said it best: "That which disturbs your soul, you must not suffer." Remember that when it seems like assholes are hard at work to disturb your soul twenty-four hours a day. Take a tip from Mr. Intolerance – don't permit them to.

"Love Will Change The World"

Love will change the world. That's what we were told in the Sixties: "Love will make you happy. Love one another. Love makes the world go 'round. All you need is love." We've talked of love nonstop for the last few decades. Actually, for the last few thousand years. Where exactly has it gotten us? Are we one step closer to paradise? Hardly. Love hasn't stopped war, cured crime, or erased poverty. Hasn't even come close. Look for any sign of improvement and I guarantee you, you'll see only the most cosmetic of changes. Window dressing. Empty symbolism. Fatuous falderal.

"Things are getting better all the time," the loveniks assure us. What about peace in the Mideast? What about harmony in South Africa? Sure, there's peace in the Mideast ... in between bombings. And there's plenty of harmony in South Africa, if you're wealthy enough to live behind electrified fences and locked gates. In reality, things have turned to shit. Social and moral decay is like an out of control cancer that's taken charge, a cancer born of love. If some people are actually stupid enough to believe things are improving, it's only because their poor brains are so benumbed by love that they can no longer think straight.

Love: Sickly love, brotherly love, unconditional love, cowardly love, geek love. A love that says, "Relinquish judgment." A love that encourages acceptance, at the expense of discernment. It's no wonder people imagine things have changed for the better, when in fact all that's changed is their capacity to accept any amount of shit, unconditionally. So the verdict on love is both bad and good. The bad news is that love has turned the world into a sewer. The good news is that people have learned to *love* the smell of shit.

"Alone With The Calm"

When I desire a lazy day
There's a place that I go to,
Not so far away.

But it's distant from concrete
And noise, and strife,
And far, far removed from the frictions of life.

It's a place with no pests,
But for spiders and chiggers,
With no loudmouth assholes, or unruly niggers.

Just grassy fields
And brooks that babble.
No witless or homeless, or other such rabble.

And off in my respite,
Alone with the calm,
I pray for some despot to drop the A-bomb.

Scorpion Wind
(Death In June & Boyd Rice)
Heaven Sent

(New European Recordings, 1996)

Liner Notes:

March on. March on. May you, "NOT GO TOWARDS THE LIGHT."

"Love, Love, Love (Equilibrium)"
Words: Marquis de Sade

The reprisals of the weak against the strong do not really come within nature. They do from the moral point of view but not the physical, since to take these reprisals the weak man must employ forces that he has not received from nature. He must adopt a character that he has not been given; he must, in a way, constrain nature. But what does really come within the laws of this wise mother is the harm done to the weak by the strong, since to bring this process to pass the strong man makes use only of gifts which he has received from nature – he does not, like the weak, take on a character different from his own – he merely utilizes the sole effects of that with which nature has endowed him. Therefore everything resulting from that is natural. His acts of oppression, violence, cruelty, tyranny, injustice – all these diverse expressions of the character engraved in him by the hand of the power which placed him in the world are therefore quite as simple and pure as the hand which drew them. And when he uses all his rights to oppress the weak, to plunder the weak, he is therefore doing the most natural thing in the world.

If our common mother had desired the equality that the weak strive so hard to establish, if she had really wanted the equitable division of property, why should she have created two classes; one weak, the other strong? Has she not, with this distinction, given sufficient proof that her intention was that it should apply to possessions as well as bodily faculties? Does she not prove that her plan is for everything to be on one side, and nothing on the other; and that precisely in order to arrive at that equilibrium which is the sole basis of all her laws? For, in order that this equilibrium may exist in nature, it is not necessary that it be men who establish it; their equilibrium upsets that of nature. What, in our eyes, seems to us to go against it, is exactly that which, in hers, establishes it, and for this reason; it is from this lack of balance, as we call it, that are produced the crimes by which she establishes her order.

The strong seize everything; that is the lack of balance, from man's point of view. The weak

defend themselves and rob the strong; there you have the crimes which establish the equilibrium necessary to nature. Let us therefore not have any scruples about what we can filch from the weak, for it is not we who are committing a crime, it is the act of defense or vengeance performed by the weak which has that character. By robbing the poor, dispossessing the orphan, usurping the widow's inheritance, man is only making use of the rights he has received from nature. The crime would consist in not profiting from them: the penniless wretch that nature offers up to our blows is the prey she offers the vulture. If the strong appear to disturb her order by robbing those beneath them, the weak re-establish it by robbing their superiors, and both are serving nature.

"Preserve Thy Loneliness"
Words: Adapted from the writings of Meister Eckhart

There is a way that seemeth right unto man.
There is a way that seemeth right unto man
But the end thereof is death.
But the end thereof is death.
Is death.
Is death.
There is another way.
There is another way.

Preserve thy loneliness from all men; remain undisturbed by all accepted impressions. Free thyself from anything that could be foreign to thy being and direct thy conscience toward the solitary view by which thou bearest a beast in thine soul as an object from which thine eyes never wander. Complete isolation of soul brooks no imitation of creatures, no self-humiliation nor self-elevation, and strives to be neither below or above, wanting only to rest in itself, reaching neither toward love nor towards suffering. It does not consider its equality, or inequality, with other beings. It wants neither to be the one, nor the other. It wants only to be at one with itself.

Preserve thy loneliness from all men.
Preserve thy loneliness from all men.
Preserve thy loneliness from all men.
Preserve thy loneliness from all men.

"In Vino Veritas"

So won't someone pour me another martini,
To sip while Rome is afire?
So won't someone pour me another martini
And we'll toast the world's funeral pyre?

I was born in a blizzard of bubbles,
Rising as toward the sun.
Bacchus ruled over the dead,
But I'll bet he had plenty of fun.

I've been drinking, and I've been thinking
And I think that I'll drink some more.
So here's to your health and here's to crime,
And here's to sex and war.

I'm a man of the grain
And not cocaine.
I treasure my pleasure
And cherish your pain.

So won't someone pour me another martini,
To sip while Rome is afire?
Won't someone pour me another martini
And we'll toast the world's funeral pyre.

So let's have another: another sherry, gin and vermouth, whisky sour, highball, seven and seven, Midori martini, chardonnay, rum and Coke, margaritas, Long Island iced tea, cognac, daiquiris, bloody Mary, shots all around; Jägermeister, Irish whisky, keep them coming, keep the glasses full.

I was born in a blizzard of bubbles,
Rising as toward the sun.
Bacchus ruled over the dead
But I'll bet he had plenty of fun.

I've been drinking and I've been thinking,
And I think that I'll drink some more.
So here's to your health and here's to crime,
And here's to sex and war.

I'm a man of the grain
And not cocaine.
I treasure my pleasure
And cherish your pain.

So won't someone pour me another martini,
To sip while Rome is afire?
Won't someone pour me another martini
And we'll toast the world's funeral pyre?

To crime, here's mud in your eye, bitoa, chin-chin, *gut heil*, *salut*, *a votre sant*é, *Heilige*, kin' oath.

"Paradise Of Perfection"
Words: Savitri Devi

All men, inasmuch as they are not liberated from the bondage of time, follow the downward path of history, whether they know it or not and whether they like it or not. Few indeed thoroughly like it, even in our epoch, let alone in happier ages when people read less and thought more. Few follow it unhesitatingly, without throwing at some time or other a sad glance toward the distant lost paradise, into which they know – in their deeper consciousness – that they are never to enter; the paradise of perfection in time. A thing so remote that the earliest people of whom we know remember it as only a dream. Yet they follow their fate away. They obey their destiny; that resigned submission to the terrible law of decay. That acceptance of the bondage of time by creatures who dimly feel they could be free from it, but who find it too hard to try to free themselves; who know beforehand that they would never succeed, even if they did try, because at the bottom is that incurable unhappiness of man, deplored again and again in Greek tragedies, and long before these were written.

Man is unhappy because he knows – because he feels, in general – that the world in which he

lives and of which he is a part, is not what it should be – not what it could be – not what, in fact, it was at the dawn of time, before decay set in. He cannot wholeheartedly accept the world as it is, especially not accept the fact that it is going from bad to worse, and be glad. However much he may try to be a realist and snatch from destiny whatever he can – when he can – still an invincible yearning for the better remains at the bottom of his heart; he cannot, in general, stomach the world as it is.

In heralding the most widespread massacre, I believe that war is preparing mystical spheres for the apparition of great ideals. Where the charnel house dissolves, joy will be born in from it; where the weight of mortality sinks down, the soul's freedom will be uplifted. The greater the offering, the greater will be the wonder and the miracle.

"Roasted Cadaver"

I am the night that robs you of light,
The night wind that chills to the bone.

I am the cold stillness,
The stars and the harshness.
The darkness you wander alone.

I am the sun that parches the desert.
I am that desert where you meander forever.

I am the heat that scorches your feet,
As you collapse untold miles from water.

I am the vulture that feeds and feasts
On the flesh of your bloated cadaver.

I am the rain that subdues the heat,
Albeit for you I arrive somewhat late;
But in time to wash the dust from your bones
And moisten the place you repose all alone.
But in time to wash the dust from your bones
And moisten the place you repose all alone.

I am the breeze that scatters the leaves,
The storm that turns towns upside down.

I am the wind, the rain and the thunder;
The furious torrent that rips all asunder,
And tears what is dead from that which is living,
Without regard for what I'm taking or leaving.
And tears what is dead from that which is living,
Without regard for what I'm taking or leaving.

"The Cruelty Of The Heavens"
Words: Carl G. Jung, as excerpted from *The Seven Sermons Of The Dead*

In the night, the dead stood along the wall and cried, "We would have knowledge of God. Where is God? Is God dead?" God is not dead. Now, as ever, he liveth. There is a God whom you know not, for mankind forgot it. We name it by its name: Abraxas. Abraxas standeth above the sun and above the devil. It is

improbable probability, unreal reality ...

Hard to know is the deity of Abraxas; its power is greatest because man perceiveth it not. From the sun he draweth absolute good, from the Devil, infinite evil, but from Abraxas, life. Abraxas is the sun and at the same time, the eternally sucking gorge of the void. The power of Abraxas is twofold, but ye see it not because for your eyes the warring opposites of this power are extinguished. What the Sun-god speaketh is life, what the Devil speaketh is death, but Abraxas speaketh that hallowed and accursed word which is life and death at the same time. Abraxas begetteth truth and lying, good and evil, light and darkness; in the same word and in the same act.

Wherefore is Abraxas terrible. It is splendid as the lion in the instant it striketh down its victim. It is beautiful as a day of spring. It is the abundance which seeketh union with emptiness. It is love and love's murder. It is the saint and his betrayer. It is the brightest light of day and the darkest night of madness.

God dwelleth behind the sun, the Devil behind the night. What God bringeth forth out of light the Devil sucketh into the night; but Abraxas is the world, its becoming and its passing. Upon every gift that cometh from the Sun-god, the Devil layeth his curse: everything that ye entreat from the Sun-god, begetteth a deed from the Devil. Everything that ye create with the Sun-god giveth effective power to the Devil.

That is terrible Abraxas. It is the delight of the earth, the cruelty of the heavens. Before it, there is no question and no reply.

"There Is No More Sleep"
Words: Adapted from the writings of Gabriele d'Annunzio

Yesterday, the living mourned the dead.
Today, the dead mourn the living.

There is no more sleep.
There is no more truce.
There is no more respite.

March on,
Toward the world's battle.
March on,
Now, as then.

In wood and in mountain,
and in plain.
On river and lake,
and sea.
Let man daily invent his glory
And his death.

"Some Colossus"
Words: Arthur de Gobineau

Know from henceforth that for the kind of person whom destiny calls, the ordinary rules of life are reversed and become quite different. Good and evil are transferred to another and higher plane; then the virtues which might be applauded in an ordinary person would in you become vices, simply because they would only be the source of obstacles and ruin.

Now the great law of the world is not to do this, or that; to avoid one thing, or pursue another. It is to live. To enlarge and develop our most active and sublime qualities in such a way that from any

sphere we can always strive to reach another one that is wider, more airy, more elevated. Do not forget that. Go straight ahead. Simply do as you please insofar as it serves your interests. Leave weakness and scruple to the petty minds and to the rabble of underlings. There is only one consideration worthy of you: the elevation and greatness of yourself.

I think that a decent man – a man who feels that he has some soul – has now more than ever the strict duty of falling back upon himself, and since he can't save others, of striving for his own betterment. That is the essential task in times like ours. Everything that has been lost by society does not disappear, but takes refuge in individual lives. The mass is petty, wretched, shameful and repugnant. The isolated man can rise above this, and just as in the ruins of Egypt, amidst heaps of rubble, broken and unrecognizable fragments, walls that have collapsed or subsided and are often difficult to repair, there will have survived some colossus, thrusting into the sky, which – by its very height – preserves an idea of the nobility of the temple or town, now razed to the ground forever. So in the same way these isolated men can help to preserve our conception of what God's noblest and finest creatures ought to be like.

"The Path Of The Cross"

Follow the path of the cross
To glory or to loss.
One cross made of iron,
One is made of wood.
One leads to forever now
And one would if it could.
Toward the cross of iron,
Toward the cross of fire,
Toward the sun within the soul
And to your heart's desire.

Follow the path of the cross
To glory or to loss.
One cross made of iron,
One is made of wood.
One leads to power,
One would if it could.

Empires tumble and fall,
Columns crumble and fall.
Swords and cannons all must rust
As stone and marble turn to dust.
But the flame within the soul,
Burns forever.

Toward the cross of iron,
Toward the cross of fire.
Toward the sun within the soul,
And to your heart's desire.

"Never"

Never forgive, never forget,
Never, never.

Never forgive, never forget,
Never, not ever.
Bring my enemies before me
And slay them.

I once imagined the lie to be the ultimate enemy, an enemy of life and of everything worthwhile in life. A petulance that would sooner or later corrupt all that is grand and noble, debasing truth and beauty in equal measure, casting its ugly shadow over everything.

Now I realize that truth, beauty and nobility are eternal. They cannot be debased by the lie. They cannot be destroyed by the lie. They live forever. Only mankind can be debased by the lie. Only mankind can be led by the lie far, far afield; from truth, from beauty, from purity. And when men become sufficiently debased, every eternal value shall pronounce judgment upon them and shall act as their judge and their jury, and their executioner.

Now I've learned to love the lie. I love the poison it spreads. I love the weakness it engenders. I love the seeds of destruction it sows and I love the judgment it brings. The lie is not an enemy of truth, it is an ally of truth. It prepares the way, it balances the books and it makes clean the slate.

NON
God & Beast
(Mute Records, 1997)

Liner Notes:

In a Promethean sense, man is a god. But on an even more profound level, man is a beast. This primary contradiction has plagued mankind for millennia. Man is a god. Man is a beast. These two aspects of his personality have been waging war with one another for countless centuries; a war whose casualties are seen everywhere and recognized nowhere. But there exists, however, a long forgotten place in the soul where god and beast intersect. To go to that place is to witness the death of one world and the birth of another ... join me.

"Between Venus & Mars"

I live on a rock between Venus and Mars.
Venus is love, Mars is war.
Venus is love, Mars is war.

I fall between dark and light.
A foot on the Sun, a foot in the night.

I fall between love and rape;
One says give, one says take.
One says give, one says take.

I fall between pleasure and pain;
Pleasure is lush, pain is a must.

I fall between stillness and fury.
I am the judge, I am the jury.

I fall between love and hate;

Love is lovely, hate is great.
Love is lovely, hate is great.

I fall between worst and best.
I am the first, I am the last.

I fall between tempest and calm.
I am the death, I am the dawn.
I am the death, I am the dawn.

I live on a rock between Venus and Mars.
Venus is love, Mars is war.

I fall between dark and light.
A foot on the Sun, a foot in the night.
A foot on the Sun, a foot in the night.

I fall between love and rape;
One says give, one says take.
Give. Take.
Give. Take.

I fall between pleasure and pain;
Pleasure is lush, pain is a must.

I fall between stillness and fury.
I am the judge, I am the jury.
I am the judge, I am the jury.

I fall between worst and best.
I am the first, I am the last.
First. Last.
First. Last.

I fall between tempest and calm.
I am the death, I am the dawn.
Death. Dawn.
Death. Dawn.

I live on a rock between Venus and Mars.
Venus is love, Mars is war.
Love. War.
Love. War ...

"Millstones"
Words: William Shakespeare (spoken by Douglas Pearce)

Your eyes drop millstones,
When fools' eyes fall tears.

Your eyes drop millstones,
When fools' eyes fall tears.

Your eyes drop millstones,
When fools' eyes fall tears.
Your eyes drop millstones,
When fools' eyes fall tears.

"The Law"

There are no rules in the iron game,
Only the law of tooth and claw.

There are no rules in the iron game,
Only the law of blood and flame.
Only the law that's always the same.

There are no rules in the iron game,
Only the law of master and slave.
Only the law, from cradle to grave.

There are no rules in the iron game.
In the iron game.
Only the law of tooth and claw.
Only the law of blood and flame,
That's always the same.

Only the law of master and slave.
Only the law of master and slave.
Only the law, from cradle to grave.
Only the law of tooth and claw.
Only the law.
Only the law.

There are no rules in the iron game,
Only the law.
Only the law.
Only the law.
Only the law.
Only the law.
Only the law.
Law.
Law.

"Out Out Out"

That which disturbs your soul you must not suffer ...

Cast it out, out, out.
Out, out.

Cut out, out, out.
Out, out.

Wipe out, wipe out.
Out.

Cast out, cast out, cast out.
Cast it out, cast it out.
Out.

Cut it out, cut it out.
Out.

Cut, cut out.
Out, out.
Cut out.
Out.

Cut it out, cast it out.
Wipe it out.
Out.

(Hidden track)

That is most powerful which remains unknown,
Except unto you and to you alone.

There are secrets that slumber behind these eyes,
And I stand by my secrets, my truths and my lies.

There are secrets that soar where the eagle flies,
Above man's truths and beyond his lies.

There are secrets that slither with snakes in the night,
Coiled in shadows, far distant from light.

There are secrets that confront you in the midday sun,
Yet remain unknown to everyone.

A secret burns bright while its law is obeyed,
But is doomed to fade when that law is betrayed.

For that is most powerful which remains unknown,
Except unto you, and to you alone.

Boyd Rice & Fiends
Wolf Pact
(NEROZ, 2002)

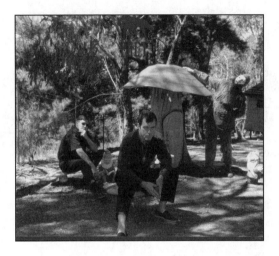

"Watery Leviathan"

At the sunrise and at noontide.
At the setting of the Sun.

Here's a health to you and wealth to you.
Honors and gifts a thousand strong.

Here's a name to you and fame to you.
Luck and blessings, your whole life long.

Look toward heaven, eyes wide open,
Turn your face toward the Sun.

And keep both feet firmly planted
On the watery leviathan.

And shall all things come from one thing.
Give your prayers to the Sun.

And keep both feet firmly planted,
In the waters on leviathan.

"The Forgotten Father / Tomb Of The Forgotten Father"
(The recounting of a dream)

I found myself in a foreign land, standing before a temple. The edifice was obviously very ancient, but looked like the handiwork of a culture unknown to me. Whatever hands had fabricated this structure belonged to a race that had lived here long before recorded history. Inside, services were starting and

the monks and attendees intoned a strange, guttural, inhuman drone. The temple stood at the center of a deep concave pit, and pilgrims were descending towards it along steep ramps, as though symbolically entering the underworld. The pilgrims were attired in military camouflage and had their faces painted to match. They gazed out from beneath hoods, and as their eyes met mine, they glanced quickly away. What was this strange religion and why were its devotees thusly attired?

Not far away I heard a man speaking in English. He stood chatting and sipping white wine. He too was sporting camouflage from head to toe, and I went up to ask him about the rites and beliefs of this sect. As I approached I thought I recognized his voice. It was Douglas. I asked what he was doing there and he replied that he quite liked this unusual temple, and stopped to see it whenever he was in this part of the world.

I soon noticed that Doug was not, in fact, dressed in camouflage. He was naked and was simply painted "camo" from head to toe. I began to wonder aloud if this wasn't all some strange dream. Doug assured me that it wasn't. That this constituted the most ancient doctrine known to man and the unknown tradition from which all known to the West had derived. These people worship the Hidden God. A god so old in antiquity, that even at the dawn of recorded history he was known only as the Forgotten Father. They dress in camouflage to honor him, and to be like unto him. Hidden, unseen, invisible. And that's why they'd turned their faces from me and refused to meet my gaze.

According to legend, the Forgotten Father had come – seemingly from nowhere – and had taught men his secrets. He took many wives from amongst the daughters of men and then vanished mysteriously back to where he had come from. Some of his descendants still walk amongst us and his understanding lives on, albeit semi-consciously, in their ancestral memory. This place is his temple and is said to have once been his palace. But, this is just a building. His true temple is in the blood, where his memory lives, though his name is long forgotten ...

... And then I found myself in a room with no doors or windows, only stairways leading to the rooms above and below. I proceeded downstairs and came into a room totally bedecked with vintage Fifties furnishings. It too had neither doors or windows. I again proceeded downstairs and entered into a room decorated in the style of the early nineteen-hundreds. It appeared that for every floor I descended I was also descending back into time. As I continued downward it seemed my hypothesis was correct, and proceeding, I passed through every historical epoch: medieval times, ancient Rome, Phoenicia, Sumeria. At length I came to a room that was empty, scorched and altogether desolate. It looked like the end of the line, yet still the stairs led further downward, and descending, I entered into a vast cavern, very dark yet illuminated by an eerie glow. My path had come to an end, seemingly deep inside the earth. Before me was what appeared to be a tomb constructed from large carved slabs of luminescent rock. The tomb was modeled after the temple I'd seen with Doug. Was this the grave of the Forgotten Father, the final resting place of the mysterious patriarch who'd vanished at the dawn of time? Turning, I retraced my steps and went back upwards, anxious to see if the upper floors in fact went into future times. And, indeed, they did. I passed through level after level of strange and wondrous things, coming finally to a large room empty, but filled with fog. Pausing but briefly, I forged ahead and found myself back in the depths of the earth, standing before the same glowing tomb. I turned to leave, but stopped short. The stairs I'd just climbed were no more.

"Wolf Pact"

When you're down on your knees,
You must say please.
When you have the upper hand,
Feel free to squeeze.

We remember a time when you could look out to sea and it was as though we stared upon a forest of periscopes ... Those times are no more.

"Worlds Collide"

Worlds above, worlds below,
Here worlds collide.

World of fire, world of ice,
Here worlds slide.

Worlds profane, worlds divine,
Here worlds combine.

Worlds below, worlds above,
Worlds beyond time.

Stars fall, flames arise,
Here are worlds sublime ...

"Their Bad Blood"

Broken wings of a dove,
The serpent descends.

Broken wings of a dove,
The serpent descends.

Broken wings of a dove,
The serpent descends.

Broken wings of a dove,
The serpent descends.

"Rex Mundi"

Before Caesar, before Alexander, before Hiram of Tyre, Thoth, or Akhenaton, a single King reigned over all. His empire was so vast that he was known simply as the Lord Of The Earth. So mighty was his power that he was remembered by some as a God; by others ... the Devil. Rex Deus ... Rex Mundi ...

His throne lies empty but the house survives. And behold, the throne is above in the Sun. And below, in the watery abyss. And lo, it stands before you. In legend it is said that the King has gone back to his sacred homeland and that he remains there still, in a near eternal sleep. One day he shall awaken from his slumber, take up his weapon once more, and return to reclaim his throne.

"The Reign Song"

On a gray, rainy day when the small streams turn into engorged torrents, as you hear footsteps behind you, do you ever wonder ... is it your past catching up with you? Will these rains cleanse you and wash away your transgressions? Or, will a drowning world reach out to take you in its embrace? Even vagrant thoughts originate someplace, and such fears aren't without basis. After all, the guilty know well who they are. They know what they've done, and so do we. Sleep with one eye open. The rain may fall sooner than you think.

"Fire Shall Come"
(Adapted from the writings of Heraclitus)

This world was, is, shall be; fire.
Fire; everlasting fire.
Fire, fire; everlasting fire.

Fire will come and judge,
And consume all things.
All things.
Fire, fire; everlasting fire.
Fire, fire; everlasting fire.

Fire, fire; everlasting fire.
Fire, fire; everlasting fire.

Fire shall come and judge,
And condemn all things.
All things.
That fire, fire; everlasting fire.
Fire, fire; everlasting fire.

This world was, is, shall be; fire.
Fire; everlasting fire.

Fire, fire; everlasting fire.
Fire, fire; everlasting fire.

Fire will come and judge,
and consume all things.
All things.
Fire, fire; everlasting fire.
Fire, fire; everlasting fire.

Everlasting fire.
Fire, fire, fire, fire, fire ...

Fire, fire,
Everlasting fire.

Death In June & Boyd Rice
Alarm Agents
(New European Recordings, 2004)

"Untouchable"

You will know what the stars are, and not know what I am. For centuries men have sought me. Poets and warriors, priests and philosophers, teachers and scholars; all have hunted me, like a wolf. And none have caught me, yet. I am everywhere and nowhere. Always within reach, yet untouchable.

"Black Sun Rising"

The stones of a house come to life
And kill those inside.

Statues of bronze begin to breathe.
Black Sun, rise.

A world is born, another dies.
Black Sun, rise.

Decaying of flesh gives birth to flies.
Black Sun, rise.

Demons and angels before our eyes.
Black Sun, rise.

Black Sun gleaming, Black Sun dreaming,
Black Sun, rise.

Columns tumble, faiths all crumble.
Black Sun, rise.

Black Sun razes, Black Sun blazes.
Black Sun, rise.

A world is born, another dies.
Black Sun, rise.

Demons and angels before our eyes.
Black Sun, rise.

Decaying of flesh gives birth to flies.
Black Sun, rise.

Black Sun gleaming, Black Sun dreaming.
Black Sun, rise.

Columns tumble, faiths all crumble.
Black Sun, rise.

A world is born, another dies.
Black Sun, rise.

"Tears Of The Hunted"

When the tears of the hunted fall like summer rain,
Flowers will blossom the color of pain.

That which is rotten does not belong to us.
Woe to the vanquished, return to dust.

That which has fallen does not belong to us.
That which is crawling inspires no trust.

When the tears of the hunted fall like summer rain.
We'll shed our skin and be born again.

That which is rotten does not belong to us.
Polish the blade, or it turns to rust.

That which has fallen does not belong to us,
And that which is crawling inspires no trust.

"Storm On The Sea (Out Beyond Land)"

(Douglas Pearce)
The seagulls are flying.

(Boyd Rice)
Yes, there's a storm on the sea.

Yesterday a storm was on the sea,
Now it's come to dwell with you and me.

Yesterday the storm was far away,
Now it's here, here to stay.

Yesterday dark clouds plagued the sky,
Now they've arrived to plague you and I.

The seagulls are flying, there's a storm on the sea,
Now it's our fatal destiny.

Yesterday a storm was on the sea,
Now it's come to dwell with you and me.

But there's always calm at the center of the storm.
Embrace the cold, feel the warm.

There's always calm at the center of the storm.
Embrace the cold, feel the warm.

Seagulls are flying, there's a storm on the sea.
Time to meet our fatal destiny.

Yesterday dark clouds plagued the sky,
Now they've arrived to plague you and I.

But there's always calm at the center of the storm.
Embrace the cold, feel the warm.
Embrace the cold, feel the warm.

"Summer Is Gone"

Winter has come, gray shrouds the Sun.
Gray shrouds the sun.
Winter has come, gray shrouds the Sun
And summer is gone.

Cold wind let me hear you whine.
White world you are a friend of mine.
But you, you've been fallen down,
Fallen down such a long time.

Skeletal trees shiver in the breeze,
Leaves have fallen down.
Skeletal trees shiver in the breeze,
Snow is on the ground.

Cold wind let me hear you whine.
White world you are a friend of mine.
But you, you've been fallen down,
Fallen down such a long time.

Leaves have fallen down, snow is on the ground.
The sky is bright gray.
Leaves have fallen down, snow is on the ground.

The night's run away with the day.

Cold wind let me hear you whine.
White world you are a friend of mine.
But you, you've been fallen down,
Fallen down such a long time.

Winter has come, gray shrouds the Sun.
The night's run away with the day.
Winter has come, gray shrouds the Sun,
And the summer is gone.

Cold wind let me hear you whine.
White world you are a friend of mine.
But you, you've been fallen down,
Fallen down such a long time.

Skeletal trees shiver in the breeze.
Leaves have fallen down.
Skeletal trees shiver in the breeze.
Snow is on the ground.

"An Ancient Tale Is Told"
Words: Adapted from *The Builders* and the writings of Omar Kayan

An ancient tale is told of how the gods, having stolen from man his divinity, met in council to discuss where they should hide it. One suggested that it be carried to the other side of the earth and then buried, but it was pointed out that some men are great wanderers and that they might find the lost treasure on the other side of the earth. Another proposed that it be dropped into the depths of the sea, but the same fear was expressed; that man in his insatiable curiosity might dive deep enough to find it even there. Finally, after a space of silence, the oldest and wisest of the gods said, "Hide it in man himself, because that is the last place he will ever think to look for it."

I sent my soul to the invisible, the afterlife to foretell.
And returning it said to me, "I myself am both Heaven and Hell."

I myself am both Heaven and Hell.

"Are You Out There?"
(Sung as a duet with Douglas Pearce)

(Pearce)
Are you out there?

(Rice)
I am the same.

(Pearce)
Are you out there?

(Rice)

I'll never change.

(Pearce)
Are you out there?

(Rice)
I remain.

(Pearce)
Are you out there?

(Rice)
I am the same.

(Pearce)
Are you out there?

(Rice)
I'll never change.

(Pearce)
Are you out there?

(Rice)
I'm here now ...

"Sunwheels Of Your Mind"

Like a flame within a fire,
Like the light within a flame.
Ever flowing, ever pulsing,
Like the blood within your veins.

Like the aftermath of love,
Or the aftermath of war.
You may find yourself fulfilled,
Still you're always wanting more.

Like the instinct that propels you,
To what's just around the bend.
The desire that compels you
And that has no start or end.

That's the fire you will find,
In the sunwheels of your mind.

"Get Used To Saying No!"
Words: Jose Maria Esquivias

Get used to saying no. Turn your back on the deceiver when he whispers in your ear. Why complicate your life? Willpower, energy, example; what has to be done is done. Without wavering – without

worrying about what others think.

Let obstacles only make you bigger. Get rid of those useless thoughts which are at best a waste of time. Don't waste your energy or your time throwing stones at the dogs that bark at you on the way. Ignore them.

Don't put off your work until tomorrow. Don't succumb to that disease of character whose symptoms are a general lack of seriousness, unsteadiness in action and speech, foolishness, in a word: frivolity.

If you clash with the character of one person or another, it has to be that way. You're not a dollar bill to be liked by everyone. If your character and that of those around you were soft and sweet like marshmallows, you would never become the person destiny has ordained.

Don't stop to think about excuses. Get rid of them and do what you should. You say you can't do more? Couldn't it be that you can't do less?

You never want to get to the bottom of things, at times because of politeness, other times – most times – because you fear hurting yourself. Sometimes again, because you fear hurting others, but always because of fear. With that fear of digging for the truth, you'll never be a man of good judgment. Don't be afraid of the truth, even though the truth may mean your death.

"Symbols In Souls"
Words: Adapted from *The Chaldean Oracles*

Enlarge not thou, thy destiny,
For nothing proceeds from paternal principality imperfect.
The paternal mind hath implanted symbols in souls.
Everywhere to the unfashioned soul stretch out the reins of fire,
Extending the like fire sparklingly into the spacious air.
Or like fire unfigured, a voice issuing forth,
Or fire abundant, whizzing and winding about the earth.
But also to see a horse more glittering than light,
Fiery or adorned with gold.
For then neither appears the celestial concave bulk,
Nor do the stars shine and the light of the moon is covered.
The earth stands not still, but all things appear thunder,
When thou seest a sacred fire without form.
Shining flashingly through the depths of the world,
Hear the voice of fire.
Hear the voice of fire.

"An Ancient Tale Is Told Again"
Words: Rudyard Kipling

When I was a King and a mason,
A mason proved and skilled.
I cleared me ground for a palace,
Such as a King should build.

I decreed and dug down to my levels,
Presently under the silt.
I came on the wreck of a palace,
Such as a King had built.

"Boyd's Gift"

On my own, hour after hour,
Sipping cocktails and reading Schopenhauer.

Living in a world without imagination,
I see that hope is a lack of information.

I turn my back, I shut the door, I lock the key.
A prisoner in my home, but it's lovely to be free.

Non-album tracks and collaborations
(Many re-released on the Boyd Rice album,
The Way I Feel, Soleilmoon, 2000)

Liner Notes to *The Way I Feel*:

This is an album about *feelings*. Those of you who only know Boyd Rice from his rather brutish and insensitive noise music will no doubt be surprised to discover the sensitive, at times passionate individual lurking beneath his often gruff exterior. Here, Rice opens up for us. He shares how he feels about a wide range of topics, and we bet you'll be surprised just how often his thoughts and feelings mirror your own.

"The End of The World" (Introduction)
(Originally released on Current 93's *Swastikas for Noddy*, 1988)

The end of the world doesn't come suddenly and without warning. To imagine it does is to be fooled by popular misconception and thus fail to recognize the larger picture. The end of the world is an ongoing process. It starts slowly, imperceptibly, and blossoms unnoticed in our very midst until it has engulfed all that there is and none is
free from its spell.

Hear now my words and heed them well: all that you think is great and mighty is but a disease upon life and must be made to perish if life is to continue. That which seems grand and noble is but an affliction. All that appears to grant freedom to mankind has in fact ordained its enslavement, impairing and crippling from within, while outwardly bearing the banner of liberty.

The body of humanity has been poisoned and even as it strives for new horizons and constant advancement, rigor mortis has preceded the approach of death and the lives of men are dragged into the grave along with it. Seek now those motions which sow for humanity the seeds of death, as they harvest for you the bounty of life.

"Bring In The Night" (Psalm Of Destruction)
(Released on Death In June's *Wall Of Sacrifice*, 1989)

The order looks upon humanity with disdain. Humanity, that false construct of the ignorant beast, man. Man is a destroyer. His destruction is vast. His destruction is all-encompassing but it is uniquely human. His is not the joyous, self-confident destruction of the barbarian. Nor is it the matter-of-fact and purposeful destruction of a predator fulfilling its natural imperative. Man's destruction is the sour byproduct of life in dysfunction. Man's destruction follows the deadly rhythm of life out of balance. Man destroys his own life while also destroying all life on earth, neither admitting to his destruction nor even recognizing it. Man has squandered his powers and our scorn for him has grown boundless.

By its pitiful motions mankind has demonstrated its unworthiness. Let the destruction it has unleashed devour it. An eye for an eye, a tooth for a tooth, a stripe for a stripe. Let us not misuse the sacred gift of destruction. Let us view it in its true light that we may embrace it. Destruction does not stand opposed to creation. Destruction is an ally of creation, and both are necessary for life to function and flourish. Destruction can no longer be permitted to move outside the will of life. It must regain its rightful place in the order. It must be put to the service of those who serve the will of life.

Let the strong bear witness to my message. Let the strong heed my words. Take up the mighty powers of destruction, for therein dwells the power of life. Wield it wisely and wield it ruthlessly. Order is divine. Hail the order. Hail the wheel of the law.

"Electricity" (Introduction)
(Released with Blood Axis on the compilation *The Lamp of the Invisible Light*, 1991)
Words: Richard Strauss

We three, when all these things are done, and the stream of blood has veiled the murky skies with palls of crimson, which the sun sucks upwards, then we shall dance, all thy blood, around thy tomb. And over the piled corpses I will lift my limbs, high with each step, and all the folk who see me dance, yea, who from afar, only my shadow see, will say: "For a great King, all of his flesh and blood hold high festival and solemn revel, and blessed is he that hath children who shall dance 'round his tomb such holy dances of victory."

"Pack 44" (Fuck Fuck, Kill Kill)
(Released on The Electric Hellfire Club's *Calling Dr. Luv*, 1996)

Man was placed on earth to fuck and to fight. The balance between these two seeming extremes of existence is the substance and essence of life itself. But, we are forced to ask, "Are love and aggression – sex and warfare – truly at opposite ends of life's spectrum, separate and mutually exclusive? Or are they merely different aspects of the same powerful life-affirming force?" Surely the latter must be the case. At this point in human evolution we no longer have the luxury of denying that they are, in every meaningful way, in fact one and the same. Fucking is war, just as fighting is sex.

Aggression and love are both rooted in the same primordial concern: self-preservation. Every act of aggression, whether we know it or not, whether we admit it or not, is an act of self-preservation. Man fights for self-preservation, he kills for self-preservation – and is not the same with love, and sex? Man fucks for self-preservation. Sex is yet another weapon in the struggle for dominance. In sex and war can be seen the grand designs of man's will to power. In the will to dominate – be it territories, peoples, or sex partners – man is a beast of conquest. This is his story, this is his legacy, and this is his destiny. Yesterday, today and tomorrow.

Fuck fuck, kill kill.
Fuck fuck, kill kill.

Fuck fuck, kill kill.
Fuck fuck, kill kill.
Fuck fuck, kill kill.
Fuck fuck, kill kill.

"Absence Makes The Heart Grow Fonder"
(Sung as a duet with Tiffany Anders)
(Originally released on the soundtrack to the film *Grace Of My Heart*, 1996)
Words: Boyd Rice and Tiffany Anders

(Anders)
Absence makes the heart grow fonder.
How I miss him when he wanders.
Now he's gone and I'm alone,
Sitting by the telephone
To hear his sweet voice.

(Rice)
Out of sight, out of mind.
Left my ball and chain behind.
Wild women, wild times
Waiting for me.

(Anders)
Absence makes the heart grow fonder.
How I miss him when he wanders.
How I pine and how I yearn,
Count the days 'til his return to me.
Boy can't you see?

(Rice)
Out of sight, out of mind.
Got to have a swingin' time.
Neon lights, girls galore
Waiting for me.

(Anders)
Absence makes the heart grow fonder.
How I miss him when he wanders.
My heart's so lost and lonely.
He's my all, my one and only love.
He's the one I dream of.

(Rice)
Out of sight, out of mind.
Never know what I might find.
Bedroom eyes, lips of wine waiting for me.
She's out of sight, out of mind.
Out of sight, out of mind.
She's out of sight,
(Absence makes the heart grow fonder)
Out of mind.
Wild women, wild times.

(Absence makes the heart grow fonder)
Out of sight,
(Absence makes the heart grow fonder)
Out of mind.
(Absence makes the heart grow fonder)
Wild women, wild times.
(Absence makes the hear grow fonder)
Out of sight, out of mind.
(Absence makes the heart grow fonder)

"Untitled" (Track #9, Introduction)
(Released on Der Blutharsch's *The Pleasures Received In Pain*, 1999)
Words: Wolfgang Rice

When you were a child, I was a man.
Now, you're my father ... and I'm your child.
The things I know now, I knew then.
The things I know now, I knew then.

"The Cross Of Lorraine"
(Originally released on Luftwaffe's *International Condemnation*, 1999)
Words: Charles Péguy

The arms of Christ are the Cross Of Lorraine,
Both the blood in the artery and the blood in the vein.
The arms of Satan are the Cross Of Lorraine,
In the same artery and the same vein.

The arms of Christ are the Cross Of Lorraine,
Both the blood in the artery and the blood in the vein.
The arms of Satan are the Cross Of Lorraine,
In the same artery and the same vein;
And the same blood in the troubled fountain.

The arms of Christ are the Cross Of Lorraine,
Both the blood in the artery and the blood in the vein;
Both the source of grace and the clear fountain.

The arms of Satan are the Cross Of Lorraine,
In the same artery and the same vein;
And the same blood and the troubled fountain.

"Discipline"
(Released on the compilation *In Formation: A Tribute To Throbbing Gristle*, 1999)
Words: Genesis P-Orridge

Discipline, discipline, let's have some discipline in here.
Discipline, discipline, we need some discipline in here.
Discipline, discipline, we need some discipline in here.

Are you ready girls?
Are you ready boys?
Let's have some discipline in here.
Discipline, discipline, let's have some discipline in here.
Discipline, discipline, I want some discipline in here.
Discipline, discipline, we need some discipline in here.
You know what I need, I want discipline.
I want discipline, discipline.
Discipline, discipline, let's have some discipline in here.
Let's have some discipline in here.
Discipline, discipline, I want some discipline in here.
Discipline, discipline, let's have some discipline in here.
I want, I want, I want discipline in here.
I want, I want, I want some discipline in here.
Discipline, discipline, let's have some discipline in here.
Discipline, discipline, we need some discipline in here.
Discipline, discipline, I want some discipline in here.
Discipline, discipline, I want some discipline in here.
I want, I want, I want some discipline in here.
Discipline, discipline, we need some discipline in here.
Discipline, discipline, let's have some discipline in here.
Are you ready girls?
Are you ready boys?
Let's have some discipline in here.
Discipline, discipline, let's have some discipline in here.
I want, I want, I want some discipline in here.
Let's have, let's have, let's have some discipline in here.
In here, in here, in here.
You know what I need, discipline.
Discipline.
D.I.S. – C.I.P. – L.I.N.E.
Discipline, discipline, let's have some discipline in here.
Have some discipline in here.
I want, I want, I want some discipline in here.
I want, I want, I want some discipline in here.
I want discipline, I want discipline, want some discipline in here.
In here, in here. Let's have some discipline in here.
Discipline, discipline let's have some discipline in here.
Are you ready girls?
Are you ready boys?
Let's have some discipline in here.
Discipline, discipline, discipline in here.
D.I.S.C.I.P.L.I.N.E.
Discipline, discipline, discipline.

"Assume The Position"
(Originally released on Chthonic Force's, *Chthonic Force*, 2000)

Oppression is the opiate of the masses. People genuinely get off on it. Those at the bottom thrive under conditions of oppression and those at the top revel in
imposing such conditions – human nature demands it.

Society, exactly as it now exists, is the ultimate expression of sadomasochism in action. This isn't S. and M. as a mere game; there's no role-playing involved. The roles are all real, with real masters

and real servants. There's no dressing-up required to be a player in this enactment. You don't have to wear your handkerchief in a certain pocket to signal your position as a sadist or masochist either. You simply assume the position. This is sadomasochism not as a fetish but in practical application. The sting of the riding crop is replaced by a more generalized sort of malaise, but when all is said and done it is still an expression of people luxuriating in pain and submission.

To say that people love to suffer is viewed as decadent cynicism by many, but a cursory glance at the world around us would definitely seem to support such a thesis. How telling it is that even in the context of a system created in an absolute ignorance of man's true character, he remains true to his nature regardless.

"The Blackness"
(Sung as a duet with Winona Righteous)
(Released on *The Way I Feel*, 2000)
Words: Little Fyodor

(Rice)
The blackness comes forward
And stares straight into your face.
It smothers you with its ugliness
And blinds your hope like mace.

(Righteous)
And then it goes away
And its just another day,
And you smile at everyone,
But you have little to say.

(Rice)
The blackness is powerful.
It cannot be stopped or slowed.
As the futility becomes more and more evident,
Your will to resist does erode.

(Righteous)
And no one seems to know
And no one seems to care,
And you want to tell them all,
But you know you mustn't dare.

(Rice)
The blackness is patient,
For now it can be your friend.
It can take all the time it wants,
For it knows it will win in the end.

(Righteous)
And it's coffee break at ten,
And the Broncos blew it again;
Elway's gone, now the magic's no more,
And it's really all such a bore.

(Rice)
The blackness is honest

And as sure as the steadiest hull.
It takes your pristine illusions,
Leaves them tarnished, stale and dull.

(Righteous)
You know the arguments are good and long,
Showing that all that you do is wrong.
You want to put them out of your mind,
For you know what you will find.

(Rice)
The blackness takes over,
It imbeds itself deep in your soul.
There's nothing left for you to do
Except acknowledge its complete control.

(Righteous)
And the hospital bed is flat
And you see the world from your back,
And you smile at everyone,
At last you finally can laugh ...

(laughter)

"Tick Tock" (Introduction)
(Released on Death In June's *All Pigs Must Die*, 2001)
Words: Douglas Pearce

This is a story about people who like to waste time. Waste my time, waste your time, waste their time.
But time is against them. Time is everyone's master, including them ...

"We Said Destroy II" (Introduction)
(Released on Death In June's *All Pigs Must Die*, 2001)
Words: Douglas Pearce

This is a story about three little piggies. Three little piggies who never went to market, especially on a
Friday afternoon, when they stayed at home and let other people bring home the bacon. And they still
do. But the rashers get thinner and thinner, and life's knives get sharper and sharper ...

"People Change"
(Released on Boyd Rice & Fiends' *The Registered Three* EP, 2002)
Words: Rod McKuen

People change. Time moves on.
Every midnight gives itself to dawn.
When you left, I didn't think it strange.
After all, people change.

People change, so it goes.
Come the fall, the cold wind blows.

Give your love, get heartbreak in exchange.
After all, people change.

You know as well as I;
With just the same old sky,
A bird gets mighty restless
And has to fly.

People change. Now you're back.
If there's something my old smile seems to lack;
I don't love you now, but if you think it strange,
After all, people change.

"A Noi!"
(Live version released on Boyd Rice & Friends' *Baptism By Fire*, 2004)
Words: Adapted from the slogans of Benito Mussolini

Molti nemici, molto honore.
(Many enemies, much honor.)
Molti nemici, molto honore.
(Many enemies, much honor.)

Molti nemici, molto honore.
(Many enemies, much honor.)
Molti nemici, molto honore.
(Many enemies, much honor.)

A Noi.
(For us.)
A Noi.
(For us.)
A Noi.
(For us.)

Molti nemici, molto honore.
(Many enemies, much honor.)
Non malore.
(Never give in.)
Non malore.
(Never give in.)

A Noi.
(For us.)
A Noi.
(For us.)
A Noi.
(For us.)

"The Scent Of The Vanquished"
(Released on Luftwaffe's *Event Nihility*, 2006)

When day is night and up is down,
(Fetch the rope.)
What goes around will come around.
(Fetch the rope.)
(Fetch the rope.)
As twilight glints off fallen leaves,
(Fetch the rope.)
Strange fruit is hanging 'neath the trees
(Fetch the rope.)
And carried on a summer breeze,
(Fetch the rope.)
The scent of vanquished enemies.
(Fetch the rope.)
(Fetch the rope.)
(Fetch the rope.)

When day is night and up is down,
(Please fetch the rope.)
What goes around will come around.
(Go fetch the rope.)
The birth of joy, the death of hope,
(Fetch the rope.)
The birth of truth the death of hope.
(Fetch the rope.)
What goes around will come around.
(Fetch the rope.)
(Fetch the rope.)
(Fetch the rope.)

As twilight glints off fallen leaves,
(Fetch the rope.)
Strange fruit is hanging 'neath the trees,
(Fetch the rope.)
And carried on a summer breeze,
(Fetch the rope.)
The scent of vanquished enemies.
(Fetch the rope.)
(Fetch the rope.)
(Fetch the rope.)

Boyd Rice
Standing In Two Circles: Spoken Word
(Creation Books, 2007)

"Whatever Happened To ... Quiet Desperation?"

It's been said that most men live-out their lives in quiet desperation. I don't think that's quite correct...

Life's quiet men seem to have come to terms with their lot, leading instead, lives of quiet – and seemingly comforting – submission. Where any degree of desperation exists, people seem rather noisy. They are shrill and boisterous about their desperation – they're stridently vocal about their anger and frustration. More often than not this manifests itself in an endless stream of whining and complaining. These people want to share their discomfort with the world, and by so doing, they inflict their own discomfort on others. All in all, it's enough to make one nostalgic for some time long distant, when quiet desperation may in fact have been the order of the day. It would be such a pleasant change from the altogether more abrasive desperation we have to endure these days.

"Shit List"

If ever I catch me a deadly disease,
I'll declare open season on my enemies.
And I'll hunt them down, and I'll make them pay
For the wretched things that they do and they say.
For I never forgive and I never forget,
And times healing grace doesn't soothe me one bit.

For who wrongs me with words or who wrongs me with deeds,
Has sown a very bitter seed.
And can rest assured, my desire runs deep.
That as they sow, so shall they reap.

So I'm making a list, and I'm checking it twice.
I'll remember with ease who's been naughty or nice.
So if you're on my shit list, it's not over yet.

I never forgive and I never forget.

"Have A Nice Day"
Words: Rod McKuen

Good morning, pass the orange juice.
It says in the paper, people die in Africa.
Well, Africa's a third world away,
And it looks like it's gonna' be another nice day.

This afternoon, I think I'll buy a brand new suit.
Why are you cryin'?
Starving children help sell magazines,
that's why they're always photographed.
Dry your eyes and let me see a laugh.

And what if a man falls down upon his knees,
and can't get up again?
There are lots of men who still walk tall.
And what if a child comes into life
with a rotting face and gnarled hands?
Am I to be his medicine man?
Oh no, not me.
I'll think about the children of the third world
after my own children have grown.

The TV set repeats the same old news,
about the lack of care we show each other.
Well, how can a man in the third world be my brother?
I've got relatives enough at home asking me for money.
And the radio reports tomorrow should be sunny.

Goodnight, and don't forget to say your prayers,
And isn't it nice to fall asleep without a single care?

"The New Psychedelia"

The new colors of psychedelia are black and white. Yes, black and white – the colors of truth. Light and darkness standing side by side. Noontide and midnight experienced at one and the same time.
 Duality is dead, killed by the new psychedelia. Killed to signal the coming of the final messiah. And when that messiah makes the scene, he won't be riding no donkey ... he'll be on a zebra. And cloaked in the garments of the sun and the night.

"Television: The Great Healer"

Stress-related illness kills countless Americans yearly. Excess stress can even compound your risk for cancer immensely. Stress comes from an over-abundance of beta rhythms in the brain; these are the rhythms produced when the mind is in its alert, problem-solving mode. Alpha rhythms are the mind's healing rhythms and confer a kind of inner peace. It is no mere coincidence that the vibratory frequency of the television set in your home corresponds precisely to the brain's alpha rhythms. It is

the work of God. Merely watching your television for a few short minutes induces the alpha-state and invokes the brain's own healing rhythms. So, for your health's sake, turn on your television and turn off your mind. Shut-out the chaotic static of the outside world. Tune in, turn on, and drop in.

"The New Imperium"

The new imperialism is not a matter of nation invading nation and imposing its ideology. It is more a case of psychic imperialism, of invading the mindspace of others by imposing a *total psychic imprint*, be it good or bad.

Andy Warhol, Adolf Hitler and Jesus Christ are all dead. Love them or hate them, they demand more of your mindspace than Gandhi or Mother Theresa. Love and hate are mere commodities, abstractions with differing meanings for every given spectator.

Fun is a different question altogether. It is the great equalizer. A rollercoaster ride represents the same experience to those on both the left and right, to Christians, Satanists, atheists, and Pagans. Fun is the new imperium, the last bastion of revolution. It transcends ideology and dogma, and renders both irrelevant.

"Ladybird"
Words: Traditional (Mother Goose Nursery Rhyme)

Ladybird, ladybird,
Fly away home.
Your house is on fire,
Your children will burn.

"Bandy Legs"
Words: Traditional (Mother Goose Nursery Rhyme)

As I was going to sell my eggs,
I met a man with bandy legs.
Bandy legs and crooked toes,
I tripped up his heels and he fell on his nose.

"Goosey Goosey Gander"
Words: Traditional (Mother Goose Nursery Rhyme)

Goosey, goosey, gander,
Where dost thou wander?
Upstairs, downstairs
And in my lady's chamber.
There I met an old man
That wouldn't say his prayers.
I took him by the hind legs
And threw him down the stairs.

"Two Little Blackbirds"
Words: Traditional (Mother Goose Nursery Rhyme)

As I went over the water,
The water went over me.
I saw two little blackbirds,
Sitting on a tree.
One called me a rascal
And one called me a thief.
I took up my little black stick
And knocked out all their teeth.

"Birds Of A Feather Flock Together"
Words: Traditional (Mother Goose Nursery Rhyme)

Birds of a feather flock together
And so will pigs and swine.
Rats and mice have their choice
And so will I have mine.